THE ARCHITECTURE OF ISLAMIC IRAN

The Il Khānid Period

BY DONALD N. WILBER

GREENWOOD PRESS, PUBLISHERS
NEW YORK

PREFACE

THIS study includes a large share of the material relating to the art and architecture of Iran collected by the author in that country during more than a decade. This field work was carried out on a number of occasions: during a first trip to Iran in the winter of 1934 and the spring of 1935; as a member of the Architectural Survey expeditions of the Iranian Institute in the summer and fall of 1936, the summer and fall of 1937, and the spring and summer of 1939; and, during continuous residence in Iran from September 1942 until June 1946.

Material collected by the author and by other members of the Iranian Institute through the season of 1937 was given preliminary publication in Section VI, "The Architecture of the Islamic Period" in *A Survey of Persian Art*, edited by Arthur Upham Pope and published in 1938. However, a great deal of the field material had not been worked up for publication in the *Survey* and by 1939 it seemed clear that the mass of field notes and drawings would tend to become increasingly unwieldy unless the survey work were concentrated along definite lines. The author suggested that special attention be devoted to the important but relatively little known Il Khānid period. This plan was followed in part during the 1939 season and after the fall of 1942 when the author was able to travel to a number of sites located well off normal lines of communication.

The material described in this work covers the thirteenth and the fourteenth centuries A.D. which have here been entitled the Il Khānid period. There may be some question as to what extent these two centuries represent a distinctive historical and architectural period. Certainly the period has a sharply defined historical beginning, that of the Mongol invasions which so devastated Iran, and a clear-cut architectural beginning, considerably later than the invasions, when new monuments began to rise from the ashes of the old towns. As a historical period, it might seem to end with the death of the last powerful Il Khānid ruler in 1335 but it was actually prolonged throughout the life of a number of local dynasties until the conquest of Iran by Tīmūr just before 1400. As an architectural period, the death of Abū Saʿīd in 1335 was followed by no sudden break in architectural activity, and stylistic and decorative trends maintained a steady development throughout the rest of the century to find culminating expression in the Tīmūrid monuments.

Two themes should be apparent throughout the various parts of the text. One theme relates to the continuity, persistence, and vigor of Iranian culture. The pages which describe Iran under the Il Khānid rulers detail the increasing appeal of this culture to the Mongol barbarians and the final establishment of an atmosphere most fertile for artistic activity. In the realm of architecture, continuity as a vital characteristic of the Iranian culture is reflected in the close correspondence between structures of the earlier Seljūq period and the monuments erected in the Il Khānid period after an interval of more than fifty years during which there was practically no building activity.

The other theme is that of the steady development and growth of architectural style and decoration in Iran. Historians of Moslem architecture may still be faced with the need for correcting mistaken ideas about Islamic building as well as certain older prejudices which will continue to persist as long as the Moslem monuments are not better known.

[v]

Thus, Banister Fletcher in his widely used handbook, *A History of Architecture on the Comparative Method*, gives architecture in Islamic Iran the name of Persian Saracenic and includes it among his nonhistorical styles. His attitude was clearly expressed in these sentences: "Eastern art presents many features to which Europeans are unaccustomed, and which therefore often strike them as unpleasing or bizarre; but it must be remembered that use is second nature, and, in considering the many forms which to us verge on the grotesque, we must make allowance for that essential difference between East and West which is further accentuated in purely Eastern architecture by those religious observances and social customs of which, in accordance with our usual method, we shall take due cognizance. These nonhistorical styles can scarcely be as interesting from an architect's point of view as those of Europe, which have progressed by the successive solution of constructive problems, resolutely met and overcome; for in the East decorative schemes seem generally to have outweighed all other considerations, and in this would appear to lie the essential differences between Historical and Non-Historical architecture." Such a statement is no longer taken at its face value but the suspicion that there is something exotic, chaotic, and disorganized about Moslem architecture still lingers. The real truth is that in any country, over any extended period of time, the exhaustive familiarity on the part of the builders with materials of construction results in logical changes in method, style, and decoration, while over a still longer period the successive phases of experimental trials, developed style, and gradual disintegration of style appear. This truth has full validity for architecture in Islamic Iran. It is, however, true that stylistic developments may follow a rather different course than in western architecture and distinctive features such as the long continued use of design elements, the relative lack of interest in experimental construction, and the care lavished on revetted surfaces are given special emphasis in the text.

My primary acknowledgment is to Arthur Upham Pope, until lately Director of the Iranian Institute and Chancellor of its parent organization, The Asia Institute of New York City. This obligation dates from the moment when the first sight of Mr. Pope's splendid photographs of architecture in Iran aroused such an overwhelming desire to see these monuments that within a few months I was on my way toward that far-off land, and it has been prolonged in a friendship formed and tested during the rigors and delights of travel over the length and breadth of Iran. A present and specific obligation is for permission to make published use of material collected for the Iranian Institute.

Thanks are also due in large measure to the following individuals, all members at one time or another of Architectural Survey expeditions: Eric Schroeder for generously supplying information from his own field records, for reading an earlier draft of this study and for offering a host of precise and provocative comments and suggestions; Mary Crane Hope for her exhaustive field notes and epigraphical records of several of the monuments; Margaret Surre Wilber for field notes and sketches of architectural details; Stephen H. Nyman for photographs of several monuments; and again to Arthur Upham Pope for his photographs which comprise the bulk of the illustrative material of this volume. Also to Dr. George C. Miles for his kindness in examining two of the inscriptions.

Thanks also go to friends and acquaintances within Iran. André Godard, long Director of the Archaeological Service of Iran, kindly read the manuscript of the catalogue of archi-

tectural monuments and made valuable suggestions firmly based upon a score of years of study of Iranian architecture and archaeology and, in addition, generously offered a number of photographs. M. T. Mustafāwī, now head of the Archaeological Service, and 'Abbās Eqbāl, Professor of History at the University of Tehran, were unfailingly helpful. Pleasant memories are associated with a host of hospitable and helpful individuals, including officials of the Ministry of Education, provincial officials, school teachers, road guards, and voluntary hosts in remote villages.

For advice and aid with the organization and presentation of the subject matter and with the content of specific passages I am deeply indebted to E. Baldwin Smith, Chairman of the Department of Art and Archaeology of Princeton University—my early teacher, valued friend, and stimulating critic.

Further thanks are due the Department of Art and Archaeology and the Department of Oriental Languages and Literatures of Princeton University for their generous aid.

DONALD N. WILBER

Princeton, New Jersey
October, 1953

INTRODUCTION

THIS book comprises a historical sketch of the Il Khānid period of Iran, a discussion of the style of the architecture of this period, and a rather exhaustive catalogue of the surviving monuments.

In speaking of the architecture of the Il Khānid period a political rather than a stylistic label is being applied. Rulers and events were to favor and foster the development of architecture during the period but not to create it, and the history of this time must be presented at some length in order to illustrate why this was the case.

The accounts of actual witnesses to the events of the thirteenth and fourteenth centuries, many of them still available to the scholar only in manuscript form, are largely concerned with personalities, rivalries and plots, campaigns and insurrections, while the bulky secondary treatments by western scholars emphasize the barren framework of names, dates, and places. Drawing upon the mass of primary and secondary material studied as background to the monuments, the author has put together a running account of the Il Khānid period in which all specific references to architectural activity have been included and in which some stress has been placed upon the cumulative effect of Iranian cultural traditions upon the Mongol intruders.

The most detailed substance of the study, the catalogue, is the outcome of many weeks of observation in the field and of many months of dissection and reconstruction in the study. While the author's sketch of the history of the period or his account of the features of style may be superseded, the description of the monuments themselves should have a lasting validity. However, since a limited number of readers may be expected to follow those pages with eager attention, the catalogue has been relegated to the end of the volume.

The force and continuity of Iranian culture was a potent element in the changing historical pattern over a period of many centuries. From the earliest times the lofty plateau of Iran offered an attractive corridor for the westward sweep of migratory groups and represented a rich destination for the campaigns of great military leaders. Invasions and conquests frequently devastated the country beyond any apparent possibility of recovery, but after each such bitter trial its culture reemerged. Peoples who entered Iran in mass migrations or as members of a victorious army tended to settle in an environment which was more attractive than their places of origin—often the barren steppes to the northeast. Thus, while such important dynasties of internal origin as the Achaemenid, Sāsānian, and Ṣafavid brought world renown to the country, the Parthian, Seljūq, and Mongol dynasties all stemmed from invaders, nomadic in character, who overran Iran from the east and ruled over the area for long years. None of these intrusive major dynasties, nor other less significant ones of foreign origin which could be cited, introduced significant cultural features to Iranian civilization, but the members of their ruling classes were profoundly influenced by the established artistic and literary traditions of Iran.

The Seljūqs, a Turkish clan of nomads who established their hold over all Iran by 1055, had a meager cultural heritage of their own, but once established in Iran the hardy, illiterate overlords became patrons of learning and the arts. In the field of architecture they encouraged or directed the erection of imposing structures which worked to give a

precise character and quality to the earlier experimental forms of Islamic architecture in Iran. Thus, this royal patronage served to crystallize and formalize architectural types which might otherwise have remained at a less monumental level for a much longer period of time. Seljūq prototypes are few in number: less than a score of important structures erected between the Arab invasion of Iran in the seventh century and the year 1055 still stand. With regard to plan, these earliest buildings reflect a lack of interest or an inability to combine separate units into a balanced ensemble; with regard to structural methods, they display a reliance upon pre-Islamic Sāsānian models and feature massive bearing walls and a timid use of free standing columns; with regard to constructional materials, a swing to brick rather than the stone or stone and brick systems of Sāsānian times; and with regard to decorative interest, a facility in plaster ornament and a growing interest in brick bonding patterns.

The standing monuments from the Seljūq period are predominantly religious in character. They display a complete mastery, in brick, of the architectural forms inherited from Sāsānian times and in these buildings the basic character and construction of the dome and the īvān—a rectangular, barrel vaulted hall completely open on one short end—was fixed for all later periods. However, experimentation toward the crystallization of a unified mosque plan was still being carried on: the trend was to dispose dome, īvān, and flanking elements around an open court and the solution, arrived at during the period and featured during the Mongol, Tīmūrid, and Safavid periods, probably stemmed from the traditional domestic architecture of the general region. While structure would be lightened and refined and while decorative surfaces would be more highly developed, the general character of Seljūq architecture was to survive across the long span of years of the decay of their authority and the terrible destruction wrought by the Mongol hordes.

As the Mongols under Chingiz Khān and his successors moved across the breadth of Asia, armies, tribes, and clans gradually established themselves in regions which may have seemed to be almost infinitely remote from the homeland of Lake Baikul. Traveling with their *yurts*, a dome-like tent of felt or skins stretched over a framework of bent wood and easily taken down for transport by horse, these Mongol warriors were at home wherever there was good pasturage for their horses and they continued in their nomadic way of life long after they had decided to remain in Iran. As did the Seljūqs before them, they brought little cultural and intellectual baggage to contribute to the brilliant crescendo of art, architecture, and literary production which was to culminate at the end of the Il Khānid period.

In the realm of architecture, most of the building done during the period would have been erected by the native inhabitants during a time of internal tranquillity regardless of the rulers then in power. The Il Khāns themselves displayed little positive concern with architecture, in the sense of occupying the newly erected structures themselves, until nearly the end of their reigns. What they did do was to issue the edicts and orders, drawn up by their Persian ministers, which provided for building construction on an extent and scale beyond the resources of the individual communities. Until near the end of the Il Khānid period, these rulers seem to have spent only a restricted amount of time in urban courts and palaces and instead held their court, according to season, on the warm plains or the cool mountain slopes, sheltered by spreading tents and canopies or living in open pavilions

constructed of wood. However, the last important rulers of this line did take a real personal interest in the planning and erection of several outstanding monuments and by this interest brought about a general uniformity of architectural style throughout Iran. These great structures followed established plan types but were on a scale which surpassed all earlier efforts. Their very size demanded that artisans be called in from all over the country. On the job these workmen were exposed to the most advanced techniques of the period, with each master contributing his special knowledge, and when the structures were completed they returned to their several provincial areas to put into local practice the developed skills of the period. Thus, even after the Il Khānid authority had lost its hold, the high style was not lost but was continued and developed at provincial centers, preparing the ground for an early fifteenth century crescendo of architectural activity under still another conqueror— this time Tīmūr.

Transliteration of Persian and Arabic words.

Consonants					*Vowels*		
b	ب		s	س	w or v	و	
t	ت		sh	ش	y	ى	
th	ث		ṣ	ص	bā	با	
j	ج		z	ض	bī	بى	
ch	چ		t	ط	bu	بو	
h	ح		ẕ	ظ	bay	بى	
kh	خ		ʻ	ع	a	ه	as in khāna
d	د		gh	غ	iya	تّه	
dh	ذ		f	ف			
r	ر		q	ق			
z	ز		k	ك			
zh	ژ		g	ك			
			m	م			

The system of transliteration indicated above is the one employed in the majority of publications in this field. However, in a very limited number of cases this system has been abandoned for the use of more familiar forms of certain names and places. As a conspicuous example, Āzerbāijān is used instead of Ādharbāyjān. Iran is correctly Īrān but in view of the extreme frequency with which the word is used the vowel markings have been omitted, while Il Khānid, rather than the more correct form of Īl-Khānid is used.

CONTENTS

PART I

IRAN UNDER THE MONGOL IL KHĀNS

1. The Mongol Invasions

AT THE opening of the thirteenth century a lull in the tempo of military, domestic, and artistic activity prevailed over the vast expanse of Iran. It was the ominous calm before the storm.

Iran had enjoyed material prosperity under the rulers of the Seljūq dynasty who had wielded great power for almost one hundred and fifty years, but before the middle of the twelfth century a decline had set in and by the end of the century the Turkish Khwārazm Shāhs were supreme. Originally vassals of the Seljūqs, the Khwārazm Shāhs revolted and secured position of Khwārazm and Khurāsān and then spread over central Iran. In the first two decades of the thirteenth century their ruler, Shāh Muḥammad, controlled 'Irāq, Fārs, and Āzerbāijān. Muḥammad had far-reaching plans for the expansion of his kingdom and was on his way to Baghdād when reports of the eastward movement of mounted warriors called him back to his capital city of Samarqand. With large forces already in the field he had no reason to fear possible invaders.

However, Muḥammad was to face no ordinary warrior but Chingiz Khān, whose hordes fell just short of sweeping over the entire civilized world. Rising from complete obscurity, Chingiz had marshaled the Mongol tribes and, like a tidal wave, swept south and east, then west. In 1205 he invaded northwest China, in 1211 the Kin Empire and by 1215 he had reached the Yellow River and captured Peking. In 1219 he turned west at the head of an estimated 700,000 men.

In his sweeping course across Asia, Chingiz reached the confines of the lands held by the Khwārazm Shāhs. At first Chingiz had neither reason nor desire to attempt the conquest of Iran. Muḥammad, however, was exceedingly undiplomatic in his correspondence and in his treatment of the Great Khān's ambassadors. Friction arose and Chingiz set his armies in motion.

Opposition to the Mongol advance was poorly organized and in 1220 Bukhārā was taken. Chingiz Khān rode on horseback into the great mosque and startling revels were held in the enclosure: first the sacred books and then the city itself were burned. The next town to fall was Samarqand and in the accounts of its destruction we find the first mention of the fact that a certain number of the artists and artisans were spared. Then great Balkh was taken, burned, and every living thing therein put to the sword. Scouting columns of cavalry were despatched to hunt down Sultān Muḥammad. Relentlessly they pursued him for hundreds of miles across the high plateau until he escaped from the Caspian shore just ahead of his pursuers to land on a small island where he died soon after.

The sack of the other important cities continued: all were burned or were flooded out of existence by diverting the courses of entire rivers. Merv and Nīshāpūr fell in 1221. Certain towns have been selected for mention because they later arose from their ruins, but countless other flourishing places were so thoroughly destroyed that their very location is not known to us. There is no need to exaggerate the extent of the destruction they wrought: statisticians have concluded that in certain areas such a large percentage of the population was killed that if the regions had been repopulated by the meager remnants at

a normal birth rate, to this day there would still be fewer people living there than before the appearance of the Mongols.

After his unbroken victories Chingiz retired to the east where he died in 1227. The council which named Ogotai as his successor also decided to renew the campaigns against the battered Khwārazm Shāhs. Within Iran the gallant son of Muhammad, Jalāl ad-dīn, was attempting to build up a means of resistance against future attacks. With filial piety he had ordered a splendid tomb erected at Iṣfahān to house his father's remains, but the body never reached the town and it is even doubtful whether the mausoleum was built.

Churamgun was the newly named Mongol commander who led fresh forces across the province of Khurāsān and on to Iṣfahan and Rayy, while a single contingent roamed much farther west to attack Jalāl ad-dīn on the Mūghān plain in Āzerbāijān. Jalāl moved north and east around his pursuers to spend the winter of 1231 at Mahan, while the Mongols apparently wintered at Aūjān. With the coming of spring the Mongols moved out of camp in pursuit of Jalāl ad-dīn until, in lonely flight, he was slain by Kurdish tribesmen. The Mongols then devastated the regions of Diyār-Bakr, Erbīl, and northern 'Irāq.

Marāgha and Tabrīz surrendered and so escaped destruction. As these raids and excursions continued year after year the districts of Āzerbāijān, Armenia, Persian 'Irāq, and Arrān were parceled out by Churmagun as prizes to his leaders. Countries and districts which yielded immediately and paid a high ransom were spared: thus, Georgia was allowed to retain its princes who entered into alliances with the Mongols. Kirmān and Fārs in southern Iran also capitulated and were spared, while Khurāsān which had been sadly ruined and heavily taxed was favored with a notable governor named Kurguz who settled at Ṭūs and worked in all earnest to assure public safety and to reestablish prosperity. During these same years, 1243 until 1246, attacks were begun against the powerful Caspian fortresses of the Ismāʿīlites, the sect known to the western world as the Assassins.

Between periods of active duty the Mongols continued to winter on the grassy plains of Arrān to the west of the Caspian and to summer on the slopes of Mount Ararat. As these troops became permanent garrisons domestic life tended to return to familiar channels. At the same time the situation could not have been favorable to artistic enterprise, since almost no monuments have survived which can be dated between 1220 and 1270 and the ceramic workshops are known to have produced very little during these same years. It might be expected that in Fārs and Kirmān, the part of the country entirely spared from destruction, there might be a continuous record of building activity. The literary history of the monuments themselves, as given in the catalogue, illustrates that such was not the case.

In 1241 the Georgian princes had sent the Rabban Simeon to Ogotai to plead for the protection of all those who had not opposed the Mongols. This petition was granted, free exercise of religion became the rule in the Mongol lands, and Simeon was sent back with full authority to look after the welfare of the Christians in Georgia and Armenia. Churches were soon built in such fanatically Moslem cities as Tabrīz and Nakhichevan. Simeon himself baptized numbers of the Mongols into the Nestorian faith. The Nestorians had their own communities throughout Asia, many of which had survived and prospered from the early years of the Christian church. Not only were there large numbers of them in northern

'Irāq, Georgia, and Armenia, but their colonies had spread throughout the east so that by the eleventh century the great Kerait tribe was converted to Christianity. This tribe was a strong ally of the Mongols and from its members came several of the wives of the Mongol Il Khāns who openly professed and practiced their faith. The khāns visited the Nestorian churches and witnessed the ceremonies on many occasions. Waves of conversion were features of the thirteenth century and Iran was so ardently adherent to the church that it supported nearly a score of metropolitan sees.

In Europe the first real awareness of the new problems presented by the Mongols came after the invasion of Poland and Hungary by the horsemen of Batu and in 1245 Innocent IV called a council at Lyons to devise measures to defend Christendom against the Tartars. The naive decision to convert the Mongols instead of fighting them was taken. The fantastically unreal ideas that had grown up a century earlier about a sovereign named Prester John, who was a Christian and a powerful figure in the east, were still current and aided the belief that mass conversion might not be so difficult. Further, reports had reached Europe that in many places the Mongols were destroying the Moslem armies, but displaying tolerance towards the Christians. If an active alliance could be arranged it would not only save Europe from invasion but would aid the situation in the Holy Land where the soldiers of the later Crusades were having increasing difficulty in defending their coastal towns against the attacks of the Moslems of Syria and Egypt. Thus, in the same year Innocent IV wrote letters from Lyons which he dispatched with two separate embassies. The six Dominican members of the party which went to Batchou in Iran were too headstrong to make the proper obeisances and only just escaped with their lives to carry back arrogant letters, recorded by Vincent of Beauvais. One reads in part: "If you, Pope, wish to retain your patrimony, you must come to us in person, and present yourself before the master of the whole world."

Prior to this time there had been no accredited Mongol authority in Iran for such negotiations, but in 1246 Arghūn was appointed civil head of the area with a commander named Ilchikidai as head of the armed forces. Arghūn began to draw up a summary of the resources of the country, instituting a tax register of all males above ten years of age and levying taxes on artisans, iron mines, and fishing rights. An inventory of all animals and land was made, and one man from every nine was selected for compulsory military service. Ilchikidai sent ambassadors to St. Louis at Cyprus to announce that the Mongols would aid in operations in the Holy Land: the letter is preserved in the Chronicle of St. Denis. An early reply was the dispatch of three priests who bore as presents a "chapelle d'ecarlate"— a portable tent-church of scarlet material—paintings representing the life of Christ, a fragment of the True Cross, and letters expressing gratification that the Mongols had adopted Christianity. This appears to have been the first example of a cherished misconception by the Franks—that the Mongols had been, or were about to be, converted *en masse*. In 1253 St. Louis sent Guillaume Rubruquis and Barthelemi de Cremone from Constantinople to the court of Mangu Khān, who returned a rude reply. Rubruquis wrote a detailed and valuable account of his journey, including a resounding condemnation of the Nestorians.

[5]

Hayton I, King of Lesser Armenia, went himself to the court of Mangu in 1254 to secure favorable treatment for his country and from this time on Armenia did everything possible to bring the Mongols and the Franks together, to oppose Islam and to promote the Crusades. In his own record Hayton took credit for an event of great historical significance: the dispatch of Hūlāgū to the west.

2. Hūlāgū, The First of the Il Khāns

HŪLĀGŪ was a Mongol of the highest rank: brother to the Khakans Mangu and Kubilai. In the great council held at the accession of Mangu it was decided to send Kubilai against China, a campaign soon undertaken, and to dispatch Hūlāgū to the west. This latter action was considerably delayed, but in 1245 the advance guard set out with Hūlāgū following with the main army of about 70,000 men. This force was made up of contingents from all the Mongol tribes and was remarkably well equipped with siege machines of every type. Families of Chinese experts superintended the movement of these machines on carts: arbalists, mangonels, flame throwers, and throwers of fiery arrows. It is usually said that Hūlāgū was sent to attack and destroy the Ismāʿīlites and to come to terms with the Caliph at Baghdād and that he had no commission to establish himself as civil and military ruler over Iran.

Hūlāgū's initial progress was marked by festivals rather than by fighting. The reports of a great feast held at Balkh give some idea of the portable equipment taken along for regal display in the account of a huge tent of gold cloth which was held to the ground by one thousand gold pegs. Passing the present frontier of Iran he moved on to Torbat-i-Haidari: his route is of interest since many of the towns through which he passed have surviving monuments erected in the reigns of his successors.

Turning north, he went to Ṭūs which had earlier been selected as the principal head-quarters of the Mongols in eastern Iran. The route led on to Rādkān and to Khābūshān (Qūchān) and at the latter site Hūlāgū commanded that the ruins caused by previous waves of invasion should be restored. At this point he seems to have turned south across the mountains until he struck the age-old east-west highway. He paused at Bisṭām and then moved on to Fīruzkuh, Lār and Demāvand—the latter site in the region of Tehrān, the modern capital. A settled camp must have been established at Qazvīn for records state that first nearby Maymūndiz was besieged and then Alamūt. Alamūt was the principal center of the Assassins and was considered to be the strongest fortress ever devised by man: it was stocked with provisions for five years of siege and had supposedly impregnable walls. However, the siege engines were unleashed in full fury, the citadel soon fell and the walls were utterly razed. This momentous blow led to the surrender of the other strongholds of the Assassins.

Apparently Hūlāgū wintered in this same vicinity, at Lemser, and in the spring of 1257 moved south, again along the great east-west highway, to Hamadān. Messengers were sent to the Caliph al-Mustaʿṣim advising him to dismantle the fortifications of Baghdād and yield to the Mongols. The Caliph was a weak and debauched figure; beset with conflicting advice by his courtiers, he was probably betrayed by traitors in his high council. Negotiations failed and in the winter Hūlāgū moved behind his advance guard, first to Kirmānshāh and then to Khaniqin where the baggage was stored. Early in January 1258 he set up camp outside of Baghdād and after a month of siege the city fell by storm. Thousands of its residents were slaughtered and the royal palace, the great mosque and the tombs of the Caliphs were set afire. A great booty of gold and silver, precious stones and pearls, products of Greece, Egypt, and China, and fine horses and slaves in quantity fell to the soldiers and

their leaders. The Caliph and his family were put to death, probably at the urging of the Persian Shī'a followers of Hūlāgū who were natural opponents of the Sunnī Caliphs.

From Baghdād Hūlāgū returned to Iran by way of Kirmānshāh and Hamadān with the fixed intention of settling in Āzerbāijān. In the fall of 1259 he set out for Syria to bring about the subjection of the Egyptian Mamlūks and he probably had planned to invade Egypt proper. His army advanced at a steady pace, taking the towns of Akhlāt, Nisībīn, Harrān, and Raqqa, and in January 1260, the city and citadel of Aleppo fell. While there, news came of the death of Mangu Khān and since, by Mongol custom, all the princes were required to attend the great council held after the death of a Great Khān, he started back toward China. However, when Hūlāgū reached Marāgha he learned of the accession of Kubilai as Great Khān and turned aside to his summer quarters in the Mūghān. His army pressed south from Aleppo and quickly captured Damascus where, as at Baghdād, the Christians in the city were spared from harm. Then, his army met the full force of the Egyptians in the open field at 'Ayn Jālūt in Palestine and when victory was nearly in sight they were forced back and fled in disorder across the waste lands and over the Euphrates. This was the first major blow administered to the hardy warriors from the east, but it was enough to persuade them of the value of forming military alliances. From this moment they were anxious to have help against Egypt and tried to obtain it from Europe by promising unlimited aid to the Crusaders.

Between 1259 and 1265 Hūlāgū and the vast body of his followers resided in Āzerbāijān. Kubilai had divided the domains of the Mongols into four principal divisions: the share of Hūlāgū included Iran proper, Khurāsān, Āzerbāijān, 'Irāq, Georgia, Armenia and a part of Asia Minor. Hūlāgū assumed the title of Il Khān which can be translated as "subordinate khān" or "ruler of the tribe": the title was passed on to his successors as the designation of a dynasty. The area under his power was divided into several administrative sections with his sons as governors of two of them—notably his eldest son, Abāqā, who controlled central Iran, Māzanderān and Khurāsān with his capital at Nīshāpūr. An amīr was stationed at court as the personal representative of the Great Khān in whose name the coins were struck. Apparently Tabrīz was named as the capital of the newly authorized realm and the concentration of the Mongol power in Āzerbāijān caused a sudden shift of the wealth and the culture of the country from Khurāsān where it had been for several centuries. Tabrīz began to take on a more imposing status than it had formerly had as the chief city of a district. The destruction of the power of the caliphate had taken from Baghdād and such towns as Mosul a large amount of their commercial importance although trade through Baghdād to India by way of the Persian Gulf was still flourishing at the time of Marco Polo's visit about 1300. Traders and commercial agents of the Italian city states who had long been established along the Syrian coast now began to make their way inland, following directions and information furnished by the priestly envoys to the Mongols.

Hūlāgū, his court, and his followers could no longer continue to live and move about as simple nomadic warriors; they were rapidly influenced by the impact of contact with a refined civilization and by their physical environment. A great deal more concentrated intellectual activity was needed to control large agricultural areas and to govern many towns and countless villages than had been the case during a predominantly nomadic

existence. The Mongols, quite unwittingly, were gradually and profoundly affected by their contact with Islamic and Iranian culture. The Mongol *yasa* or the code laid down by Chingiz Khān as a proper authority for controlling turbulent tribal units and dealing with such elemental problems as the ritual methods for sacrificing animals or the retributive punishment for common crimes was scarcely adaptable to the new situation. The interior divisions and the management of the country soon returned to the routine set down under the ancient Iranian feudal system. Indeed, immediately after the fall of Baghdād Hūlāgū had delegated considerable regional authority to notable Iranians. Probably the fact that civil and criminal law and many manners and customs were to stem from Moslem ways began to prepare the way for the adoption by the Mongols of the Islamic religion to replace the void of their general indifference or their mild inclination to Buddhism. Christians were well treated throughout the reign of Hūlāgū and the Georgian and Armenian historians recount a number of specific instances of this kind. Certainly this was a perfectly natural state of affairs for the mother of Mangu, Kubilai, and Hūlāgū was a Nestorian Christian as was Doqūz-Khātūn, the principal wife of Hūlāgū. She openly professed her faith and chapels were set up at the various encampments by her command. Indeed, Hūlāgū himself said to an Armenian monk, "My brothers and I have fallen out on this subject; I love the Christians and hold their cult in favor in the palace; they are favorable to the Moslems and profess their creed."

Hūlāgū and his followers continued to pass the hottest and the coldest periods of the year in nomadic fashion. Most of the popular sites—Mūghān, Berdaa, Ālāṭāgh, Aūjān, and Qarābāgh—were within a few days' journey from Tabrīz. His own favorite residence was Marāgha. The site was one which especially suited his needs. The ground was rolling, watered by a small river and with cool mountains behind. In front lay the wide flats bordering Lake Urmiya which provided fine pasture for the countless horses of his followers. Such encampments were certainly the direct outgrowth of the tent communities common to Mongol tribal life but now endowed with a certain air of elegance and semi-permanence.

In these camps his princes and amīrs had their houses and there were numerous tents of horsehair and felt and enclosures for the domestic animals. Bazaars were set up and supplies of all kinds were plentiful, but naturally rather dear because of the locations isolated from the large towns. Buddhist temples, Christian churches, and mosques all appeared in portable forms. At Ālāṭāgh Hūlāgū ordered a palace built and a chance note in an Armenian history tells that an Armenian prince was sent to a certain district to cut wood for the palace. Another such palace was constructed at Khoi.

The years of Hūlāgū's reign gave rise to construction of a less ephemeral nature. Immediately after the fall of Baghdād, Hūlāgū sent a high officer to Āzerbāijān to build a treasure house for the prizes of Baghdād and other campaigns. This fortified structure was said to have crowned a rocky height of that island of Lake Urmiya whose peaks are visible from Tabrīz on a clear day. Ker Porter, an intrepid traveler of the eighteenth century sought to identify the spot, while all the detailed histories of the Mongols have lengthy footnotes of speculation on the problem, some writers placing the site in the mountains to the east of the lake. In more recent years, aerial photographs of the rocky island of Shāhī showed traces of walls and led to the exploration of this inaccessible spot.

A description of a rocky crag protected with walls and bastions and provided with a hewn stair leading to a series of rock-cut platforms and cisterns is given in the catalogue but none of these remains can be established as contemporary with the time of Hūlāgū.

At this same period, Hūlāgū ordered construction begun on an astronomical observatory at Marāgha. Certainly this idea had been suggested to him by Nāṣīr ad-dīn of Ṭūs, a brilliant figure and one of the intellectual adornments of his time. Some mention of the learning and accomplishments of this man will demonstrate the attachment of the Persians to culture even during the most troubled periods. Nāṣīr had formerly been in the service of the Assassins and had already written on such subjects as economics, politics, and society, working under the inspiration of Greek sources. The pressing duty of the new observatory was to make observations of the heavens and to draw up a new series of tables; such tables would not only have a scientific value but would be useful in casting the horoscopes so much in demand, for the Mongols undertook important steps only at times judged favorable by an interpretation of the heavens. Hūlāgū insisted that the tables be assembled with utmost rapidity and the observations were completed in twelve years, a feat made possible only by taking full advantage of Ptolomaic tables and others assembled in Baghdād and Syria a few centuries before. Hūlāgū went to Marāgha at this time and probably saw work begun on the building which soon housed astrolobes, armillary spheres, and a terrestrial globe. A slit in the great cupola allowed the rays of the sun to record the height of the meridian upon the pavement below. The vast sum of 30,000 dinars was spent upon instruments alone and one wing was probably given over to a library for manuscripts taken at Baghdād and elsewhere. Nāṣīr had four learned Persian assistants and skilled helpers brought from China. A notable member of the staff was al-'Urdi, an architect and an engineer as well as an astronomer, who was in charge of the foundry and tool shop; his written description of a number of the instruments used in the observatory has survived in manuscript, and it was probably he who supervised the construction of a fine celestial globe now in the museum at Dresden which bears an inscription stating that it was made at Marāgha in the year 1279.

The revival of architecture which began under Hūlāgū was a slow and laborious process. Almost two generations of inactive designers or master builders had intervened since the last great monuments had been erected and yet the structures soon to be built were the immediate successors in plan arrangement and decorative details of the monuments of thirteenth century Iran. Probably the hereditary training of the craftsmen within their own family circles served to preserve these faculties over this span of years. Possibly the fact that south and central Iran had enjoyed comparative peace meant that the crafts had continued to flourish there. Possibly the various techniques had been nurtured in Asia Minor, and master builders from Iran whose names are recorded on the monuments of Asia Minor gradually drifted back to their homeland as conditions became more favorable for craftsmen.

Hūlāgū died in 1265 and was buried on the island of Shāhī near the site of his treasure house or, according to a less reliable source, in the mountains near Qazvīn. In the years immediately following his death the control of the country passed through the hands of several less able members of his family: two sons and two grandsons.

3. Five Successors of Hūlāgū

ON SUCCEEDING to the throne at the age of thirty-one, Abāqā continued the fundamental policies of Hūlāgū. Governmental authority was divided into the three main branches of military, civil, and financial. Certain sections seem to have been granted greater independence: a measure of sovereignty was accorded to Kirmān, Fārs, Herāt, Georgia, and Armenia. The principal vazīr, Shams ad-dīn Muḥammad, was himself a member of a very distinguished Persian family. Abāqā definitely concentrated the seat of government at Tabrīz, but he spent a large part of his time in the open as Hūlāgū had done: summering at Ālāṭāgh and Siāh Kuh and wintering at Arrān, Baghdād, Jagātu and other places whose names should be mentioned in order to emphasize the continuity of the tribal mode of life.

The Mongol forces in Persia no longer had the strength of the first conquering armies nor were the rulers the generals of their own armies, for many of the soldiers had been withdrawn to Mongolia. Moreover, the daily tenor of life was not always placid and uneventful. Internal dissensions, attacks from the north, and campaigns against Egypt were all constant sources of worry and alarum. Soon the Egyptians under Sulṭān Bībars attacked Cilicia and went on to fresh triumphs, which included the capture of Antioch in 1268. The Crusaders sent a direct appeal for help to Abāqā and troops were dispatched as far as Apamea in Syria where they joined with Crusaders in an attack on Caesarea. This one evidence of active union was followed by much fruitless exchange of letters and embassies. The struggle with the Mamlūks of Egypt was generally unfavorable to the Mongols, and Abāqā finally determined to invade Egypt in person. But before this resolution could be put into effect, he died at Hamadān in 1282. He was buried beside his brother Mangu in the famed mausoleum of Hūlāgū.

During the reign of Abāqā Khān, the actual administrative control had passed more and more into Persian Moslem hands: the vazīr Shams ad-dīn was aided by Majd ol-Molk of Yazd, who had been awarded high honors and the complete control of financial matters. The astronomer Nāṣir ad-dīn of Ṭūs continued to write on logic and natural science and to compose commentaries on Euclid, Plato, and Aristotle, while the poet Saʿdi, enjoying the renown of advanced age, lived on at Shīrāz. Poets flourished throughout the realm and many of them were effectively subsidized by grants of administrative posts. However, records of artistic and architectural activity are scanty and only a single structure at Takht-i-Sulaymān bears witness to the construction work of Abāqā.

Abāqā had selected his son Arghūn for the throne but the Mongol code decreed that the eldest prince of a reigning family should inherit so that the selection council had to approve Takudar, a brother of Abāqā. In his youth this man had been baptized under the name of Nicholas but he now took the name of Aḥmad, the title of Sulṭān, and publicly professed the Islamic faith. He sent embassies in an attempt to establish friendly relations with his co-religionist the Sulṭān of Egypt and thereby brought about his own downfall, for the Mongols had long been accustomed to regard the Moslems of Syria and Egypt as mortal enemies. Plots against his life developed rapidly and in 1284 Aḥmad was killed by having his back broken at the command of Arghūn.

The accession of Arghūn took place in the open air with traditional ceremonies. The nobles prostrated themselves before the throne, while a new vazīr, Buqā, was honored by having as much gold poured over his head as would cover him. Arghūn soon declared war on Egypt and revived the interchange of messages and embassies with Europe, beginning with a letter written at Tabrīz in 1285 and addressed to Pope Honorius IV. Again in 1288 Arghūn dispatched a Nestorian priest called Rabban Sawmā to Europe and in the next year sent another embassy headed by Biscarellus de Gisulfo, a Genoese, which went first to Rome and then on to France and England. French archives preserve the original letter from Arghūn to the King of France. The message was on a scroll, written in the Mongol language in Ouigur characters and stamped with Chinese seals: such seals must have been entirely new to the western countries. The language is a dialect peculiar to the Mongols in Iran. Although the state ruled by Arghūn was far different from that established by Hūlāgū, the scroll contains a phrase which denotes the continued submission of the rulers of Iran to the Great Khān of Mongolia. In 1291 Arghūn again sent letters to the Pope and to Edward, King of England, but the moment was most unfavorable for the Franks had just been driven from the town of Ptolemais in Syria and no longer had the resources to wage effective war in the area.

Rabban Sawmā, the envoy sent to the Papal Court on several occasions, is an interesting figure in the events of these years. He and Rabban Mark had originally been fledgling Nestorian monks in China who set out together on a long voyage so that they might worship at Jerusalem. Arriving in Iran, they met the Catholicus of Baghdād at Marāgha, who decided to send them straight back to their own country, naming Mark as Metropolitan of the See of Cathay and Huang and Sawmā as Visitor General. Turbulent conditions to the east prevented their return, and when the Catholicus died in 1281 Mark was named Mar Yahb-Allāhā III and chosen to succeed the deceased as Patriarch of the Throne of Seleucia and Ctesiphon. This appointment was confirmed by Abāqā and Mark was enthroned at Baghdād in the presence of more than thirty bishops. He was soon honored by a visit from Abāqā who gave him permission to levy a tax for the support of his church. Aḥmad imprisoned the Patriarch but during the reign of Arghūn his authority increased and many churches were built, frequently under the supervision of Rabban Sawmā. One description of such a building operation runs: "He pulled down the church of Mar Shalita which was in Maragha and he rebuilt it at a very great expense. And instead of using [the old] beams [and making a single roof] he made [the new church] with two naves; and by the side of it he built a cell in which to live." Arghūn also gave Sawmā permission to build a church at the "Gate of Our Kingdom." The church was erected so close to the door of the throne room that the curtains of the church intermingled with those of the king's house: these constructions must have been neighboring tents at a royal encampment. As an additional sign of his favor, Arghūn visited the Patriarch's cell at Marāgha and had him baptize his son Öljeitü.

There were at this time many metropolitan sees of the Nestorian church within Iran proper: that of Dailam on the Caspian; of Rayy; of Gundēshāpūr near Shūstar; of Halwan near Kirmānshāh; of Fārs; of Merv, which included Khurāsān; of Urmiya and Āzerbāijān; and of 'Irāq. Sawmā, although a member of a heretical sect, had been cordially received at

Rome and had been asked to demonstrate his own ritual in the presence of the Pope. However, friendly relations between the Nestorian and Roman Catholic churches were fleeting. Jean of Montecorvino who carried letters to Tabrīz and then went on to the court of Kubilai said that, "the Nestorians, a certain body who profess to bear the Christian name, but who deviate sadly from the Christian religion, have grown so powerful in those parts that they will not allow a Christian of another ritual to have ever so small a chapel, or publish any doctrine different from their own."

About this time more frequent mention is made in contemporary accounts concerning commerce and trade between Iran and the countries to the west. As a matter of consistent policy the Il Khānids did everything possible to encourage trade. At first the notices of commercial transactions are rather fragmentary. Thus, we know of a Pisan who was living at Tabrīz and occasionally aided the missionaries there—letters written to him by Nicholas IV have been preserved. At a time when the nearest important Venetian post was at Acre on the Syrian coast, we come across the will of a Venetian named Pietro Viglioni who died at Tabrīz leaving such a stock of Iranian and European goods that he must have been either a commission agent or the representative of one of the Italian states. Definite steps were taken by the Mongols to increase the flow of goods: a certain Guillielmus Adae, a member of the suite of the bishop of Sulṭāniya, speaks of plans made by Arghūn to shut off the Red Sea at Aden in order to force all traffic to come through the Persian Gulf. As far as we know these plans never materialized.

The actual administrative control of the kingdom continued to be in the hands of professional and permanent officials who held power as long as they could quiet the ever restless suspicions of their overlords. We have already seen that very soon after the first invasions selected Iranians were given very important posts. A number of brilliant and prominent families devoted themselves to such service, probably as their personal contributions towards the rehabilitation of the country. The Juvaynī family is a fine example of such a family. Its outstanding member was Shams ad-dīn Muḥammad who served as prime minister for ten years under Hūlāgū, in the same office under Abāqā, and who was finally killed in 1284 by order of Arghūn. Well into the fourteenth century every single prime minister met a similar and violent end. A brother of Shams ad-dīn, 'Alā ad-dīn, won renown as a historian while a son of the former was named governor of 'Irāq and Fārs. It is a characteristic fact that this fine family suffered not as much from failure to please their sovereigns as from the pernicious jealousy of other Iranians. Such a bitter enemy was Majd ol-Molk, who was associated in the government with Shams ad-dīn under Abāqā and who pursued his rival with a series of traps and plots. Shams was succeeded by another Persian, Jalāl ad-dīn Simnānī who survived for four years before he was executed in 1289. At last the power was concentrated in the hands of Sa'd ad-dawla' of Abhar, a man who had previously practiced medicine at Baghdād and had later been attached to the finance office there. This appointment of a Jew to such a high post was to establish a new precedent, for from this time on the Il Khāns seem to have admired the energy and capacity of the Hebrew community. Sa'd ad-dawla' was conversant in Turkish and Mongol as well as Persian. He hated the Moslems and abused them in many ways, going so far as to promote a scheme for the raising of a fleet to attack Mecca. His relatives were given posts as tax farmers and Jews

were appointed to important positions throughout the country. An effort was made to reform serious abuses associated with tax collections and the disregard of the laws of property rights by the nobles. S'ad made the proposal that Arghūn set himself up as the head of a new religion, saying that, "there should always be on earth a man who dominated his contemporaries, whose existence was necessary to maintain order among men, and who introduced according to the exigencies of the day, and the needs of the people, new religious laws, employing either force or persuasion as needs be, to secure their obedience."

The historians are very definite in their statements that Arghūn was interested in architecture but literary sources must be employed to augment the handful of standing monuments dated in these years, none of which are on a monumental scale or have any direct connection with the personal interest of, or use by, the ruler. A good deal of work was done in the neighborhood of Tabrīz where a splendid suburb called the Arghūniya was begun by him and completed by a successor. Work was also undertaken at Sharūyāz in the Qazvīn plain; a site later known as Sulṭāniya. In the favorite Il Khānid resort of Ālāṭāgh and at Manṣūriya in Arrān, summer palaces were built and a similar structure, called Arghūn's Kiosk, was erected at Lār in the Demāvand region. Arghūn also constructed a fortified entrance to the fantastic natural mountain fortress of Kelat-i-Naderi in Khurāsān where, according to Curzon, "a fine inscription on a smoothed surface of rock upon the right-hand wall of the defile beyond the gate records this act of the sovereign."

Arghūn died in 1291 in his palace at Bāghchi Arrān and was then buried in the mountains of Sijās (or Sojās or Sujās); a site in the well-watered country south and west of Sulṭāniya.

Ghaykhātū, brother of Arghūn, was installed near Akhlāt with the customary ceremonies. The course of his reign followed the established pattern, but since he died in four years important events were few in number. He paid honor to the leaders of all religions whether Christians, Moslems, Arabs, Jews or pagans. He issued an order permitting the Nestorians to erect a church at Marāgha dedicated to Saints Mary and George. A few years later he gave money to the Patriarch to enable the latter to begin construction about two miles north of Marāgha on a monastery of John the Baptist. Soon, "he built up the wall nearly to the top, and the nave up as far as the springing of the roof."

The three Polo brothers passed through Tabrīz during the reign of Ghaykhātū. They had embarked at a Chinese port in 1292 in the company of a group of nobles who were escorting a Mongol maiden destined to be the bride of Arghūn. The party was more than two years on the way to Iran and, arriving after Arghūn's death, the young lady was given in marriage to Ghāzān. Ghaykhātū received the Polos well, gave them golden tablets of authority and an escort of some two hundred horsemen for the trip to Trebizand. Possibly the Polos stayed for several months at Tabrīz, for near the end of his work Marco Polo describes the character and reigns of Arghūn, Ghaykhātū, and Bāidu as well as the ascent of Ghāzān to the throne. Marco calls Tabrīz a great and noble city and a very prosperous commercial center but gives no specific details beyond some uncomplimentary words as to the character of the native Moslem residents of the city.

In 1295 Ghaykhātū was opposed by his relative Bāidu, was deserted by his generals, was strangled with a bowstring and was buried at Qarābāgh. Bāidu, destined to rule only for

a period of months, was enthroned in suitable style, the throne used for the coronations of Abāqā and Arghūn being taken from Tabrīz and set up in the camp at Aūjān. Again the pendulum of religious preference swung back to its earlier position, for Bāidu favored the Christians; he held a feast in honor of the Nestorian patriarch at Shaharzur in Kuristan, encouraged the construction of churches, and prohibited the preaching of Islam. This pronounced partiality aroused the hostility of the highly placed Moslems and he was soon confronted with the forces of Ghāzān, a son of Arghūn, who had been governor of Khurāsān for a number of years and who had embraced Islam in an imposing public ceremony held at Lār in the Demāvand region. Ghāzān had previously been a devoted Buddhist and had built a large Buddhist temple at Khābūshān (Qūchān). The conversion was certainly a political move and its results were of prime importance in bringing about a new alignment of the political elements of the country and a new direction to the entire future of Iran. Bāidu was deserted by his own vazīr and by many of the generals; was captured and put to death after a reign of only eight months. This second murder of a powerful prince as well as these successful revolts against the supposedly supreme authority were evidences of the slackening hold on the vast territories which eventually resulted in the break-up of the Mongol Il Khānid kingdom. Ghāzān Khān and a powerful successor managed to stave off this disaster, but before considering their reigns some attention should be paid to those parts of Iran most remote from the Mongol court and influence.

South Persia had been spared by the Mongol invaders and the local Iranian dynasties continued to wield restricted authority. Some names must be mentioned since they can be related to the monuments which still survive. Notable were the Salghurīd family who are also known as the Atābeks of Fārs. At the time of the invasions, Sa'd ibn Zangi who had been paying tribute to the Khwārāzm Shāhs was ruling. His son Abū Bakr succeeded him in 1231 and received the title of Qatlāgh Khān from Ogotai and paid tribute to Ogotai and later to Hūlāgū until his death in 1260. Members of his family ruled, quarreled, and were punished by the Mongols for several years until a woman named Abīsh Khātūn was raised to the throne. She then married a son of Hūlāgū and reigned until her death in 1284 when this local dynasty came to an end. The family had controlled the area south of Iṣfahān, the region around Shīrāz, and a section as far east as Yazd where they came into contact and conflict with the Muẓaffarids, another local dynasty which was extending its power at a somewhat later date. As this part of Iran, a most considerable one, had been spared the horrors of deliberate destruction it is logical to expect that there was continuous activity from Seljūq times and that this region may have furnished the impetus for the slow revival of building in the more northern regions of Iran. Shīrāz, which according to the literary records, was embellished with many fine buildings during these years, at the present time displays only scattered traces of work of the thirteenth century. The present author has carefully examined some one hundred and thirty mosques, madrasas, shrines, and tombs in Shīrāz and feels certain that no structure belonging to these years could have been overlooked. The many structures at Shīrāz must have vanished during the tribulations of later periods just as most of the many buildings known to have been constructed at Yazd in the same years have disappeared.

4. The Golden Age of Ghāzān Khān

With the accession to the throne of Ghāzān Khān, great-grandson of Hūlāgū, in 1295 began a pseudo-golden age which was to continue during the reign of his successor Öljeitü. Ghāzān was a stronger figure than his predecessors, an outstanding personality by any historical standards, and the fact that his deeds were fully recorded by Rashīd ad-dīn makes him loom even larger in the pages of Iranian history.

At the formal installation of the new ruler at Qarābāgh, he took the Moslem name of Maḥmūd and appointed as prime minister an Iranian named Sa'd ad-dīn of Zenjān. Ghāzān himself took a more personal and active interest in the government than had the earlier Il Khāns. In the first months generals and princes were led to execution in great numbers for Ghāzān would brook no possible rivals and was determined to put out of the way everyone who had been disloyal to his predecessors. To us this implacable cruelty seems a serious blot on the character of this great man. His first vazīr soon gave place to a second and then to a third Iranian. The court was still not firmly established at Tabrīz and we read that Ghāzān spent the winter of 1296-1297 at Baghdād and the following summer at Ālāṭāgh.

The first act of Ghāzān which was to affect architecture was a severance of all remaining semblances of allegiance to the Mongol Khakan in the east which meant a further abandonment of Mongol tradition and greater acceptance of Iranian culture.

The second act was to bring an end to the long years of fairly consistent religious tolerance. On the one hand, this was to result in the destruction of idol temples, churches, synagogues and fire temples. Christians were to wear a distinctive girdle and Jews a special headdress. The Buddhists were brought under certain restrictions, but they were permitted to retire to their monasteries, one of which had been built by Ghāzān's father and decorated with paintings which included one of Arghūn himself. By 1296 churches at Erbīl, Tabrīz, and Hamadān had been destroyed and one at Baghdād was taken over by the Moslems. On the other hand the new attitude was bound to have an enormous effect upon the erection of Moslem cult structures.

The pattern of life in Iran now swung more sharply in the direction of a Moslem state. Moslem headdress was formally adopted by the court. Finances were the object of studied attention, work was begun on a codification of laws, less attention was devoted to military pursuits than formerly, and as the peasantry was protected against thieving officials the internal prosperity and tranquillity of the country greatly increased. Ghāzān must have had an active hand in all these matters since his vazīrs were never in office long enough to assert their own personalities. His third vazīr was killed in 1298 and was succeeded by Khwāja Sa'd ad-dīn, probably with the great Rashīd ad-dīn as his colleague.

In spite of the fervent attachment of Ghāzān to Islam, he did not establish friendly relations with Egypt, possibly because he is thought to have favored Shī'ite tenets and hence would not be well disposed toward the Sunnī Sulṭān. At any event, conditions to the west were unsatisfactory. The Mamlūks who had been ravaging Cilicia were split asunder by internal dissensions and Ghāzān resolved to take advantage of this situation. He issued a call for his army to assemble, some 90,000 strong, at Diyār-Bakr. In the spring of 1299 his

forces defeated the Egyptians in battle near Homs and then occupied Damascus. A fresh army was raised in Egypt, however, and after one hundred days of occupation the Mongols were forced to retire. This was once more the familiar pattern: initial Mongol successes in Syria were not followed up promptly and in sufficient force so that an eventual retreat was inevitable. The following year Ghāzān invaded the Aleppo region, but withdrew before meeting the main body of the Egyptians.

In October 1297 Ghāzān had construction work begun at Arghūn's suburb of Shenb, west of Tabrīz. First the foundations for his tomb were laid and we can read that Ghāzān supervised the work and that the architect asked him whether low windows should be put in the structure to light the great underground vault. This is the first statement in the history of these times that a ruler could be concerned with specific problems relating to the arts. Statements of his historians that Ghāzān had practical knowledge and skill in architecture, natural history, medicine, astronomy, and chemistry are both too precise and too detailed to be discounted as sheer flattery of royalty. For example, we read that Ghāzān visited the observatory at Marāgha, displayed great interest in it, and ordered the construction of a new dome for it and that a little later he had another observatory built at Shenb which was crowned with a cupola shaped to his own design and supplied with instruments made after his own descriptions.

Apparently the construction work at Shenb went on at a good pace for when, less than a year after the tomb was begun, one of Ghāzān's sons died, work was far enough along so that he could be buried in it. Many other monuments were now started at Shenb; the details come from two separate contemporary accounts and hence are subject to comparison as to accuracy. Among the new structures was a monastery for dervishes; a college for the use of the Shāfi'ī sect; a college for the Hanafī followers; a hospital; a palace or administration building; a library; the observatory; an academy of philosophy; a splendid fountain; a residence for the descendants of the Prophet; and a splendid garden kiosk called Aardiliya. Rugs for all the buildings were made to order at Shīrāz.

The focal point of the entire development was the Lofty Tomb of Ghāzān Khān. Today its site is a level area strewn with broken bits of brick and glazed material and the presence of many pot holes shows that the debris is several meters in depth: the tomb has all but returned to the earth and sand from which it was formed.

Fortunately, a good deal of information about its construction and appearance can be assembled. We know that it stood in fairly good condition into the seventeenth century. Some fourteen thousand workmen, including a number of Armenians and Georgians are said to have been employed on its building. The tomb was twelve-sided in plan and had a crypt at, or below, the ground level. A great dome rose above the projecting cornice of the outer walls and the cornice level of the mausoleum was encircled with a golden inscription.

The descriptions of the structure given in contemporary accounts are not easy to interpret but in this task we are aided by an illustration of the complex which has survived in a contemporary manuscript. In this miniature the various structures are represented by an artistic shorthand. Fixed points in the illustration are the central court and several domes, the one to the left in the picture bearing the inscription, "Sultān Mahmūd Ghāzān, may Allāh increase his reign and his Caliphate and may it be prolonged."

[17]

Attempts were made to insure the upkeep of the entire complex on a scale in keeping with the magnitude of its concept. A special council headed by two great nobles was in charge and a vast sum of money was spent every year. Charitable foundations were set up in connection with the complex and some of them were for most unusual things. One was to provide furniture, lights, carpets, wood, and perfume for the buildings; a second was to pay for the burial of strangers who died at Tabrīz without leaving any money for a funeral; a third was to buy grain to place on the roofs for birds to feed on during the winter months. Another was to supply five hundred widows with wool for spinning and still another was to replace the pottery vessels which slaves might have the misfortune to break while they were drawing water.

The pious foundation was surrounded by gardens which were in their turn encircled by a suburb called Ghāzāniya which soon rivaled Tabrīz in size. In the gardens near each of the gates of this town a caravanseraı, markets, and baths were built so that merchants entering the city might have all commercial facilities and personal conveniences at hand: indeed, we have the complimentary first-hand account of a traveler who some fifteen years after their construction stayed in one of these rest houses.

Ghāzān carried out a number of other architectural projects. Tabrīz itself was provided with a fine new wall, the roads were cleaned of stones for miles around the city, many bridges were built and Ghāzān himself spoke against having either narrow streets or lofty houses in the city as being most unhealthy. Aūjān was rebuilt with new markets and bath and Shīrāz was given a high wall and a moat. Many villages in the kingdom had not the proper facilities for the Moslem ritual and Ghāzān issued an edict that in every community a mosque and a bath should be built; the upkeep of the mosque to come from the receipts of the bath.

As far as administration and commerce are concerned there is much more information available about the years of Ghāzān's reign than any of the preceding ones. Students of special topics can find details of the tax registers of the government, of the areas of tilled and barren land, of the artisan guilds, of military reforms, notes concerning inventories of the royal treasury, material on the courts, titles and deeds, details of coinage, weights and measures, and many other of the minutiae of a well-organized government. The evils inherent in previous systems of tax collection received special attention and one long edict of Ghāzān in regard to those abuses has been preserved in full.

Tabrīz was certainly a very cosmopolitan city at this time. Chinese astronomers, physicians, and theologians were active, and not far away Chinese engineers were in charge of irrigation work on the banks of the Tigris. Commerce with the western countries was now coming into its own. Now two civilizations, two different ways of life—the east and the west—had been brought together after having lived as if in isolated compartments for many centuries, since Europe had been cut off from the rest of the world after the fall of the Roman Empire. The comparatively few written accounts that have survived describing the intercourse of these years must stand as representative of the experiences of hundreds of private travelers and of commercial negotiations and agreements in great number. Thousands of people were now moving about the world to places infinitely remote from the land of their birth and were exchanging objects and ideas with other races of men.

Ghāzān went to great lengths to establish easy and swift communications. The road guards were no longer themselves the corrupt robbers of the traveler, but were a highly efficient force. Brigands were relentlessly hunted down, while the guards and villages along the main roads were held responsible for any thievery in their own localities. Road tariffs were based on the animal load and the amounts were officially determined and plainly posted. Most of the access routes to and from Tabrīz are still important highways. One led from Ezerum to the Aras (Araxes) River, then to Khoi and Tabrīz. Another began at Trebizond on the Black Sea and came through Lesser Armenia. The long route to India led from Tabrīz to Kāshān, Yazd, and Kirmān to the Persian Gulf. Only the direct overland road via Mashhad, Ghazna, and Kābul was not important at this period.

Venetian merchants were present in some number at Tabrīz and had their own consul there. Special commercial envoys passed between Iran and Venice and a treaty was drawn up which gave the Venetians the freedom of all the roads in Iran, exemption from all taxes except for customs and road guards, and provision for consular trials for civil and criminal actions among members of their own community. Genoese merchants were also established at Tabrīz and were transporting goods on the Caspian Sea. The Genoese consul at Tabrīz was assisted by an assembly of twenty-four members which had authority over its own citizens and power to guarantee credit for their enterprises within Iran.

Although Ghāzān became a more ardent Moslem with each passing year he seems to have displayed a benevolent tolerance. In the year 1300 he visited the Nestorian patriarch at Marāgha and remained with him for three days. Soon after, secure in high favor, the patriarch resolved to complete the monastery of John the Baptist at Marāgha and work must have gone forward at a rapid rate since the dedication ceremonies were held less than a year later. The description of the complex reads: "The buildings were handsome, the doors were things to be admired, and its superstructure was raised above on worked slabs [or pillars?], and its foundations of dressed stones were truly laid. Thus it was, he made its doors of dressed slabs, ornamented with designs, and its stairways were also of dressed stone. . . . The length of the temples [the nave and the aisles] of the monastery, together with the altar is, according to what those who have measured them say, sixty cubits [about a hundred feet] and the width of the middle nave is twelve cubits [about twenty feet]. The altar, and the chamber of the holy of holies, and the treasury are very spacious. The whole of the outside of the dome of the altar is inlaid with green glaze [*kāshānī*] tiles, and on top of it is placed a cross." From this account it is apparent that neither the plan type nor the materials used had anything in common with the contemporary Moslem religious construction: indeed the structure sounds as if it stemmed directly from the Syrian basilica type and the variations of that general scheme erected during the following centuries in northern 'Irāq. The patriarch was overjoyed to see the work completed "and he gave apparel to the holy men (bishops?) and the monks, and architects, that is to say, the carpenters and the handicraftsmen, and everyone who had toiled on the building." The monastery was endowed with the income from an entire village and the revenue from gardens, vineyards, and fields. The crowning honor was a state visit from Ghāzān in 1303 when he brought with him a "splendid cross made of fine gold, wherein rare stones of a very great price were set and in it was a fragment of the adorable wood of the Cross of our Vivifier, which had been

sent to the king as a mark of honor by Mar Papa of the Romans. . . ." This fragment of the True Cross was probably the one sent by St. Louis to Arghūn.

Amid all this varied activity, Ghāzān continued to regard his feud with the Sultans of Egypt as of paramount importance. In 1303 he set out for Syria with his troops, stopping at Karbalā to honor the tomb of Ḥusayn, the Shī'a martyr. His forces succeeded in occupying Aleppo and Hama but once more they were badly defeated by the Egyptians near Damascus. Ghāzān was much distressed by this disaster and it may well have been a contributing factor in his sudden death in May 1304. From Qazvīn where he died his body was conveyed on horseback, amidst universal grief, to Tabrīz and there placed in his magnificent tomb—the first of the Mongol Il Khāns whose place of burial was known to the general public. The text of his long will has been preserved and the lofty sentiments and moral precepts contained therein encourage us to believe that the man himself was an exceptional personality and not merely a puppet figure created by the historians of the east who were always able to clothe the sparsest form with the garments of exaggerated rhetoric and adulation.

Ghāzān Khān has taken on the proportions of a truly heroic figure, and yet we shall never be able to visualize his personality as well as we can that of his great vizier, Rashīd ad-dīn Faḍl Allāh. Born at Hamadān in 1247, Rashīd was an Iranian, a practicing physician in the time of Abāqā and then later the court historian and principal administrator under Ghāzān Khān and Öljeitü. As vazīr for the two rulers he very capably administered the vast kingdom, but he himself considered his highest achievement to be the compilation of a universal history. Originally he had been instructed by Ghāzān to write only a history of the Mongol empire; this work, begun with high resolve and great determination, was soon expanded in scope. In his larger work he used only the best and most reliable source material: the official Mongol chronicle was drawn upon; a Kashmiri hermit aided in composing the Indian history and two learned Chinese dealt with the material in that language. His information upon Europe and upon political conditions there was distinguished by great accuracy: he knew far more of Europe than the Europeans knew of Asia at this period. He even knew that there were no snakes in Ireland. Every precaution was taken to see that the work, which was finished in 1310, survived. Many copies were sent to the libraries of all the large towns, anyone was welcome to make his own copy of the manuscript and a number of fresh copies in different languages was made annually. After his death in 1318 such special provisions ceased and the fact is that the manuscripts of the work which survive are few in number and usually far from complete. For this reason it is surprising to find that copies of fifty-three of his personal letters written to his sons and to his officials have survived in copies and furnish fascinating details about his administrative plans.

As a result of his important position Rashīd ad-dīn had vast financial resources at his disposal. Drawing on these he undertook the building, outside and to the east of Tabrīz, of a suburb called the Rab'-i-Rashīdi or the "Quarter of Rashīd." The area was dedicated to the encouragement of the arts and sciences and the ideal which Rashīd had in mind is described in his letters. Number fifty-one, written to one of his sons, who was governor in the Aleppo region of Syria, reads in part: "Therefore we have sent, with the utmost celerity, letters and couriers to the scholars of the time and the learned of the epoch, saying, 'Turn

the bridle of [the courses of] your setting out toward us; for we would, henceforth, provide means for you to spread knowledge in peace of mind.' . . . Now crowds of scholars and men of science arrive continually and we do our best to keep them free of cares. The Rabʿ-i-Rashīdi, for the establishment and construction of which we had already made plans and preparations at the time of your departure, is now complete. In it we have built twenty-four [great] caravanserais, 1500 . . . shops and 30,000 charming houses. [Healthful] baths, pleasant gardens, store [houses], mills, factories for cloth weaving and paper making, a dye house and a mint have also been constructed.

"People from every city and country have been removed to the said foundation. . . . Among them are 200 reciters of the Qurʾān . . . and we have given dwellings to 400 other scholars, theologians, jurists and traditionalists, in the street which is named the 'Street of the Scholars'; daily payments, pensions, yearly clothing allowances, soap money and sweet money have been granted for them all.

"We have established 1,000 other students, who had come from all the possessions of Islam in the hope of being educated under our protection, in the capital Tabrīz, and we have given orders for their pensions and daily pay to be granted free from the tribute of Rūm, Constantinople and Hindūstān, in order that they may be comfortably and peacefully occupied in acquiring knowledge and profiting people by it. We have prescribed, too, which and how many students should study with which professor and teacher; and after ascertaining each knowledge-seeker's aptness of mind and capability of learning a particular branch of the sciences, either the fundamental or the derivative, the intellectual or the transmitted, we have ordered him to learn that science. To all these students residing in the Rabʿ-i-Rashīdi or settled in the city of Tabrīz, we have given orders to frequent every day the colleges which we or our sons have founded."

When the copies of the universal history were made at the Rashīdiya they were embellished with pictures and the records tell that the manuscript painters were held in high favor. Some of the work naturally continued to reflect the formulae of the Baghdād school of painting of the thirteenth century. Unusually fine and large sheets of paper were still brought from Baghdād but in general the style of illumination changed markedly and in so doing reflected both the facts and the very spirit of the times. Many pictures show the Il Khānid rulers wearing Chinese costumes and surrounded by bevies of wives: Iranians, with their own distinctive headdress, are less frequently portrayed and then in an auxiliary position, such as that of a poet reciting his work to the ruler. Not only had the attire come in with the invaders from the east, but the very technique and choice of pictorial values of the paintings reflect a strong Chinese influence. Trees and flowers are brushed in with the rapid strokes of the brush and ink style and the clouds display twisted and voluted shapes. The buildings themselves are often modeled after the columnar and wide-eaved architecture of the east. However, many of the details of the architectural subjects show a striking correspondence with the patterns of the panels of mosaic faïence which were now being executed in Iran by the local artisans.

Illustrated manuscripts of sections of Rashīd's universal history, the *Jāmiʿ at-Tavārīkh*, are guarded in widely scattered collections. The best known copy, of 1304-1314, has its

extant pages divided between the Edinburgh University Library and the Royal Asiatic Society. A copy of 1317 is in the Museum of the Palace of Topkapu at Istanbul. Pages thought to have been painted about the middle of the fourteenth century are in India at the Rampur State Library, while another of near the end of that century is in the Bibliothèque Nationale. Some fifty pages of still another copy are in the hands of two or more private collectors.

5. Öljeitü, Abū Saʿīd, and the Decay of Mongol Authority

ÖLJEITÜ, a brother of Ghāzān Khān, came to the throne at the age of twenty-three. By his mother he had been baptized as a Christian and named Nicholas but later, under the influence of one of his wives, he embraced Islam, taking the name of Muḥammad Khuda-bānda. Once he was a Moslem, he did everything in his power to promote the creed. Jews and Christians were separately taxed and required to wear distinctive garments. His unstable attachments to one and then another of the various sects and doctrines of Moslem theology are not easy to trace and yet they are of definite importance since they have a bearing on the interpretation of the principal architectural monument erected during his lifetime. At times he was by turns a Ḥanafī, a Shīʿa and a Sunnī; historians differ in their attributions of his interests in the different sects.

Before the death of Ghāzān, Öljeitü had been governor of the eastern provinces and while there he was much on the move, wintering at Māzanderān and summering at Ṭūs, Merv, or Sarakhs. At the proper moment he marched in triumph to Aūjān where the ceremonies of enthronement were held. He soon fell into the customary routine of the Il Khānid rulers. He went to Marāgha to visit the famous observatory and strengthened the authority of a learned family by naming Aṣīl ad-dīn, son of the renowned Nāṣir ad-dīn, as its director. He then proceeded to Mūghān for the winter season and from this place began to send letters to the western powers. One of these, still preserved in French archives, is addressed to Iridfarans which can be expanded to Roi de France who was, at that time, Philippe le Bel.

On the first of Muḥarram, the first day of the year 705 [1306], Öljeitü ordered work begun on the city of Sulṭāniya which was designed to replace Tabrīz as the capital. The site was an extensive plain near Qazvīn which had been a favorite summer camp of the Il Khāns under the name of Qunghurölöng or "the falcon's hunting ground." Historians record that in undertaking this task Öljeitü was respecting the wishes of his father Arghūn, who had established the plan of the new city and had directed that materials be assembled there, but had died before construction was actually started. A citadel 500 gaz [cubits] on a side and protected by a wall and sixteen towers of cut stone was soon finished. Several mosques were erected, the principal one, which was built at Öljeitü's expense, being orna-mented with marble and porcelain. A hospital and college were built and an elaborate royal residence in which the principal palace was a high pavilion or kiosk surrounded at a distance by twelve smaller ones; the entire ensemble set in a marble paved court. The courtiers added buildings on their own account and the two prime ministers, Rashīd ad-dīn and Tāj ad-dīn ʿAlī Shāh, vied with each other in erecting palaces and public buildings or even entire quarters of the new city. One such quarter had one thousand houses all com-pletely furnished.

Within the walls of the city a great mausoleum was begun for Öljeitü. Records state that it was an octagon sixty gaz on each side with a cupola one hundred and twenty gaz high, that it was pierced by a number of windows each with a rich iron grill, that the building

[23]

had three doors of polished steel, and that the trellis around the actual tomb was of the same material and was brought from India. Such meager accounts are augmented by the witness of the standing structure: one of the greatest monuments of Iran and one which would be a credit to any country and architectural style.

Apparently when the construction started Öljeitü had made no serious choice among the Moslem sects, but in 1310 while work was progressing he visited the tomb of 'Alī in 'Irāq and accepted the doctrines of the Shī'ites. He then had a brilliant idea—he would bring the bodies of 'Alī and Ḥusayn, the Shī'a saints, to Sulṭāniya and turn his own mausoleum into their shrine. Probably this idea was shrewd as well as pious for he may have visualized the commercial advantages of attracting crowds of pilgrims to the shrine and to the hostels and bazaars of the new city. The decoration was carried forward with this idea foremost; the name of 'Alī can still be read in the brick patterns and in the stucco ornament, and a special chapel was added at the back of the monument, filling out one side of the octagon. At the same time Öljeitü had another and much more modest tomb erected for himself which apparently was a simple pyramid of masonry built in a few weeks.

At first Öljeitü was so attached to the Shī'a beliefs that he had coins struck which bore the name of 'Alī. Then he had letters sent to the governors of all the provinces directing that the people should all embrace that doctrine. At Baghdād, Shīrāz, and Iṣfahān, the Sunnīs refused to obey and Öljeitü ordered that the Moslem judges of those towns be sent to him at his summer camp at Qarabāgh. The representative from Shīrāz was led out into the open plain and savage dogs were loosed at him. When they fondled rather than attacked the saintly man, Öljeitü was convinced that he was in error and ordered that the Sunnīte creed be followed. Whether this story of a contemporary is correct is open to question but it is true that Öljeitü became a Sunnī before his death. Perhaps even before switching his allegiance he had become convinced that his plan to bring the bodies of 'Alī and Ḥusayn to Sulṭāniya was impractical. At all events he decided to reconsecrate the great mausoleum as his own tomb. The fired brick patterns and the mosaic faïence of the interior decoration were now completely covered with a heavy coat of white plaster upon which were painted countless inscriptions and floral and geometric patterns in a bright blue pigment.

Sulṭāniya did not absorb all the attention of the king and his court. Domestic tranquillity was continually shattered by enmity and discord. For a while the great Rashīd shared the control of the state with Sa'd ad-dīn of Sāva; an implacable enemy who was put to death in 1312. Then a new figure appeared to challenge the prestige of Rashīd. This was a Persian named Tāj ad-dīn 'Alī Shāh whose gift of superabundant energy seems to permeate the matter-of-fact records of the period. A jewel merchant and traveler in his youth, he seems to have made his way up in the world by sheer boldness and brashness. Forcing himself to the attention of Öljeitü he charmed the Khān by a display of industry, ability, wit, pleasant manners, and a series of magnificent presents. He supplied a beautiful ship in which Öljeitü took pleasure cruises on the Tigris and in 1307 enlivened a festival at Sulṭāniya with the dancing and singing of Rebu'l-Kalub, an Arab from Baghdād who so took the fancy of 'Alī Shāh that he married her. At Sulṭāniya he spent vast sums of money, building more solid and beautiful monuments than anyone else. His wholehearted attention was given to a structure erected in Tabrīz. This was a great mosque, called Masjid-i-'Alī Shāh, said to

have been designed by 'Alī Shāh himself. He was buried in it and its massive ruins still dominate the city of Tabrīz. 'Alī Shāh and Rashīd were soon bitterly distrustful of each other and only the efforts of Öljeitü, who was aware of the merits of both men, brought a temporary harmony in the administration.

While the work went steadily forward at Sulṭāniya Öljeitü continued to spend a good deal of his time in the different camps and dealt with a variety of business. In 1312 he laid the foundations for the new city of Sultānābād. About this time he decreed that all the writings of Rashīd should be assembled in an edition of ten volumes. He named his son, Abū Saʿīd, to be governor of Khurāsān, the latter having reached the ripe age of nine years. In these same years the situation of the Nestorian community became increasingly precarious; for a year or two the Moslem nobles would burn churches and monasteries and then the ruler would halt these abuses and give presents and protection to the bishops. Tolerance, a Mongol virtue, was fading fast: it was the twilight period for Christianity in Iran and all the results of centuries of devotion, sacrifice and toil were to be swept away in the course of a few years.

By the year 1313 practically all the construction work at Sulṭāniya—the name means Imperial—was completed and a state celebration presided over by Öljeitü was held to commemorate the occasion. The move from the ancient city locale of Tabrīz to a site quite like that of Marāgha was a daring step and one must admire the attempt to create a capital city in one tremendous operation. The fundamental weakness of Sulṭāniya as a site was that it was not at the intersection of established trade routes. Öljeitü seems to have been aware of this fact and tried in many ways to establish the town as a commercial center. However, within a few years after the city had been dedicated rapid decline set in. In a hundred years ruins dotted the site and by the end of the seventeenth century only crumbling fields of debris marked its location. The mausoleum alone continued to loom far above the level plain. Indeed, this lofty monument was the visible symbol of the highest skill of hundreds of artisans. Once the structure and the city had been completed the score upon score of trained workmen must have been dispersed throughout the kingdom to the villages and hamlets from whence they had originally been assembled. In their home surroundings they showed the result of their association with other master craftsmen in tangible form—in hundreds of buildings, many of which still survive. Yet in a sense the mausoleum was more than a training ground for the artisans themselves; it was the final moment of formation of a Mongol style, a moment when all the heritage of the earlier historical periods, all the details of technique already displayed at Shenb Ghāzān, the Rashīdiya and elsewhere culminated in this monument.

The final years of Öljeitü's reign passed rapidly and without great incident. The mass of diplomatic correspondence with Egypt brought no understanding between the rival powers; a tremendous expedition was sent against Egypt, but it got no further than the Euphrates. Öljeitü was fond of the lighter pleasures of life and strongly addicted to drink. Indeed alcoholic excesses may have brought on his illness in 1316 and his death at the age of thirty-six. His body was put in a coffin of pure gold and silver which was placed for several days on the royal throne. Universal mourning was held for a period of eight days and the people, reviving an age-old Iranian custom, clad themselves in blue garments.

Abū Saʿīd, who was now twelve years old, was enthroned. Rashīd had continued to carry out the duties of state with unflagging zeal and had thirteen sons in vital administrative posts: it was now his misfortune to fall victim to the machinations of ʿAlī Shāh. In 1318 Rashīd was put to death at Juskeder, a small town near Tabrīz. His suburb of Rashīdiya was looted, his family mistreated, and his memory reviled. We can, at this long distance from the events, recognize him as a physician, administrator, philosopher, historian, author of a code of law; one of the finest intellects ever to arise in Asia.

A brief chronicle should suffice for the reign of Abū Saʿīd. Letters continued to arrive from the Popes. Abū Saʿīd passed each winter on the Caspian at his camp at Qarābāgh. Mongol ascendancy had passed its peak and it would have taken a greater figure than this ruler, who was a mere youth during most of his reign, to arrest the ever-accelerating decline. There was no longer any question of leading an army against Syria; instead the ministers and generals were busy coping with internal disorders for the powerful amīrs were becoming more and more unruly. Sections of the kingdom were breaking off as independent units.

In Fārs a Princess Kordujīn, descendant of the Salghurīds, had been appointed governor and soon minted money bearing her own name. She was famed as a great builder and Shīrāz again became a splendid city and the resort of the learned. To her are ascribed the erection of seven guest houses or hostelries, a new mosque, an aqueduct for the old congregational mosque, a hospital, a madrasa, a bath and a fountain. Kirmān had been the stronghold of the Muẓaffarids; one of them, Muḥammad, being honored by Abū Saʿīd with a royal robe and a girdle set with precious stones, also drums, a standard and a yearly allowance. As the Mongol power disintegrated, this family spread its authority over Kirmān, Fārs, and western Iran.

About 1320 several embassies were sent to Egypt and Syria in an attempt to arrange an alliance and costly presents were sent to the Sulṭān of Egypt; notably 700 pieces of cloth in which the names and titles of the Sulṭān were interwoven. Peace was finally made in 1323 and its details read in the great mosque at Tabrīz. The Egyptians had been well satisfied with the orthodox principles of the current Mongol regime; strong drink had been prohibited in Iran, singers and dancers sent into exile and churches destroyed.

The authority of the vazīr ʿAlī Shāh had been somewhat curtailed by the rising power of one of the generals. In 1324 he died, the first vazīr of the Il Khāns to die a natural death rather than be killed by his master, and was buried in his mosque at Tabrīz.

Commerce with Europe was still flourishing. A string of fine caravanserais was built along the road to Syria and the records show that the communities of Venetians and Genoese at Tabrīz increased in size and importance. A Franciscan monk said of Tabrīz: "a nobler city and better for merchandise than any other which this day existed in the world and containing a great store of all kinds of provisions and goods, the whole world having dealings there."

Abū Saʿīd was fond of the company of men of learning and his reign was marked by an active literary renaissance. Poets swarmed about the court. An important figure was that of the geographer and historian Ḥamd Allāh Mustawfī of Qazvīn, who was a great admirer of Rashīd ad-dīn, held himself an important official post, and left a firsthand account of these years. The records do not say that Abū Saʿīd himself had a pronounced interest in architec-

ture and yet his reign was productive along these lines. No less than twelve fine structures dated in these years survive and some of them have inscriptions containing the name and the titles of the rulers.

In 1335 Abū Saʿīd died at Qarābāgh, according to some sources after an extended illness, and according to others, poisoned as the victim of a harem intrigue. The ferocious slaying of Ghāzān Khān had decimated the royal family and during the reign of Abū Saʿīd all the princes of the line of Hūlāgū were living in retirement and obscurity in order to escape unwelcome attention. Ghiyāth ad-dīn Muḥammad, vazīr and son of Rashīd ad-dīn, prevented an immediate dissolution of the kingdom by prevailing upon the rebellious amīrs to agree to the succession of Arpāgaūn, a descendant of a brother of Hūlāgū. Quite soon Arpāgaūn was defeated in battle, Ghiyāth was killed, the Rabʿ-i-Rashīdī was again plundered, and in 1336 Arpāgaūn himself was killed.

From this time on the amīrs settled in different regions became increasingly independent and troublesome. As the disintegration became accelerated, certain dynasties native to the periphery of Iran extended their authority. Mobārez ad-dīn Muḥammad, second of the Muẓaffarid dynasty, had ruled over Yazd and its district confident in the friendship and protection of Abū Saʿīd. In 1340 he acquired Kirmān and in 1353 took Shīrāz. Almost continuous local warfare marked his expanding ambitions. In 1357 he turned north and captured Iṣfahān and in the next year mastered Tabrīz. His son, Shāh Shujāʿ, who reigned until 1384, managed to maintain an uneasy hold over south central and northwestern Iran. On his death bed he wrote to Tīmūr commending his sons and brothers to the latter's care, but nine years later the great conqueror massacred the entire family.

There would be no purpose in reciting a list of all the petty princes of the fourteenth century. Each region drew in upon itself and in spite of the unsettled times architecture and the arts flourished at a number of local centers.

However, the Mongol cycle of invasion, ascendancy, and decline had now reached its final end and a new cycle on a similar pattern began. Tamerlane, or Tīmūr, whose conquests were to rival those of any earlier warrior, now appeared on the scene. In 1385 Tīmūr reached Sulṭāniya and returned the following year to pass the summer at Shenb Ghāzān. Tabrīz ransomed itself from destruction, but much of the rest of the country was pillaged and thousands of artisans were sent to Samarqand. The independence of Fārs and Kirmān was ended and in 1389 the last vestige of the local power of the Kurts at Herāt and the Sarbadārs in northeastern Iran was destroyed.

THE STYLE OF THE ARCHITECTURAL MONUMENTS

6. Major Features of Il Khānid Architecture

THE monuments of the Il Khānid period represent one phase in the continuous history of Islamic architecture in Iran, reflecting the forms of earlier periods and displaying particular features of design and detail.

In Iran architectural style followed a course of direct and logical evolution but did not find an outlet in a culminative effort which builds up slowly to reach a brilliant crescendo of integrated form such as may be observed in Europe in medieval times. We do not find in Iran a reflection of a dynamic impulse or urge which continues from generation to generation: in such a stylistic evolution every detail or form and construction is examined and then rejected or reused in a more expressive manner. In Iran the formative forces of architectural style appear to have been dormant for long years until aroused by a period of economic prosperity to a development which was not quite rapid enough to keep abreast of the general progress of the time. That is, the most striking monuments of a period were frequently erected at a moment when the political authority and economic power were already in a state of serious decline: typical examples may be found in the Sāsānian period and again in the Seljūq period when the tomb of Sulṭān Sanjar was erected after the strength of that dynasty was all but lost. At such successive high points the elements of construction and decoration were fused in a temporary unity but full organic unity was not established and carried over to the following period.

While organic unity is not an important feature of Moslem architecture in Iran, the work does have its own highly expressive character. Iranian art, in all its forms, has always been decorative and, normally, nonrepresentational. The so-called minor arts of the west were so studied and cherished in Iran that they reached the level of the major arts. This decoration, in whatever medium it might take shape, is always characterized by precision, clarity, and lucidity. In architecture interest in ornamental surfaces was at least equal to concern with structural forms and these decorative patterns were executed with a feeling for the relationship of parts to the whole which was not as common to the interrelation of the actual structural elements. In any period of Iranian architecture we may find that the decorative elements are developed in the same cycle of experiment, mastery, and decline common to western art but that the stages of the cycle cover a longer period. Ornamental style develops slowly and with frequent throwbacks to decorative devices of earlier times: for example, architectural inscriptions employ *kufi* characters long after these characters were no longer used in manuscripts.

The architectural style of the Il Khānid period derived directly from that of the Seljūq monuments. Four and a half centuries had gone by from the time of the Arab conquest of Iran until the high point of the Seljūq period was attained. Tentative forms of these earlier centuries culminated in the precise and distinctive Seljūq style, known to us from scores of standing structures. In certain respects the conditions under which Seljūq and Il Khānid architecture found expression were comparable. The Seljūq Turks had driven westward into Iran about the middle of the eleventh century as unlettered conquerors and had then become increasingly interested witnesses of the brilliant Iranian activity in the fields of literature and the fine arts. Native officials held the reins of government for their new

[31]

masters and the continuity of Iranian culture was little altered or influenced by contributions from the overlords.

The Seljūqs were orthodox Sunnī Moslems and used every means at their disposal in an effort to stamp out local Shī'a tendencies. However, such efforts never really endangered the typical Iranian reaction to the religion of Islam, for not long after the Arab invasion the country had begun to adopt the new faith and to bring it in line with hereditary traditions and beliefs. Shī'ism, with its cult of the twelve Imāms, won the eternal affection of the masses in Iran, while two other developments found reflection in the architecture of the Seljūq and Il Khānid periods. These were, a predilection for Sufism, the mysticism of Islam, and the devotion offered to the Imāms and to local Moslem saints. At such places as Mashhad, Qumm, and the Shī'a holy sites in 'Irāq every attention was lavished upon the tombs of the Imāms or those of members of their immediate families. Throughout the length and breadth of Iran thousands of Imāmzādas—a tomb shrine in honor of a so-called "son of the Imām"—were built as pious acts. The tombs of revered Sufis and of outstanding local saints became the spiritual centers of districts or regions and some, such as the shrine of Bāyazīd al-Bisṭāmī at Bisṭām, were constructed, added to, or rebuilt over a period of centuries.

In both the Seljūq and Il Khānid periods religious architecture—mosques, religious schools, shrines, and tombs—far outweighed secular construction and reflected the material prosperity of the times. Very little is known about the fine palaces and elegant houses which certainly were erected for, built of more perishable materials, they have long vanished from sight and record.

During the Seljūq period architecture and design were in an experimental phase, while in the Il Khānid period the major interest was in the assimilation and recombination of forms of construction and decoration. Seljūq efforts were largely concentrated on the mosque type, which, evolving through the formative centuries of Islam in the several occupied lands, had in Iran been combined with traditional elements of the local pre-Islamic Sāsānian architecture to emerge in distinctly Iranian forms. The mosques of the first centuries of Islam originally displayed a central open area or court which was built up on one or more of its sides. The type naturally tended to turn in upon itself; exterior walls were plain and bare or hidden from sight by surrounding construction and all architectural emphasis was reserved for the interior of the structure. The colder climate of Iran— colder in contrast to the Moslem lands to the south and west—led to the specific development of sheltered elements along the central court. Sāsānian secular and religious structures supplied such elements as the square sanctuary chamber crowned by a dome and the barrel vaulted īvān.

A number of the Seljūq mosques appear to reflect a gradual approach to a standard Iranian mosque plan, but compositional unity of this type was reached only late in the period. The Il Khānid builders took over all the plan elements and materials and methods of construction common to these Seljūq structures. Tomb towers had an important place in Seljūq architecture and again served as models for the Il Khānid period.[1]

[1] For a comprehensive account of the architecture of the Seljūq period see "The Seljūq Period," by Eric Schroeder in *A Survey of Persian Art*, pp. 981-1045.

The major features of Mongol style should be described in precise and concise terms. In defining the artistic character of a less well-known period of European art history, comparisons and contrasts may be made with one of the major periods with which everyone is familiar. Considering that the Seljūq period covers approximately the same chronological term of years as the Romanesque and the Il Khānid as the Gothic we might wonder whether the relationship between the two periods in Iran has anything in common with the development from Romanesque to Gothic in Europe. Certain specific features, which will be cited later, do seem to support such an analogy but, in general, there was not such a revolution in concept and forms as brought Gothic style out of the Romanesque.

It can be said that Seljūq architecture is a proto-form of Il Khānid style and that during some three hundred years architecture in Iran followed a regular course of evolution. A few examples of this development of forms may be cited. Il Khānid construction places a decided emphasis upon verticality and upon refinement of selected forms. In comparison with Seljūq monuments, the proportions of rooms are altered: chambers tend to become loftier in relation to their horizontal measurements. The elevations of the Seljūq īvāns are massive and broad, while in the Il Khānid period they become narrower and higher. Corner colonnettes are grouped in greater number and have more attenuated lines. The structural strength of the monuments is deliberately concentrated. The massive walls of the Seljūq īvāns give way to walls which are broken by openings and bays. Exterior and interior panel divisions are developed in depth—a feature which tended to produce thin lateral walls and heavy corner piers. Within the dome chambers the walls were lightened in the same manner with a full thickness retained only at the points which received the full weight of the dome.

The types and forms of Seljūq vaults and domes continue. Stalactite vaults increase in popularity. Stalactites had been used in a rudimentary form on the Gunbad-i-Qābūs of 1007.[2] In Seljūq times they appear as an elaboration of the exterior cornice of the tomb towers and then are found within the corner angles of sanctuary chambers. From Sāsānian times the Iranian builders had made use of the squinch as the mediating element between the square plan and the crowning dome. The use of this ancient form was continued without the Moslem masons feeling any need to develop alternative structural solutions to the problem of placing a dome over a square plan. However, the aspect of the deeply shadowed squinch seems to have offended the sensibilities of the builders. In Seljūq times a trilobed stalactite was used to break up the area of the squinch and then, as so frequently happens in the history of architecture, a form which began with structural connotations was not only elaborated for its own sake but taken out of its logical context and applied more generally for decorative effect. Thus, the Seljūq builders began the trend, so elaborated in Mongol times, of using stalactites in a greater number of tiers with less and less internal stability and of transferring the squinches to entrance portals and to domes where they were spread with great cunning over expansive surfaces.

Il Khānid architecture was both cosmopolitan and imperial and provincial. The countries of the Near East had long been accustomed to construction on a large scale by royal decree and in the early centuries of Islam the famous round city of Baghdād and the vast

[2] *A Survey of Persian Art*, p. 972.

developments at Samarra were fiat architecture. In the Il Khānid period royal commands brought into being such ensembles as the Ghāzāniya and the city of Sulṭāniya, while a single edict of Ghāzān Khān directed that a mosque and a bath were to be erected in every community of his realm. At such structures as the mausoleums of Ghāzān Khān and Öljeitü where thousands of workmen were employed the most talented artisans of the time displayed their ideas and techniques and provided a rich source of inspiration for the more humble craftsmen gathered from the smaller communities. These lesser craftsmen, doing the bulk of the total building in provincial towns and villages, kept abreast of current trends, while continuing to take into account local tastes, traditions, and materials. Only at Yazd and in the region of Āzerbāijān were local variations sufficiently distinctive so that these regions may be said to have had provincial styles.

Foreign influence was not strong throughout the Il Khānid period. In stereotomy and carved decoration, influences from Asia Minor penetrated Āzerbāijān, while the stalactite systems in vogue in Syria and 'Irāq may have affected the development of this element in Iran.

7. Classes of Structures

STRUCTURES of religious character include: 1) the mosque, 2) the madrasa, and 3) the mausoleum. Some fifty-six of the monuments described in the catalogue fall into one or another of these three classes. In addition, three shrine complexes are composed of combinations of these major classes and thirteen badly damaged structures display elements of one or another of these same classes. The few structures of secular character include: the ruins of a palace; the traces of one observatory; and three damaged caravanserais.

The three major religious classes each appear in various types. Thus, the mosque and madrasa reflect either a "standard" or a "non-standard" plan.

The "standard" mosque, although it began to take shape in the Seljūq period did not become common until after the end of the fourteenth century, in monuments of the Tīmūrid and Ṣafavid periods. In its fully developed Iranian form it is characterized by the following features: at the beginning of a longitudinal axis an īvān portal leads into an open court; arcades surrounding the court are interrupted by four īvāns, two on the longitudinal axis and two on the cross axis, with prayer halls in back of the arcades; the major īvān, on the longitudinal axis and across the court from the entrance īvān, opens into a square sanctuary chamber crowned by a dome and with a miḥrāb, or prayer niche, in the rear wall of the chamber at the end point of the longitudinal axis.

The earliest mosque surviving in Iran which contains all these elements is the small Masjid-i-Jāmiʿ at Zavāra, first described by André Godard,[1] which was erected in a single building campaign and completed in 1135. The period of the Il Khānid rulers offers only a single monument which fulfills all the conditions and which was built in one campaign, the Masjid-i-Jāmiʿ at Varāmīn (Fig. 37), but a structure built later in the century, the Masjid-i-Jāmiʿ at Kirmān, also displays the fully developed plan. However, it is quite logical to include in the category of standard mosques those structures of the general period which include most of the elements of the fully developed plan since it is clearly indicated that there was a steady movement towards the developed plan using the common Islamic element of the arcaded court and the Iranian pre-Islamic elements of the īvān and the square chamber crowned by a dome. Some seven of the catalogued monuments may be considered as standard mosques. They are: Masjid-i-Jāmiʿ at Bisṭām, the mosque in the complex at Naṭanz (Fig. 23), Masjid-i-Jāmiʿ at Ashtarjān (Fig. 26), Masjid-i-Jāmiʿ at Farūmad (Fig. 39), Masjid-i-Jāmiʿ at Varāmīn (Fig. 37), Masjid-i-Jāmiʿ at Kirmān, and Masjid-i-Pa Minār at Kirmān.

Seven other surviving mosques may be classified as "non-standard." In all but one of these structures the dominating element is the square dome chamber, in the exception the principal element is a great īvān. Without attempting at this point to trace the development of the mosque form, it is possible to say that in Iran attention was early concentrated upon the īvān and the dome chamber, with the latter element especially favored. Thus, in many examples from several historical periods the dome chamber was erected as a single unit and either 1) left as an isolated structure, 2) supplied at the same period with an arcaded court and other features of the standard plan, or 3) supplied with these features at a sub-

[1] *Athār-é Īrān*, I, part II (1936), pp. 296-305.

sequent historical period. The seven mosques of this category display cases 1) or 3) or case 2) but with the auxiliary elements either too few in number or not regularly arranged so that the standard plan is not arrived at. These mosques are: Masjid-i-Bābā ‘Abd Allāh at Nāyīn, Masjid-i-Jāmi‘ at Ardabīl, Masjid-i-Jāmi‘ of ‘Alī Shāh at Tabrīz (Fig. 30), mosque at Dashti (Fig. 43), mosque at Kāj (Fig. 41), mosque at Eziran (Fig. 42), and Masjid-i-Gunbad of Āzādān at Iṣfahān (Fig. 58).

Madrasas, the religious schools of Islam, are represented in the catalogued monuments by three standard and one non-standard plan. The standard plan of the madrasa is so close to that of the mosque, in spite of the different function of the types, that the Iranian version has been called the madrasa-mosque plan. Controversy has raged over the probable place of origin of the Moslem madrasa and stages in its development but this problem is not a matter of present concern. It need only be said that in Iran the mosque seems to have achieved the fully developed standard plan before the madrasa, although this conclusion is based only upon the chance survival of structures. Both the Madrasa Imāmī at Iṣfahān and the madrasa in the Masjid-i-Jāmi‘ at Iṣfahān display the fully developed standard plan which differs from that of the mosque in that the place of the prayer halls is usually taken by a line of living chambers in one or two stories.

Mausolea comprise some thirty-nine of the catalogued monuments. They include two categories: the square chamber crowned by a dome—twelve examples—and the tomb tower. The tomb towers, with round, square, or polyhedral plans and distinguished from the dome chambers by their much greater height in relation to plan dimensions, may be separated into structures crowned by exposed domes and structures crowned by polyhedral tent domes or conical roofs. All of the mausolea display an inner dome over the chamber and their religious character is emphasized by the fact that more than half the total number contain miḥrābs. Burial in these tombs was either in a sarcophagus placed at the center of the chamber or in a vaulted crypt located below the chamber and entered from a lateral face of the structure.

Most of the mausolea of both types were imāmzāda (literal meaning—"descendant of an Imām"), that is, places of burial of a descendant of one of the Shī‘a Imāms. For the Shī‘as of Iran the arduous journey to Mecca and Medina was not the only goal of pilgrimage, since special blessings derived from pilgrimage to the Shī‘a shrines of ‘Irāq which house the remains of several of their Imāms and special merit came from pious visits to the great shrine of the Imām Riẓa at Mashhad and to that of his sister Fatema at Qumm. Also, the Shī‘a theologians had ruled that visits to each one of the imāmzādehs were advisable on account of their connection with the Imāms and because of the probability that visits to these tombs might be a means of blessing. Such sanction gave increased impetus to pious donations for the construction or repair of these tombs, with miḥrābs being provided to properly orient the prayers of the visitors. The theologians also stated that the graves of great Shī‘a scholars and traditionalists should be visited whenever possible and at such places as Bisṭām, Linjān, and Gārlādān the high regard of the pious for the saintly deceased brought imposing structures into being.

In each type of religious structure mentioned, the square chamber crowned by a dome

has played an important role and this form may be considered to be the primary architectural feature of Moslem architecture in Iran.

Structures of secular character need only brief mention. The caravanserais at Sīn (Fig. 56), Sarcham (Fig. 57), and near Marand (Fig. 55) are so badly damaged that only the plans of their portals are perfectly certain. However, they followed the normal caravanserai plan which was in use for several centuries and which is very like that of the standard madrasa-mosque type. With its living chambers around the open court the form is very close to that of the madrasa, except that the court is much larger—the area being required for the animals of the caravan—that bastions flank the exterior walls, and that the dome chamber is less frequently used at the end of the longitudinal axis.

Structures which are known to have been erected during this period but which are no longer extant are listed separately in the Supplementary Catalogue. Many of these buildings were secular in character and a number were palaces that were built largely of wood. Structures of a more ephemeral nature, the tents used for both winter and summer occupancy are not so listed. It has, however, been pointed out that the Mongols entered Iran as tent-dwelling people and continued this way of life for at least a generation after they settled in the country. As late as the reign of Abū Sa'īd, the Il Khāns and their court spent the winter under tents at favorite sites on the warm plains of Āzerbāijān and at least a part of the summer in the high mountain valleys of western Āzerbāijān. Such tents, at these places and elsewhere throughout the realm, were of considerable elegance. Arghūn, the governor of Khurāsān, entertained Hūlāgū in a tent of golden cloth, fastened down with 1,000 gold tent pegs, which consisted of an antechamber and a hall of audience. The wintering site of Aūjān was an extensive tent community. The principal courtiers had their own sizable tents of felt or horsehair cloth and temporary bazaars and mosques were erected along a number of wide avenues. When summer came all the lesser tents were burned. The summer palace of Ghāzān Khān at Aūjān, located at the intersection of two tree-lined avenues, was a tent of golden tissue which the most skilled artisans had worked two years to make. According to one account, it consisted of a hall of audience and several appendages, the whole being so vast that it took a month to erect.

Another contemporary account speaks of a tent at Shūstar which was of satin and erected over forty pillars. While these tents were unquestionably numerous, large, and splendid, the statements about them are not very informative. However, the picture can be filled in, in part, by the more detailed accounts of the tents of the Mongol kingdoms to the east. Friar John from Perugia saw a huge city of tents at Karakorum in 1246 and William Rubruck quite fully described the royal tent of Mangū which he saw at Karakorum in 1254. In addition, Marco Polo has left us a vivid picture of the sumptuous reception tent of Kubilai Khān. Certainly those of the Iranian Il Khāns were of equal size and splendor. Nor did the tradition of tent life die out with the Mongols; their structures were the direct inspiration for the tents of Tīmūr at Samarqand, which have been so charmingly described by Clavijo.

8. Relation of Structures to Their Sites

AT NO site in Iran has any monument of the Il Khānid period been preserved along with an urban area contemporary in date so that we cannot be certain of the relation of the structures under consideration to their original surroundings. At Sulṭāniya where a great city was built within the course of a few years on an unclustered site nothing remains above ground except two monuments. Although the houses of Iranian villages and towns have been destroyed and rebuilt several times since the fourteenth century the fact that the plan types and materials of construction have remained the same is an indication that the general aspect of these settlements has altered but little until recent years except that most of them now cover a smaller area than in the earlier centuries. Certain monuments which were once engulfed within built-up areas now are free standing and owe their preservation to their religious character and to the fact that their construction was far superior to that of the domestic architecture. In a similar manner the existence of Il Khānid structures, or of earlier or later monuments, along streets and lanes has served to preserve circulation lines over a long period.

The mausoleums of the Il Khānid period followed early practice in being free standing and visible from all sides. The evidence of the surviving monuments indicates that royal tombs were placed on a specially selected site and that tombs of very important individuals were occasionally erected in built-up areas adjacent to an existing mosque or shrine, but that the normal site for the location of a tomb tower or tomb shrine was in one of the local cemeteries. These cemeteries were situated some distance outside one or more gates of each town. In the very extensive cemeteries which have been in use for a number of centuries, such as the one across the Zāyindā-rūd River from Iṣfahān, scores of structures are scattered in an area strewn with thousands of flat stone grave slabs. At Qumm the tombs of the Il Khānid period are to be found in two general areas, one in the cemetery to the east of the town and the other in the cemetery west of the town (Fig. 2). A number of the Il Khānid tombs have actually outlived the cemeteries within which they were built and now stand in gardens or on ground which has been swept clear of all grave slabs. In certain cases a simple grave slab or an unimportant grave structure may have become so venerated that an important structure was erected at the spot. This appears to have been true in the cases of the Pīr-i-Bakrān near Iṣfahān and the īvān below the shaking minarets at Iṣfahān. Conversely, after the erection of a tomb within a built-up area, the sanctity of the shrine may have brought such a demand for burial places on neighboring ground that a cemetery gradually replaced the other buildings in the area. This may have been the trend of events at the shrine of Bāyazīd at Bisṭām. The very form of the tombs was well suited for a free standing location in that the square, round, or multi-sided structures lacked any directional orientation or any one side which was much more important than the others. The location of the tombs in cemeteries was also a factor in their continued survival; the site and character of the structures entitled them to respect and helped to preserve them from the local raids in search of building material which destroyed structures at every period.

In addition to the mausoleums, one other type of structure was normally free standing. This was the caravanserai which was built either in open country along a trade route or

near the gate of a town. There are also three structures which appear to owe their isolated location to a failure to carry through a planned development of the sites. These are the mosques at Kāj, Dashti, and Eziran, located within a few kilometers of each other to the east and south of Iṣfahān. No one of the three was ever completed, nor are there traces of much building in the vicinity and it seems possible that these mosques were erected as the focal point of planned settlements and that the idea of establishing the settlements was abandoned before the completion of the structures.

Monuments serving other functions were usually erected in built-up areas and normally had both a fixed orientation and a longitudinal axis. Religious in character, their orientation was determined by the fixed direction of the miḥrāb and the greatest length of the structure was from entrance portal to miḥrāb. Occasionally the restrictions of a chosen site or the necessary relation of the new structure to some feature already in existence made it necessary to locate the miḥrāb at some point other than the end of the long axis of the plan. Thus, the miḥrāb of the shrine of Pīr-i-Bakrān near Iṣfahān is built against a low wall which was erected across the open end of the īvān (Pl. 27). The shrine of Bāyazīd had to be crowded among existing structures, as is shown by its irregular exterior outline, and its longest extension is at right angles to the main entrance portal with the miḥrābs also at right angles to the portal axis.

The problem of determining the exact direction from each site towards Mecca, so that the front face of the miḥrāb could be built at right angles to it, apparently caused a lot of trouble at every period. Ḥamd-Allāh Mustawfī of Qazvīn, author and official of the Il Khānid period, tells in one of his works how to establish the direction of Mecca—by placing a stake in the ground, measuring the points where its shadow crossed a circle drawn on the ground, etc.—and the present writer has wondered if Mustawfī was aware of the fact that the miḥrābs of the two fine Seljūq monuments in his home town of Qazvīn were a number of degrees to one side of the correct direction. Not too infrequently a reexamination of the problem gave a fresh answer and in the shrine at Naṭanz the new orientation of the tomb of Shaykh ʿAbd aṣ-Ṣamad threw this structure several degrees out of line with the earlier mosque to which it was attached.

When structures were erected in built-up areas, they were either deliberately related to existing means of circulation through the area or little attention was paid to means of access. In the latter case streets and lanes were finally relocated to pass by the monument.

A number of the surviving monuments of the period face on streets or lanes which are older than the buildings in question. The south exterior face of the complex at Naṭanz is angled to follow the slightly irregular course of an existing street (Fig. 22). The principal portal and a side entrance of the Masjid-i-Jāmiʿ at Ashtarjān open directly onto narrow lanes. A rather long passage leads from the adjacent street to one corner of the court of the Masjid-i-Jāmiʿ at Farūmad (Fig. 39), and two exterior façades of the Imāmzāda Bābā Qāsim at Iṣfahān (Fig. 59) join at an unusual angle at the intersection of two narrow streets.

In those structures which presented a considerable surface to existing streets comparatively little effort was devoted to giving these façades a finished character. Indeed, it was not until the seventeenth century that anywhere near as much care was lavished upon the exterior of the monuments as on their interiors. Several meters of the street façade of

the complex at Naṭanz were beautifully finished and decorated but in general only the entrance portal received careful architectural treatment. Thus, the mosque at Ashtarjān displays blank, drab mud walls to the bounding streets and the exterior of the mosque at Farūmad is treated in a similar fashion.

The most elaborate and most architecturally satisfying means of emphasizing the street entrance was the high īvān portal crowned by paired minarets, a feature which had not been developed before Il Khānid period. Surviving examples of the period are at Ashtarjān (Pl. 91), Qumm (Pl. 156), and Abarqūh (Pl. 157) and at Iṣfahān in the Do Minār Dardasht (Pl. 158) and the Do Minār Dār al-Baṭṭīkh (Pl. 163). While the portal at Ashtarjān was placed to one side of the longitudinal axis of the mosque, the others cited are the sole elements which have been preserved of their original monuments. Monumental portals without crowning minarets have survived at Bisṭām (Pl. 35) and in the mosques at Varāmīn (Pl. 131) and Kirmān. It is doubtful whether any of these impressive portals were erected with additional consideration given to the needs of the beholders, that is, introduced by a wide and long cleared area so that the entire height of the façade could be taken in from an easy point of view. The concentration of architectural detail and interest upon interiors explains the lack of attention given to monumental planning as we understand it in the west or even as practiced in the seventeenth century during the Ṣafavid period. Such devices as the opening of vistas, the climactic arrangement of successive structures or elements of the same structure, the establishment of important communication means to a major monument, or a planned relationship between important structures located in the same general area were simply not practiced.

The three greatest structures of the period were the mausoleum of Ghāzān Khān, the mosque of ʿAlī Shāh and the mausoleum of Öljeitü. Contemporary documents indicate that the vanished tomb of Ghāzān was situated at one side of a large open courtyard. However, nothing is known of its relationship to avenues or approaches and descriptions of the general area suggest that it was one of a number of structures scattered throughout a park-like area. The mosque of ʿAlī Shāh was clearly visible from an extensive area, lined with arcades, placed before the monument, but again material relative to its approaches is lacking. The tomb of Öljeitü, an octagonal plan without inherent direction, was erected at a site which soon included a mosque and other important structures (Pl. 70) but contemporary texts give no indication that the monument was part of a large scale composition. Indeed, traces of construction walls abutting against the tomb suggest that other structures may soon have approached the tomb, whose principal entrance may have shifted from the west to the north side of the structure.

In Il Khānid times there was a continuity of the general Islamic tradition in Iran of building up complex structures. The growth of complex structures by agglomeration seems to have been characteristic of Islamic architecture in Iran. Such a careless disposition of additional structures around a central core element is well displayed in monuments whose histories cover several centuries, such as the shrine of Imām Riżā at Mashhad, the shrine at Turbat-i-Shaykh Jām and the Masjid-i-Jāmiʿ at Iṣfahān. The complexes at Bisṭām and Naṭanz, almost entirely of the Il Khānid period, reflect this same type of growth and it is

probable that the monuments sponsored by Ghāzān Khān, ʿAlī Shāh and Öljeitü were partially surrounded by auxiliary structures.

In both earlier and later periods the important mosques of several towns were located either at the beginning or end of the covered bazaar or in close proximity to its course but none of the standing Il Khānid mosques have such a relationship.

A somewhat elevated site was always preferred for the location of an important structure. In many cases where an early monument was erected at the street level of the period it is now some distance below the modern street: such is the case at the Naṭanz complex, at the Imāmzāda Bābā Qāsim and the Madrasa Imāmī at Iṣfahān and at the Masjid-i-Jāmiʿ at Kirmān. However, the conspicuous elevations upon which such structures as the Pīr-i-Bakrān near Iṣfahān, the Masjid-i-Jāmiʿ at Ardabīl, the Hārūniya at Ṭūs, the Gunbad-i-ʿAlayivan at Hamadān and the caravanserai at Sīn still stand are at a height of from one to several meters above the level of the nearest modern streets.

9. Methods and Materials of Construction

DESIGN AND CONSTRUCTION OF THE MONUMENTS

RASHĪD AD-DĪN included among his several literary productions a work entitled *Kitābu'l-Ahyā wa'l-Āthār* (Book of Animals and Monuments).[1] The twentieth chapter of this work dealt with the rules to be followed in building houses, structures consecrated to pious purposes, fortresses and all types of buildings and the twenty-first chapter included information on the construction of tombs. Unfortunately no copy of this manuscript has survived, nor is any other study of a like nature known to exist. In the absence of documentation it may be questioned whether structures of this period were precisely designed in advance of construction or whether they were the products of day by day work on familiar plan types with specific variations introduced by the experienced craftsmen.

No material from earlier periods which deals with advance planning seems to exist and only a single shred of evidence suggests that the monuments of the Il Khānid period were produced from studied plans. Rashīd ad-dīn, in writing of the erection of the High Tomb of Ghāzān Khān, stated: "He himself [Ghāzān] drew the plans (خویشتن طرح کشیده)."[2] Historians have always been prone to credit their sovereigns with comprehensive talents and we may be rather certain that Ghāzān did no drawing himself. However, the very use of this phrase is a positive indication that preliminary plans were prepared.

Interesting material of a contributory nature, nearly contemporary in date, comes from Asia Minor. A. Gabriel has published the town walls and structures of Diyār-Bakr and recorded their inscriptions. Four inscriptions contain the name of Shujā' ad-dīn Ja'far ibn Maḥmūd of Aleppo.[3] Each inscription ends with the same formula: 1) built by (البّاء), 2) name of a craftsman, 3) ترسیم, and 4) the name of Shujā' ad-dīn in variant forms. The word tarsīm (ترسیم) is translated by Gabriel as, "sur les plans du." The actual root means to draw or to trace and as used in these inscriptions the form might be translated as, "tracing by," or "drawing by," or "design by."

No drawing of a true plan, elevation or section is known to have survived from the Il Khānid period or from earlier times. The illustrated manuscripts of the time, especially the copies of the history of Rashīd ad-dīn, do portray many buildings but always with the linear distortions common to the manuscript style. Generally a building is shown as if it were a cardboard model which had been unfastened at the rear, then opened out slightly and viewed from the height of its cornice. Where an actual monument, such as the tomb of Ghāzān Khān (Pl. 31), is represented, the drawing had little correspondence with the original. On the other hand, the details of brick bonding and of plaster and tile decoration are carefully and accurately done just as they appear on the standing monuments.

It might be assumed that the plans and other drawings for a structure, possibly executed at the site on large smooth slabs of plaster, would be carefully preserved on paper by the individual designer or by a craftsmen's guild and that later structures would be based upon

[1] E. M. Quatremere, *Histoire des Mongols*, Paris, 1836, pp. cxii-cxiii.

[2] K. Jahn (Ed.), *Geschichte Ġāzān-Ḫān's aus dem Ta'rīḫ-i-mubārak-i-Ġāzānī des Rašīd al-Dīn . . .* (Persian text), London, 1940, p. 208.

[3] A. Gabriel, *Voyages archéologiques, dans la Turquie Orientale*, Paris, 1940, I, pp. 324 and 331.

this material. However, no monument of the period is an exact copy of any other and even in those structures which are quite similar no corresponding parts have identical dimensions.

Structures erected at earlier periods in Syria reflect the use of arithmetical and geometrical systems of measurement and it is possible that the master builders, engineers and craftsmen of Iran made use of some simple form of notation. Proportional notation is at the same time both simple and precise. If such a method were used, one established plan dimension, such as the length of the sides of a square chamber, might serve as the basis for the vertical dimensions. The dome chamber of the Masjid-i-Jāmiʿ at Ashtarjān was studied in detail with this possibility in mind and the results appear rather convincing. Thus, half the length of the side walls equals the distance from the floor to the apex of the miḥrāb arch; the length of the side walls equals the distance from the floor to the apex of the wall arches; and, one and one half times the length of the side walls equals the height from the floor to the apex of the dome. In the nineteenth century M. Dieulafoy attempted to demonstrate a proportional relationship between certain plan and section measurements in the mausoleum of Öljeitü at Sulṭāniya, but his explanation appears too complicated to be convincing.

Whatever preliminary decisions were made with regard to the particular monuments were not always carried out unaltered, for a number of examples can be cited in which changes were made during the course of the erection of the fabric of structures. Rashīd ad-dīn wrote: "When they brought the foundations of this dome (Ghāzān's tomb) to the level of the ground, the engineers asked (Ghāzān), 'In how many places shall we put windows?' "[4] In the tomb tower of Chelebi Oghlu at Sulṭāniya the elaborate brick bonding of the exterior walls abruptly gives way to common bond at a point 2.50 m. above the base (Pl. 171). In the mosque at Dashti a horizontal line around the chamber at about one m. above the base of the zone of transition is marked by the introduction of bricks of an entirely different size and color from those used below (Pl. 147). The mosque at Kāj displays a comparable change in technique and material: at a point just below the zone of transition the elaborate bonding of the interior surfaces of the chamber gives way to common bond laid in lighter colored and somewhat smaller bricks (Pl. 152). The mosque at Eziran also displays a break in construction at the base of the zone of transition (Pl. 155).

In some cases the decoration of the actual fabric of the structure kept pace with the rising structural walls and in others the decoration represents a revetment applied to the completed fabric. Changes in the bonding patterns at Eziran and in the tomb tower of Chelebi Oghlu at Sulṭāniya represent cases in which the pattern was carried up along with the fabric. However, examples of applied decoration are much more numerous. It is probable that a crew of specialists was brought to each structure after the fabric had been entirely completed. Thought was given to the needs of this crew during the earlier construction stages. Scaffolds were almost certainly left in place. This is suggested by the fact that scaffold holes are always left unplugged and hence the scaffolds were probably not removed until all the decoration was completed. In many structures recessed panels, which either com-

[4] K. Jahn (Ed.), *op.cit.*, p. 117.

pletely encircle the chamber (Pl. 152) or which are located in the heads of wall panels (Pl. 147), were left to be filled by plaster or tile inscription bands.

It does appear likely that decorative features were executed from carefully made drawings, some made at full size on plaster following copy book designs. Logic and later practice both support this assumption. For example, it would be impossible to execute an inscription band in plaster or tile within the limits of an existing recessed panel unless the lettering had been laid out in advance. At the present time craftsmen in mosaic faïence, who closely follow the technique and patterns of much earlier work, use full size drawings. A series of drawings of brick bonding patterns, executed during the nineteenth century, if not earlier, is still in existence. A number of the pages of a decorated Qur'ān (Pl. 82), made especially for Öljeitü, display elaborate patterns which are almost identical with those found in the plaster ornament at Öljeitü's tomb and in other monuments (Pls. 80-84). It is very probable that the decorative details of such illuminated manuscripts were a constant source of inspiration to the building craftsmen. At a somewhat later date certain noted calligraphers both compiled manuscripts and designed the inscription friezes for buildings.

A special illustration of the fact that the decorative features were frequently applied to the finished fabric is the existence of several structures in which the decoration was never completed. Among these monuments may be cited the caravanserai at Sīn and the mosques at Dashti and Eziran.

In the case of the more elaborately decorated monuments it is probable that it took a longer period of time to execute the ornament than it had to erect the fabric. In the Masjid-i-Jāmi' at Varāmīn an inscription in the īvān before the dome chamber is dated 1322 while the date 1326 is found within the chamber itself. The ensembles at Bisṭām and Naṭanz were erected and decorated over a period of several years: at Naṭanz the entrance portal of the mosque is dated 1304 and one of the īvāns of the court 1309.

From the moment the outlines of a structure were marked out on the ground until it was brought to completion a measuring scale of some type must have been used, regardless of whether or not drawn plans were followed. Precise information concerning this scale is lacking but several suggestions may be made. Manuscripts of the period which record the dimensions of structures give the unit as the "gaz" and it is known that a unit of this name was also used for the measurement of cloth at this general period. In the catalogue of monuments, under the description of the tomb of Ghāzān Khān, mention is made of the fact that the gaz is usually translated as "ell" or "cubit." Either "cubit" or "coudée" would appear to be the proper approximation of a unit which, in many countries at many periods, represented the distance from the elbow to the end of the middle finger. This unit is normally given a value in the neighborhood of forty-five centimeters. The Persian editor of the modern edition of the history of Hâfiz-i-Abrû states that the gaz equals thirty centimeters but gives no authority for this statement. A comparison between measurements of the tomb of Öljeitü as given by Vaṣṣāf with the actual measurements seems to give the gaz a value of about twenty-five centimeters. The field notes, covered with dimensions, of a score of structures have been examined in search of a common denominator and unit of measurement for these dimensions. A number of the important dimensions of several of the structures were found to be multiples of twenty-six centimeters with only

slight plus or minus remainders and the suggestion is made, with all reserve since the material is far from conclusive, that the gaz in use was approximately twenty-six centimeters long. However, in view of the known fact that several sections of the country used, until very recent times, local systems of weights and measures it is probable that no particular standard was in general use.

Other possible kinds of measuring scales are the length of a standard brick and a measuring stick for bricklaying marked with the widths of a brick plus its joint. The use of either the brick length or a stick marked off with brick courses is not reflected by the monuments themselves. Not only do the sizes of bricks vary from one structure to the next, but in a number of tested monuments none of the dimensions are multiples of brick lengths. While it does seem probable that the masons at each job had measuring sticks to ensure that the walls rose horizontally throughout their length there is no way to transfer the divisions of this theoretical unit of measure to the dimensions of the existing buildings.

Structures were erected with a considerable range of accuracy and care. The easiest check on attention given to accuracy is to compare corresponding dimensions, such as the lengths of the sides of a dome chamber, or the sides of an open court, within a single structure. Reference to field notes shows that relatively few of the monuments have corresponding parts of absolutely identical length. On the other hand, in a number of monuments, and notably in the structure at Dashti, Kāj, and Eziran near Iṣfahān, corresponding parts vary by several centimeters. It seems logical to equate the relative accuracy of dimensions with the experience and attitude of the master builder in charge of the construction.

THE ROLE OF THE CRAFTSMAN

The names of a number of the craftsmen who were engaged in the construction and decoration of certain of the monuments have survived in a variety of places on the structures: within historical inscriptions; at the end of religious inscriptions; as signatures within miḥrāb inscriptions; and, within separate friezes, plaques, or roundels.

The names of twenty-one individual craftsmen were noted during the recording of the structures. Translations of portions of inscriptions which refer to craftsmen follow:

CATALOGUE
NUMBER OF
MONUMENT LOCATION AND TEXT

16 Miḥrāb signed, "the work of 'Abd al-Mu'min ibn Sharafshāh, the painter of Tabrīz . . ."

25 In the right and left spandrels of the portal arch, "the work of the servant . . ." and "Mīrzā (the builder?)."

26 On the tomb, an inscription ending ". . . the work of Sarāj."

28 A miḥrāb, an inscription frieze and the inscription band at the cornice level of the tomb tower all bear the name of Muḥammad ibn al-Ḥusayn ibn Abī Ṭālib of Dāmghān who is described as engineer (المهندس), builder (البنّا) and plaster worker. One of these inscriptions includes the name of "his brother Ḥājjī" (see Catalogue Number 53 below).

44 Miḥrāb signed, "the work of Ḥasan 'Alī Aḥmad Babuyeh (? Ābūd 'Alī ?)."

46 Miḥrāb signed by "Mas'ud of Kirmān."

[45]

48 Construction of the miḥrāb was supervised by 'Azad ibn 'Alī al-Māstari. The *Survey* states that the miḥrāb is signed, "the work of Badr."

49 Signatures within inscription bands reading, "the work of Aḥmad ibn Muḥammad, the builder" and, "the work of Ḥajjī Muḥammad, the (tile-) cutter."

53 A panel reading, "the work of Ḥajjī ibn al-Ḥusayn, the builder of Dāmghān."

61 On the wall above the miḥrāb, the signature of, "master workman 'Alī Jāmi' al-Sanai' of Simnān."

64 Small plaster panel with, "the work of 'Alī of Qazvīn. . . ."

79 Miḥrāb signed, "the work of the poor servant Niẓam, the mason of Tabrīz."

89 The signature, within a plaster panel, of "Ḥajjī Muḥammad, the builder of Sāva."

100 At apex of vault of north īvān, "Muḥammad ibn 'Umr bin al-Shaykh."

104 Within spandrels on the interior face of the entrance portal, "work of 'Alī bin Muḥammad bin Abū Shujā'."

109 Within an inscription band, "written by Aziz al-Taqi al-Hafiz."

109 Miḥrāb signed, "written by 'Alī Kūhbār al-Abarqūhi."

109 Within a panel, "Fakhr ibn 'Abd al-Vahhāb of Shīrāz, the mason."

109 Within a panel, "the work of the servant, the weak, Shams ibn Tāj."

109 Two signatures of "Morteẓa bin al-Ḥasan al-'Abbāsi al-Zainabī."

When the Il Khāns began to build they were dependent upon native local and itinerant craftsmen and throughout this entire part of the world there had always been a tradition of itinerant workers and artisans. Eight of the twenty-one known craftsmen include their natal town as part of their names. Such usage frequently reflected the pride of a person—author, soldier, official, or craftsman—who had made a name for himself in the larger world. It does not necessarily imply that he had left his place of birth or origin for good; in the case of these craftsmen they certainly moved from their home towns to various jobs. This range of travel seems to have been fairly limited. Thus, we find men from Tabrīz working at Marand and Riẓā'iya; a man from Dāmghān at Bisṭām; one from Simnān at Farūmad; one from Qazvīn at Varāmīn; one from Sāva at Sīn; one from Abarqūh at Iṣfahān; and, one from Shīrāz at Iṣfahān. The Ḥajjī Muḥammad who worked at Ashtarjān in 1315-1316 may be the same individual as the Ḥajjī Muḥammad, builder of Sāva, who worked at Sīn in 1330. The record for long distance travel—2,600 kilometers air distance—seems to be held by Muḥammad ibn Muḥammad ibn Osman of Ṭūs who signed an inscription band dated 1243 at Qonia in Asia Minor.

These craftsmen—master workmen, builders, masons, engineers, painters, calligraphers, plaster workers, tile-cutters—received their training as apprentices in guilds which had their local headquarters within the bazaars of the towns and the tradition of pursuing a particular craft ran through generations in the same families. This family tradition seems to have been very strong among the ceramic artisans of Kāshān for the names of many members of several generations of two such families have come down to us. The guild training and the family heritage favored conservatism of method. However, in this period the increasing use of glazed tile offered opportunity for experimentation and the display of individuality. The glazed material originated in the shops of the potters and was at first handled by the masons. As the complexity of the medium was recognized, specialists appeared: Ḥajjī Muḥammad, the tile-cutter, was such a man. The mark of individuality

is clearly visible in the faïence decoration at Bisṭām where it would seem to reflect the many-sided skill of Muhammad ibn al-Ḥusayn ibn Abī Ṭālib of Dāmghān.

The craftsmen whose self-descriptions have been variously translated by others as "builder," "engineer," or "architect" are actually designated in the inscriptions only as "builder" (banna'—البنّاء or بنّاء) or as "master workman" (ostād—استاد). Rashīd ad-dīn, in describing the construction of the tomb of Ghāzān Khān, speaks of "master builders" (ostādān banna'—استادان بنّاء) and of "engineers" (mohandesān—مهندسان). It is not easy to know whether such men were actually master masons, whether they were supervisory foremen, whether they worked out the details of the structure as the work went forward, or whether they were architects who made drawings in advance of construction.

The specific terms for "architect" (mi'mār—معمار, or mohandes mi'mār—مهندس معمار)[5] have not been found in any of the inscriptions of the catalogued monuments. However, the term mi'mār was in use in India and Asia Minor as early as the thirteenth century A.D.[6] and an Arab inscription from the Caucasus region, dated 759/1358, also employs the word mi'mār[7] and it is thus most likely that recognized architects were active in Iran proper during the Il Khānid period. Such individuals would have been of a higher social or economic level than the builders who signed their detailed handiwork and we possess one suggestion as to the possible capacities of such an architect. The poet Niẓami, writing in the twelfth century, describes the talents of a mythical architect, Shīda, who designed and erected a fabulous seven-domed palace for Bahram Gur.[8] Shīda was of honorable birth, a master in drawing, a famed geometer in surveying, a finished worker in the building art and an artist skilled in sculpture and painting. In addition, Ibn Khaldun, writing in North Africa in the last quarter of the fourteenth century, stated that a certain knowledge of the problems of geometry was indispensable to the practice of architecture; that familiarity with the theory of conic sections was useful in such practical arts as carpentry and architecture; and that in order to develop perfect forms from their concept through their execution the laws of proportion must be understood.[9] From these sources the inference may be drawn that a careful examination of the structures of these centuries might reveal that proportional and geometrical relationships are present in plan, elevation, and section.

BRICK: SIZES, SHAPES AND TYPES

Fired Bricks: Standard

The standard or common bricks were square, continuing a tradition extending far back in the pre-Islamic period. A considerable variation in sizes as well as variations in color

[5] Mi'mār derives from the root 'imir—عمر, "to be inhabited." Another form, 'imāra—عماره, "building," is frequently found in inscriptions which begin: "the order for the construction of this building . . ."

[6] At Bihar in Bengal the mausoleum of Shāh Fazlallah was built shortly after the middle of the thirteenth century by the architect (mi'mār) Majd al-Kābuli, while a sarcophagus in the Qonia Museum, dated 672/1273, mentions a tomb built by the architect (mi'mār) 'Abd al-Wāhid bin Salīm. See E. Combe, J. Sauvaget, and G. Wiet, *Répertoire chronologique d'épigraphie arabe*, XII, pp. 121-122 and 186-187.

[7] N. de Khanikoff, "Mémoire sur les inscriptions musulmanes du Caucase." *Journal Asiatique*, 5th series, XX (1862), p. 148.

[8] C. E. Wilson (Trans.), *The Haft Paikar*, London, 1924, I, p. 110.

[9] M. de Slane (Trans.), *Les Prolégomènes d'Ibn Khaldoun*, Paris, 1934, II, pp. 375 and 378; III, p. 143.

and texture suggest that these bricks were made at many points throughout the country rather than in a relatively few important centers.[10] The range of variation also runs counter to a theory that the date of Moslem monuments in Iran may be determined by establishing tables of the size of bricks used in successive periods. It does not even seem possible to establish the relative age of a number of constructional periods at the same monument by a comparison of brick sizes. It seems logical to believe that there was less change in size from one period to another than there was variation in size from one brick-producing point to another. Marked changes in size would normally result from changes in kind and method of construction, and in Iran such changes did not take place frequently, while the conservatism of the builders led them to use the same size and shape of units over very long periods of time.

Fired Brick: Small Standard

A relatively few monuments contain bricks of the standard square shape but of a size only about half as large as normal. Bricks of this type had been used in the Seljūq period.

Fired Brick: Cut

Cut bricks are found in nearly all monuments which display elaborate bonding patterns. Probably the wet bricks produced in the standard moulds were cut and trimmed with a sharp knife or wire and then fired. These cut bricks were made in a limited number of rectilinear forms and also with forty-five degree corners at one or both ends of the brick.

Fired Brick: Moulded

A relatively few monuments of the period display bricks which were made in specially shaped moulds for use in specific parts of the structures, such as for angle colonnettes and the edges of recessed panels (Pls. 16, 144). The fact that nearly each monument in which they are used has its special and particular shapes of moulded bricks suggests both that they were made locally at or near the monument and that the details of the monument had been carefully planned before actual construction was begun. Typical shapes of these moulded bricks follow:

Fired Brick: Color and Texture

The fired bricks display a wide range of color from a light buff, almost a yellow ochre, through reddish buff and red to a drab dust color. Possibly the local earths gave the color to the bricks rather than added pigments. The brick colors are never intense and the monuments of Āzerbāijān use a red brick which is not common to other sections of the country. In general, the bricks were well baked. They are not friable and in many structures are as sound as when first made. Firing was not always uniform as many bricks are slightly warped and there is a range of 1 cm. to 2 cm. in the length of bricks in the same wall.

[10] The bricks range from 18 cm. to 31 cm. square, with the most usual sizes between 20 and 22 cm. square. The thickness of these bricks varies from 4 cm. to 7 cm. with between 4.5 and 5 cm. as the most common thickness.

Mud Bricks

Mud bricks were used in three ways. The entire structure was built of mud brick; the lower walls were of mud brick and the dome of the structure of fired brick; or, the core of the walls were of mud brick and the exposed surfaces of fired brick. This third method seems to have found greater favor in the fourteenth century than at any earlier period. It should be noted that structures in which mud brick was used probably far outnumbered those of fired brick, especially in the smaller villages, but that few of those buildings have survived because they were so readily subject to damage and destruction by wind, rain, and snow.

Reused Brick

Many of the structures of the period contain older, reused bricks. The deliberate destruction of older monuments to obtain material for new building was common throughout the entire Islamic period.

Mortar

Gypsum (Plaster of Paris) mortar, made by calcining hydrated calcium sulphate in small kilns built of rubble masonry, was apparently much preferred to lime mortar, made by calcining limestone. The predilection for the gypsum mortar resulted from its more rapid set which aided greatly in the erection of arches and vaults over temporary or permanent armatures. Samples of gypsum mortar from various structures indicate that it was frequently mixed with clay, sand, fine gravel, and even mud. In hardness its range is from very hard to soft and in color from white through light buff and buff to grays. In certain monuments it appears as if the color of the mortar consciously copies that of the bricks.

Brick Joints

There appear to be three principal classes of relationship between width of horizontal and rising joints, all in common use prior to the Il Khānid period. In one class both horizontal and rising joints are about 2 cm. in width. In another class the horizontal joints are 2 cm. or more wide and the rising joints of minimum width. In the third class the horizontal joints are of minimum width and the rising joints from 2 cm. to 6 cm. wide. This third class lent itself effectively to decorative elaboration. Thus, the rising joints were filled with: insets of carved plaster (commonly called brick-end plugs) (Pls. 40, 200); insets of carved or moulded terra cotta (Pls. 16, 171), or, insets of glazed terra cotta (Pl. 177).

Pointing

The bricks were usually laid up either on a full bed of mortar which brought the mortar in the joint flush with the finished wall surface or on a scanty mortar bed with the result that the finished wall surface appeared to have raked joints.

In a majority of the monuments the wall surface was pointed after the structure was completed. Flush pointing was most commonly done, but raked joints varying from slightly raked to a depth of 2½ cm. are frequently noted (Pl. 144). A single example of a beaded joint was recorded (Pl. 166). In a few examples a line was scratched along the middle of the flush pointed joints. In a few structures the joints have been painted white (Pl. 200).

False joint lines and false bonding patterns, both executed in a plaster coating applied to the structural fabric, were widely used and are described under *Plaster Decoration.*

Bonds

Brick bonding is limited to a relatively few patterns but each major pattern displays a considerable variety in surface treatment and in size and character of units. These patterns were executed in three general ways: 1) a uniform frontal plane with rising and horizontal joints of similar widths, 2) the use of wider rising joints, either recessed or filled with projecting units, and 3) the use of wider rising joints, filled out to the uniform frontal plane either with glazed or unglazed units.

Elaborate bonding had been a feature of Seljūq architecture and, in general, the bonding patterns of the Il Khānid structures reflect a less avid interest in variety of pattern and less attention to establishing a close adhesion of pattern layer to fabric. The patterns of the Mongol period do show a new feature, the use of glazed insets, and the use of elaborate brickwork falls completely out of favor by the end of the fourteenth century as faïence decoration spreads over large surfaces.

The following bonding patterns were used:

1. *Common bond.* In each successive horizontal course the rising joints are staggered half the length of a brick. This most usual brick lay is found in both core walls and on many exposed exterior and interior wall surfaces.

2. *Doubled common bond.* Rising joints are lined up through two horizontal courses, then staggered half the length of a brick for each successive pair of horizontal courses. Two monuments display this pattern: on one the wider rising joints are recessed (Pl. 16); on the other wider rising joints are filled with knot-shaped units of unglazed terra cotta (Pl. 34).

3. *Diagonal square pattern* (sometimes called the diamond or lozenge pattern). This most frequently used of the elaborate patterns was executed in a variety of ways. Where only standard bricks were used and a uniform frontal plane maintained the squares were established either by laying bricks vertically throughout the horizontal courses (Pl. 13) or by the use of wider rising joints (Pl. 156). In nearly all the other variant techniques the surface was laid in horizontal courses and the outline of the squares stressed by the special treatment given to the wider rising joints: these joints were either recessed (Pl. 94), were filled with square end bricks projecting beyond the frontal plane (Pl. 118), or were filled with unglazed or glazed units (Pl. 157). In one monument the outline of the square was created by color contrast between red and buff bricks (Pl. 152). Very elaborate patterns combined diagonal squares with alternating swastikas or with a strapwork pattern (Pl. 160).

4. *Sacred names or phrases.* The use of rectilinear Arabic characters to spell out the names of holy Moslems or religious phrases was second only to the diagonal square pattern in popularity. Usually the surface was laid up in regular horizontal sources and the characters formed by the selected position of wider rising joints, the joints either recessed or filled with glazed terra cotta units (Pls. 148, 153, 162). Occasionally the sacred names were executed within the framework of a diagonal square pattern (Pl. 130) and in one case the characters were made by using square ends of red brick in the wider joints of horizontal

courses of buff brick (Pl. 153). In the later monuments the sacred names were often executed in light blue, dark blue, and white glazed brick against a ground of buff brick (Pl. 177).

5. *Strapwork pattern* (sometimes called cross or interlace pattern). Some half dozen of the monuments display interlacing patterns executed in standard bricks laid both horizontally and vertically (Pls. 17, 92, 93). The shafts of the minarets of the portal at Qumm are covered with such a strapwork pattern which is elaborated by a continuous diagonal square pattern, the squares outlined by recessed rising joints (Pl. 156).

6. *Chevron pattern.* This pattern is found on only four monuments. In its simplest form standard bricks are laid at an angle in a surface of horizontal courses. In other examples the pattern was created by recessed wider horizontal joints (Pl. 118) or by filling the wider joints with glazed terra cotta units (Pl. 122). On one monument the spaces between several rows of chevrons was filled with sacred names executed in glazed bricks (Pl. 129).

7. *Herringbone pattern.* There are only a few examples of this pattern, which was usually executed either by laying the bricks at an angle or by the selection of proper wider rising joints. The entire exterior wall surface of the tomb tower at Khiav is revetted with herringbone bond with the wider rising and horizontal joints filled with square end light blue glazed units which spell out sacred names (Pl. 177).

DRESSED STONE

With the single exception of the structure within the court of the Masjid-i-Jami' at Shīrāz (Pls. 196-198), the ten monuments listed in the catalogue which displayed the use of dressed stone are located in Āzerbāijān and were erected between 1300 and 1333.

Six of these monuments—the tomb towers at Salmās, Sulṭāniya, and Khiav, two tomb towers at Marāgha, and the caravanserai at Marand—have bases of cut stone, laid in from two to five regular horizontal courses and with the vertical faces of the base flush with the face of the upper wall. The materials used include sandstone, limestone, and a close-grained gray-green stone. The stones are very accurately cut and fitted, with fine horizontal and rising joints, and were apparently laid on thin mortar beds (Pl. 170). The size of the blocks and the height of courses varies considerably but many of the blocks have exposed faces of about 1.50 m. by .70 m. Mason's marks were recorded on the blocks at two of the structures.

Three of these monuments have portals of dressed stone. The pointed arch portal, of slightly elliptical profile, of the caravanserai near Marand has jambs and voussoirs of sandstone (Pl. 179). A narrow incised moulding runs along the edge of the jambs and voussoirs and the keystone is decorated with a hemispherical boss. Sides, spandrels, and head of the stone portal are of fired brick. The entrance portal īvān of the caravanserai at Sarcham is filled between its side walls by a pointed arch door crowned by a square head (Pl. 188). The blocks of the jambs, voussoirs, and head are of sandstone decorated with narrow raised and sunken mouldings. The raised moulding knots over the keystone and surrounds an inscription panel, executed on two horizontal courses of marble slabs, which is inset in the head (Pl. 189). Either the blocks were not quarried to proper size or they were damaged in transit and setting for several of the voussoirs have been patched with smaller pieces. Adjacent to the tomb tower of Chelebi Oghlu at Sulṭāniya are the rather extensive ruins

of a structure contemporary with the tower. Built into the east wall of these ruins is a pointed arch portal erected of cut stone slabs carved with shallow false joints imitative of interlocking voussoirs (Fig. 50).

Other elements of dressed stone which survive in the structures in the region of Āzerbāijān include a complete door frame in the Masjid-i-Jāmiʿ at Marand and a threshold and floor of stone slabs in the tomb tower of Chelebi Oghlu at Sulṭāniya.

The ruined shrine located within the court of the Masjid-i-Jāmiʿ at Shīrāz is dated 1351. Dressed slabs, wedge shaped behind their finished face, line the rubble masonry walls. The corner bastions of the shrine display regular horizontal courses with square and rectangular stones bonded to give irregular repeats of a cross pattern. The bastions are crowned by inscription bands of cut stone letters inset in light blue glazed tiles—a unique combination of materials—and above the bands are cornices of cut stone which are carved with rudimentary stalactites (Pl. 197).

RUBBLE MASONRY

Although construction in brick predominates throughout the Moslem centuries in Iran, each period does display one or more structures of rubble masonry. Only one such monument of this nature has survived from the Il Khānid period; the tomb-shrine of Pīr-i-Bakrān in the vicinity of Iṣfahān (Pl. 27). The lofty īvān of the shrine was originally constructed of uncoursed rubble masonry, the stones set in medium hard, gray-white mortar. Either because of the lack of experience in handling the material or because of the limitations of the material itself, the vault of the īvān collapsed shortly after it was erected and was replaced by a conventional vault of fired brick.

Three structures of the general period display the use of core walls of rubble masonry which were lined with either cut stone or fired brick. These structures are the circular tower at the site of the Rabʿ-i-Rashīdi at Tabrīz (Pl. 45); a destroyed tomb tower at Rayy (Pl. 42); and the shrine within the court of the Masjid-i-Jāmiʿ at Shīrāz (Pl. 196).

WOOD

Wood was used in a structural or semi-structural fashion in seven structures of the period and it is highly probable that many of the remaining monuments contain wood which has not been exposed by deterioration of the fabric of the structure.[11] This wood is most frequently used in the form of round pieces of considerable length which are embedded within the structural wall, horizontally and parallel to the direction of the wall. Use of wood in this manner was fairly common in structures erected prior to the Il Khānid period.

[11] The trees most common to the Iranian plateau are the poplar and the *chenar*, the latter related to the plane tree. The poplars, grown in irrigated groves at many villages, supply material used in domestic construction for roof rafters and the framework around openings but they are not sufficiently strong and durable for carrying heavy loads. The chenar, grown to great size as a shade tree, has limited practical use.

Where it has been possible to examine closely the timbers used in the Il Khānid structures the wood seems to be either oak or walnut. Neither of these trees is prevalent throughout the plateau, although great walnuts do grow in some areas. It appears probable that large timbers had to be brought to construction sites from a considerable distance.

The intent was certainly to knit the fabric closely together in an effort to counter the possible damage from earthquake, which is common to the country. Such timbers might also help to prevent an uneven settling of the structure on its new foundations. The most studied use of embedded timbers is found in the mosque at Dashti: eight such pieces remain in position, one below each wall arch of the zone of transition, and serve as a chain to bind together the base of the dome. Unfortunately, it is not possible to dissect the walls and dome of a structure to determine how many rows of such timbers were used but the effectiveness of the system appears to be reflected in the fact that few of the walls and none of the domes are split by vertical cracks.

Wooden pieces were also used to support portions of the structures. In the Masjid-i-Jāmiʿ of ʿAlī Shāh at Tabrīz, wooden beams embedded at right angles to the direction of the wall support offset walls of fired brick which project as much as 20 cm. beyond the lower wall face (Pl. 109). In the Masjid-i-Jāmiʿ at Varāmīn the stalactite vaults of the entrance portal are hung on and supported by beams which project from a semicircular brick vault (Pl. 131). At each corner angles of the portal of the caravanserai at Sīn squared timbers, placed just below a horizontal recessed panel, meet at right angles. In the dome chamber of the Masjid-i-Jāmiʿ at Herāt sawn boards, laid horizontally, bridge the corner angles of the chamber forming a shelf upon which the squinch arch rests (Pl. 64).

A pair of carved and dated wood doors are preserved in the shrine at Turbat-i-Shaykh Jām but other types of decorative woodwork, such as carved wall brackets, abacus blocks, and inscription panels, which are found in both earlier and later periods, are lacking.

IRON

At the two exterior corner angles of the entrance portal of the caravanserai at Sīn square cut timbers embedded in the walls meet at right angles. At the point of juncture and on the under surface of each pair of timbers is a right angle piece of iron which is nailed to the wood. There is no reason for doubting that these stiffening elements are contemporary with the erection of the caravanserai.

10. Features of Construction

FOUNDATIONS

ALTHOUGH no excavations have been undertaken, it is evident from the erosion around existing structures that the foundations usually consisted of rubble masonry. Thus, it is not known to what depth foundations go or whether they become broader than the walls above grade. However, they have served to carry the weight of the superstructures without signs of uneven settling. In fact, the major damage caused by settling appears to be of fairly recent date and it is the result of underground or surface irrigation lines which have been led so close to the structures that seepage has soaked the earth below the monuments.

In the majority of the monuments the brick walls seem to continue below the present grade. Six of the structures have bases of horizontal courses of cut stone and in each case the lowest course continues in depth below the present grade. Five of the structures display small stretches of foundations of rubble masonry and it is probable that this type of foundation was in most general use. These foundations are the width of the walls above grade and are built of field stones—large water-washed boulders—which are laid in hard mortar and irregularly coursed.

SCAFFOLD HOLES

The number and arrangement of plugged and unplugged scaffold holes apparent on exterior or interior surfaces of a majority of the monuments enables certain conclusions to be drawn regarding constructional methods in general and the use of scaffold in particular.

In the rural areas of Iran and in other countries of the Middle East as well, local masons lay up walls in a manner which has been common for centuries. Once the wall has risen about one meter above the ground the mason mounts on the wall and builds it up under him. Mortar he obtains by pulling up a loaded basket. The bricks are thrown up to him by an apprentice who times his throws to accents in a chant and who speeds them up to the mason's hand with marvelous accuracy. In this manner the wall rises to a height of about four meters, the range of throw, but more lofty construction requires scaffolding.

The scaffold holes are square in profile, usually two bricks plus joints and thus about 15 cm. on a side. A few are only one brick plus joints or 9 cm. on a side. The holes are generally about 40 cm. deep; none were found which pierce the entire thickness of the wall. The wood supports built into the holes are the round branches or trunks of trees. In one structure the rounded supports remain in place.

Certain of the monuments have rows of holes on both exterior and interior wall faces (Pls. 145, 147, 151, 152). The lowest rows are never less than three meters above the ground level and are usually considerably higher; a feature which is in line with the manner of construction described above. If the scaffold served only to convey materials to the top of the rising walls we would expect these holes to be found only on one face. Actually the scaffolds served as many as three purposes: as staging for passing up material; as a working platform for erecting complex elements such as wall arch heads and cornices; and, as plat-

forms for applying a decorative revetment to the structure. In some cases the scaffolding served for only one of these needs, in others, for all three.

To our modern eyes the presence of gaping scaffold holes on many of these structures seems unaesthetic, but apparently the builders and the patrons of the monuments were not at all disturbed by them. The Imāmzāda Jaʿfar at Iṣfahān displays exterior walls of common bond laid up with meticulous care which are marred by a single row of holes encircling the structure (Pl. 144). However, in a limited number of examples the exterior wall surfaces were left unbroken and rows of holes used only on the interior. Examples are the Masjid-i-Jāmiʿ of ʿAlī Shāh at Tabrīz (Pl. 110) and the Gunbad-i-Ghaffariya at Marāgha (Pl. 164). Lofty tomb towers lined with engaged columns or stellar flanges also present unbroken surfaces; examples are the towers at Rādkān (Pl. 13), Varāmīn (Pl. 18) and Bisṭām (Pl. 39).

In monuments where the scaffolds were used for the erection of complex elements the rows of holes are normally concentrated in certain areas. On the exterior walls, rows of holes appear below the springing line of pointed arch recessed panels (Pl. 144), in relation to the successive stages of recessed panels on the flanking walls of īvāns, within the cornice level, and below the springing line of portal vaults. On the interior walls the rows are related to the heads of recessed wall panels and are especially prominent within the area of the zone of transition (Pl. 153).

A special case of the use of scaffolds falls midway between the need for staging to erect structural walls and the need for scaffolding in applying a decorative revetment. In a limited number of structures the elaborate brick bonding patterns were actually applied to the structural core as part of a single operation, that is, the decorative bonding rose with the core. In certain monuments holes pierce the elaborate bond, that is, elements of the decorative bond were deliberately omitted where the holes occur. This feature is found on the exterior walls of the Gunbad-i-ʿAlayivan at Hamadān (Pl. 115), on the side walls of the entrance portal at Bisṭām, in vaults at the Masjid-i-Jāmiʿ of Varāmīn (Pl. 132), and on the interior walls at Kāj (Pl. 152).

Extensive use was apparently made of scaffolding in the application of revetment. At least five of the structures display rows of scaffold holes on the exterior surface of the dome. Stages of scaffolds along the exterior of the dome would have served no practical purpose during the erection of the dome. Instead, the scaffolds were used in lining the exposed surface with light blue glazed bricks. Bricks of this type still adhere to the dome of the mausoleum of Öljeitü at Sulṭāniya (Pl. 69). In the application of revetment to both dome and lower wall surfaces the work was probably carried out from the summit toward the ground. Evidence in support of this suggestion is the existence of scaffold holes below finished revetment surfaces of plaster and terra cotta which have been exposed through the deterioration of the revetment. Working in this fashion, the scaffold would be taken down stage by stage as the revetment was applied in horizontal zones. It is quite possible that the ideal concept of the builders was of a structure which had all its surfaces sheathed with a decorative revetment. On many occasions this revetment was never completed. Thus, the flanking walls of several of the lofty īvān portals display rows of scaffold holes while the holes of the portals at Bisṭām and the Masjid-i-Jāmiʿ at Ashtarjān are concealed by elaborate revetments.

The execution of plaster decorated wall surfaces was a rather special problem. At the Gunbad-i-'Alayivan at Hamadān rows of holes beneath the incised relief plaster on exterior and interior walls suggest that the decoration was done as the scaffolding was taken down. However, in the case of plaster miḥrābs, very large surfaces of plain white plaster, and large areas where false bonding patterns were incised on the plaster surface, it is probable that free standing scaffolds, built away from the wall, were used.

STAIRS

All the minarets of the period display the usual interior stair which rotates spirally around a circular core of fired brick.

Eleven of the monuments display stairs built within the thickness of their structural walls. Eight of these stairs are of the spiral type while the others are straight flights of steps.

The stairs of all structures other than the minarets served for the inspection, maintenance and repair of the fabric. Two of the stairs begin at a point some distance above the ground so that they must have been reached by ladders and a third has its portal so high above the ground that it must have been entered from the roof of an adjacent structure. These stairs end either on the roof of a structure or within the space between the upper surface of an inner dome and the inner surface of an outer dome.

The method used to keep the roof surfaces in good condition was certainly the same one still used at the present time. Flat and curving surfaces were so sloped as to drain toward holes in the parapet walls. The surfaces were covered with a layer of mud, sometimes mixed with straw and pebbles, which was packed firmly by a stone roller which was kept on the roof. After each heavy fall of rain or of snow it was necessary to roll the roof and possibly to add additional binding material.

VAULTS

While the Il Khānid period was to be distinguished by the full development of the double dome in brick, other types of vaults were among the varied forms that had been common to the Seljūq period. No new technical devices appeared, no fresh forms were evolved, and as structural surfaces were increasingly hidden beneath decorative overlays interest in elaboration of the fabric of the structures fell off.

The vaults of the period can be classified by a few major categories: barrel vaults; vaults over square or rectangular bays; half domes; and, stalactite vaults. The stalactite vaults, non-structural forms, will be considered in a later section.

The inner surfaces of the vaults were given a variety of decorative treatments, while their outer surfaces were exposed to the weather. Some protection was given by coating the exposed outer shell with a mixture of mud and clay, or with a mixture of mud and straw, or with a revetment of bricks laid flat on the surface of the vault. Superimposed wooden roofs, common to Europe and sometimes found in the architecture of the more westerly situated Moslem lands, were not used nor was the device of Islamic Turkey, that of sheathing the exposed vaults with lead sheets. As long as the coating of mud, clay, or brick was periodically renewed and the drains, spaced along the exterior walls, kept open the vaults

survived. When these precautions were not taken the vaults suffered, and many of the monuments contain vaults which were inserted as repairs at later periods.

Like the builders of the Seljūq period, the masons of the Il Khānid period strove to erect their vaults with a minimum amount of centering and of scaffolding. Quite recently André Godard devoted an entire issue of *Āthār-é Īrān*,[1] some 180 pages, to a uniquely valuable study of vaulting in the Sāsānian and Islamic architecture of Iran. Throughout this study Godard uses text, photographs, and drawings to demonstrate how the local builders were able to erect vaults and dome without using supporting centering. According to his account the key to the builder's ability to construct vaults rapidly and with a minimum of scaffold and centering was the standard use of planks made of gypsum plaster stiffened with reeds. Liquid plaster and reeds had originally been permitted to set together in a mould whose curvature reflected the profile of the planned vault. Several such plaster planks, placed in position upon the bearing walls, could both define and subdivide the envelope of the proposed vault so that the masons had only to fill in the segments between the planks. How this filling operation was accomplished is described in detail by Godard, here it is enough to note that sometimes the planks were left in place within the core of the completed vault and sometimes were removed after they had served as temporary supports upon which armatures of fired brick had been erected.

While the present writer is in general agreement with Godard as to the methods employed in putting up the vaults, he believes that a more extensive use was made of form boards, of staging scaffolds, and of beams to support form boards and scaffolds. Form boards consisted of planks which had been water-soaked and then bent to the curvatures of the most frequently erected arches and vaults. Such form boards filled the same function as the gypsum plaster planks, but they were more permanent. With their shapes unaffected by the dry climate of Iran, a number of such boards may have been part of the stock in trade of the master masons. There is no evidence to indicate that there were regional preferences for either the plaster planks or the form boards and it is merely speculation to suggest that form boards were probably used for all vaults and domes of large span.

While Godard uses modern examples to stress the fact that the earlier masons worked standing upon the fabric of the vaults as they rose into place, the writer believes that an extensive use was made of staging scaffolds placed upon beam ends thrust into walls and vaults and finds supporting evidence in the great number of scaffold holes still to be seen in the monuments themselves.

However, one factor was far more important than the use of plaster planks, of form boards, or staging, or of any other technical device in enabling the Iranian masons to put up large vaults without supporting centering. This factor was the consistent use of gypsum plaster which took its initial set almost within a matter of seconds. This meant that if the bed of a row of bricks in one segment of a vault was at all inclined from the vertical the mason could hold the bricks of the segment in place until the mortar had set. In this manner each rising row of the growing vault was completed, segment by segment, without the need for support other than the hands of the masons. As a result of the method of construction,

[1] A. Godard, "Voûtes Iraniennes," *Āthār-é Īrān*, IV, part II (1949), pp. 187-359.

these Iranian vaults tended to be monolithic units rather than of the type of mediaeval Europe where thrusts were collected and concentrated.

While the use of the plaster planks has been described by Godard, his material does not include information on how form boards were employed. In 1945 the author saw a series of contiguous barrel vaults—each vault was to house a shop—under construction at Tehran (Pls. 216, 217). The bearing walls were first completed and then a number of beams, each inserted into holes located just below the projected springing line, were put into position to span the bays. Then the form boards were put into place. One end of the curved form board rested on the beam and snug against the bearing wall and the upper end was held in position, to establish the apex of the vault, by a brace which ran up diagonally from the other end of the beam. A second form board, put into place on the opposite side of the bay, completed the arch and vault profile. A series of cross arches were then laid up on the flat outer surfaces of the form boards. The bricks of these arches were sometimes laid on their flat sides so that the joint lines of the arch were at right angles to the direction of the arch and sometimes on their thin edges with radial joints. After several such cross arches, spaced two meters or more apart, were in position, the compartments between were rapidly filled in, the masons standing on a staging and holding each row of bricks in place until the quick acting mortar had taken hold.

The first of the major categories of vaults which will now be given specific attention is the barrel vault. Barrel vaults were extensively employed in the Il Khānid period, either as simple, continuous vaults, or in more elaborate variants. Parthian and Sāsānian īvāns had been roofed by barrel vaults and the form was much used in the Seljūq period. Such vaults could be easily erected without centering and without intermediary cross arches by a device which was known as early as Sāsānian times. The rear wall of the īvān having been built up to its full height, the first and then all the succeeding courses of the barrel vault were inclined toward the wall so that the bricks, laid on their thin edges, had less tendency to slip out of place during the setting of each complete ring of the vault. Continuous barrel vaults of this type were employed over the īvāns of the Pīr-i-Bakrān at Linjān and the Masjid-i-Jāmi' at Ashtarjān and certainly over the Masjid-i-Jāmi' of 'Alī Shāh at Tabrīz where the total span was some thirty meters. Other barrel vaults display the use of cross arches and hence a direct reflection of the form board method of construction described earlier. These vaults could also be provided with a more formal unity by using a cloister vault at one or both ends of the barrel vault. However, the continuous barrel vault does have certain drawbacks: no large openings can be pierced in the sides of the vault without endangering its stability and its unbroken surfaces are apt to be monotonous and uninteresting. Local experiments with the basic form did lead to a more complex variant which did not have these drawbacks.

This variant form may be described as the covering of a rectangular area by a series of cross arches, with each cross arch then joined to its neighbors by transverse filler vaults of modified barrel profile. This Il Khānid solution seems similar to one arrived at much earlier in the Sāsānian structure known as the Īvān-i-Karkhā.[2] In the Sāsānian monument,

[2] For the Īvān-i-Karkhā see M. Dieulafoy, *L'art antique de la Perse*, Paris, 1881, IV, pp. 79-98, Figs. 55-62, Pls. VII-IX and F. Sarre and E. Herzfeld, *Iranische Felsreliefs*, Berlin, 1910, pp. 130-131.

now badly damaged, a long, rectangular plan area was spanned by five cross arches and the short distances between the cross arches probably covered by barrel vaults whose axes were parallel to the cross arches. Within the Il Khānid period the steps taken toward the similar solution did not follow in strict chronological order, but apparently reflected the trials of a number of talented masons. In one such experimental form—found in the īvāns of the Masjid-i-Jāmi' at Naṭanz and the Madrasa Imāmī at Iṣfahān—the cross arches are joined by barrel vaults whose springing lines curve upwards to parallel the profile of the cross arches. In this form the vertical distances between the ends of the barrel vaults and the exterior roofs of adjacent prayer halls or other structures were still not great enough to allow for adequate openings. A more sophisticated variant of this form appears in the early fourteenth century Khān Ortma at Baghdād where the barrel vault between the cross arches is broken into separate sections which rise in steps along the profile of the cross arch. In another example, that of the īvān below the shaking minarets at Gārlādān, the barrel vaults continue the curvature of the cross arches but are broken at their crowns by the introduction of shallow decorative vaults. In a long rectangular hall in the Masjid-i-Jāmi' at Abarqūh the barrel vaults are divided into three segments, a wide center section and narrower end sections. The wide center section has a barrel vault which parallels the curvature of the cross arch, while the horizontal barrel vaults at the ends have their crowns at the level of the middle of the center sections. However, the final stage in the development of this system appeared in the oratories flanking both sides of the dome chamber of the Masjid-i-Jāmi' at Yazd (Pls. 136-137). These long, rectangular halls, probably erected after 1365, have spans of 8.10 m. and 9.37 m. The cross arches are narrower than in the examples already noted. The transverse space between the cross arches is divided into a short center section and longer end sections. The center section is crowned by a lantern vault and the ends by barrel vaults whose springing lines are almost at the height of the apex of the cross arches. Light floods into these oratories from very large windows between the cross arches and also from the smaller openings of the lanterns. While certainly of the same building period, one of the halls displays a refinement of proportion and of details not possessed by the other.

The vaults over the square or rectangular bays of the prayer halls of mosques and of other areas display a considerable variety of types, but nearly all these forms had been in use throughout the Seljūq period (Pls. 99, 132). In the earliest surviving Iranian mosques the bays behind the court arcades were covered by barrel vaults. The use of these vaults over the bays not only resulted in complications of construction at the corner angles of the court but offered little opportunity for displays of technical skill. Thus, the Seljūq builders replaced the barrel vaults by vaults of domical types and, judging by the number of types and richness of decorative fabric, appear to have enjoyed the creation of fresh and varied forms. The list of vaults common to both the Seljūq and the Il Khānid periods is indeed impressive. It includes groin vaults, cloister vaults, vaults on groin squinches, vaults on reticulated squinches, vaults on triangular false pendentives, vaults displaying systems of interlacing armatures, domical vaults, domical lantern vaults, saucer domes, and flat vaults.

In general, however, there are not as many examples of each of these types surviving from the Mongol period as may be seen in standing Seljūq structures. Comparatively few of the

surviving Il Khānid monuments display extensive plan areas of piers crowned by vaults. In addition, the masons of the period seem to have lost interest in executing a great variety of forms. Thus, while each of the vaults in those areas of the Masjid-i-Jāmiʻ at Isfahān which are assigned to the Seljūq period is different from its neighbors, in the Masjid-i-Jāmiʻ at Varāmīn a few types are used over and over again. Cloister vaults were frequently employed in the Il Khānid structures and squinch vaults were also common. Groin vaults, comparatively rare, are found in the bays of the Masjid-i-Jāmiʻ at Varāmīn. However, the flat vaults, employed over entrance portals or in galleries, such as in the galleries of the mausoleum of Öljeitü (Pl. 79) and of the Masjid-i-Jāmiʻ at Yazd, were much more extensively used than in earlier periods.

Structural half domes were frequently employed to cover the bays or īvāns which formed the entrances to a number of the monuments of the period. These half domes were erected of bricks laid in horizontal courses all the way from the springing line to the apex, with each course slightly corbeled out beyond the course below. Often the plan of the bay was not an exact half-square and when it was deeper from front to back than half its transverse width, the vault was warped out in that direction. Such half domes were erected without centering or form boards. Their inner surfaces, originally concealed from sight by a decorative system of stalactites, may now display the holes which once held the pieces of wood used to stiffen and to support the built brick or plaster stalactite systems.

In the Seljūq period the surfaces of the vaults had been given interest by the pattern of the armatures or by the use of elaborate brick bonding in the compartments of the vaults. In the Il Khānid period the inner surface of the vault was frequently coated with white plaster, and this plaster cut with geometric patterns, which were heightened by the addition of color (Pl. 80). Also, plaster was used to build up simulated armatures or ribs (Pl. 48). After the middle of the fourteenth century all vaults were covered with a smooth coat of hard, white plaster (Pl. 137) and some years later this device became one of the most characteristic features of Tīmūrid architecture.

In the preceding pages it has been noted that the first step in putting up compartmented vaults was the construction of armatures, erected either upon plaster planks or upon form boards. The normal and natural reason for putting up the armatures was that they established the envelope of the proposed vault and defined its multiple compartments. However, armatures might be erected merely to provide points from which suspended stalactite work could be hung or the system of armatures could be made deliberately complex so that its members created a decorative pattern on the inner surface of the completed vault.

In the familiar cloister vault two armatures were flung across the vaulting bay to bisect two sides of the bay while two additional armatures bisected the other sides, with each parallel pair spaced a meter, more or less, apart. Each such armature element was a full brick—.20 m. or more—in depth, and many were two bricks deep. Between the armatures the fabric of the vault was at least a full brick in thickness. When the fabric of the vault does not come up to the face of the armatures on the interior of the vault, the armatures give the appearance of interpenetrating ribs. In a number of cases the vault fabric does not come up to the outer faces of the armatures and hence from the exterior the armatures again appear as ribs.

Even from the limited space devoted to technical description in the preceding pages it should be apparent to the reader that these armatures do not play a functional role. It should also be noted that many vaults do not have such armatures. The armatures are not functional in character in that they do not carry the full weight of the fabric between successive armatures nor do they concentrate the weight of the fabric of the vault upon a few points of thrust. The armatures do increase the resistance of the vaults to torsion stresses and to earthquakes, so common to Iran and frequently so severe. However, the fact that these armatures are occasionally exposed in relief upon the interior or exterior surfaces of the vault has played an important role in the long-lived controversy.

Since 1884, when Dieulafoy stated that the origins of Gothic architecture were to be found in Persia, these armatures, or interpenetrating ribs as they have been called, have been a focal point in a serious controversy. One group, most active in the period from 1930 until about 1945, holds that prototypes of the Gothic ribbed, ogival vault are to be found in Iran, that the ribs of these early Iranian vaults are structural and functional, and that the compartments between the ribs were shells of fabric lacking structural form. Opposing groups and individuals, currently more vocal, hold that these armatures are not functional in nature, but are either a direct reflection of the technical means by which the vaults were erected or are one of the architectural expressions of that decorative geometry so favored by the Moslem builders.

While these armatures have their origin as a means of establishing vaulting compartments of convenient size, it is clear that they do not play the vital role within their own system that the interpenetrating rib plays in the Gothic vault. Some individuals who deny that Persia had any influence on Gothic architecture also deny that these armatures have any structural function, possibly feeling that such an admission would merely encourage the growth of heresy. It is my personal belief that recorded Moslem structures in Iran do not display armatures of provable prior date which can be cited as prototypes for any use of the rib in medieval vaults in Europe. In addition, the great gap in requirement and techniques between the brick armatures of Iran and the stone ribs of Europe makes it very unlikely that there could be direct influence. If there was interplay and influence in technical devices it might better be sought for in a suggested eastward expansion of the stone vaulting forms of Armenian church architecture. Ties between greater Armenia and Iran were strong throughout both the Seljūq and the Il Khānid periods and it is within the realm of possibility that the type of the massive ribs of the Armenian structures are reflected in the exposed armatures of the Persian vaults.

DOMES

Some twenty-eight of the monuments of the Il Khānid period are featured by domes and a number of others once had domes which have not survived. The existing domes fall into three categories: 1) single domes, 2) true double domes and, 3) an inner dome concealed by a polyhedral tent dome or a conical roof.

Each of these types was in use in Iran before the Il Khānid period. Type 1) is a direct descendant of the Sāsānian domes and many examples of the form are found in monuments of the Seljūq period. Type 2) has as its most conspicuous prototype the tomb of Sulṭān

Sanjar at Merv, c. 1157, while the most renowned earlier example of Type 3) is the Gunbad-i-Qābūs of 1007. These types require detailed consideration.

Type 1), the single dome, appears on six monuments where it was used over either a square or an octagonal chamber. The contours of these domes display considerable variety. The great dome of the mausoleum of Öljeitü at Sulṭāniya, which has been so carefully studied by André Godard, spans 24.5 m. and is over 1 m. thick at its base. Its section is ovoid; the inner base rests on tiers of continuous corbels which convert the octagon of the chamber to a circle. The thickness of the shell decreases from base to apex by means of a series of steps but a smooth and regular exposed profile was obtained by building up a thin shell of brick above these steps (Pl. 86). Patches of the exterior surface are still covered by light blue glazed bricks. The dome of the Masjid-i-Jāmiʿ at Varāmīn displays a similar profile with a series of steps around the exterior but there are no traces to indicate that an auxiliary shell was used to regularize the profile (Pl. 133).

The main chamber of the Masjid-i-Jāmiʿ at Ashtarjān is crowned by a dome whose interior and exterior surfaces are not parallel; the inner surface is ovoid while the outer rises to a definite point (Pl. 90). At Iṣfahān the tomb chamber of the Do Minār Dardasht displays a dome of pointed ovoid section set upon a very high circular drum (Pl. 158).

Type 2), true double domes, appear on ten monuments where they were used over either a square or an octagonal chamber. The double dome of the tomb of Sulṭān Sanjar at Merv of about 1157 appears to be the only earlier example of the type in Iran and a tradition of the double dome does not appear to exist in the regions to the east of Iran. In general, the inner domes are hemispherical, while the outer ones have a steeper, sharper profile. In three examples the outer dome has vanished so that the outer surface of the inner dome is clearly visible.

On the tomb tower at Bisṭām the outer surface of the inner dome is rough and uneven and seems to have a stepped profile (Pl. 39). At Ziaret the inner dome is flatter than a true hemisphere; its brick beds are radial, and at the apex the fabric is a single brick in thickness (Pl. 47). At Ṭūs, the exposed inner dome has a hemispherical inner surface and an almost pointed exterior surface (Pl. 103). Three structures southeast of Iṣfahān—Kāj (Pl. 149), Dashti (Pl. 145), and Eziran (Pl. 154)—bear an inner dome of hemispherical section and an outer dome which is raised on a rather high drum and is pointed in profile.

Type 3), inner hemispherical domes covered by an outer conical roof—the "tent dome"—or by a polyhedral dome, appears on twelve monuments with the inner dome crowning square, circular, octagonal, decagonal, and duodecagonal plans. This general type is popularly supposed to derive from the royal tents of the nomadic peoples of this entire part of the world, when the round tent with its conical roof of cloth took on permanent form as a brick cylinder with a conical brick roof.

With regard to the basic problem—and its solution—of placing a dome upon a square plan, the Il Khānid monuments continue to employ the device common to the Seljūq period. Squinch arches, spanning the corners of the dome chamber, establish the size of the octagon upon which the dome rises. When the intrados of the surface of the dome was tangent to the mid-point of the sides of the octagon, each of the corner angles of the octagon hung out over a void. In a number of structures these awkward angles were avoided by

creating a secondary zone of transition above the octagon. This zone was a sixteen-sided figure created by as many wall arches and provided a base for the dome which had only very slight overhangs at the corner angles. This device was employed in the Masjid-i-Jāmi' at Varāmīn (Pl. 134) and in the domes at Kāj, Āzādān and Ashtarjān.

Domes of the Il Khānid period do reflect a striving for enhanced monumentality and a fresh approach to familiar problems of structure. These two features will be discussed in turn.

During the Il Khānid period the system of the double dome in brick suddenly appears as fully developed in spite of the fact that there is only one standing earlier example of the type in Iran and that one nearly one hundred and fifty years before the Mongol examples. How did the double dome in brick come into Iranian architecture? Several possibilities can be suggested: 1) that standing double domes of wood were copied directly into brick masonry, 2) that protective wooden domes which had been erected over the traditional Iranian brick dome began to be executed in brick, 3) that the double dome was inspired by the vault and lantern system found over the crossings of the Armenian churches, 4) that the conical or polyhedral roofs over the inner domes of the tomb domes were converted into regular brick domes, and 5) that the hollow stupas, with their double domes, of central Asia were copied in brick.

It does seem most probable that the double dome evolved from wood to masonry and that the inspiration for the double dome came from the west of Iran. The double cupolas, built entirely of wood, which were conspicuous features of early Christian and early Moslem monuments at Jerusalem, Bosra, Damascus, and other sites are well known through literary references and actual remains. Herzfeld has suggested that their systems of girders and ribs reflected the application to architecture of the shipbuilding techniques of this coastal region. That the form and technique traveled to Iran is suggested by references to impressive wooden domes at Baghdād and Nīshāpūr in the Seljūq period,[3] although it is not known whether these examples had a single or a double shell. We may, however, believe that the wood dome was destined for limited popularity in Iran because of the strength of the tradition of brick vaults and domes and because of the relative scarcity of timber in Iran.

As a tentative conclusion from the general evidence we may subscribe to the second of the suggestions made above: that some wooden domes were built over brick domes in Iran and that then this outer dome was transformed to brick. Evidence from the monuments may support this conclusion. The double brick dome of the tomb of Sulṭān Sanjar at Merv, dated to 1157 only because Sanjar died in that year, is clearly an experimental form since the outer shell is needlessly lightened by pointed arch arcades in two disproportionate storeys. On certain structures of the Seljūq and Il Khānid period which retain their inner dome a thick collar, unfinished along its upper edge, runs around the base of the dome and interrupts its rising silhouette. It is possible that: 1) the collar was constructed in the form in which it survives for no structural purpose, 2) the collar was the base of an outer wood dome, and 3) the collar was the base of an outer brick dome. In the case of the very

[3] C. Schefer (Trans. and Ed.), *Mélanges orientaux, Tableau du règne de Mouizz eddin Aboul Harith Sultan Sindjar tiré du Rāhat as-sudūr*, Paris, 1886, p. 27.

[63]

early Seljūq dome shrine of the Duvāzdeh Imām at Yazd, the collar could have served only the first or second of these possibilities. The octagonal dome chamber at Kirmān, called the Jabal-i-Sang and tentatively assigned to the late twelfth century, displays an inner dome which was never completed to its apex but which is surrounded by a high collar which may have carried an outer wood or brick dome. At Tūs the so-called Hārūniya retains the lower third of its outer brick dome and the top edge of the collar is marked by a slight projection (Pl. 103).

The popularity of the double dome in Iran, beginning at this period and continuing into Tīmūrid and Safavid times, resulted from a union of symbolic, aesthetic, and practical considerations.

In the field of symbolism, scholarly research has given strong support to the theory that in the Mediterranean world the dome won high favor and monumental expression when, and only when, it came to be associated with the sacred character of the structures it crowned.[4] In the early Islamic centuries a parallel symbolism must have been in force as countless domes rose above tombs, shrines, and mosques. However, while Christian literature contains numerous references to the symbolic values of the dome, the writings of the Arab and Persian theologians and philosophers are devoid of any symbolical interpretation of the dome or, indeed, of any other architectural feature. When the Ommayyads and the Abbasids in Palestine and Syria took over the system of the double wood dome from Christian religious architecture they also took over the sacred character of the dome. The Moslem Dome of the Rock, with its double wooden shell, was erected over a spot at Jerusalem which was sacred to Moslems, Christians and Jews. At Kazimayn, near Baghdād, great teakwood domes crowned the shrines of the holy Imāms Mūsā and Muḥammad—shrines which were erected after 834.[5] Under Islam the dome was a concrete symbol of civil and spiritual authority. Thus, at the Round City of Baghdād, completed in 766, the central building of the palace of the Caliph Mansur was crowned by a green dome which rose above the hall of royal audience to a height of one hundred twenty feet.[6] Later, in the twelfth century, the reigning caliph received the oath of allegiance from his subjects under the principal dome of the Tāj palace at Baghdād.[7] Some domes, such as that shown in the manuscript illustration of the mausoleum of Ghāzān Khān, bore the inscription, "May his Caliphate endure" and thus emphasized the role of the domed building in housing spiritual and temporal power.

Aesthetic considerations brought about an accentuation of the height, the outline and the conspicuousness of the dome. Had height been gained merely by elevating the single—shell dome higher above its supporting fabric, the result would have been to introduce an unsatisfactory relationship between its great interior height and the plan dimensions of the dome chamber (as in Grant's Tomb in New York City). However, while the outer dome rose high in the air, the much lower inner dome remained in a pleasant and proper relationship to the chamber. Not only did these outer domes rise higher than the earlier single domes, but the drum of the dome was also increased in height so that it became fully

[4] E. B. Smith, *The Dome. A Study in the History of Ideas*, Princeton, 1949.
[5] G. Le Strange, *Baghdad during the Abbasid Caliphate*, Oxford, 1924, p. 164.
[6] *ibid.*, p. 31.
[7] *ibid.*, pp. 260-261.

detached from the lower walls. This development was in contrast to the Seljūq domes, whose lower profiles fade from sight behind massive shoulder walls. The Seljūq manner of treating the exterior of the dome chamber—crowning the cube with an octagonal element above which rose the dome—was retained, but the octagonal zone became increasingly higher. In a few Mongol monuments the octagonal stage is replaced by a sixteen-sided figure and later in the period the polyhedral stage tends to give way to the circular drum.

The outline of the pointed ovoid domes of the Il Khānid period appears very close to the profile of the pointed arches of the arcades and wall arches of the monuments: this identity of profile may have been a conscious effort. Finally, the model of the Il Khānid pointed ovoid dome upon its high drum led to the development of the bulbous dome common to the fifteenth and later centuries, a form in which sound structure is sacrificed in favor of maximum emotional impact. Such bulbous domes on very high circular drums are characteristic of fifteenth-century design, notably on tombs and mosques at Mashhad and Samarqand, and retain their popularity throughout the considerably later Ṣafavid period.

Aesthetic considerations, plus the desire of making the dome an outstanding landmark, were responsible for the covering of its exterior surface with light blue glazed bricks or tiles. Several of the Il Khānid domes are still partially clad with this material, but the technique was not peculiar to the period. In the eighth century the palace of Mansur at Baghdād had its green dome, while early in the thirteenth century the Arab traveler Yaqut visited the tomb of Sulṭān Sanjar at Merv and wrote: "And his tomb is in it beneath a great dome. . . . The dome is blue and could be seen from a day's journey."

Why were light blue, or in the earliest examples greenish-blue, tiles always used? Perhaps because the copper compound used to produce the light blue glaze was available at so many places and was so easily worked to separate the glazing material from the ore. (If iron was mixed with the copper in the ore the resulting glaze was greenish-blue.) Perhaps because of the anti-atrophic power of this color, for it is a well-known fact that the peoples of the Near East have for thousands of years used beads and amulets of light blue glaze to ward off evil. Still other suggestions may be made. One concerns the tradition in this part of the world of covering the ceilings of the royal tents with a blue fabric representing the sky. It is known that the Achaemenids referred to their tents as "heavens" and Clavijo, in describing a tent of Tīmūr at Samarqand, speaks of the ceiling fabric whose four corners bore the figures of eagles resting with folded wings.

From the practical point of view the advantage of the double dome system was that the inner dome and the dome chamber, with their fine decorations, were adequately protected from the weather. Several of the structures crowned by double domes had intramural stairs which led into the space between the two domes—normally about a half meter in width at the bases of the domes—and which must have been used for inspection of the fabric and for carrying out repairs.

A number of points relating to the construction of these domes remain to be examined. The domes erected during the period continue the direct line of tradition from Sāsānian times through the Seljūq period but do reflect a definite concern with achieving sections which offered the greatest possible stability. Thus, the thrust of these brick domes was met

not by buttressing or by relying upon the massive lower walls of the Seljūq period, but by the use of an ovoid or pointed ovoid profile which turned the diagonal thrusts toward the vertical. On the other hand, hemispherical or flattened inner domes continued in use since their thrust was met by the weight of the outer dome at its base. Internal cohesion was enhanced by the use of wood in "rings" within the base of the outer or single dome. Such a ring was employed at Dashti and the base of the great dome at Sulṭāniya was apparently encircled by three rings of great beams.

Scaffolding has been considered in another section, but it must be mentioned again in relation to these domes. Holes existing on the exposed exterior surfaces of several of the domes were certainly for members supporting the scaffolds from which the blue glazed revetment was laid (Pls. 145, 149). In a number of the monuments scaffold holes appear within the dome chamber on the inner surface of the dome at the level of the zone of transition and higher up on the curving surface of the dome (Pls. 121, 134). The scaffolds carried on beams projecting from these holes might have served one or more of the following three purposes: to carry supporting centering or form boards for the dome proper; as a staging for the masons engaged in laying up the courses of the dome; as a staging from which the decorative revetment common to many of the domes was applied in a final operation.

With regard to the first of these three possible purposes it seems very unlikely that these domes were erected upon a supporting centering. Even form boards were probably not used except for the relatively few domes containing ribs or armatures: the domes of the mausoleum of Pīr-i-Jāsūs at Mashīz and of the Khānaqāh at Safiabad display such armatures. It appears much more likely that a single staging served the needs of the masons laying up the dome and of the artisans who applied the decorative revetment. A staging of this nature could have been built up and in from the springing line of the dome as a kind of hammer beam construction in two, three, or more stages. The staging would not have to run up to the crown of the dome for as its profile began to flatten out markedly, the masons could have stood directly upon the outer surface of the dome to lay in the apex courses.

A staging of this kind could not easily have been erected had the beds of the brick courses of the dome been radial to its striking center for then the scaffold holes would have pointed sharply downward. However, in those monuments where it has been possible to examine the beds closely it is clear that they are not radial but at a considerably flatter angle, tending toward the horizontal. Both because of the change in angles of the beds of the dome near its apex and the fact that scaffold holes have not been observed in the upper third of the inner surface of any of the domes it seems clear that the workmen engaged in applying the finishing decorative touches could not have reached the extreme under surface of the dome from the hammer beam staging. It may be assumed that the upper level of this staging carried horizontal timbers which bridged the remaining width of the dome and which supported a platform from which the under surface of the crown was easily accessible.

Some of the shells of the domes are of uniform thickness, others diminish in thickness from base to peak. Given the long sides of the bricks in use it was impossible to diminish the thickness at a regular rate and such diminution is betrayed by a series of steps around the exterior surface of a dome. As stated, such steps are visible on the exterior of the domes

of the tomb of Öljeitü at Sulṭāniya and the Masjid-i-Jāmiʿ at Varāmīn as well as on the dome of the Imāmzāda Yaḥyā at Varāmīn. Quite in contrast to these normal types is the unusual feature, clearly discernible at the Masjid-i-Jāmiʿ at Ashtarjān and lightly suggested by the profiles of other domes, of a dome whose inner surface is curved at the crown while the outer surface is pointed at the apex so that at the tip of the dome the shell is thicker than in its lower profile.

The partial disintegration of the upper part of the tomb tower at Rādkān has exposed a feature which may be present in other structures where a polyhedral tent dome or conical roof crowns an inner dome. Above the inner dome are substantial spur walls, radial in direction and triangular in direct elevation with the vertical side of the triangle toward the center and the sloping side attached to the shell of the conical roof (Pl. 15). These walls served the purpose of a stiffening membrane for the upper structure.

In the mosque at Dashti the space between the two domes is filled to some height with a number of stiffening walls of fired brick, erected along the radii of the inner dome.

More detailed field observations of these domes are required before a number of interesting and important questions relating to their design and construction can be answered: many section and elevation drawings should be made. Data available are insufficient for a table of comparative profiles and to determine whether the shells of the domes were thinner in relation to span than in the Seljūq periods. The sections of the domes should also be examined in order to determine whether geometrical layouts determined the proportions of the dome and the chamber below it.

11. Features of Design

ARCHES

IT WAS customary for the pointed arches of this period to present a profile struck from four centers. These arches were high crowned—with a height greater than their half span. This type was normal to all periods of Islamic architecture in Iran and was also much used in Irāq and other regions where Iranian influence was strong and the form came to be known as the *'ajemānī*, or *'ajemāna*, after 'Ajem, the medieval name for western Iran.

Misconceptions with respect to the profile and location of the centers are to be met with in earlier publications. In the present case the actual arches of a number of monuments have been carefully examined and a simple proportional layout evolved which appears to explain the method of striking the profile (Diagram A). The centers employed for one

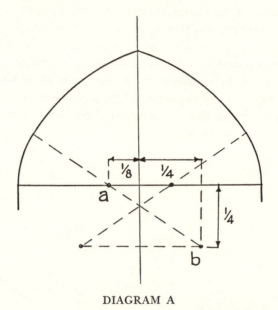

DIAGRAM A

side of the arch fall along a single striking line with point a as the center for the shoulder of the arch and b the center for its upper curve. This profile could be altered at will by moving center a to the right or left and center b up or down. Thus, the main arch of the miḥrāb from the Imāmzāda Rabi'a Khātūn from Ashtarjān displays one variant form (Diagram B) and the īvān arch of the Pīr-i-Bakrān at Linjān still another (Diagram C).

In the Il Khānid period the arches frequently sprang from projecting offsets, a few centimeters in depth (Pl. 38). They were also stilted with the visually effective profile which begins at this offset being carried up as a vertical line for some distance to the actual point of springing (Pl. 41). A careful consistency in the use of one selected or favorite arch profile held no attraction for the Iranian builders and the various monuments of the period do display a considerable variety in arch profile. On the one hand, such variations may

have resulted from the relative degree of accuracy with which the forming boards were made and used. Also, since the material was brick and not stone it was not necessary to stick to identical profiles which were designed for precut voussoirs of standard shape. In a number of structures the apex of the pointed arch is not sharply defined: in monuments of some antiquity at Yazd and in contemporary buildings at Tehrān (Pl. 217), arches may be seen which are not pointed at all but which have the elliptical curve common to Sāsānian architecture in Iran.

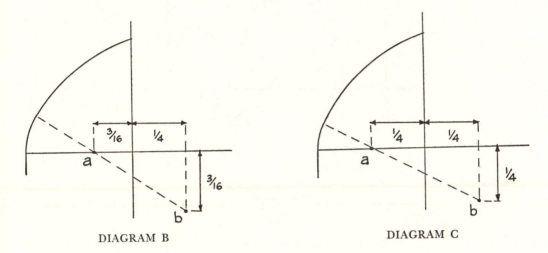

DIAGRAM B DIAGRAM C

As a final variant from the elusive norm, a number of monuments contain arches which appear to be struck from only two centers. Again the careless shaping of forming boards might produce this result. However, it might have been deliberate since a fifteenth century manuscript believed to be from Herat[1] presents, in a section devoted to the calculation of areas bounded by curves, a diagram for the construction of a two-centered arch (Diagram D).

In addition to the structural arches mentioned, the arch profile found extensive use as a decorative feature. The segmental arch, infrequent in the Seljūq period but quite common in Mongol work, appears in a screen wall on the shrine of Pīr-i-Bakrān at Linjān (Diagram E), in the vaults of the īvān below the shaking minarets at Iṣfahān and in wall arcades upon the exterior of the mausoleum of Öljeitü at Sulṭāniya (Pl. 71). An arch with a flat head was also used, as in the head of the window over the entrance to the caravanserai at Sarcham (Diagram F) and, executed in plaster, in the interior of the tomb of Shaykh Rukn ad-dīn at Yazd (Diagram G). An elaborate ornamental variant occurs in the plaster decoration on the exterior walls of the Masjid-i-Jāmi' of 'Alī Shāh at Tabrīz (Diagram H).

The double reverse curve found occasional use as an ornamental device. It appears in the inner plaster arch of the miḥrāb from the Imāmzāda Rabi'a Khātūn at Ashtarjān (Diagram I) and in a broken profile in the Masjid-i-Jāmi' at Bisṭām (Diagram J) where this profile is a plaster segment projecting beyond the face of the normal structural arch.

[1] Jamshīd al-Kāshī, *Meftāḥ al-Hesāb*. Yahudi Ms. 1189 in the Princeton University Library. This manuscript was written on European watermarked paper dated 1780, but may be a copy of a much earlier work.

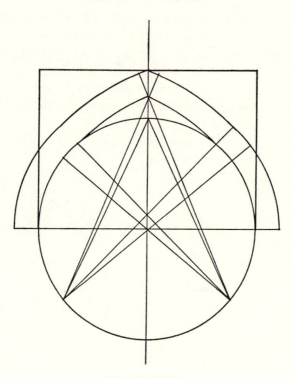

DIAGRAM D

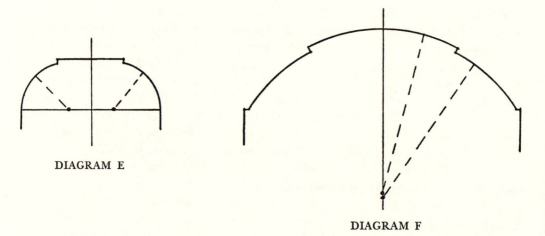

DIAGRAM E

DIAGRAM F

A variety of the pointed segmental arch in which the sides approached, or reached, straight lines was a common feature of decorative plaster and even of painted design. In such examples the area within the arch heads is that of two right angles or, if the profile is steeper, of an equilateral triangle. In the shrine of Pīr-i-Bākrān (Diagram K) a small curved section is introduced at the points of springing, but in panels on the interior of the tomb of Shaykh ʿAbd as-Samad at Natanz the outline is purely linear (as in Diagram L).

DIAGRAM G

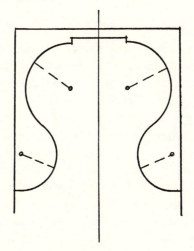

DIAGRAM H

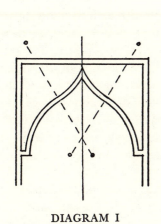

DIAGRAM I

DIAGRAM J

DIAGRAM K

DIAGRAM L

SQUINCHES AND STALACTITES

The most important design form of both pre-Islamic architecture of the Sāsānian period and of Islamic architecture in Iran was the use of the dome over a square sanctuary chamber. Placing the circle of the base of the dome upon the square of the lower walls presented a major structural problem: the Iranians early developed a single solution which they retained for many centuries. This was the squinch, developed as the primary motive of the zone of transition between cube and dome.

Within the dome chamber diagonal arches spanned the distance between two side walls of the chamber at points well in from the corner angle of the room. Four such arches having been erected, the weight of the dome which rose from and above them was distributed to eight points or areas along the side walls. Eight intermediate areas along these walls carried little appreciable weight and offered opportunities for decorative treatment: these areas were the midpoints of each side wall and the areas within the arches themselves. The midpoint areas were frequently pierced by windows. The squinches, the areas within the angle arches, might properly have been treated as a false pendentive and filled with a spherical triangle of masonry, or given some other pseudo-structural treatment. However, the builders were more concerned with finding decorative roles for the squinch areas. In a few structures these areas were completely opened up as pointed arch windows, but this device was given up in favor of decoration by the multiplication of parts, a treatment which gave interest to the otherwise blank and shaded inner surface of the squinch. The trend toward multiplicity began in the Seljūq period with the trilobial division of the squinch area: a narrow, stilted arch at the center of the squinch was flanked by stilted quarter domes. This division overaccentuated the central element and the next step was to achieve uniformity of surface effect by employing several tiers of stalactites. While the elaboration of the squinch area led to the ever-increasing use of stalactites, the squinch did not give birth to stalactites. Stalactites were already being employed in structures erected in Iran and in other Moslem countries.

In Iran stalactite systems have been designated by the Arabic word *muqarnas* or "joined" which also has the broader meaning of "vaulted" and by the Persian word *khonj* whose basic meaning is a "corner" or a "solid angle." A stalactite system may be described as follows. The filling of a concave surface or area by two or more tiers of combinations of miniature quarter domes, with the apexes of the quarter domes in each tier projecting forward from the tier below. Between each concave quarter dome or cell is a convex bracket. Normally the two base points of each cell are brought forward on their bracket bases beyond the apexes of the cells in the tier just below. Considerable variety in the shape of the cells is displayed: simple quarter domes; cells with a joint line down the middle, a device which permits an attenuated form; cells with miniature tunnel vaults at their head.

Stalactites were a fairly common feature of Seljūq architecture, but in the Il Khānid period the forms were both elaborated and employed in a greater variety of ways. Later paragraphs will detail the manner in which stalactites were used as cornices, capitals, half-domes, and domes and will indicate the distinctive forms and treatments of this period.

The conception and execution of the more complex of the stalactite systems represented

a problem in descriptive geometry which must have been simplified by special devices and tricks of the trade. The field worker is today faced with an exhausting task merely to draw an accurate reflected plan of the stalactite system of a dome or a half-dome. After long examination from a prone position the pattern of the intricate geometry of the system begins to appear. However, this geometry was frequently needlessly complicated—by slightly rotating successive tiers—in the interest of creating a display of sheer virtuosity. How were the masons able to transfer the concept of their master workman into three dimensions? This writer believes that the Persians employed a technique which is fairly well known from studies of the construction of stalactite systems in both 'Irāq and Morocco.[2] This technique involves the use of sets of standard wood form strips and in the hands of a specialist these strips could be combined in a great variety of ways to establish the brackets of the stalactite system. As such a system was erected the strips shaping each tier were embedded within the growing system, while a limitation on the size and curvature of the strips established consistency and unity within the system. Evidence for the use of form strips in Iran is now rather inconclusive; instead there is evidence that the master workmen made detailed preliminary designs. At Iṣfahān the writer saw such an elderly workman who had been charged with repairing a badly damaged stalactite half-dome of the Ṣafavid period. On the floor below the damaged element he had prepared a bed of white plaster and on this surface was engaged in incising a half plan of the original stalactite system. As the damaged element was constructed of strips and units of faïence he would work directly from his plan, without employing form strips.

While any stalactite system must be classed as a nonstructural form, some distinction is possible between the various methods of erection and the resulting systems may be described as corbeled, superimposed, or suspended. Corbeled systems contain materials similar to those of the fabric of the structure and these materials are bonded into the fabric. This type occurs infrequently as most of the stalactite systems were erected as a part of the general operation of giving a decorative revetment to an architectural monument. The superimposed systems were built up against and out from concave structural surfaces and because of the materials employed—whole and cut bricks and strips of terra cotta—had an inherent cohesion and stability. In the suspended systems the successive tiers were attached and hung, by various expedients, to the concave structural surfaces.

Stalactite cornices, used on the exteriors of structures, were either of the corbeled or the superimposed types. The lower walls of the mausoleum of Öljeitü at Sulṭāniya (Pl. 73) and the crowning elements of the enclosure walls of the caravanserai at Sīn (Pl. 186) display corbeled cornices, while the principal cornice of Öljeitü's mausoleum is a superimposed system clad with mosaic faïence (Pl. 71). In the Il Khānid period relatively few pier capitals display corbeled stalactites; this treatment was much more popular in the Moslem monuments of Syria and Asia Minor. Niche heads, including miḥrāb niches, squinches, and half-domes were filled either with superimposed or suspended systems. In the superimposed type there was no hollow space between the back of the tiers and the structural face con-

[2] For material on the use of forms and form strips in stalactite construction, see O. Reuther, *Das Wohnhaus in Baghdad und anderen Stadten des Irak*, Berlin, 1910, p. 105; J. Galotti, *Le Jardin et la Maison Arabes au Maroc*, Paris, 1926, I, 86-87.

cealed by the stalactites. Customary procedure was to build up a rough approximation of the envelope of the system from whole bricks, broken bricks and plaster, with this mass stiffened and supported by horizontal timbers projecting forward from the fabric (Pl. 135). Upon this backing the delicate stalactites were applied. From this type evolved the more expeditious but more fragile suspended type. Here the shell was held in place on horizontal beam ends and by lumps of plaster affixed to the ends of vertical pieces of wood or lengths of rope. The plaster squinches of the Masjid-i-Bābā 'Abd Allāh at Nāyīn are of the suspended type (Pl. 41).

Stalactite cupolas or domes were employed in at least two Seljūq monuments and the superimposed type of the cut brick stalactite cupola of the Imāmzāda Bābā Qāsim at Iṣfahān is very similar to the earlier examples (Pl. 194), although it is impossible to say whether it is of superimposed or suspended construction.

However, the plaster stalactite cupola of the tomb of Shaykh 'Abd aṣ-Ṣamad al-Iṣfahānī at Naṭanz is clearly of the suspended type and a masterly predecessor of many post-Mongol examples (Pl. 57).

Stalactites of the Il Khānid monuments do display features not known to the Seljūq period and these reached full development in the fifteenth-century structures of the Tīmurid period. These features include the use of the suspended type of plaster stalactite systems, the popularity of a white coat over the entire stalactite system, the use of straight-sided cells and the concentration of systems into pyramidal areas. The use of straight-sided cells certainly paralleled the decorative popularity of straight-sided plaster arches. In the filling of large squinches the trend was away from the use of a series of equal tiers with cells of comparable size and shape in which the decorative impact was spread evenly over the system to the pyramidal concentration of cells at the corners or in the center of the area, leaving considerable triangular areas of unadorned vertical surface. The concentration of stalactites, as well as the other features just mentioned, find a brilliant fruition in the suspended stalactite work of the mihrāb īvān of the fifteenth century mosque of Gawhar Shād at Mashhad.

MIHRĀBS

Every Moslem structure of a religious character should be provided with a mihrāb, the prayer niche whose axis indicates the direction toward Mecca. Some thirty-one mihrābs of the Il Khānid period have survived in good condition, a few of them not in their original positions but now on display in important museums. Several of the mihrābs of the period were installed in monuments erected in earlier times, possibly in the course of repairs of damage suffered during the Mongol invasions. A number of monuments contain roughly built niches intended for mihrābs which were never installed, while in certain buildings it is clear that mihrābs have been removed which have not reappeared in museums or on the antique market.

The surviving mihrābs are executed in several media: in plaster modeled and carved in high relief; in plaster with flat surfaces combined with a system of stalactites; in luster faïence; and, in mosaic faïence. In the earlier discussion of plaster decoration it was pointed out that the surface enrichment of the Islamic architecture of Iran was of three types: brick

patterns, plaster, and mosaic faïence, and that in point of time the use of each medium overlapped that of the other two. It was also noted that brick patterning tended to die out in the Il Khānid period, that plaster was favored throughout the period and that mosaic faïence was fully developed near the end of the period. It can be demonstrated that the same statements are valid when applied to the element of the miḥrāb.

A number of Seljūq monuments contain miḥrābs executed in small cut bricks and in units of unglazed terra cotta but this technique was not used in the Il Khānid period. The twenty-three miḥrābs of plaster treated in high relief are distributed throughout the entire period—from the miḥrāb in the Masjid-i-Jāmi' of Riẓā'iya which is dated 1277 to that of 1389 in the tomb of 'Imad ad-dīn at Qumm. The five faïence luster miḥrābs are all of the thirteenth century with the earliest in date the miḥrāb from the Masjid-i-Maydān at Kāshān which was put into place in 1226, just two years after the town was taken and devastated by the first wave of Mongol invaders.

The compositional type of the other two techniques, unmodeled plaster and mosaic faïence, is very similar, combining flat decorative or plain bands with a stalactite niche head. The earliest of the five miḥrābs in unmodeled plaster are after 1300 while the three mosaic faïence miḥrābs are all later than about 1330.

All the miḥrābs mentioned above are of imposing size and were placed in a commanding position in their monuments. Their number does not include a considerable number of secondary miḥrābs. Such smaller, secondary miḥrābs were frequently placed in the side walls of a structure whose longitudinal axis was not oriented toward Mecca, as was the case in the Pīr-i-Bakrān at Linjān and in the īvān of the Masjid-i-Buzurg at Gaz (Pl. 114). Small miḥrābs were also used in certain of the tombs.

Because of the primary importance of the miḥrāb as the single architectural element endowed with significant symbolic values and because of its commanding position within the sanctuary area extreme care was lavished on this feature. The basic composition, a pointed arch borne on colonnettes which framed a recessed niche and was surrounded on three sides by two or more bands decorated with inscriptions or ornament, had been established before the opening of the Seljūq period.

Monuments of the Seljūq period contain miḥrābs in relief plaster which resemble very closely the miḥrābs of the Il Khānid period. Outline drawings at the same scale were made of a number of both Seljūq and Mongol miḥrābs in an effort to determine whether the later miḥrābs show appreciable changes in proportions or arrangement of parts. However, the compositions of both periods appear indistinguishable and stylistic changes in script, type of ornament, etc., cannot be detected. It has already been noted that in Iran ornamental patterns and forms are altered and developed at a very slow rate but the decoration of the miḥrābs seems to carry on unchanged for an even longer period than does decoration on other surfaces. Perhaps the sacred and symbolic character of the element was responsible for a conscious preservation of its details and possibly this deliberate conservatism was promoted by copying the features and details of earlier miḥrābs. Thus, the miḥrāb of 1330 in the Masjid-i-Jāmi' at Marand (Pl. 167) is extremely close in a number of significant features to that of 1277 in the Masjid-i-Jāmi' at Riẓā'iya (Pl. 9).

However, certain signs may be detected which suggest that there was a steady, although

very slow, development in the design and execution of the miḥrāb from Seljūq through Mongol times. First, traces of color in a wider palette are more apparent on the Il Khānid miḥrābs; second, inscription bands are given an increasing emphasis; and third, the naturalistic ornament is less well organized with the result that in certain cases pattern and background elements tend to be indistinguishable.

THE REFINEMENT OF ARCHITECTURAL ELEMENTS

During the Il Khānid period elements and details of architecture common to the earlier Seljūq period were refined along lines which suggest a comparison with the developments which produced Gothic style from the experimental forms of Romanesque architecture. On one hand, verticality of structural expression was consciously sought for through the deliberate emphasis of ascending lines and on the other, the fabric of the structures was lightened and thinned out except in areas where heavy bearing loads had to be supported. The lightening of the fabric served to create larger openings and thus to relate the interior and the exterior of the monument by the penetration of atmosphere to the interior and by a homogeneity between exterior and interior wall surfaces. It also tended to enhance the vertical lines of the structure.

The deliberate emphasis upon verticality was achieved in a number of ways. Not all of them are devices new to the period but in combination they reflect a concept foreign to the Seljūq period. Such devices include the following:

1. *Chambers display an altered relationship of height to breadth.* From ground level to the crown of the dome the distance is greater in proportion to the interior width of the chamber than in the structures of the Seljūq period. This greater height is further emphasized by diminishing the actual height of the zone of transition which in Seljūq times tended to compete in size and importance with the height from the floor to the base of this zone. However, no real articulation of ascending lines was possible as long as the feature of the encircling inscription band at the base of the zone of transition was retained. Within the period this band was minimized but since it was the vehicle for Qur'ānic verses emphasizing the sacred character of the monument it could not be completely abandoned.

2. *The composition of īvān façades.* A characteristic and striking feature of the Il Khānid period was the lofty īvān portal crowned by a pair of soaring minarets, although it is worth noting that the most developed use of this feature, the incredibly high and slender portal of the Masjid-i-Jāmi' at Yazd, appeared at a later date. The great arch of the īvāns, which had been relatively low and wide in such Seljūq structures as the Masjid-i-Jāmi' at Ardistan, became a lofty opening found at Ashtarjān, Bistām, Natanz, and elsewhere. At Ashtarjān the height of the īvān arch is three times its width (Pl. 91). The emphatic verticality of these arches was reflected in the treatment of their flanking façades where the panels are multiplied with some of them four and a half times as high as they are wide.

3. *Increase in overall height of domical structures.* This feature requires little demonstration. The common use of the double dome which freed the builders from having to maintain a proper proportional relationship between the width of the chamber and the distance to the crown of a single dome sent the apex of the exterior dome higher and higher into the air and sharpened the significant silhouette of the structure.

4. *Increase in the height of tomb towers.* This feature was not necessarily an increase in absolute height since none of the Il Khānid examples, with the possible exception of the vanished tomb of Ghāzān Khān, rivaled the impressive height of the much earlier Gunbad-i-Qābūs but they did become proportionally taller in relation to their plan dimensions. This fact may be demonstrated by comparing the aspect of the flanged tower at Bisṭām with that of the flanged tower of Tughril Beg at Rayy, a structure of the Seljūq period, and by comparing the appearance of the earliest tomb towers at Qumm with the later ones in this same series.

5. *Attenuated compositions.* The miḥrābs of the Il Khānid period continue the precise compositional arrangement of the Seljūq period but certain of them display attenuated proportions. The miḥrāb of the Masjid-i-Jāmiʿ at Ardabīl (Pl. 58) is one such example but more striking are the miḥrābs of the Masjid-i-Jāmiʿ at Ashtarjān (Pl. 95) and of the Gunbad-i-ʿAlayivan at Hamadān (Pl. 116). In these two examples the upper part of the miḥrāb continues on through the band of the horizontal inscription frieze of the chamber and includes within its composition the entire head of the wall arch of the zone of transition.

Framed portals display a comparable attenuation with this trend best exemplified by the entrance portal of the now vanished tomb tower at Salmās (Pl. 122).

6. *Attenuation of details.* Both within and without the monuments the recessed wall panels became increasingly tall in relation to their plan width. Angle colonnettes, an effective medium for stressing verticality, were frequently used and were of slender proportions. Such colonnettes flank the opening of īvān arches, flank the sides of wall recesses and accentuate the corners of the tomb chamber of Shaykh ʿAbd aṣ-Ṣamad at Naṭanz (Pl. 57).

The conscious interest in emphatic verticality carried on throughout the fourteenth century but appears to have lost its hold in the fifteenth. Although the reason for its abandonment is not a matter of present concern, it may be said that it was possibly due to the compositional requirements of complete mosaic faïence.

Attenuation of structural masses was a constant goal of the builders of the Il Khānid period. The early Islamic centuries in Iran had inherited the Sāsānian tradition of thick, massive walls with a restricted number of portals and almost no windows. This tradition remained strong throughout the Seljūq period and it was not until the Mongol times that the monuments reflect a conscious effort to relate the thickness of the walls to the actual load borne by them.

Two elements may be singled out as illustrations of this trend: the īvān and the dome chamber. Quite in contrast to the solid appearing īvāns of the Seljūq period are such Mongol structures as the īvāns of the Masjid-i-Buzurg at Gaz and the īvān below the shaking minarets at Iṣfahān. At Gaz two fairly wide portals pierce each side wall of the īvān, and the rear wall, now filled by a brick screen, was originally open across almost its entire width (Fig. 29). At the Iṣfahān īvān the fabric is composed of seven piers, three to a side and two in the rear, which are united by a thin curtain wall (Fig. 33).

Many of the dome chambers of the period reflect attenuation of the structure both in plan and in section. The chambers at Dashti, Kāj, and Eziran were entered by very wide portals which rise to the level of the zone of transition (Pl. 148). Other structures, such as the mausoleum of Öljeitü at Sulṭāniya (Pl. 69) and the so-called Hārūniya at Ṭūs (Pl. 103),

display very large windows in the level of the zone of transition. As a result of the increasing use of more and large windows the interiors of many of the Il Khānid structures received a generous amount of light, a feature quite in contrast to the rather dark interiors of the Seljūq structures. As regards the plan form of these chambers, the lower walls were provided with rather deeply recessed panels so placed that the full width of the wall occurred at only those eight points which had to carry the weight of the dome above.

The general trend toward planned breaks in the course of the structural walls is well illustrated by certain octagonal structures of the period. Thus, at the tomb of Chelebi Oghlu at Sulṭāniya each interior side wall displays a deep, wide niche (Fig. 37) and each exterior side a recessed panel (Pl. 169). On the shrine at Ziaret deep niches appear on the exterior (Pl. 47). This development reaches full culmination only in Tīmūrid and Ṣafavid times with the garden pavilion as its most characteristic form. The pavilion is basically the familiar square chamber but with so many openings in section that the exterior atmosphere of the garden seeps throughout the structure and with so many niches, stairs, and small rooms within the thickness of the walls and corner angles that in a plan representation the poché seems to be only a bare minimum.

12. Methods and Materials of Decoration

PLASTER

THE extensive and extraordinarily skillful use of plain, modeled, appliqué, and painted plaster is certainly one of the most characteristic features of Il Khānid architecture. Throughout the centuries Moslem architecture in Iran displays three types of surface enrichment; elaborate brick bonding, plaster, and mosaic faïence. In point of time the use of each of these types overlapped that of the other two but plaster was employed for a longer time than the other materials. Thus, decorative brick-lay appeared in pre-Seljūq work, reached its maximum effectiveness in the Seljūq period, and tended to die out during the fourteenth century. The first halting attempts to use faïence were made in the Seljūq period and the Il Khānid period brought mosaic faïence to the threshold of the virtuosity it was to display in the Tīmūrid and Ṣafavid periods. On the other hand, plaster was an important feature of the decoration of the earliest Islamic monuments in Iran and held its popularity through all the later centuries. Monuments of the Seljūq period display examples of some of the manners in which plaster was put to use in the Il Khānid period. These include the covering of large wall areas; inscription friezes; mihrābs; simulated brick bonding; and plaster accentuated with color.

The practical advantage of plaster decoration resides in the fact that this material may be spread and worked very rapidly and hence inexpensively while both brickwork and mosaic faïence, one popular before this period and one after it, take much longer to execute and are relatively more costly.

Plaster is used only on interior surfaces. It might seem obvious that the poor weathering quality and the high reflectiveness in sunlight would prevent its use on exterior walls but it is more likely that it was a matter of Iranian taste, for Moslem structures in other lands display exterior surfaces which are coated with white plaster or which are whitewashed.

Variant, yet parallel, developments in the handling of plaster appear throughout this period. Plaster in high relief, often built up in several layers and with the pattern forms deeply undercut, was used almost to the end of the period. Within the period grew up the popularity of level surfaces bearing elaborate punched designs and near the end of the period the use of plaster in very low relief, of what might be called linear plaster, appeared. Polychromy brightened each of these styles.

The manner in which plaster was used in the monuments studied will be treated under a number of headings with some of the material included in these headings finding a fuller treatment in other sections.

1. *Plaster as an adjunct to structure.* In a few structures a relatively thick coat of plaster was spread over vertical wall surfaces and before it hardened a brick revetment was thrust into the plaster. In one structure this plaster coat is .03 m. thick and holds a revetment of small cut bricks (Pl. 23) .04 m. in thickness and in another example the holding material appears to be a mixture of mud and plaster (Pl. 95).

Plaster arches, of normal and trefoil outline, were used to bridge the gap between the heads of adjacent flanges and colonnettes (Pl. 13). A fairly thick coat of plaster was fre-

quently employed to give precise form to systems of stalactites that were rather roughly constructed of fired brick.

Two structures display numerous plaster colonnettes built out from flat structural walls (Pls. 57, 95) and one shrine has a cornice crowned by a row of plaster finials (Pl. 144).

Plaster was frequently used to soften the abrupt transition between surfaces. Thus, at places where a vertical or horizontal wall surface broke back in depth for a few centimeters the right angle was filled with plaster to establish a forty-five degree angle of transition (Pl. 205).

2. *Brick-end plugs.* Brick-end plugs occur in a number of monuments. These plugs were made in this manner. The wider rising joints of a brick wall were raked out or a part of a brick along a vertical joint was cut away. These cavities were plugged with hard plaster which was knife-cut, while still soft, with a great variety of patterns, although in some instances the patterns may have been stamped with wood blocks. The patterns include simple geometric designs (Pl. 62), stylized floral forms (Pl. 200) and such sacred names as Allāh and ‘Alī (Pl. 210).

Brick-end plugs had been very popular during the Seljūq period and the same type of patterns continued in use so that an examination of the plugs alone would not serve to tell whether a structure was of the Seljūq or Mongol period. The extensive scattering of these plugs gave an interesting texture to the wall surface. Usually they were quite carefully executed but near the top of one lofty tomb tower they consist merely of three vertical grooves which convey the desired effect to the ground. During the Il Khānid period as plaster became increasingly popular, a new method of executing these plugs was devised, probably as a means of saving time. The first step in the change was represented by the use of a thin plaster slip with the patterns incised at the exact locations of the rising joints (Pl. 210). Then, the plugs were simulated in a plaster surfacing without reference to the position of the bricks beneath: this technique is discussed in a later paragraph.

3. *Flat plaster surfaces.* Although the use of a plaster coating over large areas of a structure had been fairly common in the pre-Seljūq and Seljūq periods this type of treatment reached full development only in the Il Khānid monuments.

In a number of structures the entire inner surface is coated with hard, white plaster while in others only certain areas are so treated. The thickness of the covering varies; in one example the coat is .01 m. thick; in another structure it is .035 m. thick and finished with a thin slip; and, in a third monument there is a total thickness of .08 m. which includes a thinner coat of hard, white plaster applied to a coarser plaster undercoat.

These flat surfaces were rarely left completely white and completely plain. The plaster color ranges from intense white to gray or buff. Horizontal zones, especially that of the dado, were given emphasis by the use of color; in one structure by red, in another by blue-gray.

A number of monuments make extensive use of simulated brick bonding patterns. The plaster coat bears incised lines to represent the horizontal joints and the patterns of the brick-end plugs are incised at the assumed position of rising joints (Pls. 85, 102). The Masjid-i-Jāmi‘ at Ashtarjān (Pl. 95) and the tomb chamber in the Masjid-i-Jāmi‘ at Herāt (Pl. 63) are examples of this extensive use of this technique. In the latter structure zigzag

incised lines along the supposed location of horizontal and rising joints spell out sacred names. Two monuments have the false joint lines drawn in white paint.

4. *Plaster in high relief.* The use of plaster modeled and carved in high relief was a typical product of the Seljūq period which carried over into Il Khānid work, where it displays similar stylistic features with the new element of a swing towards over-ornate and restless decoration which was in vogue only for a brief time until the rather abrupt loss of interest in high relief caused this type to disappear by the middle of the fourteenth century. The interior of the Gunbad-i-'Alayivan at Hamadān best represents the exuberance and lushness of carved plaster (Pl. 116). Naturally, floral forms were most suitable for work in high relief (Pl. 87) although carved and modeled geometric designs appear on colonnettes and mouldings.

Miḥrābs of carved plaster survive in some twenty-three of the monuments under consideration and have certainly disappeared from a number of others. A number are of impressive size and close examination has revealed that they were gradually built up in height, breadth, and depth by the multiplication of successive layers and areas of plaster which were bonded together by applying segments of fresh plaster against the jagged edges of hardened plaster. In general arrangement, composition, pattern details, and technique these miḥrābs are extremely close to their Seljūq prototypes. So close, in fact, that it is very difficult to distinguish between a miḥrāb of the early twelfth century and one of the early fourteenth. The slow rate of stylistic development thus revealed is of such interest that a special section has been devoted to a more detailed consideration of the miḥrābs.

Inscription friezes and inscription panels containing Arabic script set against floral grounds are found in more than twenty of the monuments, in others it is certain that the final work of executing the inscriptions was never completed (Pl. 131) and in still others they have been destroyed. By rights every structure should have borne an inscription, certainly sacred in character if the building had religious connotations, and possibly of historical interest if the patron wished to commemorate its erection. Such inscription friezes are frequently used as a continuous band encircling a square chamber below the zone of transition or just above it (Pl. 209), or around three sides of an entrance portal (Pls. 113, 130), or along the edges of arches (Pl. 95), or in the heads of pointed arch wall panels (Pls. 165, 94). The remarkably varied calligraphy of these friezes is a joy to the beholder and such pleasure must have always been almost entirely aesthetic for very few people of the period of the monuments were able to spell out the closely woven Arabic. Many of these friezes still bear considerable traces of color, and several color combinations may be seen in the various structures. There are white letters against a black ground (Pl. 200); white letters against a dark blue ground (Pl. 48); the entire frieze dark blue with red borders (Pl. 93); red letters against a dark blue ground (Pl. 95); and dark blue letters against white (Pl. 41).

5. *Solid and void plaster decoration.* This term is an attempt to describe in a few words a technique which is very different in execution and effect from that of the carved plaster with its deep piercing, modeling and undercutting of forms. In this technique the pattern is cut back from a smooth front surface to a depth of not over .02 m. to establish a back plane parallel to the front surface. The outlines of the design elements are either cut

straight back or are chiseled in slanting strokes which penetrate to a uniform depth. An intermediate stage in the change from the carved plaster to this fresh technique is represented by such examples as the soffits of the shrine at Turbat-i-Shaykh Jām (Pl. 175) and the miḥrāb of the Imāmzāda Rabiʻa Khātūn at Ashtarjān (Pl. 68).

Good examples of this technique, which was used on dados, wall surfaces, and mouldings but which seemed especially suitable for the soffits of arches and the undersurfaces of vaults, appear in the Masjid-i-Jāmiʻ at Ashtarjān (Pl. 101), in three or four of the tomb towers at Qumm, in the Masjid-i-Jāmiʻ at Farūmad (Pl. 126), and in the mausoleum of Öljeitü at Sulṭāniya (Pls. 80-81). At Sulṭāniya a gallery runs around the octagon of the mausoleum far above ground level. Each of the sides of the gallery is composed of three bays and the twenty-four vaults crowning all these bays are decorated with this solid and void plaster, each vault bearing a distinctive design and all remarkably well preserved. By trimming the haunches of the vaults with border strips at different levels and different angles three shapes of pattern area are outlined on the various vaults—squares, lozenges, and hexagons. Within each pattern area, designs of splendid ingenuity were executed with an unrivaled finesse and precision. The depth of the cutting from the front surface to the back plane is about .01 m. so that the three-dimensional quality of the work is minimized. There is, in fact, a remarkable relationship between the designs of these vaults and contemporary two-dimensional ornament in other media: to metalwork, to book illustration, and to the overglaze pottery made at Sāva. The correspondence with the vaults and decorative pages of Qurʼāns made during Öljeitü's reign is especially marked.

In the vault designs at Sulṭāniya the pattern solids are indicated in simulated strapwork divided into short lengths by painted false joint lines and the voids hold carved geometric elements or stylized floral forms. Perhaps even more striking than the variety of designs and the skill of cutting is the presence of almost perfectly preserved strong and exuberant color, for every square centimeter of their surfaces is painted in white, red, yellow and green. Although color was widely used on the high relief plaster it is certainly more effective on the flat surfaces of this technique, indeed almost too effective for it tended to conceal and deny the character of the medium to which it was applied.

Certain inscription friezes reflect the style of this technique. In such examples as the tomb shrine at Ziaret (Pl. 48), the Turbat-i-Shaykh Jām shrine and the tomb of Sayyid Rukn ad-dīn at Yazd (Pl. 140) the cutting is shallow and the calligraphy has lost some of the sweep and sway of the inscriptions in high relief for the letters tend toward more rigid upright strokes and the background pattern is either minimized or entirely lacking. Inscriptions executed in this same manner may be observed in the much later Tīmūrid and Ṣafavid monuments while inscriptions in high relief are seldom used after the middle of the fourteenth century except for attempts at deliberate archaism.

6. *Appliqué plaster.* This term has been selected to characterize a technique which is at variance with both the high relief and the solid and void plaster. Plaster of this type appears in close association with painted linear decoration on flat surfaces and the combination is a deliberate one. Appliqué plaster was executed as follows. On a smooth finished white plaster surface the outlines of simple or complex designs were drawn in pigment and then the plaster worker carefully modeled his fresh plaster along the lines of the design, keeping

the work in very low relief but with minute detail. The completed plaster has a dry, brittle quality with the ornamental forms not always related to the shape of the surface on which they appear. But in most examples the forms have a compositional relationship with painted linear designs.

Tentative efforts at using appliqué plaster may be seen in the mausoleum of Öljeitü at Sulṭāniya (Pl. 78) and in the Imāmzāda Rabi'a Khātūn at Ashtarjān. The mausoleum at Ṭūs displays a limited number of areas which have very simple designs executed in thin ropes of plaster (Pl. 104) but the technique was especially popular, as far as the surviving monuments go, at Yazd and at nearby Abarqūh. The tomb of Ḥasan ibn Kay Khusraw at Abarqūh, the Gunbad-i-Sayyidun at Abarqūh (Pl. 181), the tomb of Sayyid Rukn ad-dīn at Yazd (Pl. 141) and the Madrasa Shamsiya at Yazd (Pl. 207) display a close family relationship and the plaster ornament has a sumptuous character much like that of the over-glaze pottery with gilded relief which was made in Iran during the thirteenth and fourteenth centuries. The plaster is painted with a number of colors—light blue, dark blue, red, green, yellow, brown—and bears traces of gilding.

7. *Painted plaster.* Mention of the use of painted plaster has already been made in the discussion of solid and void plaster and of appliqué plaster. High relief plastered was also polychromed in white, light blue, dark blue, buff, red, and green.

A complete list of all the colors noted on the three types of plaster is as follows: white, light blue, dark blue, green, red, orange, ochre, beige, buff, reddish-brown, brown, black, and gold (gilt). It is easy to imagine that the interiors of many of the monuments were, when newly completed, ablaze with bright tones. Such a varied and extensive use of color was not common to the previous periods and did not long continue for the brilliant palette was taken over by a new medium, mosaic faïence.

Polychromy was present not only in the plaster in relief but on two-dimensional designs executed on smooth plaster surfaces. This treatment was not entirely a new one for a very few structures of earlier centuries still display linear inscription bands painted in light blue or dark blue against a white plaster ground but the real development of painted ornament took place entirely within the Il Khānid period.

At first the structures of the period continued Seljūq practice in employing only light and dark blue tones; these are the Masjid-i-Bābā 'Abd Allāh at Nāyīn with its palmettes and *kūfī* and *naskhī* inscriptions (Pl. 41) and the Masjid-i-Jāmi' at Ardabīl with its triangles of delicate floral tracery in the squinch faces (Pl. 60). In the heads of the pointed-arch wall panels of the Imāmzāda Rabi'a Khātūn a third color, green, is introduced and in the two-dimensional painted decoration of the mausoleum of Öljeitü eight colors are on display (Pls. 76, 77). Other monuments where this type of decoration is used include the two structures at Abarqūh and Yazd, mentioned a few paragraphs earlier, and the Masjid-i-Gunabad of Āzādān at Iṣfahān.

These painted designs were employed on surfaces of many different shapes, in some cases as separately spaced elements on large areas of white plaster, in others an entire wall section is covered with fluid tracery. At the apex of the dome of the tomb of Sayyid Rukn ad-dīn is a huge multicolored sunburst design and pendant from it are rows of smaller circular elements (Pl. 143). The extension of this type of design over rectangular surfaces calls to

[83]

mind the compositions and patterns of decorated manuscript pages and book covers while some elaborate areas recall textile design. Inscriptions, stylized vegetation, and geometric interlaces predominate in this linear ornament except for the unique decoration on the walls of the mosque of Āzādān where there are views of Mecca and Medina, flags (Pl. 203), and two-bladed swords.

Much of this painted ornament may have been stenciled on the plaster, a possibility which seems to be a certainty in the case of the Masjid-i-Jāmi' at Ardabīl where there are absolutely identical patterns on two faces of the same squinch.

MOSAIC FAÏENCE

If one mentions Islamic architecture in Iran to a person who is familiar with the Middle East, the latter will probably think at once of Iṣfahān and of the great square bordered by the multicolored surfaces of the Imperial Mosque and the Masjid-i-Shaykh Luṭf Allāh—both structures of the early seventeenth century. It is well known that these and other structures of the Ṣafavid period are clad in unbroken coverings of mosaic faïence and that such faïence was used in an even more sensitive and skillful manner at Herāt and Mashhad during the fifteenth century. However, "complete mosaic faïence," obtained when an architectural surface is entirely covered by a patterned arrangement of closely fitted small pieces of tile which have surface glazes of different colors, did not suddenly spring into being. Actually more than two hundred years elapsed between the earliest tentative architectonic use of small elements of light blue glazed tile on monuments of the Seljūq period and the production of complete mosaic faïence. Since this evolution has previously been traced in considerable detail by the present writer,[1] only a summary statement of the development need be given.

Some fifteen monuments of the Seljūq period display, on interior or exterior, glazed tile used in inscriptions or patterns. Near the end of this period in the Gunbad-i-Kabud at Marāgha of 593/1196, the development had reached the state at which strips of glazed tile were set in a plaster ground to form an elaborate strapwork pattern. Then came the Mongol invasions to interrupt architectural activity for long years. When the revival did begin, the use of faïence seems to have gone on from just the point it had reached at the end of the twelfth century. Fragments from the site of Shenb Ghāzān and the Rab'-i-Rashīdī suggest that the threshold of complete mosaic faïence was attained in the opening years of the fourteenth century and with the mausoleum of Öljeitü at Sulṭāniya complete mosaic faïence found extensive use on both exterior and interior surfaces. In this monument geometric patterns were made of small pieces of dark blue, light blue, and white glazed tile, fitted as closely together as careful cutting and a thin line of mortar in the joints would allow. Pieces of black glaze are also used at Sulṭāniya.

Once mosaic faïence had attained maturity the technique was elaborated along two lines: the geometric patterns were joined by patterns based on floral forms and additional colors of glaze were brought into use. Of the sixty-three items on the catalogue list which are later in date than the mausoleum of Öljeitü some twenty-five display mosaic faïence.

[1] D. N. Wilber, "The development of mosaic faïence in Islamic architecture in Iran," *Ars Islamica*, VI, 1 (1939), 16-47.

Centers for its use appear to have been at Iṣfahān, Yazd, and Kirmān. To the four colors of Sulṭāniya a fifth, green, and a sixth, a brown or eggplant shade, seem to have been introduced about 1340 at Iṣfahān and a seventh, golden-yellow, appears near the end of the century at Kirmān. However, the tonality of the two blues, light and dark, predominated not only in the fourteenth century but throughout the Tīmūrid and early Ṣafavid period.

This development, as outlined, appears to be both considered and logical and only a single point needs to be raised. This is the question of the area priority in the execution of complete mosaic faïence. Since the Iranian monuments at Herāt, Mashhad, and Iṣfahān are so well known and since mosaic faïence seems so characteristic of Islamic architecture in Iran that country has always been credited with priority in this technique of architectural decoration. Now that the successive stages of its development in Iran can be precisely dated it seems advisable to examine this assumption by a comparison of the Iranian material with the mosaic faïence used on monuments of Asia Minor.[2]

Construction workers from Iran proper were certainly active in regions to the west of Āzerbāijān even earlier than the first Mongol invasion. The builder of the so-called Mosque of the Chateau at Divrik, dated 1180, was the "master workman Ḥasan ibn Pīrūz of Marāgha" and the portal of this monument recalls the portals of the tomb towers constructed at Marāgha in the second half of the twelfth century.

As the waves of Mongol horsemen rode across Iran, thousands of its inhabitants fled before them. Those of the refugees who possessed special talents were warmly received in districts far removed from their native towns. It is known that the Sulṭān ʿAlā ad-dīn Kay Kobad, Seljūq ruler from 1219 to 1236, whose capital was at Qonia summoned to his court learned men and artists who had fled to Iṣfahān to escape the Mongols. Inscriptions in Asia Minor give the names of three builders from towns in Iran who were active at important sites between 1220 and 1243. It seems very likely that a considerable body of Iranian craftsmen did move into the region and contribute largely to its architectural embellishment.

In the tomb of Kay Kaus, erected in 617/1220 in a lateral bay of the Chiffaiyeh hospital at Sivas, surviving elements of the original decoration indicate a use of architectural faïence at about the same stage in its development which had been reached in Iran during the second half of the twelfth century. There are patterns executed in light blue and black glazed bricks as well as an inscription frieze comprising sections of moulded and assembled faïence, of white letters on a blue ground. Cartouches in the tomb read: "Work of Aḥmad ibn Bakr of Marand." (Marand was, and is, a town a short distance north of Tabrīz.) The tomb tower called Kirk Kizlar at Tokat displays badly damaged geometrical patterns with elements of light blue glazed brick. The inscription, now destroyed, once read in part: "Work of Aḥmad ibn Abū Bakr . . ." and it is probable that this is the same individual from Marand and that the date of the structure is c. 1220.

At Amasia a mosque known as the Burmali Minar, dated by a portal inscription to 634-644 (A.D. 1237-1247), contains a miḥrāb framed by a faïence revetment consisting of four

[2] For the material from Asia Minor, the sources listed under the following names in the Bibliography have been consulted: Gabriel, Mendel, Raymond, Sarre.

rows of square light blue glazed tiles. Above the miḥrāb a cartouche contains the phrase: "Work of Muḥammad ibn Maḥmūd of Errān." (Errān, or Ārrān, was a village and district name in the north of Āzerbāijān.)

At Qonia the Madrasa Sirtchali, constructed in 1243, displays an inscription frieze and a miḥrāb executed in incomplete mosaic faïence. Geometric patterns are carried out in strips of light blue, dark blue, black, and white glazed tile but voids in the design were filled with plaster. The inscription contains the statement: "Work of Muḥammad ibn Muḥammad ibn Osman, the builder of Ṭūs." (Ṭūs is, of course, near Mashhad in eastern Iran.) In another monument at Qonia, the Madrasa Karatay or Kara Tai of 1252, the same four colors of glazed tile are employed but the plaster insets are not present and hence complete mosaic faïence has been achieved in an example which is some fifty years earlier in date than any complete mosaic faïence thus far recorded in Iran proper.

Three other monuments at Qonia of about this same period also display complete mosaic faïence. They are the so-called Larinda mosque of 1258; the mosque of Sahib Ata of 1270; and the tomb tower of Fakr ad-dīn 'Alī, just adjacent to the Sahib Ata mosque.

In the Gok Madrasa at Amasia, of about 1267, white and blue glazed bricks are employed in a type of incomplete mosaic faïence while the Gok Madrasa at Tokat, of c. 1275, displays complete mosaic faïence in light blue, dark blue, and black glazed tiles.

In the above paragraphs only a few out of a considerable number of pertinent structures have been selected to document the statement that complete mosaic faïence was developed in the regions to the west of Āzerbāijān considerably before the first recorded examples of its use in the structures erected in Iran at the height of the Il Khānid period. We may believe that itinerant or refugee Iranian craftsmen carried the technique to Asia Minor, developed it there and that later it was brought back to Āzerbāijān and Iran. Later research should be able to settle this point. What is certain is that mosaic faïence was especially well received in Iran and during the period from the fourteenth to the early seventeenth century executed with a skill, spirit, and sense of architectonic values not approached in other areas. That the technique had much more appeal in Iran than to Asia Minor is clearly indicated by the fact that it was never fully developed nor accepted in that region with its classical heritage of stone architecture. In Asia Minor and Anatolia the mosaic faïence was not kept under control and in relative subordination to structural surfaces through the use of a restricted color harmony and restrained patterns. Instead, the palette of glazes was considerably increased and green vied with blue for the position of the dominant tone, while naturalistic floral patterns were developed which tended to attract attention to particular areas rather than to large surfaces. Further, the combination in the same structures of elaborate stone carving and areas of faïence was not aesthetically successful.

An important and thoroughly fascinating subject which remains wide open for investigation is that of the possible relationship between architectural details of monuments of the period and the depiction of these details in contemporary, or nearly contemporary illustrated manuscripts. However, some material is ready to hand which indicates a possible relationship between faïence decoration and the representation of such decoration.

The entrance portal of the shrine of Bāyazīd at Bisṭām is largely clad with distinctive patterns executed in complete and in incomplete mosaic faïence (Pl. 32). Repeat patterns

are employed as border strips or as allover patterns on a vertical wall surface (Pls. 34, 35). Some of the pattern elements are made up of single pieces of moulded and glazed terra cotta, while others are composed of interlacing units of faïence. Also, floral motifs appear as glazed insets in plaitwork patterns. The decorative ensemble, with the emphasis upon moulded pieces and interlacing patterns, is quite unlike that of any other monument of the period. However, these features find an interesting reflection in a number of the paintings from the Demotte Shāh-Nāma, a manuscript which has been assigned to 1335 and to 1350-1375.[3] The similarity of motives is particularly apparent in the painting entitled "Mirān Sitād selects a Chinese Princess for Nūshīrwān" (Pl. 215).[4] Many of the border strips are close to those found at Bisṭām and one plaitwork repeat pattern is almost identical. Other paintings from this manuscript depict additional faïence patterns and panels, as well as decorative brick-end plugs.

[3] The so-called Demotte Shāh-Nāma whose pages are now rather widely dispersed is customarily dated about 1335. Eric Schroeder argues for the third quarter of the fourteenth century, in "Ahmed Musa and Shams al-Dīn: A Review of Fourteenth Century Painting," *Ars Islamica*, vi, 2 (1939), 125.

[4] This painting is in the collection of the Museum of Fine Arts, Boston.

13. Regional Schools and Relationships

THE SCHOOL OF ĀZERBĀIJĀN

THE political power and prestige of the Il Khāns was concentrated in the province of Āzerbāijān, the successive capitals of Marāgha, Tabrīz, and Sulṭāniya, all lying within its boundaries. However, Mongol supremacy also extended north and far to the west of the limits of the province as it is defined today. This extensive area included the Caucasus region between the Caspian Sea and the Black Sea, Georgia, Armenia, and Asia Minor as far west as Qonia near the Mediterranean. Asia Minor had been held by Seljūq princes, direct descendants of a general of the Seljūq ruler Malik Shāh. These princes had Qonia as their capital and the outstanding figure of their line was ʿAlā ad-dīn Kay Kobad who ruled from 1219 to 1236.

The Mongols took over this extensive area in brief order: Kayseri was captured in 1243 and Akhlāt in 1245. The nominal rule over certain regions was frequently turned back to the local dynasties: the Sultanate of Asia Minor was divided by the Mongols between two grandsons of Kay Kobad and their descendants remained powerful until the early fourteenth century, while Akhlāt was handed over to a Georgian princess who had married the ruler of Armenia. During the thirteenth and fourteenth centuries conditions were rather unstable throughout the entire area and the general tendency was toward the formation of more and smaller principalities but the Il Khāns were able to maintain effective sovereignty. This latter fact is reflected by surviving inscriptions of the Il Khānid rulers: one of Öljeitü at Nasmus and long edicts of Abū Saʿīd at Yeni Khān, near Sivas and in the mosque with the polygonal minaret at Ānī.

Ties between northwestern Iran and the vast area to the north and west had always been strong. From a very early period an arc stretching from Syria up through Asia Minor and down into Iran had been a traditional center of stonecutting and fine craftsmanship in this material was always a feature of the area. The extent of direct relations is reflected in surviving inscriptions of the general period under consideration which give the names of Iranian workmen active in Asia Minor. Thus, we know that Ḥasan ibn Piruz of Marāgha worked at Divrik in 1180-1181; Aḥmad ibn Abū Bakr of Marand at Tokat and Sivas in 1220; Muḥammad ibn Maḥmūd of Arrān at Amasia in 1237-1247; and Muḥammad ibn Muḥammad ibn Osman of Ṭūs at Qonia in 1243. It is easy to believe that for each Iranian whose name has come down by chance a dozen or a score of others were at work. The possibility that many of these individuals had fled from Iran before the Mongol onslaught and had helped to develop techniques which were reflected at a later period in the revived construction of Iran has been discussed in the consideration of mosaic faïence.

In order to define the character of the regional school we shall first survey the monuments of Āzerbāijān and then suggest relationships between their distinctive features and similar features on monuments of the much greater area.

The standing monuments for which instructive comparisons may be made number nine: all were erected between 1300 and 1335. These structures are: the tomb towers of Joi Burj and Ghaffāriya at Marāgha, the tomb towers at Salmās and Khiav, the Chelebi Oghlu at

Sulṭāniya, the vanished tomb of Ghāzān Khān, the mosque at Marand, the caravanserai at Sarcham and the caravanserai near Marand. It is interesting to note that two of the three greatest structures of the period—the mausoleum of Öljeitü and the mosque of 'Alī Shāh—do not display the features which will be described.

Features which these structures have in common and which are not found in central, southern, and eastern Iran are: 1) the use of red brick, 2) the use of cut stone, 3) the use of the crypt, and 4) the use, as portal or window feature, of a distinctive composition within a rectangular frame.

Red brick

The bricks of the two tombs at Marāgha, of the two caravanserais and from the site of Ghāzan's tomb are of a special plum color which is quite different from the drab buff tones common to the rest of Iran. It would seem that the use of these red bricks was distinctive to the narrow limits of Āzerbāijān, although a detailed consideration of the structures of northern Mesopotamia might show that the same color was used in the Mosul region.

Cut stone

Since a fairly extensive account of the use of cut stone has been given in another section (see pp. 51-52), only a brief description of the manner in which it was used will be made at this point.

Dressed stone masonry is used for the base courses of the two tombs at Marāgha, of the Chelebi Oghlu, of the tombs at Salmās and Khiav, and of the caravanserai near Marand. According to contemporary historians all the walls of the citadel at Sulṭāniya were of dressed stone and stone certainly was used in the tomb of Ghāzān. The caravanserai at Sarcham and the one near Marand retain their entrance portals of cut stone and door frames of dressed stone exist in the mosque at Marand and in the ruins adjacent to the Chelebi Oghlu.

Throughout the rest of Iran the only monument of cut stone of the thirteenth and fourteenth centuries known to the present author is the shrine in the court of the Masjid-i-Jāmi' at Shīrāz.

Crypts

Vaulted crypts are found in the Chelebi Oghlu at Sulṭāniya, in the Joi Burj and the Ghaffāriya at Marāgha, in the tomb at Khiav, probably in the tomb tower at Salmās and certainly in the tomb of Ghāzān. These crypts were normally entered or lit by a low pointed arch opening on the east side of the structure. The presence of the crypt resulted in the floor level of the main chamber of the tomb being a meter or more above the ground level so that a flight of steps led up to the portal.

Such crypts, used in combination with cut stone base courses, were also common to the twelfth century tombs at Marāgha: to the Gunbad-i-Surkh, to the so-called Round Tower, and the Gunbad-i-Kabud.

Composition within rectangular frame

This feature, used as portal, window, or exterior recess treatment, may be described as follows. Within a rectangular frame a moulding is carried up on both sides of the panel

area to establish a pointed arch. The moulding is knotted at the peak of the arch and continues as a frame around a horizontal panel, usually filled with an inscription. The head of the pointed arch outline is treated with a stalactite system. This system is only one cell in width at its apex and fills the width between vertical mouldings only at the lowest stage of the stalactites. Below the stalactite system is a lintel and below the lintel either portal, window, or recess.

This compositional unit may occur as described above, or one or more of its elements, such as the knot, inscription panel, or stalactites, may be lacking. Thus, the Joi Burj and the Ghaffāriya at Marāgha and the tomb tower at Khiav display the complete composition while at Salmās the stalactite system fills the full width of the pointed arch outline and the portal at Sarcham has only the moulding, knot and panel.

It should be noted that this basic composition was already in use in Āzerbāijān before 1200: in the Gunbad-i-Kabud at Marāgha and the Se Gunbad at Riẓa'iya.

We must now relate these features to monuments in the area north and west of Āzerbāijān. Monuments by the score still stand throughout these regions, but most of them have been incompletely described in accounts by travelers of the nineteenth century. Some have been given more comprehensive treatment within recent years but as yet no effort has been made to work out relationships between regions or to establish general stylistic features. The task of assembling the entire mass of this material is tremendous but it is also beyond the scope of this present consideration. The necessary comparative material has been drawn from standing structures at the following sites: Baku, Nakhichevan, Ānī, Akhlāt, Van, Wostan, Kayseri, Amasia, Sivas, Divrik, Tokat, Ezerum, Qonia, and Sulṭān Khān.[1]

Most of the comparative monuments are of dressed stone although brick was sometimes used, especially in the region of Lake Van and north of the Aras River. When all this material is available it seems scarcely necessary to subscribe to the view of André Godard that Syria was the source of the details of the moulding, knot, and inscription panel on the portal of the caravanserai at Sarcham.

Throughout this entire area the basic type of the tomb tower was well established by the middle of the twelfth century, the period of the Seljūq towers at Marāgha, as the tomb tower called Kahlifet Ghazi at Amasia and the tomb tower within the mosque of 'Alā ad-dīn at Qonia show. Such towers were erected until near the middle of the fourteenth century but the majority of the standing towers, including tombs at Akhlāt, Kayseri and Amasia, are dated around 1275.

These tombs, almost always of dressed stone, are usually octagonal, less frequently round or polyhedral. The shaft rises from a high square stone base, the upper corners of which are chamfered, and is crowned by a conical or polyhedral roof. The exterior faces are decorated with arcading cut in high relief on the stones of the structure and most of the tombs have four windows or portals on the axial lines of the tower. The crypt, common to almost every tower, is entered at ground level with the result that the floor level of the

[1] Sources listed under the following names in the Bibliography, in addition to those cited in note 2 on page 85, have been consulted: Bachmann, Dorn, Hommaire de Hell, Jacobsthal, Klaproth, Khanikoff, Lycklama, Lynch, Marr, Ker Porter, Preusser, Riefstahl.

main interior chamber is at least two meters above the ground. Built flights of steps to these chambers are rarely found; they were probably entered by means of a ladder. The interior of these tomb towers is usually perfectly plain and the chamber is always covered by an inner dome of cut stone.

The question of the possible relationship between these and other Moslem structures and the Christian monuments of the same years has not been studied as yet. It would appear that the Christian monuments had priority in the use of many architectural forms. However, the same builders probably worked on both church and mosque. Thus, there is a marked similarity between the type of the tomb tower and the lantern towers of the churches. The arcading on the lanterns normally displays round-headed arches but at least one such lantern displays pointed arches, while at least two of the Moslem tombs at Akhlāt have round-headed arcades.

This summary description and listing of a few of the structures should be sufficient to prove the existence of a basic type in both Āzerbāijān and Asia Minor. On the other hand, an examination of the Seljūq and Mongol tomb towers in other regions of Iran indicates that this same type came into use at such sites as Qumm, Iṣfahān, and Naṭanz when some, but not all the features of the Āzerbāijān towers were taken over. The material should also establish the overall area relationship in the use of cut stone and of the crypt.

The element of the compositional feature of the pointed arch crowned by a horizontal panel and partially filled with a stalactite system remains for consideration. This decorative element was very popular throughout the extensive area north and west of Āzerbāijān. It appears in the entrance portals of two madrasas of the middle of the thirteenth century at Qonia, in a handsome example as the portal of the caravanserai at Sulṭān Khān, near Qonia, built in 1229 and restored in 1276, in the portal of the mosque of Hājji Kilij of 1275 at Kayseri, in the portal of the tomb tower of Saughar Agha of 1275 at Akhlāt and even in the portal of the church of the Apostles at Ānī—to name only a few characteristic examples. These examples all display the stalactite system within the pointed arch outline, most of them have the horizontal panel, but the knotting of the moulding at the peak of the arch is less frequently used. Contrasting kinds and colors of stones and interlocking voussoirs are also common, but these features are more common to Asia Minor proper than to the Lake Van region nearer to Āzerbāijān.

It is still too early to state whether the features common to the school of Āzerbāijān appeared earlier in Āzerbāijān proper or in Asia Minor. It is, however, readily apparent that the features already popular in Āzerbāijān during the Seljūq period were consistently executed in nearby Armenia and Georgia during the period of the first Mongol invasions and in the years which followed when little or no construction was carried out in Iran so that when architecture received great impetus under Ghāzān Khān the newly built structures displayed a close affinity with their predecessors of more than a century before.

Only the barest mention can be made of a secondary school related to Āzerbāijān. This brick fabric, plaster and terra cotta decorated, style was represented in the Seljūq period by the mosques at Qazvīn, the Ulu Jāmiʿ at Van, the tomb towers at Nakhichevan, one or two of the Marāgha towers. With the Mongol invasion these craftsmen may have moved

to the region of Mosul for it is in this general vicinity that structures of the thirteenth century, recorded by Sarre and Herzfeld, seem to carry on these same features.

THE SCHOOL OF YAZD

According to its historians, the town of Yazd enjoyed unusual prosperity during the fourteenth century. The entire southern region of Iran, including the major settlements of Yazd, Kirmān, Shīrāz and Iṣfahān, was the scene of almost uninterrupted conflict between rival princes of the Muẓaffarid line during most of the century. The control of Yazd changed hands on several occasions but the city was spared any destruction and the level of commercial and architectural activity was maintained.

A son of the founder of the Muẓaffarid dynasty, Mobārez ad-dīn Muḥammad ibn Muẓaffar, was on friendly terms with Sulṭān Öljeitü. In 1319 he took Yazd from the last of the important Atābeks of the region and was confirmed in its possession by Abū Saʿīd. In 1333 he visited the court of Abū Saʿīd where the ruler granted him a title and loaded him with gifts. After the death of Abū Saʿīd he lost the powerful support of the Il Khāns and, having aroused the enmity of his own sons, was blinded and died in 1365. These sons, Shāh Shujāʿ and Shāh Maḥmūd, were soon bitter rivals for local power. In 1362-1363 Maḥmūd took Yazd but it was quickly recovered by one of his nephews, Shāh Yaḥyā, who seems to have held the town until about 1387. However, time was running short for all such petty princes as a great conqueror, Tīmūr, was on the march. In 1388 he passed through Abarqūh and in 1390 issued an order which directed that all the princes of the Muẓaffarid line should be put to death.

Āyati, on pages 138 through 141 of his *Tārīkh-i-Yazd*, gives a considerable amount of information concerning construction in Yazd during the fourteenth century. Following older sources he states that some twelve mosques, one hundred madrasas and two hundred tomb shrines were erected during the century. He also lists some twenty structures with the name of the patron of each monument and frequently the date of construction. None of these buildings are assigned to Mobārez but one madrasa is said to have been built by order of Shāh Yaḥyā and another by the mother of the latter. There seems to be no reason for doubting that the monuments in the following list were actually erected and in the years given:

1. Masjid-i-Rīk (structure of this same name still stands)
2. Masjid-i-Sarāb-i-No
3. Madrasa Ziāʿiya
4. Bath adjacent to the Madrasa Ziāʿiya
5. Madrasa Ḥusayniyan
6. Madrasa Saʿdiya 762/1360-61
7. Madrasa Shahābiya 737/1336
8. Madrasa Khātūniya 787/1385
9. Madrasa Nasratiya 789/1387
10. Madrasa Ghiyasiya 767/1365-66
11. Madrasa Ishaqiya 740/1339 some remains exist

12.	Madrasa Qādriya	743/1342
13.	Madrasa Amīr Ākhūriya	759/1357-58
14.	Madrasa Żiā'iya	788/1386
15.	Madrasa Qatbiya	732/1331-32
16.	Madrasa Buvālmīri	787/1385
17.	Madrasa Asiliya	740/1339
18.	Madrasa 'Amādiya	787/1385
19.	Madrasa Bāvardiya	743/1342
20.	Madrasa Maḥmūdiya	

At least two structures bearing these same names still stand in Yazd but are said to have been so extensively remodeled that no trace of fourteenth century work remains. Other of these monuments may still be discovered in Yazd.

While the very number of structures built during this period does suggest the possibility of a local or regional style it is necessary to base any assumptions along these lines on the standing monuments of the period. There are three such structures at Yazd and three at Abarqūh. Abarqūh is situated about 250 kilometers west of Yazd on an east-west connecting route between the main Isfahān-Shīrāz highway and the important Isfahān-Yazd-Kirmān road. Abarqūh owed its importance to this location on a caravan route and during the thirteenth and fourteenth centuries was very prosperous. The distance to Yazd was far less than that to Iṣfahān, Shīrāz, or any other major town in south and central Iran, and Abarqūh certainly had close commercial and other relations with Yazd. With the insecurity of travel which began in the second half of the fourteenth century Abarqūh began a steady decline and today only a few houses nestle near the ruins of its monuments of the Seljūq and Il Khānid periods.

The actual monuments which enable us to postulate a school of Yazd are the tomb of Sayyid Rukn ad-dīn, the Madrasa Shamsiya, and the Masjid-i-Shāh Kemali—all three at Yazd—and the tomb of al-Ḥasan ibn Kay Khusraw, the Gunbad-i-Sayyidun, and the Gunbad-i-Sayyidun Gul-i-Surkhi—these three at Abarqūh. Full information regarding the Masjid-i-Shāh Kemali and the Gunbad-i-Sayyidun is not now available.

All these structures have a similar type of decorative treatment. All interior surfaces were covered with a thick coat of hard white plaster and upon this base elaborate designs were executed in appliqué plaster and in polychrome painted designs. A more detailed discussion of these techniques is given in the pages devoted to plaster decoration. There is every reason to believe that the mausoleum of Öljeitü was the first structure in which the possibilities of appliqué plaster work and painted linear designs were thoroughly exploited. The overwhelming importance of the mausoleum resulted in the immediate spread of the techniques employed to all parts of the country. We may believe that this decorative style reached Yazd either with craftsmen from Yazd who had been summoned, along with a host of others, to work at Sulṭāniya, or by craftsmen originating in other towns, who, after working at Sulṭāniya, were attracted to Yazd by reports of the general prosperity of the town and the amount of building activity going on there.

It is unnecessary to repeat the description, already given, of the character of the decoration of the three monuments most representative of this school: the tomb of al-Ḥasan ibn Kay Khusraw, the tomb of Sayyid Rukn ad-dīn and the Madrasa Shamsiya. Two assumptions with regard to this school should be made. First, that many of the structures known to have been erected in Yazd during the fourteenth century and which have since vanished bore this same type of decoration. If we ask why so many structures have so completely disappeared the answer may well be that both at Yazd and Abarqūh the use of a rapid and inexpensive, but impermanent, method of construction in mud brick was very popular at this period. Second, that this school had a rather short life, giving place to the new and striking fashion of mosaic faïence. Indeed, such mosaic faïence appears on the court façades of the Madrasa Shamsiya as well as at the Masjid-i-Jāmiʿ at Yazd where it is dated 777/1375. It should be noted, however, that polychrome painted plaster was not completely replaced by mosaic faïence. Painted plaster patterns continued in use on the interiors of such monuments of the fifteenth century as the Masjid-i-Gawhar Shad at Mashhad and the shrine of Zayn ad-dīn at Taiyabad.

CATALOGUE:

ARCHITECTURAL MONUMENTS

CATALOGUE

Material included: The catalogue contains over one hundred items and includes architectural monuments, architectural elements, and inscriptions. These items, of the thirteenth and fourteenth centuries A.D., are arranged in chronological order. Undated monuments have been placed in what appears to be their proper place within the series, except that a few, Nos. 116-119, not seen by the author and for which almost no material is at hand, are listed at the end of the catalogue.

Period covered: The period begins with the time of the initial Mongol invasion of Iran. The rule of the Mongol Il Khāns may be considered to end with the death of the last powerful figure of this line, Abū Sa'īd in A.D. 1335. However, since the incident of the death of this ruler was followed neither by a marked decline in building activity nor by changes in architectural style, the catalogue includes the structures of the rest of the fourteenth century, although those structures erected after 1335 are treated in a summary fashion.

Geographical area: Certain arbitrary limits have been set for the material to be included in the catalogue. Nearly all of the monuments included are to be found within the frontiers of present-day Iran. Of course, Iran was much larger in earlier centuries and during the Il Khānid period stretched far to the north and northeast of its present boundaries and to the west included Georgia, Armenia, and a portion of modern 'Irāq.

The limits set for the catalogue resulted from the fact that the field work upon which it is based was carried out in modern Iran. However, a few monuments have been included which are a short distance beyond the frontiers of Iran. The map (Figure 1) gives the location of all the architectural sites covered by the catalogue.

Recording of monuments: Items included in the catalogue were recorded between 1934 and the middle of 1946.

The identification numbers given for many of the structures come from a list of the National Monuments of Iran prepared by the Archaeological Service of Iran, a Department of the Ministry of Education. This department is responsible for the preservation of all important structures and sites and within recent years has repaired a number of the monuments listed in the catalogue. The Archaeological Service, headed for many years by André Godard, has been consistently helpful in providing all permits and proper facilities needed to carry on research work in Iran.

The monuments of the catalogue, with the exception of a few of the smaller structures were surveyed by theodolite and measured with steel tapes. Most of the plans are presented in outline form rather than with the use of poché or period indication. In a few cases where period indication is shown on the drawings, this indication is confined to construction immediately related to the time limits of the catalogue. The description of each structure is followed by statements indicating whether it has been studied in the field by the present author and whether a plan or other drawings of the structure have been previously

[97]

published. In a few cases the drawings are based upon published plans or are more detailed versions of earlier plans.

The recording and study of architectural inscriptions is a highly specialized subject. The catalogue does not pretend to include all the available epigraphical material. While working in the field all inscriptions were examined in an effort to determine if they contained historical information or dates of construction. If this was the case, copies of the inscription were made. No attempt was made to record or identify inscriptions composed of passages from the Qu'rān.

Source material: The presentation of each item is concluded with a list of references, arranged chronologically. Full titles and facts of publication for these are given in the Bibliography. While efforts have been made to make these lists as exhaustive as possible, there are bound to be many omissions. In many cases the impressive length of the reference lists may lead the reader to believe that detailed studies have been carried out at an earlier date. Actually, most of such references are to the accounts of early travelers which are of value in establishing the identification of monuments and in giving information about their condition in previous centuries, but which contain few of the precise facts required by the architectural historian. The lists include both European and Persian sources and for the latter material both contemporary sources and a considerable number of publications printed at Tehrān in recent years have been consulted.

Dates: Items in the catalogue are dated by both the Moslem and the Western calendars. Moslem dates, when they stand alone, are preceded by the abbreviation A.H. (after the Hejira). When both dates are written together, as 700/1300, the Moslem year precedes the Christian one.

Transliteration: Transliterations of Arabic and Persian words are based upon a system employed in publications in this field. Relatively few changes have been made, either in the direction of simplicity or to correspond to familiar nomenclature. Bibliographical titles retain their original transliterations.

General considerations: The catalogue has as its goal the listing of all surviving monuments erected in Iran within the specified dates. Some structures may have been overlooked and it is certain that new structures will be located through the efforts of the Archaeological Service and of expeditions or individuals. Certain areas appear to be of special interest in any search for unknown monuments of the Il Khānid period. These include the region to the south of the highway between Qazvīn and Tabrīz; the province of Khurāsān, both north of the highway between Dāmghān and Mashhad and north and northeast of the city of Mashhad; and, the region south and southeast of the town of Torbat-i-Haidari.

It now appears that the destruction of ancient monuments took place at a greatly accelerated rate during the last one hundred and fifty years throughout the entire Middle East. The comparative revival of these countries from low levels of prosperity caused a great demand for building materials and standing structures offered a ready source. Fortunately, all these countries now value and protect their ancient monuments. In the

case of Iran it may be estimated that out of every ten important structures erected more than three hundred years ago only about one still stands. This statement relates only to monuments built of stone or fired brick, for hundreds and thousands of mud brick structures have been beaten down by winter rains to vanish without a trace.

The monuments described in the catalogue are not all treated in the same amount of detail. The more important monuments are discussed in considerable detail following an outline developed by the Iranian Institute. Less important structures are covered by a summary statement as are a few other more interesting monuments for which detailed field notes are not available. All monuments later in date than 1335 are given a summary statement.

In addition to dated monuments and monuments assumed to date within the period under consideration, the catalogue includes architectural elements such as miḥrābs, tiles, and inscriptions, now disassociated from their parent structures.

The author does not believe that the monuments of the catalogue have been so carefully studied and recorded in such comprehensive detail that additional field work on many of these same structures is unnecessary. Elevations and sections of a number of the more important buildings remain to be done: the task would require considerable equipment and much time at each such site. Individual vaults deserve careful examination, dissection, and large-scale drawings, while profiles of arches and details of squinches and stalactites should also be executed at an adequate scale. However, this catalogue may be expected to establish the foundations upon which a definite treatment of one phase in the long history of Islamic architecture in Iran can be erected.

Illustrations: While it would have been most useful if all the catalogued monuments had been shown in illustration, with many of these illustrations reproduced from previous publications, such an approach would have made this publication too bulky. Therefore, certain important monuments, including comparatively well known structures at Iṣfahān and Kirmān, have not been illustrated.

CATALOGUE LIST

1

Nigār mosque and minaret
615/1218 ?

Summary: In his *Ten thousand miles in Persia*, Sykes wrote: "Nagar contains a ruin of considerable interest, which was at one time used as a mosque, but has now only the walls left. These show unmistakable signs of having been built at two periods, to the latter of which the burnt-brick *minar* must be assigned. Only some thirty feet of this are intact, and round it is a belt of blue Kufic lettering. The miḥrāb bore an inscription dated 615/1218 until quite recently."

In 1935 Eric Schroeder, engaged in carrying out an architectural reconnaissance in the Kirmān region, visited the site and recorded: "On the way back, the early thirteenth century mosque of Nigar mentioned by Sykes was recorded. . . ." In the *Survey* he gives brief mention of the minaret of the thirteenth century situated at one corner of the mosque and the minaret is illustrated.

No additional information is available.

Nigār is located some 56 kilometers just west of due south from Kirmān and may be reached from Kirmān by a direct, motorable road.

Recorded: Not visited.

BIBLIOGRAPHY

Sykes, *Ten thousand miles in Persia*, p. 425.
Schroeder, "Preliminary note on work in Persia and Afghanistan," p. 135.

Pope [Ed.], *A Survey of Persian Art*, p. 1027, fig. 364.

2

Zuzan mosque
616/1219

Summary: The walls, preserved up to the springing lines, of one great īvān and the even more ruined element of a second īvān indicate the length and character of a once extensive and magnificently decorated mosque. Around the ruins of the mosque are piles of debris from the vanished town of Zuzan, earlier one of the three main centers of the region.

André Godard, who visited the site in 1940 and translates its name as Zawzan, has published a plan, photographs of the interesting faïence and tile decoration, and a first description of the structure. Recording the surviving date of 616/1219, Godard notes that the plan type and decorative features of the mosque follow the model of twelfth century structures in Khurāsān province.

Zuzan is situated in a little known area which is bounded on the west by the main highway from Mashhad south to Zahidan, on the north by the track from Torbat-i-Haidari to Khargird and Ṭayābād and on the east by the frontier between Iran and Afghānistān.

Recorded: Not visited.

BIBLIOGRAPHY

Godard, "Khorāsān," pp. 113-125, figs. 94-106.

3

Kāshān miḥrāb from the Masjid-i-Maydān
623/1226

Summary: The town of Kāshān was taken and ravaged by the Mongol forces in A.D. 1224. This miḥrāb, originally in the Masjid-i-Maydān of Kāshān, is dated 623/1226. Did the normal life of the town and the activity of its workshops continue even after the sack by the Mongols or were immediate steps taken to repair damage suffered by important monuments?

The miḥrāb was seen in position in the mosque by Jane Dieulafoy in 1881. Subsequent to that date it turned up in Europe as part of the Preece Collection and later was acquired by the Staatliche Museen at Berlin.

E. Schroeder, who has studied and planned the Masjid-i-Maydān, states that the earliest inscription in the monument dates from the Tīmūrid period. The main fabric of the present structure probably dates from this same period, although a few heavy piers in the western corner of the structure may remain from the original building and from a time prior to, or contemporary with, the miḥrāb.

Recorded: Not visited.

BIBLIOGRAPHY

Dieulafoy, J., *La Perse*, pp. 204ff., fig. on p. 206.
Curzon, *Persia and the Persian Question*, II, p. 14.
Houtum-Schindler, *Eastern Persian Irak*, p. 111.
Sarre, *Denkmäler persische Baukunst*, p. 72.
The Collection formed by J. R. Preece, pls. 1, 2.
Stainton, "A Masterpiece from Old Persia," pp. 132-136.
Sarre, and Kuhnel, "Zwei persische Gebetnischen aus lüstrierten Fliesen," pp. 126-131.
Sarre, "Eine keramische Werkstatt," p. 63.
Schroeder, "Preliminary note," p. 130.
Survey, pp. 1162ff., 1570, 1676, pl. 704.

4

Shīrāz Imāmzāda Shāh Chirāgh
628-58/1230-59 ?

Summary: According to the list of national monuments of Iran, the Imāmzāda Shāh Chirāgh at Shīrāz is of the time of Atābek Abū Bakr Sa'd ibn Zangī (628-58/1230-59). A nineteenth century Persian book, the *Āthār-i-'Ajam*, does state that building work was undertaken at the tomb of Sayyid Amīr Aḥmad Shāh Chirāgh ibn Mūsā ibn Ja'far by a minister of this same Abū Bakr who was named Amīr Mograb ad-dīn. On the other hand, the fourteenth century *Shīrāz Nāma* does

not seem to include this tomb in its list of buildings constructed by the Amīr Mograb.

The present author has examined the monument in detail and found no traces of thirteenth century construction. The inner wall surface of the main tomb chamber are almost completely covered with later mirror work and the complex of rooms around the chamber is recent. The exterior walls are clad with nineteenth century glazed tiles and the bulbous dome is certainly later than 1500. Nor does the surrounding area yield any remains of a religious school which, according to the *Āthār-i-'Ajam*, was built next to the tomb in 750/1349.

Identification: Iranian National Monument No. 323.

Recorded: January 1935 and subsequent dates. Plan measured and drawn but not published.

BIBLIOGRAPHY

Shīrāzī, *Shīrāz Nāma*, pp. 59-60.
Forṣat Shīrāzī, *Āthār-i-'Ajam*, pp. 444-446, pl. 50.
Dieulafoy, J., *La Perse*, fig. on p. 447.
Wilber, "Preliminary report," pp. 86-87.
Survey, pl. 508D.

5

Shūshtar Imāmzāda 'Abd Allāh
629/1231
669/1270

Summary: According to the List of National Monuments of Iran, the Imāmzāda 'Abd Allāh at Shūshtar contains an inscription dated 629/1231. This inscription appears to be the earliest now known on an architectural monument in the years following the first Mongol invasion of Iran. A communication from André Godard states that the date is that of the construction of the dome chamber which houses the tomb of 'Abd Allāh. He adds that somewhat later a second dome chamber was built in front of the original one and that it may be approximately dated by a tomb bearing the date 669/1270 which exists in a section of the structure which joins the two dome chambers.

Shūshtar is a town of great antiquity, located in southwestern Iran on the eastern of two routes between Dizful and Ahwāz.

Identification: Iranian National Monument No. 364.

Recorded: Not visited.

Illustration: Pl. 1.

BIBLIOGRAPHY

Dieulafoy, J., *La Perse*, p. 686, fig. on p. 685.

6

Kirmān reference to an inscription
 640/1242

Summary: P. M. Sykes, who founded the British Consulate at Kirmān in 1895, was very much interested in the antiquities of the town. In his *Ten thousand miles in Persia*, he wrote: "Until 1896 when an earthquake completed its ruin, the Kuba Sabz or Green Dome was by far the most conspicuous building in Kirman. It was the tomb of the Kara Khitei dynasty and formed part of the college, known as the *Madrasa* of Turkabad. The *Kuba* was a curious cylindrical building, perhaps fifty feet high, with greenish-blue mosaic work outside, the plastered interior showing traces of rich gilding. An inscription on the wall was read for me as follows: 'The work of *Ustad* Khoja Shukr Ulla and *Ustad* Inaiat Ulla, son of *Ustad* Nizam-u-Din, architect of Isfahan.' The date was A.H. 640 (1242), which would be eight years after the death of Borak Hajib, the founder of the dynasty. At the same time I cannot vouch for the exact accuracy of my informant, and the tomb, which was partly destroyed by the *Vakil-ul-Mulk* in a search for treasure, is now a shapeless mound, thanks to the earthquake of 1896."

It is apparent from the photograph which he published that the structure had a double dome, the outer dome rising from a very high cylindrical drum and of slightly bulbous profile. Such a dome could not have been constructed prior to A.D. 1400. Schroeder, in writing in the *Survey*, says that at the present time only the lower walls of the tomb chamber remain, together with a lately reroofed portal, traditionally ascribed to a now vanished madrasa. This portal bears traces of mosaic faïence which is certainly not earlier than 1400.

Schroeder points out that the Ustad 'Ināyat Allāh ibn Ustad Niẓām ad-dīn, mentioned by Sykes, must have been the father of a Hājjī Beg ibn 'Ināyat Allāh ibn Niẓām ad-dīn, architect of Iṣfahān, who signed an undated miḥrāb in the Masjid-i-Jāmi' at Kirmān. According to Schroeder, this miḥrāb is related to restoration work carried out in the Masjid-i-Jāmi' about 967/1559. In a communication to the present author André Godard states that the date of the Gunbad-i-Sabz is 840/1436, in the reign of 'Abd Allāh ibn Ibrāhīm ibn Shāh Rukh.

In 1895 there may have been two inscriptions at the site, one giving the names of the artisans and the other, unrelated to it, bearing the date 640/1242, but it appears more probable that Sykes' informant read 640 instead of A.H. 849. Our primary concern is to determine whether remains of a structure erected in 640/1242 are in existence and, according to the testimony, of recent visitors, this is clearly not the case.

Recorded: Not visited.

BIBLIOGRAPHY

Sykes, *Ten thousand miles in Persia*, p. 194, fig. opp. p. 264.
Herzfeld, "Korasan," p. 171.
Sykes, *The Quest for Cathay*, p. 135.
Survey, pp. 1102, 1129, 1132, 1791, fig. 406 (after Sykes).
Répertoire chronologique, XI, p. 142, no. 4214.

7

Bākū (vicinity) khānaqāh and mausoleum
 of Pīr Ḥusayn
 641/1242
 682-84/1283-85

Summary: Seven kilometers south of Bākū, earlier known in Persia as Bādkūba, are the very badly damaged remains of a *khānaqāh* or dervish monastery. According to a communication from Vera Kratchkovskaya to the editors of the *Répertoire chronologique d'épigraphie arabe*, the structure was erected in 641/1242 in the reign of a local ruler named Warajam Afridhun Abul-Muzaffar Fariburz ibn Ghershathp ibn Farrukhzad. Other sources refer to this ruler as Shīrvān-shāh Farīborz III.

Dorn gives a drawing of the ensemble as it existed in 1860. The complex was partially enclosed by a breached stone wall which was originally of considerable height. The commemorative inscription was said to be upon a portal, surviving fairly intact, in this wall. Within the enclosure were the shattered walls of a tomb tower and the shaft of an octagonal minaret.

The tomb tower, known as the mausoleum of Pīr Ḥusayn, held a sarcophagus the sides of which were clad with luster star tiles and light blue cross tiles and having as a crowning element a frieze of luster tiles bearing an inscription in *naskhi* which included the date 684/1285. By 1913 the tiles had been completely removed and widely dispersed. Recently Vera Kratchkovskaya has been able to identify a number of these tiles in the collections of the Hermitage Museum and other museums and to prepare a drawing showing the original arrangement of star, cross, and inscription tiles. The luster tiles which are now in the Hermitage bear the dates 682/1283, 683/1284, and 684/1285.

Recorded: Not visited.

BIBLIOGRAPHY

Dorn, *Atlas zu Bemerkungen*, pl. 50.
Khanikoff, de, "Mémoire sur les inscriptions musulmanes du Caucase," pp. 67-68 and 145.

Kratchkovskaya, "Les faïences du mausolée de Pir-Houssayn," pp. 109-113, pls. XLIX-LII.

———, *The Tiles of the Mausoleum from the Khanakeh Pu Husain.*

Répertoire chronologique, XI, p. 154, no. 4231; XIII, p. 3, no. 4803 bis.; pp. 20-21, no. 4830; p. 45, no. 4865.

Bahrami, "Recherches sur les carreaux," p. 32.

Survey, p. 1681.

8

Dārāb Masjid-i-Sang
652/1254

Summary: This monument is variously known as the Masjid-i-Sang and the Qasr-i-Dukhtar. It is situated in an out-of-the-way region some 280 kilometers east of Shīrāz.

At the close of the last century a Persian, resident in Shīrāz, published an interesting account of the monument and recently Sir Aurel Stein has printed a short description and a plan of the hall.

The hall is cruciform in plan with flanking aisles. At the crossing is a flat roof of stone pierced by a large light shaft. The hall is hewn entirely in the rock and the only decorative elements are traces of three inscriptions, also cut into the rock surface. One, over the entrance, is now badly damaged, but in the drawing by Forṣat Shīrāzī it seemed to include the title of Sulṭān Abū Bakr. The second is within the hall to the left of the entrance and gives merely the date 652/1254. Both inscriptions bear out the statement of the *Āthār-i-ʿAjam* that Atābek Abū Bakr caused a miḥrāb to be placed in the hall and adorned it with inscriptions. The third surrounds the miḥrāb and is now illegible.

Structures hollowed into the rocky hills are numerous in this general region. Many are of remote antiquity and some of them were certainly altered and diverted to new functions in later periods. This particular monument may have been either a fire temple or a Christian church: the problem is not one for present discussion.

While the monument has no direct relationship with the series of Mongol structures erected in Iran, it is of specific interest. Contemporary historians recorded that building activity continued in the province of Fārs in the years immediately following the Mongol invasions when much of Iran lay in ruins and the crafts were dormant. The Salghurīd ruler, Atābek Abū Bakr, is credited with initiating considerable construction work both at Shīrāz and in its vicinity. The very large Masjid-i-Naw at Shīrāz was built in this period, but there modern repairs cover all the surfaces of the mosque.

Identification: Iranian National Monument No. 229.

Recorded: Not visited. Plan after A. Stein and Forsat Shīrāzī.

Illustrations: Pl. 2; Fig. 4.

BIBLIOGRAPHY

Shīrāz Nāma, p. 53.

Ouseley, *Travels in various countries*, II, pp. 138-139.

Hājjī Mirzā Ḥasan Shīrāzī, *Fārsnāma-i-Nāṣiri*, pp. 199-201.

Āthār-i-ʿAjam, pp. 97-99, pl. 9.

Curzon, *Persia and the Persian Question*, II, p. 111.

Stein, "An Archaeological Tour," *Iraq*, pp. 196-199, plan 15.

———, "An Archaeological Tour," *Geographical Journal*, p. 496, fig. 11.

Villard, de, "The Fire temples," p. 183.

Répertoire chronologique, XI, p. 258, no. 4393.

9

Marāgha astronomical observatory
c. 656/1258

Summary: After the return of Hūlāgū from Baghdād to Iran in 656/1258, he settled at Marāgha and soon ordered an observatory built there from plans prepared by Naṣīr ad-dīn of Ṭūs. Apparently work was begun in the following year.

Vaṣṣāf al-Ḥaẓra, writing at the end of the thirteenth century, gives detailed information about the personnel of the observatory, the instruments used, and the series of observations made at the observatory. He states that the structure had a dome, and it is known that one wing of the building housed a library. Ghāzān Khān visited the observatory during his reign and ordered the erection of a new dome. Öljeitü also visited the site, but in 1340 when Ḥamd-Allāh Mustawfī composed his *Nuzhat al-Qulūb* the building had fallen into ruins. Additional information about the observatory is given in the present text, pages 10 and 17.

A sketch plan of the ruins was published by Houtum-Schindler in 1883. The fragments of crumbling walls which remain are of no architectural significance, but they do bear witness to the revival of building activity begun under Hūlāgū.

Recorded: October 1936. Plan after Houtum-Schindler.

Illustration: Fig. 5.

BIBLIOGRAPHY

Malcom, *The History of Persia*, I, p. 425.

Porter, Ker, *Travels*, II, p. 494.

d'Ohsson, *Histoire des Mongols*, III, pp. 263-267.

Quatremere, *Histoire des Mongols*, pp. 325-327.

Fraser, *Historical Account of Persia*, pp. 50-51.

Hammer-Purgstall, von, *Geschichte der Ilchane*, I, pp. 161, 228, 250; II, pp. 98, 184.

Houtum-Schindler, "Reisen im nordwestlichen Persien," p. 338, pl. 8.

Hammer-Purgstall, von (Trans.), "Abd Allah ibn Fadl Allah," pp. 96-97.

Howorth, *History of the Mongols*, III, pp. 138, 451, 536.

Le Strange (Trans. and Ed.), *The geographical part of the Nuzhat-al-Qulūb*, p. 88.

Minorsky, "Marāgha" in the *Encyclopedia of Islam*.

Godard, "Les monuments de Māragha," pp. 19-22, figs. 11-12.

10

Shāhī island ruins at Serāi rock
c. /1265?

Summary: When Hūlāgū returned to Iran and to the region of Marāgha after the capture and sack of Baghdād he ordered a Persian, Majd ad-dīn Tabrīzī, to construct a strong fortress on the shores of a very large lake in Āzerbāijān which has borne a number of names, including Urmiya and, currently, Riẓā'iya. Booty was to be stored here after the precious metals had been melted down to bar form.

In A.D. 1265 when Hūlāgū died in a camp along the Chogatu River, his body was taken to the site of his treasure house for burial. His successor, Abāqā, received word near the end of his reign that the treasury had collapsed into the lake, but the damage must have been repaired for both Abāqā and his brother Mangu were also buried at the same place.

The problem of the location of the treasure house and the tomb of Hūlāgū is a fascinating one which has been the subject of much speculation both by the editors of manuscripts contemporary with the period and by the authors of histories of the Il Khānid times. Most of the contemporary sources indicate that the treasury was erected on an island in the great salt lake, although one source placed it on Mount Sahend which rises between Tabrīz and Marāgha. An added difficulty is that the lake was then known by several names with one, twice mentioned in connection with the treasury, being Tilā. However, the texts generally are in agreement in localizing the site at Shāhū or Shāhī Island in this lake. The largest of the islands in Lake Riẓā'iya is still called Shāhī and its high peaks are visible from Tabrīz and from the plain before Marāgha.

Documentary sources do not make it entirely clear whether the treasure house and the tomb were separate structures or a single one, but it seems probable that the treasury was pressed into service as a tomb after the death of Hūlāgū. It does seem certain that the treasury was in the form of a tower and that it was stocked primarily with coin, ingots, and jewelry rather than with the great mass of booty of all types collected in the course of the Mongol campaigns. A garrison of one thousand men is said to have been stationed at the site.

Description: In 1937 the aerial survey of ancient sites of Iran carried out by the Mary Helen Warden Schmidt Foundation of the Oriental Institute took in this general section of Āzerbāijān. Two fine photographs were made of a rocky crag at the northeast corner of Shāhī Island and traces of cuttings and a wall were visible in the pictures. Copies were kindly furnished the present author who visited the site in July 1939.

Within recent centuries the waters of the lake have receded to such a point that during the summer months it is possible to walk directly from the mainland to the island, although one river and numerous swampy areas must be crossed. Arrival at the island was exactly at the base of the conspicuous rock of the aerial photographs, adjacent to which is the small village of Serāi. Before investigating it in detail an attempt was made to locate other sites of possible interest on the island. A trip was made up and over the rocky spine of the island to the western shore and the village of Sefīd Gunbad. No ruins were found there, but local people spoke at length of a lofty peak near the western shore whose summit was most difficult of access. Several accounts agreed that near the summit were two rock-cut chambers, two deep pits or wells lined with white plaster, a spring, and a small pool, but that there were no traces of any built walls.

The rock of Serāi rises abruptly from the shore line. Its summit is inaccessible except from the northeast and this side as well could have been easily defended. On this same side, steps cut into the rock lead up to a broad, steeply pitched surface which bears traces of several rock cuttings. There are three trenches dug side by side near the summit of the rock which have a total width of 13.60 m. and a length of 4.60 m. Below them is a smoothed-off surface and still further below, two rectangular cuttings which line up with one side of the trenches referred to above and are at right angles to them. To the west of the trenches are two additional rectangular cuttings (the larger 6.90 m. long by 1.75 m. wide) placed at irregular angles and filled with water to within one meter of the rock surface. Certainly they were

cut as catch basins to store water. In this general area is a considerable amount of earth debris and rubbish upon the rock surface. Still lower down the rock are more cuttings and one hole of unmeasurable depth, all probably to collect water. Near the cliff edge are cuttings which run roughly parallel to its face.

What information is to be derived from these cuttings? First, that while they offer no information regarding their age they all appear to be of the same period. Second, that the crag must have been garrisoned and equipped to stand a possible siege since the storage of water was so carefully planned. We may go even further and hazard a guess as to the treatment of the rock itself. The rock-cut steps may have led up to an entrance portal in a wall which ran along the edge of the face of the cliff. The cuttings nearest the summit are different in character from the others on the rock and the three adjoining trenches appear to establish a level platform upon which a super-structure could be built. Was there ever such a superstructure? Certainly not of brick, for there are no traces of mortar adhering to the rock surface. Could it have been of dressed stone? No cut blocks remain in this area or on the lower slopes. However, if such a structure had collapsed in course of time the stones would have rolled far down the slope and been available for reuse in later building—possibly in the nearby village. If there was such a structure its size was no greater than 14 m. by 25 m. The existence of a considerable amount of debris clearly suggests some type of occupational living and pottery sherds were found, but all were of the coarse ware which is common to many centuries.

Below the cliff and on the water side are the lower courses of three walls which formed a fortified enclosure extending out from the rock. Nowhere are these walls higher than 3 m. and they are of rubble masonry set up without mortar. The work was poorly done and it appears likely that the wall is of later date than the cuttings on the rock itself.

Conclusion: No ruins were located on the island of Shāhī which could be identified with the treasury and tomb of Hūlāgū. Further exploration of the island, particularly of a peak near the western shore, should be carried out. Cuttings on the face of the rocky crag at Serāi are suggestive of planned work of some scale, but it is pure speculation to associate these cuttings with the time of Hūlāgū.

Recorded: July 1939. Plan not previously published.

Illustrations: Pls. 3, 4; Fig. 7.

BIBLIOGRAPHY

(Includes references to both the treasure house of Hūlāgū and the island of Shāhī.)

Porter, Ker, *Travels*, I, p. 182; II, pp. 592-593.

d'Ohsson, *Histoire des Mongols*, III, p. 406.

Quatremere, *Histoire des Mongols*, pp. 316-321.

Hammer-Purgstall, von, *Geschichte der Ilchane*, I, p. 160.

Howorth, *History of the Mongols*, pp. 136, 209.

Gunther, "Contributions to the Geography of Lake Urmi," p. 516.

Schmidt, *Flights over ancient cities of Iran*, pp. 67-68, 76, pls. 79-82.

11

Varāmīn Imāmzāda Yaḥyā

660-62/1261-63
663/1265
705/1305
707/1307

Summary: The structure known as the Imāmzāda Yaḥyā is but one of several monuments of the Mongol period still standing at Varāmīn.

The Imāmzāda consists of a square-domed chamber whose walls are enclosed within a regular series of low rooms of late date. However, until fairly recent years much more of an imposing shrine complex was visible. Jane Dieulafoy visited the site in 1881, and by using a perspective sketch given in her publication an attempt has been made to suggest the ground plan of the shrine area at that time (Fig. 7). She believed that an octagonal tomb tower, now destroyed, was pre-Seljūq and stated that it had brick bonding patterns but no faïence ornament. She wrote that the mosque (represented in the sketch plan by the arcades along the narrow court) was of the Seljūq period and she assigned the larger structure (the imāmzāda) to Mongol times. When Sarre visited the monument—prior to 1910—the entrance portal seen by Dieulafoy had fallen. Apparently Sarre was not allowed to enter the shrine, but he stated that the octagonal tower had flat niches on the interior and a plaster miḥrāb which was painted blue. He also stated that the square chamber (imāmzāda) was the source of luster faïence dated about A.D. 1262. Today, portal, arcades, and octagonal tower have vanished.

Dieulafoy wrote of the luster faïence decoration of the miḥrāb, dado area, and tomb and stated that parts of it had already been removed and sold. It was her belief that this faïence was added some time after the building was first erected and that part of the earlier decoration had been destroyed to make a place for it.

The structure is square on the exterior and

octagonal on the interior, with deep corner angle niches. The miḥrāb wall is filled with a late blocking of brick. The dado around the room has been stripped bare of its original decoration to its total height from the floor of about 1.85 m. Below the zone of transition is a plaster inscription frieze and at the squinch level are fine carved plaster panels, while the squinch faces are filled with carved plaster stalactites.

Four dates have been associated with the chamber and its supposed decoration. Bazl read the date 707/1307 in the continuous plaster frieze mentioned above. A luster faïence miḥrāb which is believed to have come from this shrine is dated 663/1265. A large number of star tiles, now in various collections, are dated about 1261 to 1263. A tombstone of luster faïence in the form of a miḥrāb, thought to be from this structure, is dated 705/1305. From this varied material it seems possible to draw probable conclusions regarding the structure and its ornamentation.

The fabric of the structure itself appears to belong to the Mongol period. The size of the bricks (.22 m. square); the use of the deep corner niches; the division of the dado area into separate bands; the type of brick-end plugs found on the upper exterior walls and the series of set-backs on the exterior of the dome are features which are more consistent with Mongol work than with the earlier Seljūq period.

As regards the many star tiles which have been associated with the monument, it is certain that Dieulafoy saw them in place in the dado area and that some had already disappeared. The earliest purchasers would probably have been told the source of the pieces and the identification of a large number of them as coming from the same structure is established by a correspondence of style, size, type of inscription and, in the dated pieces, of date. Thus, we can believe that the dado of the structure was covered with a revetment of alternating star tiles and light blue faïence cross tiles. Just above the main vertical surface of the dado is another which forms a slightly recessed continuous horizontal band some .45 m. high and it is probable that this band had either an inscription of elements of luster faïence or a carved plaster inscription.

A luster faïence miḥrāb was seen in place by Dieulafoy. The present owner of the miḥrāb has stated that it was taken to Paris by the wealthy owner of the village and sold there. Sarre, in the first scholarly mention of this miḥrāb, assigned it to the Imāmzāda Yaḥyā. The width of the miḥrāb, 2.28 m., is less than the width of a blocked up area about 2.60 m. wide in the miḥrāb wall of the structure from which a miḥrāb of some type was most certainly removed.

In order to discuss the details of the miḥrāb it is necessary to describe its compositional features. A central depressed panel, trefoil arched, with a hanging lamp against foliation and with a cursive inscription surround is placed above a horizontal inscription panel. This element is framed by a gabled panel supported by pilasters in high relief, with a cursive inscription on the gable and arabesque interlaces on the head of the arch and in the spandrels, the panel bordered on either side by a cursive inscription band. This gabled panel is set into a similar larger gabled panel which has an inscription band on the gable and interlaces in the head and spandrels of the arch; the panel is enclosed by a rectangular frame of cavetto profile bearing a cursive inscription and edged by a stylized floral border.

First, the cursive inscription band which now borders both sides of the smaller gabled panel probably originally ran across the top of the panel as well. Second, several sections of the outer rectangular frame are now in the Hermitage Museum and at least one other collection. Third, the present composition of the central panel within the smaller gabled panel is open to question. The two sections which contain the hanging lamp and the crowning motif are of the type of the tombstone miḥrāb which was sometimes used as a separate and complete unit of luster faïence as in a fine example from Qumm, dated A.D. 1264 and now in the Berlin Museum. It would be more usual to find a tri-lobed arched panel in this area, such as appears in the very similar luster faïence miḥrāb from the Masjid-i-Maydān at Kāshān, dated 623/1226, which is also in the Berlin Museum. Thus, the possibility is present that the two pieces of a tombstone miḥrāb and the horizontal panel below them were inserted in recent times to fill in a damaged or missing section of the miḥrāb. Since the date of the miḥrāb is to be found in this section, this possibility brings the dating of the miḥrāb as a whole into question. However, the three pieces under discussion do fit the space very well and if the miḥrāb is not of 663/1265 it is certainly no later than 707/1307.

Dieulafoy stated that there was luster faïence on a tomb within the structure. The tombstone in the form of a miḥrāb with a double niche, dated 705/1305 and now in the Hermitage Museum, bears the statement that it was made for the burial place of the Imām Yaḥyā. It also contains the signatures of two members of the most famous family of Kāshān potters—another member of this family signed the lowest section of the central panel of the miḥrāb previously discussed.

Thus, it appears reasonable to suppose that the Imāmzāda Yaḥyā was decorated with star

and cross tiles soon after its erection at the middle of the thirteenth century and then, nearly a half century later, the ornament was completed by the fine carved plaster of the upper walls and by the tombstone miḥrāb applied to the then extant sarcophagus. The large luster faïence miḥrāb may have been installed at either the first or second period of decoration.

Identification: Iranian National Monument No. 199.

Recorded: May 1939. Plan not previously published.

Illustrations: Pls. 5, 6; Figs. 6, 9.

BIBLIOGRAPHY

The monument

Dieulafoy, J., *La Perse*, pp. 148-149, fig. on p. 147.
Sarre, *Denkmäler*, p. 59, fig. 65.
Pope, "The Photographic Survey," p. 25.

Star tiles

Kühnel, "Dated Persian Lustred Pottery," pp. 227-231.
Bahrami, *Recherches sur les carreaux*, pp. 88ff.
Survey, p. 1678.

Luster miḥrāb of 663/1265

Sarre, and Kühnel, "Zwei persische Gebetnischen," pp. 126-131, fig. 3.
Kratchkovskaya, "Fragments du Miḥrāb du Vārāmin," pp. 134-135.
Catalogue of the International Exhibition of Persian Art, London, 1931, p. 203.
Ackerman, *Guide to the Exhibition of Persian Art*, p. 78.
Kühnel, "Dated Persian lustred Pottery," p. 234, fig. 14.
Survey, p. 1679, pl. 400.

Tombstone in the form of a miḥrāb of 705/1305

Kratchkovskaya, "The lustre miḥrāb from the Hermitage Museum," pp. 73-86, pl. 1.
Kühnel, "Dated Persian lustred Pottery," p. 235.
Survey, p. 1683.
Sarre, "Eine keramische Werkstatt," p. 68, pl. IV.

12

Qumm miḥrāb
663/1264

Summary: The Berlin Museum possessed the central part of a luster miḥrāb dated 663/1264 which was originally installed in a structure at Qumm.

BIBLIOGRAPHY

Kühnel, "Dated Persian lustred Pottery," fig. 13.
Survey, p. 1678.

Sarre, "Eine keramische Werkstatt," pl. II.
Godard, "Pièces datées de céramique," p. 315.

13

Dāmghān luster-painted tiles
665/1266-67

Summary: In 1883 a prominent Persian, Sanīʿ ad-dawlaʿ, then Minister of Publications, noticed a number of luster-painted star and cross tiles set into the wall surface of the sanctuary īvān of the Imāmzāda Jaʿfar at Dāmghān. He described these tiles in his *Maṭlaʿ ash-Shams* and shortly thereafter the tiles were surreptitiously removed. A number of them later reappeared in the Louvre Museum, the Berlin Museum, and in private collections.

Specific tiles of this identifiable group are dated 665/1266-67. Sarre, following the *Maṭlaʿ ash-Shams*, showed that the tiles actually came from a ruined palace in the vicinity of the Imāmzāda Jaʿfar and were merely reused in the tomb shrine, a locale quite improper for the profane subject matter of their decoration.

This present mention of the tiles is merely to underline the fact that Imāmzāda Jaʿfar itself is not of the historical period under consideration. The tomb shrine complex includes a structure of the earlier Seljūq period and an annex of the fifteenth century A.D.

Identification: The Imāmzāda Jaʿfar is Iranian National Monument No. 82.

BIBLIOGRAPHY

Sanīʿ ad-dawlaʿ Muḥammad Ḥasan Khān, *Maṭlaʿ ash-Shams*, III, p. 273.
Sarre, *Denkmäler*, pp. 67-68, fig. 78.
Kühnel, "Datierte perische Faÿencen," fig. 4.
———, "Dated Persian lustred Pottery," p. 228, fig. 9.
Bahrami, "La reconstruction des carreaux de Damghan," pp. 18-20, pls. XIII-XV.
———, "Le problème des ateliers d'etoiles," pp. 186-190, pls. LX-LXIII.
Pope, "New Findings in Persian Ceramics of the Islamic Period," p. 156.
Survey, pp. 1573 and 1679, pl. 721.
Yaghmāni, *Joghrāfāyī tārīkhī Dāmghān*, pp. 51-52.

14

Kāshān Imāmzāda Habib ibn Mūsā
668/1269-70
670/1271-72

Summary: The Imāmzāda Habib ibn Mūsā at Kāshān may have been erected in the second half of the thirteenth century A.D.

The tomb chamber contains the sarcophagus

of the saint which is overlaid with groups of luster-painted hexagonal and star tiles separated by light blue glazed double-pentagon tiles. A small faïence luster miḥrāb dated 668/1269-70 in numerals and 670/1271-72 in letters which once decorated the tomb chamber is now on display in the Tehrān Museum. Probably the luster tiles originally formed the decorative dado of the chamber. The stylistic features of the tiles and the possibility that tiles and miḥrāb were installed at the same time suggests a date of about A.D. 1270 for the tiles.

An historical account states that the great Ṣafavid ruler of Iran, Shāh ‘Abbās, who died in A.D. 1628 was buried in the shrine of Habib ibn Mūsā and his sarcophagus of black stone remains in place. Thus, the fabric of the shrine is certainly several hundred years old and although a description of the structure is not available, it may well be contemporary with the miḥrāb and the tiles.

Recorded: Not visited.

Illustration: Pl. 7.

BIBLIOGRAPHY

Godard, "The Tomb of Shah ‘Abbas," p. 217 and unnumbered figure.
Pope, "New Findings in Persian Ceramics," pp. 155-156, fig. 7.
Godard, "Pièces datées . . . de Kāshān," p. 315 and fig. 138.

15

Takht-i-Sulaymān vaulted hall
c. /1275

Summary: At the time of the Mongol Il Khāns, the site which is called Takht-i-Sulaymān at present was known as the town of Saturiq. Writing in the early fourteenth century, Ḥamd-Allāh Mustawfī says: "In the district of Anjarud is a town which the Mughals call Saturiq. It is situated on top of a mound, and was built by Kay Khusraw, the Kayanian. In the town is a great palace in the court of which is a spring in the form of a large pool, or rather, a small lake. . . . Abaqai Khan, the Mughal, repaired the palace . . ." The palace which was repaired by Abāqā Khān (A.D. 1265-1281) certainly included a great vaulted hall which today is a crumbling ruin. The vault fell long ago and the rear wall of the structure is missing. Nevertheless, it is possible to distinguish two main building periods, the first of Seljūq times, when the site was called Shiz, or perhaps even earlier. The second period consisted in an extensive rebuilding of the structure: rubble walls upon the earlier walls of brick, a new vault, refacing of the piers, two stories of niches in the pier faces, and a continuous inscription band. No single one of the decorative

details of this rebuilding is precisely datable, but taken together the following features are all consistent with a date of c. A.D. 1275: the deeply cut letters of the inscription band and its foliated ground, the stalactite heads of the lower niches, the small triangular pieces of light blue faïence which were originally set into the plaster coating of the niches, the thin strip mouldings in plaster and the general attenuation of proportions.

The vaulted hall may have been the throne room of a palace. It was certainly a unit in a series of structures which surrounded the central pool and the type of plaster decoration on one of the others of these structures suggests that it may also have been repaired in the same period.

Description: The lower courses of both side walls to a height of 2.30 m. above ground level are of roughly dressed masonry. Above this base the walls are of hard-fired red bricks (.28 m. by .07 m.) to an irregular height—from 5 m. to 8 m. above ground level. At 5 m. above the ground is a stucco inscription band, .70 m. high, which must have continued around the three walls of the structure. Only about 2 m. of the inscription is preserved on the south wall, just back of the south pier face. Above the brick construction is rubble masonry rising to a height of 14.20 m. on the side walls and 18 m. on the north pier. The springing line of the transverse arch between the two piers is 6 m. from the ground while the springing line of the vault was considerably higher. Both piers were repaired in rubble masonry from a point just above the stone base.

Wall surfaces were coated, in the second building period, with a .07 m. thick glazed white plaster coating and in certain areas a pattern of incised lines in the plaster simulated brick bonding.

Identification: Iranian National Monument No. 308.

Recorded: October 1937.

Illustrations: Pls. 8, 10; Fig. 8.

BIBLIOGRAPHY

For a complete listing of all documentary and descriptive material see: "Preliminary Report on Takht-i-Sulayman," pp. 71-109.

16

Riẓā‘iya miḥrāb of the Masjid-i-Jāmi‘
676/1277

Summary: The Masjid-i-Jāmi‘ of Riẓā‘iya consists of a square dome chamber flanked on two opposite sides by vaulted prayer halls.

The south wall of the chamber is dominated by a large-scale stucco miḥrāb dated 676/1277. Through gaps in the pierced patterns of the stucco, small portions of a still earlier stucco

mihrāb can be seen and this first mihrāb blocks two windows corresponding to similar pairs in the other walls of the chamber. The first mihrāb and the chamber itself must antedate A.D. 1277 and are probably of the Seljūq period, at which time the mosque was composed of the isolated square chamber with entrances on three sides. This Seljūq open-kiosk plan was used with certain regional variations: this chamber relates to the massive type of the northwest displayed in the structures at Qazvīn rather than to the architecturally articulated buildings of the Iṣfahān region.

The dated plaster mihrāb is the earliest surviving example of the feature to be erected in the years following the Mongol invasions. Probably the fabric of the chamber and the old mihrāb were in need of repair and the installation of a new mihrāb represented a way of renovating the structure at a time when craftsmen and funds were scarce. The mihrāb is signed by a workman from Tabrīz. Below the zone of transition is an encircling inscription band in stucco, nearly one meter high, which appears to be contemporary with the mihrāb.

The technical skill displayed in the mihrāb is of the first order. The patterns are more intricate than in Seljūq examples while details become very small in scale as motifs of great richness are used to elaborate the basic patterns.

Location: On the outskirts of Riżā'iya, a town located inland from the western shore of Lake Riżā'iya.

Condition: Excellent.

Plan-type: Mosque composed of a dome chamber and flanking prayer halls: originally an open-kiosk plan with entrances on three sides.

Description of mihrāb: The mihrāb wall face displays in its center a trefoil arch, deeply recessed panel flanked by half-round angle columns with elaborate fluted bipartite capitals, supporting a pointed arch recess panel of slightly horseshoe profile, surmounted by a cove; this unit is enclosed within a series of rectangular, concave, and diagonal mouldings and is surmounted by a high cove. The entire mihrāb consists of carved stucco ornament in various levels of relief. (The horseshoe arched panel of the mihrāb displays, behind its pierced work, an earlier, elaborately carved stucco mihrāb.) A few centimeters above the mihrāb cove a wide stucco inscription frieze, with the top slightly coved, encircles the chamber. Above the trefoil arch is the inscription, "the work of 'Abd al-Mu'min, son of Sharafshāh, the painter of Tabrīz. In the month of Rabī' II, of the year six hundred and seventy-six."

Identification: Iranian National Monument No. 243.

Recorded: July 1939. Plan drawn by Peter B. Baggs.

Illustration: Pl. 9.

BIBLIOGRAPHY

Wilson, J. C. "The Masjid-i-Jami' of Riza'iya," pp. 38-42, figs. 1-5.
Survey, pp. 1048-1049, fig. 377.
Répertoire chronologique, p. 237, no. 4755.

17

Sāva Imāmzāda Sayyid Isḥāq
676/1277-78

Summary: This structure, known as the Imāmzāda Sayyid Isḥāq, is located a few hundred meters east of the important Masjid-i-Jāmi' at Sāva. Sāva is reached by following the main road from Tehran toward Qumm and at 130 kilometers from Tehran turning west and continuing for some 45 kilometers.

Ḥamd-Allāh Mustawfī, writing in the fourteenth century, says that the tomb of Isḥāq, son of Imām Mūsā-al-Kāzim, lies to the north outside of Sāva.

The structure is quite small in scale and has suffered so considerably during successive rebuildings that it is not possible to state definitely when it was originally erected. Within the tomb chamber is a raised grave slab now covered by the light blue faïence plaques of an inscription frieze which contains part of Sura XLVIII and the phrase "written in the year 676 (A.D. 1277-1278)." Obviously the plaques were originally inset in the wall of a structure (this same one?) either above a dado or below the springing line of the vault and later they were reused and fitted upon the grave. One indication that the structure may be of the same period is the presence on the exterior walls of a zone of decoration. Areas of white plaster, unglazed tile and light blue glazed tile form a geometric pattern of an unusual and sophisticated type.

Identification: Iranian National Monument No. 279.

Recorded: May 1939.

Illustration: Pl. 11.

BIBLIOGRAPHY

Le Strange, *Nuzhat-al-Qulūb*, p. 68.
Herzfeld, "Die Gumbadh-i 'Alawiyyân," p. 197.

18

Qumm Imāmzāda Ja'far
677/1278-79

Summary: The Imāmzāda Ja'far is located to the west of the town and at a considerable distance

from most of the other structures of this general period and type.

The museum at Qumm displays sections of an inscription band and other tiles from an Imāmzāda Ja'far. The sections of the inscription are of moulded terra cotta thickly coated with light blue glaze and each piece contains several letters in relief. One piece includes the date 677/1268-69 and according to the *Rāhnāma-yi-Qumm* they come from this same structure.

The tomb tower is smaller in size and with simpler architectural details than the tombs to the east of the town. The construction work was rather carelessly done and many reused bricks were employed. The polyhedral tent dome has eight sides which begin abruptly at the top of the exterior wall panels. There is no cornice or exposed zone of transition on the exterior.

The structure is of Type I of the tombs at Qumm (see p. 115).

It is possible that the miḥrāb dated 663/1264, No. 12 in this catalogue, was removed from this tomb.

Location: About one kilometer west of the center of the town of Qumm.

Condition: Good. Either the interior decoration was never completed or both the plaster ornamentation common to the period and the miḥrāb have been destroyed during the course of time.

Plan-type: Tomb tower. Octagonal on the exterior, square on the interior. Polyhedral tent dome on the exterior, lower hemispherical dome on the interior.

Exterior: No visible foundations. Each exterior side displays a recessed rectangular wall panel within which is an offset, broken-headed arch. The tent dome rises directly from the top of the wall panels. All exterior surfaces are laid in common bond. There is a rectangular window in the roof, directly above the entrance door.

Interior: The interior wall surfaces display three centrally located pointed arch entrance portals (two now blocked) and a recessed rectangular miḥrāb niche. The area of the miḥrāb niche is now coated with white plaster. All interior wall surfaces are coated with white plaster to about 2 m. above ground level. Above the heads of the eight pointed arches which bring the plan of the chamber to an octagon is a slightly recessed horizontal panel which may once have contained an encircling inscription frieze (i.e. the tiles of the Qumm Museum). Above this level are sixteen wall arches and then the base of the dome, the surface of which displays a star pattern in ornamental bonding.

Structural features: The monument is a simplified version of the (later?) tomb tower of Imāmzāda Ja'far at Iṣfahān.

Date control: 1. The structure is probably to be identified with the Imāmzāda Ja'far of A.D. 1268-1269 and with the series of tiles in the Qumm Museum.

Ornamentation: Bricks: red buff, standard (.23 m. by .04).

Bond: common.

Joints: irregular. In some areas the joints are slightly raked, in others the joint lines are painted white.

Recorded: April 1944. Plan not previously published.

Illustrations: Pl. 12; Fig. 10.

BIBLIOGRAPHY

Rāhnāma-yi-Qumm, p. 131 and unpaged illustration.

Farhang-i-joghrāfīya-yi-Īrān, p. 170.

THE TOMBS OF QUMM

The Imāmzāda Ja'far of 1268-69 is the earliest in date of a number of tombs at Qumm which are included in this catalogue. These monuments have never been systematically listed and studied, and published reference to some of the structures contain errors of name and date of construction. The list which follows represents an effort to bring together all available material on the tombs while the sketch map (Fig. 2) shows the relative situation of those of the tombs which are described in the present catalogue. It is very likely that additional field work will reveal errors in this list and such field work would probably assign dates to some of the now undated structures and would probably add more monuments to the list.

The tombs listed are all on the outskirts of the town of Qumm and fall into four general groups through their association with the now vanished gates of the older city. These groups include: those of the Rayy gate to the north of the town where the structures seem to be of later date than in the other areas; those of the Kāshān gate to the east of the town, including several tombs of the Il Khānid period; those of the Qal'a gate to the south of the town; and those of an area to the west of the town, here arbitrarily called the Hamadān gate, with two structures of the Il Khānid period.

Qumm is the site of the revered Āstāna, the shrine complex of Fāṭema, sister of the Imām Riẓā. As a place of pilgrimage within Iran her shrine is second only to that of Imām Riẓā at Mashhad. The odor of sanctity attracted large

numbers of saintly men, religious teachers, and scholars; and historians record that many of them were laid to rest at Qumm. Several of the Ṣafavid and Qājār rulers were buried within the shrine of Fāṭema. It is not, therefore, surprising that a relatively large number of tomb structures have survived but it is not easy to explain why nearly all of those now standing were erected during the fourteenth century. It is probable that these tombs housed members of not more than three or four families: effective genealogical tables could be drawn up using the *Rāhnāma-yi-Qumm* and other sources. Evidence from two inscriptions also indicates that the same craftsmen may have worked on two or more structures.

The tombs erected during the fourteenth century may eventually be studied as a series and they are worthy of special consideration. They form a group with features which set them a little apart from contemporary work in other centers. As a general type the plan and elevation form seems to derive from earlier structures in greater Āzerbāijān while decorative features reflect the influence of the mausoleum of Öljeitü at Sulṭāniya. The existing tombs can be separated into three specific types and those listed in the catalogue will be identified by these type numbers.

Type I. Octagonal on exterior, slightly battered exterior walls, on each face shallow rectangular panel framing pointed arch, polyhedral tent dome rising directly from cornice line of exterior walls. Octagonal on interior, hemispherical inner dome. Example: 18.

Type II. Octagonal on exterior, slightly battered exterior walls, on each face shallow rectangular panels framing pointed arch, slightly battered sixteen-sided drum set back from face of exterior walls, on each face shallow rectangular panel framing pointed arch or pointed arch headed window, sixteen-sided tent dome. Octagonal on interior, on each face shallow reveals crowned by pointed arches, sixteen-sided zone of transition, hemispherical dome. Examples: 37, 63, and 87 (dodecagonal on exterior).

Type III. Octagonal on exterior, slightly battered walls, on each face rectangular panel framing a deep reveal crowned by a pointed arch vault, panels flanked by double stage pointed arches within rectangular panels, slightly battered sixteen-sided drum set back from face of exterior walls and on each face shallow rectangular panel either with pointed arch or pierced by pointed arch-headed window, sixteen-sided tent dome. Octagonal on interior, on each face fairly deep recesses crowned by offset pointed arch vault and enclosed by rectangular frame, with above encircling inscription frieze, with above

sixteen-sided zone of transition with as many wall arches, with above encircling inscription frieze, with above decorated hemispherical dome. Examples: 88, and 114.

Most of the tent domes are clad with light blue glazed tiles or by patches of such tiles.

The principal sources used in the preparation of the list of tombs are:

A. *Rāhnāma-yi-Qumm* (in Persian), pp. 129-134.

B. A list of sixteen tombs prepared by F. Bazl and given in "Preliminary Report on the Tombs of the Saints at Qumm," pp. 36-38.

Secondary sources are:

Field work by the present author and his associates.

A Survey of Persian Art, pp. 1098-1099, 1346.

Godard, "Pièces datées de céramique," pp. 309-311.

Monuments which are described in this catalogue are followed by their catalogue listing.

CHECK LIST OF TOMBS

Imāmzāda Ismā'īl

According to source A, glazed tiles from this tomb which are dated 661/1262-63 are preserved in the Museum at Qumm. The location and condition of the tomb is not known.

18.	Imāmzāda Ja'far	677/1268-69
24.	Imāmzāda Mūsā Mobarq'	c. 1300
37.	Imāmzāda 'Alī ibn Ja'far	700/1300
		740/1339
45.	Imāmzāda Aḥmād Qāsem	708/1308
63.	Imāmzāda Ibrāhīm	721/1321
72.	Imāmzāda Harath ibn Aḥmād Zayin al-'Abedīn	c. 1325
87.	Gunbad-i-Sabz	c. 1330-65
88.	Imāmzāda Ibrāhīm	c. 1330-65
104.	Imāmzāda 'Alī ibn 'Abi l-Ma'ālī ibn 'Alī Sāfi	761/1359-60
111.	Imāmzāda Ismā'īl	776/1374

Name and date from source B. Location and condition unknown.

114.	Imāmzāda Khwāja 'Imād ad-dīn	792/1389
	Shāhzāda Aḥmād	c. 1400

Name and illustration from source B. Date suggested by present author.

Imāmzāda Khwāja Beha ad-dīn
 Hab' Allāh Qummī 847/1443
According to source A is one of the structures in the same complex as Imāmzāda Mūsā Mobarq'.

Chihil Dokhtarān 905/1499
Name and date from source B. Location and condition unknown.

Only fragmentary information is available with regard to the following tombs:

Shāh Sayyid 'Alī
According to source B, located at the Rayy gate.

17. Chahar Imāmzāda
According to source B, located at the Rayy gate.

Shāhzāda Hamza
Listed by source B.
Shāhzāda 'Abd Allāh
Listed by source B.
Imāmzāda Sa'd Sayyid Mas'ūd
Location not known. Known to be of Type III and possibly identical with one of above monuments.
Imāmzāda Ibrāhīm
Listed and illustrated by source B. May be identical with 88, a comparison of illustrations suggests very slight differences.

19

Rādkān Mīl-i-Rādkān
c. /1280-1300

Summary: This structure, usually known as Mīl-i-Rādkān, has been visited by a number of travelers. The principal problem concerns the date of the structure whose general stylistic features would seem to place it well after A.D. 1200. In the first serious study of the inscription Max van Berchem (in Diez, *op.cit.*) suggested 60—. Later Herzfeld argued for A.H. 680, believing also that the structure was the mausoleum of Amīr Arghūn Khān whose station was at Rādkān and who died in A.D. 1274. The word "six hundred" is clearly preserved, but only the final letter stroke of the other word in the date remains. The fabric of the tower has cracked and spread at the point where the missing word occurs and if allowance is made for this spreading it appears that the original space was not wide enough to contain the word eighty. The word ninety would have taken less space and it seems probable that the tower was erected between A.D. 1280 and 1300.

This structure served as a model for the tomb tower at Kīshmār.

Location: Some eight kilometers north of the northern road between Mashhad and the Caspian Sea, from a point about one-third of the way between Mashhad and Qūchān.

Condition: Good; base damaged; large holes in fabric; upper portion of entrance portals destroyed.

Plan type: Domed tomb tower, octagonal on interior, on exterior, thirty-six engaged half-round columns above dodecagonal base.

Exterior: Rubble foundations; dodecagonal base of fired brick; half-round columns of fired brick, extending from top of base to beginning of cornice, connected at the top by means of a trefoil niche of fired brick spanning adjacent columns; two entrance portals, on southeast and northwest sides; encircling inscription frieze in terra cotta; conical outer dome.

Interior: Interior wall surfaces plain, intramural

winding stair from top of base to above springing of inner dome; below inner dome several courses of brick bridging angles of octagon; inner dome almost totally destroyed; series of buttress-like spur walls bracing construction of outer dome.

Structural features: Plan with numerous projecting flanges or columns typical of north and northeast Iran (cf. tomb tower, Kīshmār; tomb tower of 'Alā ad-dīn, Varāmīn; tomb tower, Bisṭām; tomb tower, Rayy; Gunbad-i-Qābūs).

Ornamentation: Bricks: standard (.21 by .045 m. buff); cut (trefoil niches); moulded (base).
 Bond: common; elaborate.
 Joints: raked, brick-end plugs.
 Terra cotta: glazed light blue in inscription frieze and inlaid in lobed connectives of trefoil arches; unglazed: ornamental ground of inscription frieze.

Date control: 1. Date of inscription uncertain. Possibly 60–/120–, 680/1281-82, or 690/1291.
 2. Earliest tomb tower in Iran with engaged half-columns on exterior.
 3. Plan type and elevation features like tomb tower No. 1, Akhlāṭ (Armenia), 678/1279; tomb tower No. 2, Akhlāṭ, 680/1281-82.
 4. Local tradition assigning monument to c. 673/1275.

Identification: Iranian National Monument No. 146.

Recorded: November 1937. Section drawing not previously published.

Illustrations: Pls. 13, 14, 15, 16; Fig. 11.

BIBLIOGRAPHY

Fraser, *Narrative of a Journey into Khorasān*, p. 552.
Hommaire de Hell, *Voyage en Turquie et en Perse*, pl. LXXXV.
Napier, "Extracts from a Diary," p. 84.
O'Donovan, *The Merv Oasis*, II, pp. 22-24.
Yate, *Khurasan and Sistan*, p. 363.
Sykes, "A Sixth Journey in Persia," p. 2.
Allemagne, de, *Du Khorassan*, III, pp. 69-70.
Diez, *Churasanische Baudenkmäler*, pp. 43-46, 107-109, pls. 6-8.
Herzfeld, "Khorasan," p. 171.
———, "Die Gumbadh-i 'Alawiyyân," pp. 192-193.
———, "Reisebericht," p. 276.
Byron, "Between Tigris and Oxus—III," fig. 11 on p. 543.
Survey, pp. 927, 1022, 1050, pl. 347A.
Wilber, "The development of mosaic faïence," p. 41.
———, "Preliminary Report," p. 120, fig. 13.
Répertoire chronologique, XIII, p. 3, no. 4804.

20

Sarvistān Imāmzāda Shaykh Yusūf Sarvistānī
680/1281
682/1283
714/1314
716/1316
750/1349

Summary: This structure is located in the small village of Sarvistān, some eighty-eight kilometers east of Shīrāz. Jane Dieulafoy wrote of a tomb of a Shaykh Youssef ben Yakoub for which she gave the date of A.D. 1341, but without giving the source for this date. Her illustration corresponds closely with the description of a building in Sarvistān which was seen by Sir Aurel Stein. He wrote of a chamber whose domed roof had fallen in and whose surviving elements consisted of four arches resting upon massive pillars. He also mentions a beautifully carved sarcophagus of Shaykh Yusūf Sarvistānī bearing an inscription which includes the date 682/1283. The illustration in Dieulafoy shows stone columns crowned by stalactite capitals (in stone?) with walls of dressed stone above the cross arches. She stated that the chamber was encircled by a fine decorative border composed of metallic luster star tiles and blue glazed cross tiles.

The information from Dieulafoy and Stein is augmented and partially corroborated by reliable data from the Archaeological Service of Iran, as communicated by André Godard to the present author. Thus, the street entrance of the structure bears the date 680/1281; the tomb of the shaykh is dated 682/1283; an entrance portal added later to the structure is dated 714/1314; and two tombs within the structure bear the dates 716/1316 and 750/1349.

Identification: Iranian National Monument No. 318.

Recorded: Not visited.

Illustrations: Pls. 19, 21.

BIBLIOGRAPHY

Dieulafoy, J., *La Perse*, p. 468 and fig. on same page.
Stein, "An Archaeological Tour in the Ancient Persis," *Iraq*, p. 178.
Farsnāma-i-Nāṣirī, p. 221.
Rodkin, *Unveiled Iran*, pp. 146-147.

21

Varāmīn tomb tower of ‘Alā ad-dīn
688/1289

Summary: The structure, erected in A.D. 1289, is known locally as the tomb of ‘Alā ad-dīn. Aside from the bold lines and the lofty scale of the structure, chief interest centers in the decorative details. The strap-work panels above the inscription band are reminiscent of the Seljūq combination of faïence and unglazed terra cotta as used at Nakhichevan and Marāgha, but display a definite advance in the organization of details within specific areas, in scale with relation to the tower as a whole, and in fineness of execution. It represents the culminating point in the use of glazed decoration prior to the introduction of complete mosaic faïence.

Location: On the northern edge of Varāmīn, a village some forty-two kilometers south of Tehrān.

Condition: Good; tip of conical roof missing, top and right side of north entrance destroyed, original door of southwest entrance missing. Recent repairs include interior brick dado, brick floor, and rebuilding of lower section of flanges.

Plan-type: Tomb tower; thirty-two right-angled flanges on exterior; circular on the interior.

Exterior: No foundation or base (socle) visible; flanges extend to base of roof where they are connected by corbelled groined arches; encircling inscription band below set into recesses in face of flanges. On north side, immediately above base of roof a window, of which only lower parts of jambs are intact; at summit of roof a zone laid in common bond with elaborate pattern produced by the recessing of certain bricks. Main (southwest) entrance portal has (modern) rectangular doorway, surmounted by low-crowned pointed arch filled with stalactites and plastered over (all modern), surmounted by a second pointed arch filled with stalactites and plastered panel inset between the outer edges of the flanges. North entrance has semicircular arched portal within a pointed arch recess, with flanking walls bonding into the flanges. To the west of the north entrance, placed at about two-thirds the height of the structure, is an intramural winding stair with corbelled vault; to this a pointed arch portal, sunk into the surface of the flange and of the width of one full flange gives access; the pointed arch is surmounted by two arches in the form of spherical triangles, surmounted by a third, groined, arch, bringing the surface out flush with the edge of the flange.

Interior: Four steps lead down to present floor level; interior walls of fired brick, partially plastered; inner dome displays a hole in its crown.

Structural features: Plan with numerous projecting flanges or columns typical of north and northeast Iran.

The structure was certainly erected adjacent to an existing monument, as is shown by the asymmetry of the north entrance and the height above

the ground at which the intramural stair begins: where it could have been entered from the roof of the adjacent building.

Ornamentation: Bricks: standard (.31 by .05 m.; horizontal joints .02 m.; rising joints, minimum).

Bond: common; elaborate.

Joints: flush pointed; decorative end-plugs in stucco.

Terra cotta: unglazed, cornice inscription and part of strapwork; glazed, light blue inscription ground and also part of strapwork.

(Cornice ornamentation consists of a honey-comb pattern in glazed terra cotta with stucco or unglazed terra cotta decorative insets, forming a background for the *kūfi* inscription with foliate shafts, in unglazed terra cotta; above the inscription frieze is a narrow ornamental band in unglazed and light blue glazed terra cotta, above which there are groined arches connecting the flanges; both these and the inverted triangular spaces above and between the groined arches display strapwork patterns in light blue glazed terra cotta and unglazed terra cotta, with decorative insets in unglazed terra cotta and stucco.)

Date control: 1. Historical inscription reading (in part), "He (Murtaẓā) died on the fourth of Ṣafar, in the year six hundred and seventy-five and this tomb was completed in the year six hundred and eighty-eight (A.D. 1289)," (from *Survey*, p. 1050, note 2, transl. F. Bazl).

Identification: Iranian National Monument No. 177.

Recorded: May 1939. Plan and section not previously published.

Illustrations: Pls. 17, 18; Fig. 12.

BIBLIOGRAPHY

Dieulafoy, J., *La Perse*, pp. 150 and 153.
Morgan, de, *Mission Scientifique*, XII, p. 37.
Sarre, *Denkmäler*, p. 59, fig. 66.
Herzfeld, "Riesebericht," p. 234.
———, in notes to "Imam Zade Karrar at Buzun," p. 80.
Survey, p. 1050.
Wilber, "Mosaic faïence," p. 42.
Répertoire chronologique, p. 77, no. 4912.

22

Sojās miḥrāb of the Masjid-i-Jāmi'
 c. /1290

Summary: Ḥamd-Allāh Mustawfī, writing about A.D. 1340, mentions the region of Sojās (or Sujās or Sajis). He locates it a half day's journey south of Sulṭāniya and states that its towns were ruined in the Mongol invasions. He goes on to say that
the tomb of Arghūn Khān (died A.D. 1291) was in the mountains of Sojās and that it first was concealed, but later his daughter Öljāi Khātūn built a monastery and settled people there.

From Sulṭāniya a track just passable for automobiles leads south across a low range of mountains. On the other side a branch leads west to Sojās, a total distance of fifty-six kilometers from Sulṭāniya.

On the edge of this small village is an impressive monument: the Masjid-i-Jāmi', which consists of a large square chamber crowned by a dome. The architectural treatment of the interior is strikingly close in every detail to that of the Seljūq dome chamber of the Masjid-i-Jāmi' at Qazvīn. It is certain that the structure at Sojās was erected close to the year A.D. 1100. Two inscription bands of this period encircle the chamber, but no date was located in either of them. The openings in the east and west walls have been blocked up and there is evidence that structures were built against at least three sides of the chamber some time after its original construction.

The south wall of the chamber displays a large stucco miḥrāb. A number of points indicate that it is later in date than the Seljūq structure itself. The outer edges of the miḥrāb overlap decorative brick-end plugs; the finished brick wall was cut back to provide a roughened bonding surface for the later plaster; through gaps in the pattern of the miḥrāb portions of an earlier miḥrāb, which was narrower in width, may be seen.

The later miḥrāb has inscription bands which include Qur'ānic passages, but no date was located. Certainly a second miḥrāb would not have been installed for some period of time after the original one was constructed and there are valid reasons for assigning the later miḥrāb to the Mongol period. The building activity carried on in this region as described by Mustawfī; the general style of the plaster decoration which differs from that of the Seljūq inscription bands and is in line with dated Mongol work; the extensive use of pigments on the plaster—blue, green, and red—which is a feature characteristic of the Mongol period, all suggest a date of c. A.D. 1295-1300 for the miḥrāb.

Recorded: September 1943. Plan not previously published.

Illustrations: Pl. 20; Fig. 14.

BIBLIOGRAPHY
(regional only)

Le Strange, *Mesopotamia and Persia under the Mongols*, p. 31.
———, *Nuzhat-al-Qulūb*, p. 68.

23

Gar (Iṣfahān) ruined structure
c. /1290

Summary: This badly ruined square chamber is adjacent to and south of the truncated shaft of a minaret which is dated 515/1121-22. Minaret and chamber are within the confines of a damaged enclosure wall. While this wall may be later in date than the monuments, both structures were certainly elements of a building complex. The variety of surface treatment on the north exterior face of the chamber suggests that it was erected against a now vanished structure which was even closer to, and perhaps adjoined, the minaret.

The chamber was constructed of several sizes of brick, probably reused, and dimensions and details reflect rather careless workmanship. Decorative elements comprise cut bricks, brick bonding patterns, brick-end plugs, false joint lines and relief plaster bearing traces of blue and red paint. On the badly damaged miḥrāb only short sections of inscription bands executed in plaster remain and no information can be derived from these sections. However, two small panels, one damaged, on the inner face of the north wall of the chamber do contain material relative to the structure. The panel to the west gives the name of the individual who ordered the construction of the miḥrāb (Rashīd ad-dīn Muḥammad Najār? bin Aḥmad bin Ismā'īl) and the damaged panel to the east preserves part of a proper name and the end of the date, of which only the six of 6— is preserved. The style of the decorative treatment of the structure suggests that it was carried out not long before 700/1300. There is a definite similarity between miḥrāb and panels in the rather distinctive forms of certain letters. The fact that the panels were done in plaster over a finished structural surface suggests that the panels and the miḥrāb may be later in date than the fabric itself.

Location: Some twenty-four kilometers southeast of Iṣfahān, on the south bank of the Zāyinda-rūd River.

Condition: Poor. Only fragments of the four corners of the structure remain and the ruined walls rise a little higher than the base of the zone of transition. Some of the breaks in the walls were later filled in with mud brick.

Plan-type: Square dome chamber.

Exterior: The structure lies within the shattered mud brick walls of a large rectangular enclosure. A few meters to the north (within the enclosure) is a minaret with an inscription dated 515/

1121-22 and it is quite possible that the square chamber was erected as an adjunct to construction work of the Seljūq period.

Only on the north side of the structure is any section of the finished exterior wall surface preserved. To the west of the portal of the chamber are surfaces of brick in common bond with small angle colonnettes. East of the portal the preserved surfaces are of different widths but have similar angle colonnettes. Here the surface next to the portal has an elaborate bond with wide, unpointed rising joints spelling out sacred names. This variation in width of surfaces and type of bonding is a reason for assuming that the square chamber was related to an earlier structure. Above the head of the pointed arch portal was a window some .80 m. wide.

Interior: The interior face of the north wall is in common bond with the wider rising points filled with plaster end plugs as high as the horizontal line which marks the beginning of the zone of transition. On either side of the vertical surfaces which flank the doorway was a short inscription panel (locations marked by arrows on the plan). The panel to the east of the portal is damaged while the one on the west is intact. In both cases plaster was applied to the finished wall surface and the inscription cut in place.

The south wall displays a recessed rectangular wall panel next to the corner angle of the chamber. Its face displays a diagonal square pattern done in the wider, unpointed rising joints. The rectangular head of the panel encloses a pointed arch and the face within the arch has a diagonal square pattern executed in small cut bricks. Adjacent is a vertical surface in common bond with plaster plugs in the wide rising joints. Adjacent is the preserved section of the miḥrāb. The plaster decoration was applied over a rather carefully built system of colonnettes, angles and reveals, almost as if these surfaces had been planned to be seen without added ornamentation. This existing plaster displays the use of a rectangular frame with inscription band which surrounds the miḥrāb opening. Within was a pointed arch with decorated intrados and extrados, the latter areas with an inscription band. The spandrels have cut plaster plugs of various shapes. The area behind the arch is poorly preserved. Color adheres to the plaster. Above the miḥrāb was a window corresponding to the one over the entrance portal.

Just below the horizontal line marking the base of the zone of transition is a band composed of a single row of cut bricks with wide rising joints. Above, a small section of the wall arches and squinch arches are in place. Their corners

are marked by projecting brick angles. The squinch treatment is simple and bold; on either end of the feature is a curved projecting bracket and the space between brackets was spanned by a tunnel vault which bisected the corner angle of the chamber. The surfaces within the wall arches, wall brackets, and lower part of the squinch walls were covered with flat bricks coated with plaster which displays a white painted diagonal brick pattern. Above this stage of the arches the fragments of the higher walls have a revetment of small cut and thin bricks laid in common bond.

Structural features: The structure was built entirely of fired brick, but the work was rather carelessly executed for corresponding elements vary in dimensions, brick sizes, and in such items as presence or absence of projections.

Date control: 1. The inscription, studied for the author by Dr. George C. Miles, is so damaged in the section which contained the date that only the 6 of 6— is legible.

Ornamentation: Bricks: standard (.24 m. by .045 m.); cut; small whole and cut.

Bond: common and elaborate.

Joints: horizontal .01 m. to .02 m.; rising .04 m. to .06 m.; flush pointed, end-plugs, false joints in white on plaster and white joint lines painted over real joints.

Plaster: background of inscription bands of miḥrāb are painted blue and some of the miḥrāb borders are painted red.

Recorded: April 1943. Plan not previously published.

Illustrations: Pls. 22, 23, 24, 25; Fig. 15.

BIBLIOGRAPHY

Smith, "The Manārs of Iṣfahān," p. 323.

24

Qumm tomb of Mūsā Mobarq'
c. /1290

Summary: This structure, known locally as the tomb of Mūsā Mobarq'—"Musa Veiled"—is situated at the south of the town of Qumm. The entire building complex, of which it is one element, includes an open court and a tomb structure of the middle of the fifteenth century. The brief account of the Mūsā Mobarq' given in the *Rāhnāma-yi-Qumm* suggests that the tomb may have been erected at the end of the thirteenth century A.D.

Recorded: Not visited.

BIBLIOGRAPHY

Rāhnāma-yi-Qumm, p. 133.

25

Kishmār Minār-i-Kishmār
c. /1300

Summary: This structure, usually known as the Minār-i-Kishmār, is located in a seldom visited region of Iran. The tower was inspired by that at Rādkān. Signs that construction work was hastily and carelessly executed, that corresponding elements are more complex in detail, and that a small scale prevails in the ornamentation are indications that it is later in date than the Rādkān tower. Details of the stucco decoration are similar to work in other monuments of c. A.D. 1300.

Location: Some fifty kilometers west of Torbat-i-Haidari, a town some 160 kilometers south of Mashhad on the Mashhad-Zāhedan road.

Condition: Fair: large holes in the fabric.

Plan type: Circular domed tomb tower on dodecagonal base, flanges alternating with half-round columns on the exterior, the interior octagonal.

Exterior: Rubble foundation; high dodecagonal base of fired brick; upper walls of fired brick; alternating flanges and half-round columns extending from top of base to beginning of cornice, connected at their upper termination by trefoil arches of stucco; portal with arched entrance within arched panel, the whole enclosed within a rectangular panel; above portal and below roof, horizontal channels encircling structure (formerly filled with glazed terra cotta inscriptions); stalactite cornice; conical roof of fired brick.

Interior: Eight piers divide interior walls into eight deep niches, in two stories, each niche connected with the adjacent one by a passage through pier; intramural winding stair in one pier, extending from first to second story; cavetto cornice; stalactite consoles forming transition to circle; octagonal base of dome pierced by small rectangular openings in each side; dome of fired brick, with stucco decoration multiplied on basic scheme of eight gores.

Structural features: Exterior brick lay a revetment applied to interior core, not bonded into it; brick pattern of revetment produced not by the use of varying widths of horizontal and rising joints, but by the omission of certain bricks; plan type typical of north and northeast Iran (*cf.* references to tomb tower Rādkān).

Ornamentation: Bricks: standard; cut (flanges).

Bond: common; elaborate.

Terra cotta: glazed light blue and dark blue insets in interstices of brick lay.

Stucco: scrollwork and inscriptions (spandrels of entrance portal); relief medallions with inter-

lace patterns (spandrels of second story interior arches); palmettes (crown of interior arches); pattern of interior dome; trefoil arches (connecting exterior flanges and columns).

Date control: 1. Plan type and elevation features like tomb tower, Rādkān.

2. Brick ornamental patterns of exterior similar to tomb tower, Rādkān.

3. Glazed terra cotta in light and dark blue: less developed than at mausoleum of Öljeitü, Sulṭāniya, 705-713/1305-1313.

4. Stucco offsets and details of stucco patterns similar to those of monuments of c. A.D. 1300.

Identification: Iranian National Monument No. 127.

Recorded: Not visited. Plan not previously published (drawn following description of structure in Diez).

Illustration: Fig. 16.

BIBLIOGRAPHY

Sykes, "A Sixth Journey," pp. 159-160.
Diez, *Churasanische Baudenkmäler*, pp. 46-47, 109, pl. 10.
Herzfeld, "Die Gumbadh-i 'Alawiyyân," p. 193.
Survey, pl. 347B.
Wilber, "Mosaic faïence," p. 41.
Diez, *Persien*, p. 123.
Répertoire chronologique, XIII, p. 218, no. 5125.

26

Linjān (Iṣfahān) Pīr-i-Bakrān
 698/1299
 703/1303
 712/1312

Summary: The monument known as Pīr-i-Bakrān or Pīr Bakrān contains the tomb of Shaykh Muḥammad ibn Bakrān who died in 703/1303.

The structure displays a number of periods of construction and repair, with the latter ones occurring within the space of a few years. Prior to the Il Khānid period the site was already marked by a humble dome chamber, probably the tomb of a local personage of revered memory. Against this chamber an īvān was erected, shortly thereafter the open end of the īvān was closed in, and an entrance passageway added at one side of the īvān. Still later, minor alterations were made.

Detailed examination of the structure and its inscriptions explains the progress of the building operations. Apparently Shaykh Bakrān, a venerable teacher and Ṣūfī theologian, had chosen to meet with his pupils at a spot adjacent to the existing dome chamber. As his reputation became widespread it was decided to erect an īvān to shelter teacher and pupils. While the decoration of the īvān was still incomplete, Shaykh Bakrān died and the īvān was converted into his mausoleum. This was done by placing his tomb at the rear of the īvān, by placing a screen wall containing a miḥrāb across the open end of the īvān and by providing a special entrance.

The character of the site explains the unusual features of the miḥrāb screen wall and the long entrance passage. Had the īvān been built on the opposite side of the existing dome chamber, the miḥrāb would have found its normal place in the rear wall of the īvān, but the steep rocky slope on that side of the chamber prevented such a placing. The long passageway was certainly necessitated by the existence of adjacent structures which have since vanished.

Great attention and care was lavished upon the decoration of the monument. Interior wall surfaces of primary interest were covered with carved plaster or faïence revetments, while those of secondary importance had a plaster coating with simulated brick bonding patterns and brick-end plugs. The carved relief plaster displays extreme richness and variety, particularly upon the miḥrāb. There the exuberant forms burst their border frames, show deep undercutting and defy the earlier concept of a single frontal plane. Glazed light blue and dark blue tiles are employed in different sizes and shapes and in many combinations. The star and cross tiles which normally covered only the dado area here scale the upper interior and exterior walls. Large octagonal tiles, each with a circular opening at the center, are laid up to form screen walls. Rectangular tiles decorated with a Chinese phoenix in low relief are used as horizontal mouldings.

In the following pages careful attention is devoted to the details of construction and decoration and to the chronology of the building operations. Both the accretive process, complicated by concomitant repairs and changes of intent, and the virtuosity of decorative means are so thoroughly typical of the time that this monument is an epitome of the architectural devices of this historical period.

Location: On the outskirts of the small village of Linjān, some thirty kilometers southwest of Iṣfahān.

Condition: Very good.

Plan-type: The structure comprises an īvān with a vaulted tomb chamber area, built against a domed sanctuary on the northeast, the īvān entered by a passage running at right angles to its main axis.

Exterior: The southwest face of the structure (originally the entrance to the īvān and later closed by a blocking wall), displays on the piers

flanking the īvān arch a series of pointed arched and rectangular panels surmounted by two windows. These surfaces bore a revetment (now partly destroyed) of carved ornamented plaster with certain areas showing a revetment of cross tiles and eight-pointed star tiles, glazed light and dark blue.

The īvān arch is an offset pointed arch, its intrados and spandrels faced with faïence revetment.

The low wall blocking the īvān opening is slightly battered and terminates in a decorative cornice executed in fired bricks with light blue glazed tile insets.

The surface of the southwest exterior wall of the entrance passage, which runs at right angles to the long axis of the īvān, is plain. Its entrance portal, situated on the east, displays a base course of rubble and upper walls of fired bricks faced with a coat of plaster on which false joints are incised. The portal consists of an īvān recess, the flanking wall surfaces displaying pointed arched panel divisions faced with the faïence revetment. The īvān arch is an offset pointed arch, its intrados faced with the same revetment; the lateral walls of the recess display panel divisions also faced with the revetment and with carved plaster ornament. Piercing the rear wall of the recess is the entrance portal (originally a pointed arch), the surrounding wall surfaces treated with simulated brickwork, surmounted by carved plaster ornament, and a faïence rosette at the crown of the arch. A horizontal frieze filled with the faïence revetment surrounds the three sides of the recess at the base of the vault, above which rises the brick stalactite vault (almost completely destroyed) with light and dark blue glazed tile insets.

The southeast lateral face of the main structure displays a low wall set against the main body of the building, marked off by pilasters faced with simulated brickwork, with recessed panels between, faced with faïence revetment; two openings which pierced this wall are now blocked up. Piercing the wall of the main structure, which rises above and behind this, are three offset pointed arched openings (two now blocked up) at the second story level; at the third story level are four similar windows (now blocked up); these were formerly outlined on all sides with the faïence revetment.

On the rear (northeast) face of the main structure, the domed sanctuary, with its plain outer walls (now plastered with mud), stands against the first story level of the building; the second story level is pierced by a large pointed arched window flanked by two smaller ones (now blocked up); the third story is treated as on the southeast (and northwest) lateral face, save that an offset semicircular arched opening occupies the center of that face.

The right (north) end of this wall displays the remains of a bay, vaulted with a pointed arched transverse rib. Applied to the corner of the main structure, but not bonded with it, is a small high structure of rectangular shape (not shown on the plan), two or three stories in height, constructed of fired bricks, and pierced at the second story level by an offset pointed arched opening; the function of this unit is not clear.

On the other lateral (northwest) face of the main building, the first story level shows three bays placed at right angles to the long axis of the īvān, and vaulted with transverse ribs. These bays rose to a point immediately below the second story windows, which are blocked up as are most of those of the third story (which are treated as on the other lateral face).

Interior: The entrance passage is faced with a dado 1.08 m. in height, displaying the faïence revetment; the simulated brickwork covers the upper walls. The passage consists of three bays spanned by transverse ribs (their crowns destroyed) bearing the faïence revetment on the soffits.

The entrance to the īvān structures, at the end of this passage, is by a pointed arched portal surmounted by a stucco inscription band with the date A.H. 703, above which is the band bearing the faïence revetment, the whole motif within a pointed arched recess vaulted with plaster stalactites. A frame of the faïence revetment outlines the recess.

This portal leads into the īvān. Its lateral faces display a dado 1.34 m. high, of the faïence revetment, surmounted by a plaster inscription frieze, the upper walls plastered and with simulated brick-end plugs. The first floor level bears two deeply recessed panels on each side, originally pierced. The first bay displays a small miḥrāb on the north side of the īvān while the corresponding south bay has a dated inscription of A.H. 712. An offset arched opening (now blocked up) surmounts each recess at the second story level, above which a wide band of faïence revetment rises to the base of the oversailing īvān vault.

The wall which blocks the opening of the īvān displays an elaborately carved plaster miḥrāb, polychromed red, blue, and white, composed of a pointed arched recess of semicircular plan, within a second pointed arch, each outlined by a torus moulding, the whole within a series of rectangular reveals and scotia mouldings, and surmounted by a high cove. The flanking wall surfaces are faced with faïence revetment, sur-

mounted by a screen of pierced tiles with ornament moulded in relief, glazed light and dark blue.

Blocking the opening leading to the inner vaulted area of the īvān (which serves as the tomb chamber), and dating from the period of the conversion of the īvān into a tomb chamber, is a high screen wall, with a dado of the faïence revetment 1.23 m. high, surmounted by an upper surface of the pierced moulded tiles, the whole bearing at its top a broken-headed arch of ornamented stucco, its tympanum formerly pierced; the entire motif is enclosed within a concave moulding above which rises a parapet of light and dark blue tiles crowned by an ornamented plaster finial. The entrance to the tomb chamber is by a door in the lower right hand corner of the screen wall.

The īvān vault above the tomb chamber is of brick stalactites faced with simulated brickwork in plaster.

The tomb chamber, containing an inscribed stone sarcophagus, is roofed at the level of the broken-headed arch of the screen wall, below the high stalactite vault of the īvān. The three sides of the chamber are faced with a high dado, 2.65 m. in height, of the faïence revetment; each lateral face is broken by a deeply recessed broken-headed arched panel, that in the left wall originally pierced. A door in the rear wall leads into the small, domed sanctuary.

Above the level of the low roof of the dome chamber, the upper walls of the īvān display a gallery at the second story level, and another at the third story level.

The domed sanctuary consists of a square chamber, its mud walls plastered with polychrome painted plaster. Rudimentary pointed arched squinches bridge the angles of the structure, and the ovoid dome, executed in fired bricks laid in common bond in concentric rings, springs from these.

Structural features: The structure represents the persistent tradition of the Sāsānian īvān hall. Its lofty proportions and use of recessed panels in several stories on the flanking piers recall the so-called īvān of Abāqā Khān at Takht-i-Sulaymān and the īvān below the shaking minarets at Iṣfahān.

Stone replaces the more usual fired brick in most of the structure: the walls are of uncoursed rubble with medium-hard gray-white mortar, formerly plastered with the same mortar.

The bays which surrounded the lateral and rear faces of the structure are, in their present condition, too shallow to have any observable function; the reasonable explanation is that they were originally two bays in depth, so as to be utilized as chambers. Slight supporting evidence is present: a cleared space on the southeast side, with a large rock at this point cut away apparently to make room for a structure; on the northwest side, beyond the bays of this face, the mud walls of the house enclosures across the lane display zones of rubble in alignment with the bay piers, which could have formed the bases of the piers of the additional bays.

Ornamentation: Bricks: (entrance portal) .225 by .045 m.; rising joints .025 m.; horizontal joints .02 m.; mortar medium hard, white flush pointed; over the construction core is laid a plaster coating with very shallow, narrow false joints incised, and false decorated brick-end plugs, .04 m. in width.

Terra cotta: glazed; luster tile, moulded tiles with relief ornamentation; glazed light blue and dark blue; glazed tiles in light blue and dark blue.

Plaster: partly polychromed, elaborately carved in various levels of relief.

Date control: 1. Features characteristic of the Mongol period are the use of two-color faïence; the employment of offset arches, pointed and broken-headed; the occurrence of the plaster coating over the constructional brickwork, with false joints incised; the motif of the ornamental plaster cover as a crowning member; arched panels of rectangular plan, with the upper portion from about the impost level of shallow concave plan; the stalactite vault of built brick stalactites with ornamental insets in glazed tile.

2. A luster tile found on the site dated 698/1299; an inscription on the wall of the tomb chamber and one on the sarcophagus, as well as one on the entrance to the īvān, are dated 703/1303; an inscription in the recess of the īvān wall is dated 712/1312.

3. Several periods of construction are discernible:

Period I: the period of the domed sanctuary, of uncertain date.

Period II: the period of the īvān, with its lateral walls pierced by two openings on each face, and open galleries on the second and third stories; previous to 703, when the īvān was converted into the tomb of the Shaykh at his death; the A.H. 698 inscribed tile may provide the general date of this period. The rebuilding of the īvān vault can be assigned to this period.

Period III: the period of the conversion of the īvān into a tomb shrine: the addition of the wall blocking the īvān, with its miḥrāb; the screen wall blocking off the rear of the īvān as a tomb chamber; filling up the lateral openings of the īvān; addition of the entrance passageway; the inscription frieze on the lateral walls of the īvān

and the carved plaster ornament within these recesses (since the simulated brickwork extends behind the present rear walls of the recesses; the inscription frieze breaks with a definite moulding on either side of the small grills in these recesses; the grills show the pierced, moulded tiles of the blocking wall); in the tomb chamber the blocking of the recesses (or one, at least) of the lateral walls. This period dates between A.H. 703 and 712.

Period IV: bays added to the exterior of the structure.

Period V: the structure at the northwest exterior corner and perhaps the walls blocking off the single row of bays.

Identification: Iranian National Monument No. 101.

Recorded: May 1939. Plan revised after a plan published by A. Godard.

Illustrations: Pls. 26, 27, 28, 29, 30; Fig. 20.

BIBLIOGRAPHY

Herzfeld, "Reisebericht," p. 239.
Pope, "Some recently discovered Seldjūk stucco," p. 114, figs. 6-8.
Herzfeld, *Archaeological History of Iran*, p. 106.
Bahrami, "Some examples of Il Khanid art," p. 258, fig. 1.
Godard, "Iṣfahān," pp. 29-35, figs. 6-10.
Survey, pp. 1077-1079, fig. 387, pls. 386-390.
Répertoire chronologique, XIII, p. 251, no. 5172; p. 252, no. 5173; p. 253, no. 5174.

27

Tabrīz Ghāzāniya
c. /1295-1305

Summary: About three kilometers west of the present center of the city of Tabrīz is a crumbling mound of debris which marks the site of the mausoleum of Ghāzān Khān, ruler of Iran from A.D. 1295 to 1304. Heaps of brick and fragments of faïence litter the ground but it is not possible to trace the course of any of the walls of the vanished structure. However, much of the monument stood above ground until well into the nineteenth century and the identification of the site is certain. Source material regarding the monument is abundant. In view of the original importance of the monument it has seemed advisable to restudy the source material, including available Persian texts.

Ghāzān Khān had designated Tabrīz as the capital of his realm and ordered work begun on a massive wall which would circumscribe the existing wall and take in a much greater area than the earlier fortifications. About the same time, and apparently less than a year after his accession to the throne, he ordered construction work begun at a site beyond the Royal Gate of Tabrīz where Arghūn Khān had previously planned to erect structures.

Contemporary material relating to this extensive operation comes from Rashīd ad-dīn, Vaṣṣāf, Ḥamd-Allāh Mustawfī, Ibn Baṭṭūṭa, Abu'l Qasem . . . al-Kāshānī, Shams-i-Kāshānī and a miniature painting. The most specific material comes from Vaṣṣāf who is quoted by Hammer-Purgstall in his history of the Il Khāns. Other modern writers, supposedly drawing from Vaṣṣāf, give variant versions of these facts. Hammer-Purgstall may be accepted as the most reliable interpreter since he also edited and translated the manuscript history of Vaṣṣāf.

Mustawfī writes that Ghāzān Khān founded a suburb outside his new wall at a place called Shām and erected there his own burial place and lofty edifices the like of which could not be seen throughout Iran. Rashīd ad-dīn records that Ghāzān established a city larger than old Tabrīz to the southwest of the existing town at a place called Sham or Shenb. Thus, the name of the area appears in three forms. Shām, which is also used by Ibn Baṭṭūṭa, has always been the Arabic name of Syria and it might be assumed that the area took this name because it lay outside of Tabrīz in the general direction of 'Irāq and Syria. However, the correct term is probably Shenb, meaning cupola or dome and referring to the mausoleum of Ghāzān. Sham is simply a corruption of Shenb, for in Persian written *nb* is pronounced as *m*.

Rashīd ad-dīn states that Shenb was also known as the Ghāzāniya and that it included a very spacious garden called the Garden of Justice. Within this garden were the Gates of Piety, the focal point of which was the mausoleum of Ghāzān, usually referred to simply as the Lofty Tomb.

Numerous structures were erected in the Garden of Justice, some forming part of the Gates of Piety complex and some in another part of the garden. According to Vaṣṣāf these buildings included a monastery, a school for the Shāfi'ī rite, a school for the Ḥanafī rite, a hospital, a palace, a library, an observatory, an academy of philosophy, a fountain and a pavilion.

Fortunately a surviving miniature of the period, believed to have been executed before A.D. 1318 in the suburb of Rashīd ad-dīn on the opposite side of the city of Tabrīz, illustrates the Gates of Piety (Pl. 31). The miniature portrays a spacious open courtyard enclosed by arcades. Grouped on three sides of the court are imposing

structures. The building on the right of the court bears an inscription which reads, "Sulṭān Maḥmūd Ghāzān, may Allāh increase his reign and his Caliphate and may it be prolonged." The building on the left bears this inscription, "There is no God but Allāh and Muḥammad is the Prophet of God." The structure at the back of the court is shown as a tower, square in plan and crowned by a dome. At the top of the tower wall is an inscription band the text of which is illegible in the published reproduction. The eminent French scholar of Islam, the late J. Sauvaget, was kind enough to examine the original manuscript in the Bibliothèque Nationale and to read the inscription in question. He states that it is a well-known *hadīth* and that the implication is that the entire band would have been composed of a series of these traditions. However, he adds that there is no reason to believe that the painter of the manuscript copied an actual inscription from the tomb.

It is interesting to note the correspondence of this grouping with the statement made by Ibn Baṭṭūṭa who writes, "We were lodged in a place called Shām where the tomb of Ghāzān . . . is located. Adjacent to this tomb is a splendid religious school and a monastery where travellers are fed. . . . The amir lodged me in this monastery." Possibly the religious school and the monastery are the structures to the left and right of the miniature. Certainly a fourth building fronted on the court, but for reasons of clarity was not shown in the miniature.

Ground was broken for the mausoleum of Ghāzān on October 5, 1297 and, according to Rashīd ad-dīn, Ghāzān himself drew the plans, took great pleasure in the progress of the work and was often at the site giving orders to the master builders and craftsmen. He decided such details as the size and position of the windows which lighted the crypt. However, according to Abu'l Qasem . . . al Kāshānī, the architect of the mausoleum and the other structures of the Gates of Piety was Tāj ad-dīn 'Alī Shāh.

Work continued on the structure for several years until it became apparent that it was to be much more magnificent than the tomb of Sulṭān Sanjar, the Seljūq, at Merv, which up to that time had been regarded as the greatest building in the world. Fourteen thousand workmen were busy at the structure.

Upon Ghāzān's death in A.D. 1304 he was borne in state to Tabrīz and then to the mausoleum where his body was laid to rest. The final construction work and decoration of the structure was still going on in October A.D. 1305 when the dome of the structure suddenly collapsed. Fifty

Armenian and Georgian workmen were killed and the heavy decorated curtains within the monument were torn by the falling debris. This damage may have been exaggerated in the contemporary accounts of Abu'l Qasem and Shams i-Kāshānī for when Evliya Efendi saw the structure in the seventeenth century he noted, ". . . it is a tower lifting its head to the skies. When I saw it, it was a little damaged on the side of the gate by an earthquake."

Godard has suggested that the tomb was a high tower crowned by a dome, more like the surviving towers at Marāgha than the tomb of Sulṭān Sanjar or the later mausoleum of Öljeitü at Sulṭāniya. He cites several brief descriptions by visitors to the site who were unanimous in seeing the structure as a high tower or a minaret. The assumption of Godard seems perfectly sound.

According to Vaṣṣāf, quoted by Hammer-Purgstall, the twelve-sided structure had walls which were 33 bricks in thickness. Each brick weighed ten man and the thickness of the walls was 15 gaz. The height to the springing of the dome was 130 gaz, the cornice 10 gaz high, the vertical height of the dome 40 gaz and the circumference of the dome 530 gaz.

In editions and translations of Persian manuscripts the term "gaz" usually becomes "ell" or "cubit." Occasionally the gaz and the cubit are equated as 18 inches (45.7 centimeters). However, the Persian editor of the history of Ḥāfiẓ-i-Abrū states that the gaz equals the *coudée*, or a distance of about 30 centimeters. Vaṣṣāf, in describing the mausoleum of Öljeitü, states that the dome has a diameter of 100 gaz and that each of the sides of the tomb is 60 gaz in length. Now the actual diameter of the dome of Öljeitü's mausoleum is 24.40 meters which would yield a value for the gaz of about 25 centimeters. The actual length of the sides of the tomb is 15 meters. If the text length of 60 gaz is multiplied by 25 centimeters the result is 15 meters which serves as a check for this assumed value.

If this assumed value of 25 centimeters for the gaz is applied to the dimensions of the tomb of Ghāzān, it yields a structure with walls 3.75 meters thick, a height to the springing of the dome of 32.50 meters, height of the exterior cornice of 2.50 meters, vertical height of the dome of 10 meters and diameter of the dome of 42 meters. Such comparative dimensions do not work out to a harmonious structure. The wall thickness seems about right but the diameter is very great and the vertical height of the dome very small, unless the figure refers to a shallow inner dome. However, if the figures of Vaṣṣāf are granted any validity at all they do indicate that

the gaz can hardly have been longer than the value assumed for it here.

A certain amount of material relating to the decoration of the structure is available. Vaṣṣāf states that it had a band decorated with signs of the zodiac. Such decoration may be compared with the stone panels carved with symbols of the zodiac which were set into the now ruined bridge at Gezirat ibn Omar in 'Irāq. Preusser (see the bibliography for this monument) published excellent photographs and a brief description of this bridge, situated on the Tigris about 150 kilometers to the north of Mosul. He gave no reading of the surviving inscriptions and suggested no date for the structure, but Herzfeld would place it in the second half of the twelfth century.

Vaṣṣāf also speaks of a gilded inscription, which may have encircled the structure at the cornice level, and of the fact that 300 man of lapis lazuli were used in its decoration.

Visits to the site in 1937 and 1939 resulted in the collection of fragments which are of positive aid in rounding out a picture of the vanished structure. Fired bricks, 27 centimeters square by 7 centimeters thick, littered the site as did large square end plugs with rectangular kufi inscriptions. Quantities of bricks coated with a dark blue glaze were probably once part of the exterior revetment of the dome.

Fragments of faïence were plentiful. These included pieces of light blue, dark blue, and black faïence tile. These colors were used in various combinations in strapwork patterns or as insets in a fired clay body. Glazed tiles moulded into polygonal and kite-shaped pieces were also found: some had underglaze painting, others a metallic luster.

Cut stone was not found at the site, but if such valuable building material were used it would have been removed long ago. Both the existence in the vicinity of Tabrīz of the tomb towers at Marāgha with their bases of cut stone, and the presence of Armenian and Georgian workmen at the mausoleum of Ghāzān suggest strong contemporary influences from the stone carving region of Asia Minor directly to the west of Tabrīz. Further, part of the description of the mausoleum by Rashīd ad-dīn indicates that the windows of its crypt were above the ground level and hence the floor of the tomb chamber must have been some distance above the ground level. This feature of a raised tomb chamber is common to the cut stone tomb towers of Asia Minor.

The accompanying restored elevation of the mausoleum of Ghāzān Khān stems entirely from the above discussion of the vanished structure. The drawing is to an assumed scale and since all accounts of the tomb stress its height rather than its breadth it is scarcely possible that the diameter of its dome was more than 25 meters, the dimension of the dome of the mausoleum of Öljeitü at Sulṭāniya.

Recorded: October 1937 and July 1939.

Illustrations: Pl. 31; Fig. 17.

BIBLIOGRAPHY

Jahn (Ed.), *Geschichte Ġāzān-Ḫān's*, pp. 94, 112, 113, 117, 160, 206, 208.

Le Strange, *Nuzhat-al-Qulūb*, pp. 76-77.

Browne (Trans. and Ed.), *The Ta'rīkh-i-guzída*, I, p. 595.

Abu'l Qāsim al-Kāshānī, *Tarīkh*, fol. 36 (cited by Bahrami in "Some examples of Il Khanid art").

Shams-i-Kāshānī, Bibliothèque Nationale, Ms. Suppl. persan 1443, fol. 283B (cited by Bahrami, see above).

Voyages d'Ibn Batoutah, pp. 129-130.

Hammer (-Purgstall), von (Trans.), *Narrative of Travels*, by Evliyá Efendí, II, p. 143.

Tavernier, *Les six voyages*, I, p. 51.

The travels of Sir John Chardin, I, p. 354.

Morier, *A second journey through Persia*, p. 232.

Giro del Mondo del dottor D. Gio: Francesco Gemelli Careri, p. 25.

Porter, Ker, *Travels*, I, p. 223.

Southgate, *Narrative of a tour through Armenia*, II, p. 5.

Hammer-Purgstall, von, *Geschichte der Ilchane*, II, p. 153.

Coste, *Monuments moderne de la Perse*, p. 54.

Dieulafoy, J., *La Perse, la Chaldée et la Susiane*, pp. 52, 60.

Howorth, *History of the Mongols*, III, p. 531.

Le Comte, "Tébriz (Azerbaïjan)," p. 170.

Sarre, *Denkmäler*, p. 27, pls. XVII-XIXa, b.

Texier, *Déscription de l'Armenie*, I, p. 343.

Blochet, *Les peintures des manuscripts orientaux*, pp. 264, 272, pl. XX.

Eqbāl, *Tārikh-i-mofaṣṣel Īrān*, pp. 304-305.

Bahrami, M., *Recherches sur les carreaux*, pp. 79-81.

——, "Some examples of Il Khanid art," pp. 257-258.

Survey, pp. 1053-1055.

Wilber, "Mosaic faience," pp. 42-43.

Sayili, "Ghazan Khan's observatory," pp. 625-640.

Preusser, *Nordmesopotamische baudenkmäler*, pp. 26-28, pl. 38-40.

Herzfeld, "Der Thron des Khosrô," pp. 138-139.

28

Bisṭām

tomb tower
Masjid-i-Jāmi'
shrine of Bāyazīd

700/1300
699/1299
702/1302
706/1306
713/1313

Summary: The small village of Bisṭām lies just off the highway between Tehrān and Mashhad, some six kilometers north of the town of Shāhrūd.

On the outskirts of the village are two neighboring building groups which have architectural elements dated in the Mongol period. These are the shrine area of Bāyazīd and the Masjid-i-Jāmi', flanked by an impressive tomb tower. The structures have been well covered in *A Survey of Persian Art* in a description which makes good use of accounts of earlier visitors to the site. This present summary mentions the more important features of the ensemble, but it should be noted that the site merits special treatment in a separate monograph.

The construction of the shrine area of Bāyazīd may have been undertaken soon after the death of the holy man Bāyazīd al-Bisṭāmi, near the end of the ninth century A.D. Sketchy traces of what appear to be pre-Seljūq walls remain in the area. An existing minaret is of the Seljūq period as was the early mosque of the shrine area for a portion of its wall, bearing the date 514/1120, survives.

Additional construction was carried out quite early in the Il Khānid period. Khanikoff reports a miḥrāb dated 660/1262, signed "the work of Muḥammad ibn Aḥmad . . .", which is no longer in place. However, more extensive building was done in two campaigns later in this period. Muḥammad ibn al-Ḥusayn ibn Abī Ṭālib of Dāmghān, named in the inscriptions as engineer, builder, and stucco-worker, seems to have been in charge of the work both at the shrine and in the other building complex. An inscription dated 702/1302 indicates that he was aided by his brother Hājjī. During the reign of Ghāzān Khān the mosque within the shrine area was repaired and ornamented with carved stucco, including a fine miḥrāb signed by Muḥammad ibn al-Ḥusayn and dated 699/1299. The inscriptions of the miḥrāb and stucco give the names of Ghāzān Khān and of his brother Öljeitü, then governor of Khurasān.

The second campaign probably included the enclosure of the entire shrine area, although only two features may be positively assigned to this time. One of these is the entrance portal and corridor on the east of the complex and the other is the īvān situated across the court from the entrance corridor.

The entrance portal displays the customary plan with its half dome filled with stucco stalactites. All wall surfaces are clad with faïence patterns executed in glazed units relieved by unglazed terra cotta pieces. This faïence is of a rather different type from that of contemporary examples in western Iran. In the west the faïence is used in geometric interlace patterns which are executed in simple square, rectangular, or triangular units. At Bisṭām the patterns are basically strip or border designs of interlocking elements and the single units are parallelepipeds or more complex forms. Some of the units have moulded relief and the blue glaze is rather more muddy and dull than in western Iran. The corridor behind the entrance portal has wall surfaces coated with white stucco, relieved by incised brick bonding patterns. A carved stucco frieze includes the name of Öljeitü and the date of 713/1313 and states that the work was done by Muḥammad ibn al-Ḥusayn. The portal bonds into the corridor and hence is of the same date. The īvān across the court from the entrance has faïence decoration similar to that of the entrance portal. Its relative location suggests that it served as the entrance to a second court which has completely disappeared.

The complex situated to the south of the shrine of Bāyazīd and made up of the tomb tower and the Masjid-i-Jāmi' seems to have been built in a single campaign during the reign of Ghāzān Khān, with the location of the tower determined before work was begun on the mosque. The flanged tomb tower is very similar to the tower of 'Alā ad-dīn at Varāmīn, although less well preserved than the earlier structure. Crowning the flanges are two encircling inscription bands executed in faïence. Sections of the inscription are missing and thus far only the name of Muḥammad ibn al-Ḥusayn has been read. Fraser wrote of an inscription over the entrance door of the tower containing the date 700/1300, but it seems probable that he actually saw the inscription, still in existence, on the portal of the Masjid-i-Jāmi' which gives access to the site of the tower. This inscription ends ". . . in the middle of the month of Shawwal of the year . . . 700. . . ."

The Masjid-i-Jāmi', built directly against the tower, includes a court surrounded by the prayer hall of the mosque on the east and by passages and bays on the other sides. On the south of the court the cross arches of the three bays display the broken heads characteristic of the general period, while the wall of the central bay has a fine carved stucco miḥrāb. The stucco decoration

in this area and in the recess in front of the door of the tower bears the dates 702/1302 and 706/1306. The geometric patterns of the stucco recall those of the faïence decoration on the entrance portal to the shrine complex.

Identification: Iranian National Monuments 68 and 69.

Recorded: November 1936 and November 1937.

Illustrations: Pls. 32-40.

BIBLIOGRAPHY

Merāt al-Boldān, IV, p. 98.
Matla' ash-Shams, I, p. 69.
Fraser, *Narrative of a journey*, p. 340.
Morgan, de, *Mission scientifique*, I, fig. 19.
Khanikoff, de, "Mémoire sur la partie méridionale de l'Asie Centrale," p. 79.
Curzon, *Persia and the Persian Question*, I, p. 283.
Herzfeld, "Reisebericht," p. 278.
Sarre, *Denkmäler*, pp. 116-119, figs. 158-164, pls. LXXXV-LXXXVIII.
De Kasr-e Shirin à Meshhèd et a Tus, pp. 42-43.
Byron, "Between Tigris and Oxus-III," fig. 9 on p. 543 and fig. 12 on p. 544.
Survey, pp. 1080-1086, figs. 388-390, pls. 349-350, 392-395, 416.
Jackson, A. V. W., *From Constantinople to the home of Omar Khayyam*, p. 198.
Répertoire chronologique, XII, p. 68, no. 4492; XIII, p. 197, no. 5085 bis.; pp. 217-218, no. 5124; p. 240, no. 5155.

29

Nāyīn Masjid-i-Bābā 'Abd Allāh
 700/1300
 737/1336

Summary: Nāyīn is located 159 kilometers east of Iṣfahān at the end of a direct road between the two towns.

The Masjid-i-Bābā 'Abd Allāh is dated 700/1300 and was repaired in 737/1336. The structure consists of a square chamber with an intact dome. Each interior side wall displays an axial, deeply recessed, rectangular bay. The surface of each such wall displays, first, a broken-headed arch panel with outlines in incised plaster and, second, a slightly recessed rectangular panel crowned by a pointed arch the head of which is filled with a plaster stalactite treatment. At the springing line of the chamber is a horizontal band bearing an inscription in painted dark blue letters on white plaster. The eight wall arches at this level contain, within an outer straight-sided arch, an elaborate system of plaster stalactites within a pointed arch. All wall surfaces of the chamber are coated with white plaster. The span-

drels of the miḥrāb display delicate palmettes in blue paint.

The inscription containing the date A.H. 700 is on a wooden panel which once formed part of a minbar and which is now embedded in the back wall of the miḥrāb niche. Its text begins, "had ordered the construction of this mosque..." and includes the date of Muharram I, 700/September 16, 1300. The inscription has been published by M. B. Smith who also refers to the date Rab'i I, 737, painted on the frieze below the squinches of the chamber.

The details of the structure and its decoration recall the chamber at Ziāret as well as the monuments erected at Yazd during the fourteenth century.

Identification: Iranian National Monument No. 204.

Recorded: Not visited.

Illustration: Pl. 41.

BIBLIOGRAPHY

Yate, *Khurasan and Sistan*, p. 359.
Pope, "The Photographic Survey of Persian Islamic Architecture, Part I," pp. 26 and 28.
Survey, pp. 1072, 1335, fig. 490, pl. 412E.
Répertoire chronologique, XIII, pp. 216-217, no. 5123.
Smith, "The Wood Mimbar in the Masdjid-i Djami', Nāīn," p. 27.

30

Āstāra tomb of Shaykh Maḥmūd
 700/1300

Summary: According to a communication from André Godard to the present author, the tomb of Shaykh Maḥmūd, situated five kilometers northwest of the town of Āstāra, is dated 700/1300. Āstāra is located on the shore of the Caspian Sea and on the present frontier between Iran and Soviet Russia.

Recorded: Not visited.

31

Hājiābād cave with dated inscription
 700/1300

Summary: In a few lines, Herzfeld has written of a trip from Siwand to Naqsh-i-Rustam. He mentions a valley near the village of Hājiābād and states that at the upper end of this gorge is a cavern known locally as the Qabr-i-Kalandar which contains a dated inscription of 700/1300. No description of the cavern nor of the inscription is given.

Recorded: Not visited.

BIBLIOGRAPHY
Herzfeld, "Reisebericht," p. 243.

32

Kūhrūd Masjid-i-'Alī
700/1300-01

Summary: The village of Kūhrūd is situated on an old caravan route between Kāshān and Naṭanz. According to a communication from André Godard to the present author, the entrance portal of the Masjid-i-'Alī displays a rather long inscription which begins, "This mosque and this effort (among those) of Sadr, the Imām, the learned . . ." and which ends with the date "Rabi' II in the year 700/ between December 14, 1300 and January 11, 1301."

No other information is available. Sir Robert Ker Porter who visited the charming twin villages of Kūhrūd (Kourood) in 1818 makes no mention of any religious structure.

Recorded: Not visited.

33

Rayy tomb tower
c. /1300

Summary: In 1903 A. V. W. Jackson visited the site of ancient Rayy and later published a description of its ruins. He also gave a rather unsatisfactory photograph of a badly damaged tomb tower which was not mentioned in his text.

This tower, which has not survived to the present day, was certainly situated on one of the higher slopes which overlook the ancient site. It seems very probable that it was the same structure as one seen by Sir Robert Ker Porter in 1818: marked G on his map of Rayy and described by him as "a low circular building, decorated with various coloured tiles, evidently either a tomb, or some small Mahomedan religious edifice." The following description is based upon a picture taken a number of years ago by a local Tehrān photographer.

The structure was octagonal in plan with a core of rubble masonry clad with a brick revetment which was a single brick in thickness. Each exterior face, about 2.25 m. wide, displayed a pointed arch recess within a rectangular frame. Above the panel heads a moulding of bricks cut into lozenges encircled the structure. Just above was a horizontal panel about .40 m. high which had a ground of small cut bricks. Into this ground was set an inscription, the letters of which were made of pieces of cut or moulded brick. Above was a second brick lozenge moulding and then a cornice composed of at least three stages of brick stalactites.

The type of cornice, the method of construction and the assumed use of colored tile suggests that the monument was erected before A.D. 1300. However, there is a possibility that the structure was built at the end of the Seljūq period.
Illustration: Pl. 42.

BIBLIOGRAPHY
Porter, Ker, *Travels*, I, p. 361, pl. 6.
Jackson, *Persia Past and Present*, fig. opp. p. 435.

34

Tabrīz Rab'-i-Rashīdi
c. /1300

Summary: A few kilometers east of Tabrīz and north of the Mihran Rūd stream which flows through the city is an area where low rounded hills jut out from the high mountains behind. On the barren hills and in the orchards of the valleys are crumbling masonry walls and fragments of mosaic faïence and of glazed pottery litter the ground. The French traveler Chardin visited the site in the seventeenth century and was told that the ruins were of a great castle called the Qaleh-i-Rashīdi which had been built four hundred years before by Khwāja Rashīd.

Khwāja Rashīd ad-dīn Faḍl Allāh ibn 'Imad ad-dawla Abu'l-Khayr was born in Hamadān of a Persian family in the year 645/1247. Court physician under Abāqā Khān, he became court historian and vazīr during the reign of Ghāzān Khān. Some mention of his political career and of his writings is given in another section of this present work.

Rashīd ad-dīn had concrete plans for the advancement of learning and of the arts and began —probably just before the year A.D. 1300—the construction of a university city. An historian, who at one time had been a protégé of his, writes: "In Mongol times, when this city (Tabrīz) had become the capital of the kingdom, the population here greatly increased, and they began to build many houses outside the city limits, until at length at each gate there was a suburb as great as the city itself had originally been. These suburbs Ghāzān Khān proceeded to surround by a (second) wall, which should encircle also all the gardens and their buildings, with all the villages lying on Mount Valiyan and also at Sanjan: all these came to be included therein, though the wall was not completed on account of the death of Ghāzān Khān. . . . Then above the city, and on the flank of Mount Valiyan but within the wall of Ghāzān Khān, the Vizir Rashīd ad-dīn built another suburb, which came to be known as the Rashīdi quarter, and here he constructed many high and magnificent palaces."

Rashīd commanded practically unlimited

sources of revenue and his suburb must have rivaled in splendor that built by Ghāzān Khān himself. The suburb is mentioned in four of the collection of some fifty-three surviving letters which he had sent to his sons and to provincial governors. These letters, once in the possession of Edward Browne, are now in the Cambridge University Library. Recently R. Levy has expressed doubts as to the authenticity of the group and he suggests that they were composed no earlier than the fifteenth century and may be of Indian provenance. However, it is extremely difficult to believe that letter number 51 in which the builder describes his suburb, the Rab'-i-Rashīdi (Rashīd Foundation or Estate), is not a genuine document.

This letter speaks of the erection of caravanserais, shops, baths, storehouses, mills, factories, a dye house, a mint, and thirty thousand delightful houses. According to the letter, at least two thousand reciters of the Qur'ān, scholars, jurists, theologians, traditionalists, physicians, craftsmen, weavers, etc., were already settled there and most of them were receiving a regular stipend.

In spite of these great plans the Rab'-i-Rashīdi failed to play a vital role in the cultural development of the period and it is probable that the community disintegrated after Rashīd was put to death in 718/1318. At that time has family and his retainers were stripped of their possessions and the Rab'-i-Rashīdi was plundered. His memory did not remain disgraced, however, for his son Muḥammad Ghiyath ad-dīn was soon made vazīr, and this fact probably explains the statement made by a historian that Rashīd was buried near the mosque in the Rab'-i-Rashīdi. Another writer remarked: "Later his son the Vazīr Muḥammad Ghiyath ad-dīn, enlarged his father's buildings here."

The later history of the Rab'-i-Rashīdi is difficult to trace. Ghiyath ad-dīn himself was put to death in 736/1336, and the suburb was looted at that time. During the same century a petty overlord, Malik Ashraf, occupied the site in 752/1351, and gave orders for its fortification. According to one text, his followers brought their families with them and soon splendid mosques, hospitals, and schools were erected. From 807/1404 until 810/1407 the mad prince Miran Shāh, a son of Tamerlane, was governor of this region. The story was brought to him that Rashīd ad-dīn had been a Jew, a rumor that had been current during the lifetime of Rashīd, and Miran Shāh ordered his remains exhumed and transported to the Jewish cemetery.

None of the elements of the suburb of Rashīd ad-dīn can be identified at the site as it appears today. Most conspicuous are the bases of masonry towers and the line of a circling fortification wall upon the largest of the hills in the general area. These fortifications may be those built in the fourteenth century and mentioned above or they may be the remains of defensive works constructed by Shāh 'Abbās at the site in the early seventeenth century.

The most conclusive evidence that structures were built here in the Mongol period is given by the fragments of mosaic faïence found at the site, many of which are very similar to fragments from the tomb of Ghāzān Khān and also like the decoration of dated monuments of the period. These pieces include octagonal tiles of both light blue and dark blue glaze which have had sections of the glaze scraped away to the biscuit, thus creating a secondary design on the tile; strapwork patterns with strips of light and dark blue faïence with certain of the pattern voids filled with carved plaster; fragments of inscription bands in which the background was established by scraping away the glaze; etc. It should be noted that there are also numerous fragments of multi-colored complete mosaic faïence of the Ṣafavid period.

Among the tower bases mentioned above, one demands special consideration. It is much larger than the others and differs in plan since it includes a rectangular projection. It is also more carefully constructed for its rubble masonry core was surfaced with slabs of cut stone. Large sections of the facing blocks which are still in position indicate that the upper part of the tower overhung the base. Many of these blocks are basalt and most, if not all of them, are reused pieces. There are column bases which may date from Parthian times and numbers of Islamic tombstones. The implied desecration of Moslem cemeteries is some indication that the tower may date from the time of Rashīd ad-dīn, when the authority of Islam was weaker than at earlier or subsequent periods.

The commanding position of this tower base and its unique construction suggest that it may have been the foundation for an astronomical observatory. Hūlāgū had his observatory at Marāgha and Ghāzān Khān erected one made after his own design at his suburb west of Tabrīz. There seems to be no record that Rashīd built an observatory in his suburb, but in view of his great zeal in promoting the sciences it is possible to believe that such a structure occupied a prominent place at the site. Further, letter number 51 mentioned above speaks of a dome which was apparently a landmark at the site. The word used in the text is often applied to a domed tomb,

but it may be that the lofty dome of the observatory was the landmark in question.

Recorded: July 1939.

Illustrations: Pls. 43, 44, 45, 46.

BIBLIOGRAPHY

Bayani (Trans. and Ed.), *Hâfiz-i Abrû*, I, pp. 151-152.

Quatremere, *Histoire des Mongols*, pp. xliv, xlvii, lii.

Le Strange, *Nuzhat-al-Qulūb*, p. 79.

Voyages de monsieur le Chevalier Chardin, I, p. 184.

Morier, *A second journey*, p. 231.

Porter, Ker, *Travels*, I, pp. 223-226.

Eqbāl, *Tārīkh-i-mofaṣṣel Īrān*, pp. 488-490.

Browne, *A Literary History of Persia*, III, pp. 70, 71, 86, 328.

Wilber, and Minovi, "Notes on the Rab'-i-Rashīdi," pp. 247-254, figs. 1-3.

Levy, "The Letters of Rasīd al-Dīn Faḍl-Allāh," pp. 74ff.

35

Ziāret tomb shrine

c. /1300

Summary: Apparently there has been no previous notice of this structure. It offers an additional link in the development of a plan-type: away from the solid, enclosed tombs of the Seljūq period towards the pavilion-like shrines of the Ṣafavid period. No dated inscription was found, but the structure may have been erected c. A.D. 1300.

Location: Some 50 kilometers east of Burjnurd on the northern road between Mashhad and the Caspian Sea.

Condition: Fair; inner dome intact, outer dome has large holes, exterior upper walls damaged.

Plan-type: Tomb shrine, octagonal exterior and square interior dome chamber.

Exterior: No foundation or base; walls of fired brick with usual unplugged scaffold holes; four portals with arched openings within arched niches; no trace of any decorative or finishing material on exterior walls; above window heads of dome was (vanished) stucco inscription .70 m. high; intramural stair within one corner angle leads to exterior base of dome.

Interior: Corner kite-shaped squinches resolve octagon to square; below springing line continuous stucco inscription band .25 m. high; at springing line eight arched panels pierced by windows on four sides of structure, inner dome of very flat section is one brick deep; outer dome is one brick deep.

Structural features: Fabric tied together by embedded timbers.

Ornamentation: Bricks: standard; cut.

Bond: common; elaborate on one section of dome drum.

Stucco: entire interior coated with hard, white plaster; scrollwork overlaid on main plaster coat; inscription below springing line has white letters on colored background.

Date control: 1. Plan-type is post-Seljūq.

2. Offsets in stucco overlay, incised lines in stucco, details of stucco pattern are all post-Seljūq in type.

Recorded: November 1937. Plan and section not previously published (plan drawn by John B. McCool).

Illustrations: Pls. 47, 48; Figs. 18, 19.

36

Demāvand Imāmzāda 'Abd Allāh

c. /1300

Summary: This structure is known as the Imāmzāda 'Abd Allāh. The monument has undergone considerable rebuilding in the course of which elements of construction and of decoration which would have been valuable in dating the structure have vanished. (No date was found on the inscription in the interior of the tower.) It is possible to compare the tomb tower with that at Varāmīn and hence to suggest a dating of c. A.D. 1300. Less likely is the possibility that the Demāvand tower was erected during the earlier Seljūq period since a small, well preserved tower east of the same village is clearly of the Seljūq period and differs in plan, proportion, and all decorative details.

Location: In the northern section of Demāvand village, 60 kilometers from Tehrān and five kilometers north of the northern road between Tehrān and Simnān.

Plan-type: Tomb tower; thirty-three right-angled flanges on the exterior; octagonal on the interior.

Exterior: No visible foundation or base (socle); the flanges rise directly from the ground to a point about 8 m. high where they are connected by a continuous arcade. From this point to the base of the roof, a distance of 3.50 m., the structure is revetted with blue glazed bricks; this zone is pierced at mid-point by nine pointed windows c. 1.50 m. in height. (This entire zone, from the flanges to the base of the roof, and probably the windows as well, represents a rebuilding of the tower.) Entrance portal on the north is now within a later flat-ceiling prayer hall and has door frame and carved wooden doors of a later period. At the south side of the tower an opening

closed by window grilles in two stories within a plastered frame (all of recent date). The roof is a thirty-sided cone (now clad with modern blue glazed brick).

Interior: Interior floor is of small blue glazed bricks (modern). Walls coated with white plaster (modern). Below springing line of inner dome a stucco inscription with painted ground in eight panels, each with two horizontal rows (probably later than the original structure). Inner dome intact, painted stucco star pattern.

Structural features: Evidence of extensive rebuilding and incorporation into adjoining prayer hall. It is not certain which side originally served as the main entrance.

Ornamentation: Bricks: standard (.18 by .05 m.; horizontal joints .005 m.; rising joints .025 m.).

Bond: common.

Joints: flush pointed (where well preserved in section long below present ground level).

Terra cotta: blue glazed bricks (modern).

Date control: 1. Similar to other tomb towers of Mongol period.

2. Proportions closer to Mongol than to Seljūq examples of the same general plan-type.

Recorded: May 1939 and May 1946. Plan not previously published.

Illustrations: Pl. 49; Fig. 21.

BIBLIOGRAPHY

Morgan, de, *Mission scientifique*, I, fig. 98, pl. XXI.

Byron, "Between Tigris and Oxus-I," fig. on p. 436.

Survey, pl. 348A.

37

Qumm		Imāmzāda 'Alī ibn Ja'far
700/1301	721/1321	738/1337-38
705/1305	734/1333-34	740/1339

Summary: In this account this monument will be referred to by the name currently used at Qumm rather than a longer and possibly more correct attribution. André Godard, in the *Athār-é Īrān*, calls the structure the tomb of 'Alī ibn Ja'far al-Sadīq and Muḥammad ibn Mūsā al-Kāzem, while in a later communication he refers to it as the tomb of Abu'l Hasan 'Alī ibn Ja'far al-Sadīq and Abu Ja'far Muḥammad ibn Mūsā al-Kāzem. Actually, the name of 'Alī ibn Ja'far does not seem to appear on any of the faïence originally in the tomb, but a small double funerary stela from the monument gives the names of his sons, Muḥammad ibn Mūsā al-Kāzem and 'Alī al-Morteza. In contradiction to the evidence of the stela the *Rāhnāma-yi-Qumm* states that Muḥammad ibn Mūsā al-Kāzem was buried in the tomb
of his brother, known from other sources to be situated adjacent to the tomb shrine of Shāh Chirāgh at Shīrāz.

The structure is of Type II of the tombs at Qumm (see p. 115). It is octagonal on the exterior and octagonal on the interior. The exterior walls are slightly battered and there is a deep setback above the cornice level to the vertical face of the sixteen-sided tent dome. The interior chamber is covered by a hemispherical dome.

The *Rāhnāma-yi-Qumm* states that the tomb was completed in 710/1310, without giving any authority for the statement. However, according to a recent communication from André Godard to the present author, surviving inscriptions indicate that the tomb is dated "the last day of the month Rabī' al-Akhar, in the year 700/ January 11, 1301" and that it was rebuilt in 740/1339.

The *Rāhnāma-yi-Qumm* and the *Athār-é Īrān* have a good deal to say about some forty-five pieces of glazed tile, once in the tomb and now in museums at Qumm and Tehrān. The smaller sizes of these tiles are believed to have been made at Kāshān between 710/1310 and 740/1339. The Qumm museum has a series of these star and cross tiles which were originally part of the dado of the tomb. Three of the star tiles bear the dates 705/1305, 721/1321, and 738/1337-38. Tiles of similar character are now dispersed among a number of private and public collections outside Iran. On display in the Tehrān museum is a large faïence luster miḥrāb from this structure, which was executed by the best known family of Kāshān potters of the period and which was completed in the year 734/1333-34. The Qumm museum also has a small, double miḥrāb-like funerary stela in faïence luster which is undated but which gives the names of the two saintly men cited in the opening paragraph.

The interior of the tomb is decorated with polychrome plaster in low relief. The design elements and type of carving found on the inner surface of the dome is very similar to the work in the upper gallery of the mausoleum of Öljeitü at Sulṭāniya. The colors used on the plaster include ochre, yellow, orange, brown, and red. The character of the plaster and the several dates of the faïence tiles from the structure appear to indicate that the decoration of the fabric began several years after the construction of the tomb. Possibly after 1313 when Öljeitü's mausoleum was completed, with the tiles of earlier dates having been brought from the ceramic worker's storehouse.

Identification: Iranian National Monument No. 240.

Recorded: April 1944.

Illustrations: Pls. 50, 51.

BIBLIOGRAPHY

Pope, "The Photographic Survey," p. 38, figs. 1 and 2.

Godard, "Pièces datées . . . de Kāshān," pp. 309-327, figs. 135, 139-146.

Rāhnāma-yi-Qumm, pp. 88, 89, 129.

Pope, "New Findings in Persian Ceramics," pp. 156-157, 160-161, figs. 8 and 9.

Guide du Musée Archéologique de Téhéran, p. 49, fig. 8.

Farhang-i-joghrāfīya-yi-Īrān, I, p. 170.

38

Abianeh Masjid-i-Miyān-i-Deh
 701/1301

Summary: According to a communication from André Godard to the present author, a portal inscription of this mosque "in the midst of the village" is dated 701/1301.

Abianeh is situated in the district of Naṭanz, along the road between Kāshān and Iṣfahān.

Recorded: Not visited.

39

Naṭanz Masjid-i-Jāmiʿ
 tomb of Shaykh ʿAbd aṣ-Ṣamad
 al-Iṣfahānī
 khānaqāh portal
 minaret
 704/1304
 709/1309
 707/1307
 716 or 717/1316 or 1317
 725/1325

Summary: Naṭanz, a small mountain village on the eastern road between Iṣfahān, Kāshān and Qumm, is the site of a complex of structures which bear dated inscriptions covering the years from 704/1304 to 725/1325. The combination of the bright colors of the exterior decoration, the great trees which overhang the main façade, and the bold hues of the mountains beyond make a striking picture and one reminiscent of Persian miniature painting.

A. Godard has planned and described the complex and published the inscriptions. The area includes a four īvān mosque with an octagonal domed sanctuary—the mosque displaying the dates 704/1304 and 707/1307; the tomb of Shaykh ʿAbd aṣ-Ṣamad al-Iṣfahānī of 707/1307; the portal of a *khānaqāh* or monastery whose date is probably either A.H. 716 or 717; and a minaret dated 725/1325.

Godard noted the differences in levels and the change in orientation between various sections and suggested that the lack of plan harmony throughout the structures was the result of the presence of previously existing streets or buildings. However, he seemed to believe that the complex was entirely constructed within the course of a few years. It now appears highly probable that the site itself was occupied before the dated work of the early fourteenth century was undertaken. The tomb of Shaykh ʿAbd aṣ-Ṣamad certainly antedates the four īvān mosque. At points where the plaster on the lower walls has fallen away, sections of an earlier system of decoration which included plaster brick-end plugs are visible. On the north exterior face is clear indication of an original entrance portal which was twice blocked up, the second time with plaster mouldings resembling those within the chamber itself and hence of about A.D. 1307.

Schroeder believes that the octagonal sanctuary of the mosque antedates the four īvān plan both because of the fact that they are not along the same axis and because an inscription in one īvān states that the "mosque was built in the mosque" which could well mean that the īvāns and the arcades were added to an existing structure. A study of the plan of the mosque does indicate that its location was dictated by the presence of a court or of a structure to the north of the tomb of Shaykh ʿAbd aṣ-Ṣamad. The west īvān is the key: it is much shallower than the other three. Had it been as deep as the others or of its actual depth but with the axis of the court a prolongation of the axis of the octagon, its west exterior wall would have been at least two meters further west and apparently this more normal size and location was impossible to achieve.

Thus, construction of the early fourteenth century was begun at a site presumably occupied by the octagonal structure, the tomb tower and other buildings. The portal of the mosque which opens from the street façade bears the date 704/1304. The four īvāns and the court arcades certainly date from the same period, although such later repairs as the filling of the profiles of broken-headed arches have destroyed uniformity of appearance. The wall surfaces are coated with white plaster with the exception of a fragment of an inscription band within the north īvān which contains the date 709/1309.

The tomb tower of Shaykh ʿAbd aṣ-Ṣamad has its axial miḥrāb direction at a variation of nearly ten degrees from that of the mosque itself. The plan displays four deep niches, rectangular in plan, on the axes of the structure and very shallow rectangular niches adjacent to each corner angle. The lower walls, above the dado level, are covered with hard, white plaster to the height of the encircling inscription frieze of carved plaster which bears the date 707/1307. The eight corners of the deep niches are marked by angle

colonnettes built up of cut bricks and strips of moulded and cut terra cotta. Above the inscription frieze is an extraordinarily elaborate plaster stalactite dome, rising from eight principal points above the angle colonnettes and lit by eight windows. On the exterior the square of the lower walls of the chamber changes to an octagon below the level of the frieze and a set-back to establish a smaller octagon occurs above the window heads. An eight-sided tent dome, once entirely covered with light blue glazed bricks, crowns the structure. It is possible that the entire upper section of the tomb was rebuilt at the time when the existing interior decoration was applied.

It is possible to speculate about certain vanished elements of the interior decoration. In the dado area a few light blue glazed cross tiles remain in place. It is certain that the dado was once made up of cross tiles and lustered star tiles and there are a few star tiles dated 707/1307 in public and private collections which may have come from this structure. Ettinghausen published an account of a section of a luster miḥrāb now in the Victoria and Albert Museum. The piece comprises a pointed arch, tympanum, and spandrels, and museum records state that it comes from Naṭanz. If the width of this piece be compared with the similar element in the well-known miḥrāb from Kāshān and if the other elements of both miḥrābs are considered to be in the same proportional relationship to each other, it appears that the overall width of the miḥrāb in which the Victoria and Albert fragment was used was either 1.40 m. (if the outer border contained two rows of tiles) or 1.20 m. (if the outer border had a single row of tiles). The miḥrāb wall of the tomb tower displays a plastered reveal about 1.30 m. wide which was once occupied by a miḥrāb. Border tiles, including one dated 707/1307 in the Metropolitan Museum, may also have formed part of the same miḥrāb.

The entrance portal of the khānaqāh is well preserved, although the vault has fallen, the original doorway is missing and the base of the façade is damaged. Only a single letter of the end of a façade inscription where the date was given is preserved. It is an "S" and it is reasonable to suppose that the missing date was either 716 or 717 since both "sixteen" and "seventeen" begin with "S" in Arabic. Between the khānaqāh portal and the portal of the mosque rises a minaret some 37 m. high. A panel built into its base gives the date of erection as 725/1325.

The decoration of the khānaqāh portal and of the minaret may be considered together since both display combinations of glazed faïence and unglazed terra cotta. Patterns and colors are reminiscent of decoration at the mausoleum of Öljeitü and at the shrine at Bisṭām, but the strapwork patterns are rather closer to those used at the latter site. Faïence and terra cotta are employed in a variety of ways: complete mosaic faïence in light blue, dark blue, and white with certain patterns made up of almost minute units; complete mosaic faïence in light blue and dark blue; tightly knit kūfi inscriptions in cut strips of light blue tiles against a depressed ground of dark blue strips; inscription bands made up of sections bearing light blue letters in relief on a light blue ground; moulded unglazed terra cotta inscription bands with the letters set on a depressed ground of alternating small squares of light blue and dark blue brick; panel and border designs of light and dark blue tile and and unglazed terra cotta; bands of light blue tiles on which letters or patterns have been created by scraping the rest of the surface down to the biscuit.

Identification: Iranian National Monument No. 188.

Recorded: February 1935 and June 1939. Plan after A. Godard.

Illustrations: Pls. 52, 53, 54, 55, 56, 57; Fig. 23.

BIBLIOGRAPHY

Houtum-Schindler, "Reisen im südlichen Persien," pp. 308-309.

Sykes, *Ten thousand miles*, pp. 179-180.

Dieulafoy, J., *La Perse, la Chaldée et la Susiane*, pp. 111-112.

Pope, "The photographic survey," pp. 25-26.

Ettinghausen, "Important pieces of Persian pottery in London collections," pp. 58, 59, 64, fig. 18.

Herzfeld, "Arabische Inschriften aus Iran und Syrien," pp. 93-95.

Godard, "Naṭanz," pp. 83-102, figs. 56-69.

Survey, pp. 994, 995, 995 n. 1; 1086-1089, fig. 391, pls. 367-372.

Schroeder, "M. Godard's review of the architectural section of *A Survey of Persian Art*," p. 213.

Herzfeld, "Damascus," pp. 38-40, fig. 27.

Répertoire chronologique, XIII, p. 258, no. 5182.

40

Ardabīl Masjid-i-Jāmiʿ
early 14th century

Summary: The Masjid-i-Jāmiʿ of Ardabīl is situated on the northeastern edge of the town and rises from a mound of some height in an area quite free of other construction. At present the monument consists of a square chamber, the dome of which has fallen, and a rectangular

prayer hall covered with a flat roof supported by two rows of slender tree trunks. A number of meters to the west is the stump of a circular minaret of fired brick.

A detailed study of this monument, recently published by M. Siroux, includes good photographs and excellent drawings. Siroux believes that the mosque was first erected in the eleventh century A.D., probably over the ruins of a Sāsānian structure, and that it was composed of the square dome chamber preceded by a lofty vaulted hall. He suggests that the structure may have been damaged when the Mongols destroyed Ardabīl in A.D. 1217 (actually a Mongol band sacked Ardabīl in A.D. 1220), and that the dome was rebuilt between 650-80/1252-81 at which time certain surfaces were covered with a plaster coating incised with false brick joints and false end plugs which concealed the original end plugs and joint decoration. Finally, he states that early in the fourteenth century the dome chamber was given a coat of white plaster, the plaster miḥrāb was constructed, and painted designs were applied to this plaster.

His theories are of definite interest, but present attention must center upon work presumably carried out in the Mongol period. There are elements clearly of the early fourteenth century. These include the coat of hard, white plaster which covers the interior wall surfaces of the dome chamber, the miḥrāb with its plaster stalactites and the painted decoration. The decoration occurs on the inner faces of the squinch arches and on roundels on the lower walls. The patterns are in light blue and were applied by means of stencils. This decoration is reminiscent of that used on the interior of the mausoleum of Öljeitü and in the tomb tower at Abarqūh, but at Ardabīl the patterns are more delicate in character and their use confined to more restricted areas.

It is doubtful whether there were actually two separate periods of construction and decoration within the Mongol period as suggested by Siroux. The exterior surface of the dome is decorated with small pieces of light blue faïence set at random into the brickwork. This technique is found in Seljūq work and hence the rebuilding of the dome may have been carried out before A.D. 1200. Further, the use of the false brick joints and false end plugs occurred over a long range of time. On the other hand, the rebuilding of the dome may have been carried out in the fourteenth century, just prior to the execution of the decoration discussed above which certainly dates in the opening years of this century.

Identification: Iranian National Monument No. 248.

Recorded: October 1936.

Illustrations: Pls. 58, 59, 60.

BIBLIOGRAPHY

Relation du Voyage d'Adam Olearius, I, pp. 435-436.
Bruyn, Le, *Travels*, I, pp. 168-169, pl. 48.
Morgan, de, *Mission scientifique*, I, p. 341, fig. 190, pl. XXXVIII.
Sarre, *Denkmäler*, p. 50.
Siroux, "La Mosquée Djoumeh d'Ardabil," pp. 89-100, figs. 1-16, pl. 1.

41

Kuhnagil mosque
707/1307

Summary: Herzfeld has written that at Kuhnagil, very close to Varāmīn, is a mosque dated 707/1307. The present writer visited the small village of Kuhnagil, some two kilometers southwest of Varāmīn, in search of this mosque. The village yielded only a small mosque with a tiny open court and a single prayer hall of quite recent construction. There was no inscription. The local people stated that there was no other mosque in the village nor did they know of any building containing a dated inscription.

BIBLIOGRAPHY
Herzfeld, E., "Reisebericht," p. 234.

42

Varāmīn portal of Masjid ash-Sharīf
707/1307

Summary: Near the tomb tower of 'Alā ad-dīn at Varāmīn is the badly ruined portal of a structure known locally as the tomb of Kūkab ad-dīn. A modern building, with an open court, has been erected behind and against the crumbling walls of the small scale entrance portal. However, until 1878 A.D.—according to the *Merāt al-Boldān*—the portal inscription named the structure as the Masjid ash-Sharīf.

The portal recess, of fired brick with decorated plaster end plugs in the rising joints, has a pointed arch opening in its rear (north) face. A horizontal inscription frieze, executed in plaster with *thulth* script on a scrollwork ground, once ran along the three faces of the recess just above the crown of the opening. Less than 2.50 m. of this frieze now remains: a few centimeters exist on the north face and the rest is on the west face. The end of the inscription, which contains a date, is damaged. A suggested reading is, "the year seven hundred and seven" (A.D. 1307). The words for "year" and "seven" are fairly clear and all but the last of the letters of

the "seven hundred" are visible. However, the character of the inscription and the other examples of decorative plaster would serve to place the structure in the early fourteenth century even were there no traces of a date.

Above the inscription frieze, the corners of the recess are bridged by squinches of flattened arch profile. The squinch faces and panels at the same level display geometric and floral ornament executed in plaster.

In view of the fact that this structure is probably dated A.D. 1307, it may well be that the mosque dated A.D. 1307 which Herzfeld stated was located in the nearby village of Kuhnagil may actually be identified with this monument.

Recorded: May 1939.
Illustrations: Pls. 61, 62; Fig. 22.

BIBLIOGRAPHY

Merāt al-Boldān, IV, p. 122.

43

Herāt tomb chamber of Ghiyath ad-dīn
 Muḥammad in the Masjid-i-Jāmi'
 portal of the Masjid-i-Jāmi'
 c. /1307-29
 c. /1300

Summary: The very large Masjid-i-Jāmi' of Herāt in Afghanistān has received but little attention. Niedermayer published a small sketch plan which is fairly correct except for the fact that the northeastern side of the mosque is actually much more extensive than shown on his plan since it extends several bays in depth behind the īvān on that side of the court.

References to construction work at the mosque are rather scanty and the main sources, principally of the fifteenth century, are not always in agreement. However, it seems fairly certain that the initial plan was carried out by members of the Ghurid dynasty. Ghiyath ad-dīn Muḥammad began construction work not long before his death in 500/1202 and this work included his own tomb which was surmounted by a dome. His successor Mu'izz ad-dīn, who died in A.D. 1206 continued the building as did Sulṭān Muḥammad, nephew of the latter ruler.

During the Mongol period Herāt was in the hands of the Kurt kings. Shams ad-dīn, the first of the line, commanded forces for Abāqā Khan and his dynasty continued in power until A.D. 1389. The third of the line, Fakhr ad-dīn, revolted against Öljeitü. His brother Ghiyath ad-dīn ruled from 1307 until A.D. 1329 and is said to have restored the mosque, especially the eastern and southern cloisters.

Certain areas of the mosque display features which seem related to this historical material. The mosque has a large central court with four īvāns and prayer halls behind each arcade face of the court. Sections of the court façades bear traces of stucco of the Seljūq period. A large chamber to the northwest of the mosque is commonly known as the tomb of Ghiyath ad-dīn Muḥammad. Elements of this chamber and of the portal on the northeast exterior corner of the mosque may be assigned to the Mongol period and will be the subject of the present discussion.

This square dome chamber measures some 17 m. along its interior faces. The exterior face of the northeast wall is built against the prayer halls and the rear of one of the īvāns of the mosque while the rest of the structure is free standing. The dome has collapsed and it is known that as early as A.D. 1833 debris from the fallen dome was piled up on the floor of the chamber. It is reasonable to suppose that the existing fabric dates from the Seljūq period and from approximately the year A.D. 1200. The unbroken surfaces of the lower walls and the treatment of the zone of transition and the squinch angle are consistent with construction of that period. However, the existing decoration of the chamber can be assigned to the early fourteenth century and probably to the years between A.D. 1307 and 1329.

The lower walls of the chamber are coated with plaster, which is incised with imitation brick bonding patterns spelling out sacred names. Above, a carved plaster inscription frieze, some .80 m. high, encircles the chamber. The zone of transition, which begins just above this frieze, is preserved in sections to a height of about two meters and these sections display no decoration. The reveals and niches in the walls of the chamber have a similar coating of incised plaster and also display inscription bands and bands of geometrical ornament executed in carved plaster. The style of the letters of the inscriptions and of their floral backgrounds is quite in keeping with dated structures of the early fourteenth century while the character of the geometrical ornament recalls decoration in the shrine at Bisṭām. At some later period the main inscription frieze was entirely covered with a thin coating of plaster.

The main portal of the chamber (now blocked) is decorated on the exterior not only with carved plaster but with inscriptions and geometrical interlaces executed in strips of cut terra cotta. Again the type of work is close to that found at Bisṭām. In connection with the question of the style and period of the plaster inscriptions it should be noted that Byron states that an in-

scription in the dome chamber contains the titles habitually used by Öljeitü and Abū Sa'īd, who were suzerains of the Kurts. These titles were not noticed by the present writer.

At the northeast exterior corner of the mosque is a blocked entrance portal which consists of a vaulted rectangular bay with flanking piers. The pier faces, vault area and spandrels above the vault arch display two periods of decoration. The second period is represented by complete mosaic faïence of the fifteenth or sixteenth centuries. Behind and clearly visible through damaged sections of the later work is a well preserved system of decoration which probably dates around the year A.D. 1300. The pier surfaces bear vertical inscription bands executed in cut terra cotta strips while the soffit of the vault arch and its spandrels have strapwork patterns done in the same material.

Recorded: October 1937. Measured plan not previously published.

Illustrations: Pls. 63, 64, 65; Fig. 24.

BIBLIOGRAPHY

Fraser, *Narrative of a journey*, Appendix B, p. 31.
Munshi Mohun Lal, "A brief description of Herat," pp. 16-17.
Dorn (Trans.), *History of the Afghans*, II, p. 89.
Barbier de Meynard, "Mouyin-ed-din."
Defrémery (Trans. and Ed.), "Histoire des Sultans Ghourides," p. 282.
Merāt al-Boldān, pp. 122-124.
Tate, *Seistan*, I, pp. 34, 43, 44.
Niedermayer, von, *Afghanistan*, pp. 54-57, sketch 5, pls. 145, 154-156.
Byron, "Timurid monuments in Afghanistan," p. 35.
Schroeder, "Preliminary Note," p. 135.
Wilber, "Preliminary Report," p. 121.

44

Maḥāllat Bālā	miḥrāb of the Imāmzāda Abu'l Faẓl wa Yaḥyā
	c. /1300

Summary: This structure is known as the Imāmzāda Abu'l Faẓl wa Yaḥyā. The existing complex is of Ṣafavid and more recent periods except for the stucco miḥrāb and probably the chamber in which it is found, but the walls of this chamber have been plastered inside and repaired on the exterior to such an extent that the constructional surfaces are not visible.

The miḥrāb is not an outstanding example of good craftsmanship. Patterns of geometrical figures are incised by very shallow cutting. The inscriptions display a lack of harmonious relationship between the lettered area and the background spaces and the pattern of the background fails to fill all the spaces between stemmed letters. Letters are heavy and awkward and the fluidity of fine plaster work is lacking. The backgrounds of the inscriptions are colored red and traces of blue color remain on some of the decoration.

Three of the inscriptions contain verses from the Qur'ān. Above the pointed arch of the miḥrāb is the signature of the craftsman, "Ḥasan 'Alī Aḥmād Babuyeh (Abud 'Alī ?)." At the base of the miḥrāb are two small horizontal panels, one on either side of a small axial, pointed arch niche. Each panel continues around the side walls of the miḥrāb recess—to the right and left respectively—for a distance of only .08 m. The panel on the right contains the words "the date of the year" with the beginning of the strokes of the first letter of each of the two words on the side wall. The panel to the left contains the word "seven" with no traces of any additional letters on the short side wall. It is highly probable that the original inscription read, "the date of the year seven" and, as André Godard has pointed out in a communication to the author, the reference is to the new Il Khānid era adopted under Ghāzān Khān. This new era began on Rajab 13, 701/March 14, 1302 and hence the miḥrāb was executed in 708/1308.

Location: On the road from Delijan to Khomein, some 20 kilometers from Delijan, a road branches off to the northwest and after 8 kilometers ends at the small village of Maḥāllat Bālā.

Plan-type: Tomb shrine. The complex has grown to its present size through construction work carried out at various periods.

Interior: The miḥrāb is located in the (approximately) south wall of a small square room which opens on the west to a larger chamber containing a carved wood sarcophagus, opens to the north to a narrow chamber, opens to the east to the exterior. The walls of the room are entirely coated with modern, white plaster. The villagers state that about 1920 the entire miḥrāb was moved from the east wall to its present position. Some sections do show modern damage and cracks, but it is hard to see how the local people were able to carry out such a task. The present floor is modern and its level is a number of centimeters higher than the original base of the miḥrāb.

Identification: The miḥrāb is Iranian National Monument No. 241 and is attributed to the Mongol period.

Recorded: March 1943.

Illustrations: Pls. 66, 67.

45

Qumm Imāmzāda Aḥmād ibn Qāsem
708/1308

Summary: The Imāmzāda Aḥmād ibn Qāsem, located to the south of the town of Qumm in the area of the former Qalʿa gate, survives in a ruined condition. However, the interior of the tomb does contain fairly well preserved inscriptions in plaster which are written in *kufi, naskhi* and *thulth* scripts. These include a fairly long building inscription which states that the construction was ordered by ʿAlī ibn Isḥāq, that the work was done by Muḥammad ʿAlī Abū Shujāʿ, and gives the date of 20 Moharam 708/30 June 1308.

Recorded: Not visited.

BIBLIOGRAPHY

Rāhnāma-yi-Qumm, pp. 129-130.
Farhang-i-joghrāfīya-yi-Īrān, I, p. 170.

46

Ashtarjān (Iṣfahān) Imāmzāda Rabiʿa Khātūn
708/1308

Summary: The Imāmzāda Rabiʿa Khātūn, situated a few hundred meters from the Masjid-i-Jāmiʿ of Ashtarjān, contained a miḥrāb dated 708/1308. Similar constructional materials and decorative details are present in both structures. The walls of the Imāmzāda and of the dome chamber of the mosque are of mud brick. The details of the arched heads of the side wall recesses of the Imāmzāda are very close to those of the arched head of the miḥrāb of the mosque. However, at the tomb shrine the polychrome plaster decoration was confined to the side wall recesses and the miḥrāb while at the mosque the decoration spreads over the entire surface of the dome chamber.

Inscriptions are—or were—present in both structures and suggest that the smaller structure was completed some seven years before the mosque. Actually the construction work may have been carried out at the very same time and the extensive decoration of the mosque brought to completion after several years of work.

Location: At Ashtarjān, a village some thirty-three kilometers to the southwest of Iṣfahān.

Condition: Fair. Until a few years ago, the chamber remained without a roof and was completely exposed to the weather. Then the fine stucco miḥrāb was removed to the Tehrān Archaeological Museum. At the same time an attempt was made to preserve the rest of the structure. The exterior of the miḥrāb wall was faced with fired brick. The corner angles of the chamber and the mid-points of the east and west walls were filled with brick piers which carry a modern roof. A new portal was opened in the west wall of the chamber. None of the modern repairs are indicated on the accompanying plan.

Plan-type: Tomb shrine. Square dome chamber.

Interior: The walls of the chamber are built of mud bricks which contain small pebbles and straw. Mud is the bonding material. The walls are covered with an .04 m. thick coating of matted straw and mud on top of which is about .01 m. of white plaster.

The eight shallow recesses in the side walls begin at 1.10 m. above the present (modern) floor. Apparently the plaster below the bottom of the recesses was painted red. The recesses are .18 m. deep and rise to 5 m. above the floor level. At each head is a pointed arch, .95 m. high, with almost straight side angles. The area within each arch is divided into five lobes and details are painted in dark blue, white, and green. Below the arch head the back wall of the recess has an axial undulating floral pattern in applied plaster. Stems and leaves are full half rounds of plaster. Dark blue and white border lines set off the patterns and details of the stems and leaves are painted in the same colors.

The walls of the structure are preserved to a height of 5.25 m. There is a single row of large scaffold holes at 2 m. above the floor level. Fragments of mosaic faïence were found in the debris and as crudely applied ornament on the roughly built tomb at the center of the chamber.

Structural features: All walls are of mud brick.

Date control: 1. The miḥrāb inscription is dated 708/1308. It is signed by its maker, "Masʿud of Kirmān."

Ornamentation: Bricks: mud (.28 m. by .06 m.) with pebbles and straw.

Joints: mud; horizontal joints .02-.03 m., rising joints .01 m.

Terra cotta: glazed; eight-pointed stars, hexagons, and filler pieces to form complete mosaic faïence in light blue, dark blue, and white glazed tile; inscription fragments with letters of dark blue and ground of light blue glazed tile.

Plaster: miḥrāb is on display in Tehrān Museum. Decoration of structure in applied plaster with details painted in dark blue, white, green, and red.

Recorded: April 1943. Plan not previously published.

Illustrations: Pl. 68; Fig. 25.

BIBLIOGRAPHY

Smith, "Islamic Monuments of Iran," p. 215.
Guide de Musée Archéologique de Téhéran, p. 54.

47

Sulṭāniya mausoleum of Sulṭān
Muḥammad Öljeitü Khudābanda
705-13/1307-13

Summary: Towering above the rather drab modern village of Sulṭāniya is the mausoleum of Sulṭān Muḥammad Öljeitü Khudābanda who reigned from 1304 until A.D. 1317. In 1270 the ruler Arghūn Khān had selected this fertile meadow area as the site for a proposed city and had ordered work begun on an enclosure wall. As soon as Öljeitü came to the throne he asserted his intention of carrying out the plan of his father. The work was started in 1305 and pushed rapidly forward. Historians of the fourteenth century write of the construction of a massive citadel wall of cut stone and of scores of imposing structures; and the new city, planned to be the commercial and political center of the kingdom, was dedicated in 1313.

The focal point of the city was the mausoleum of Öljeitü and the monarch probably followed the example of Ghāzān Khān when he erected his own tomb at the outset of his reign. Probably details of the mausoleum of Ghāzān Khān were a source of architectural inspiration. The fabric of the great octagonal structure must have been fairly well completed by 1309. At this time Öljeitü transferred his allegiance from the Sunni to the Shī'ite sect of Islam. His coins minted after 1309 bear the name of 'Alī and inscriptions on his miḥrāb dated A.D. 1310 in the Masjid-i-Jāmi' at Iṣfahān contain Shī'a phraseology. Öljeitü visited the holy tombs of Imām 'Alī and Imām Ḥusayn in 'Irāq and was struck with the idea of transporting their remains to Sulṭāniya. This action would make his new city a place of pilgrimage and help to swell its revenues. His own splendid mausoleum would make a fitting resting place for the Shī'a martyrs and so the interior decoration of the structure was carried out with this purpose in mind. However, his ambitious scheme was never executed. It has been stated that the chapel on the south side of the structure was added to contain the bodies of the martyrs, but the existing decoration is entirely of the second period. The interior was completely redecorated, probably by the year A.D. 1313, and traces of the name of Sulṭān Khudābanda are still visible. Near the end of his life Öljeitü reverted to the Sunni sect and was finally laid to rest in his mausoleum.

Ḥāfiẓ-i Abrū, a historian of the Tīmūrid period, gives dimensions of the mausoleum which fail to check with the real ones and adds: "It is a unique monument which has no equal even in the most distant lands." Godard has aptly characterized the structure in these words: ". . . it is certainly the finest example known of Mongol architecture, one of the most competent and typical products of Persian Islamic building and technically perhaps the most interesting."

A score of travelers have described and drawn or photographed the mausoleum. Godard, in his masterful study of the history, architectural features, and construction of the monument, and Pope, in his penetrating remarks on the ornamentation—both accounts in *A Survey of Persian Art*—have dealt with the mausoleum in full detail. The present account will not go over this same ground but will be restricted to some general considerations and to a special consideration of the two schemes of interior decoration of the structure.

The monument has an interior diameter of just under 26 meters and its wall are 7 m. thick. Three features complicate the simple octagonal plan: triangular blocks of construction at the north corners of the structure, which establish a longer façade on the north; a turret stair on the southwest corner angle; and a mortuary chapel on the south side. The exterior walls of the building display finished ornamental surfaces on the north, east, and west and were attached on at least the east side to adjoining structures.

In section the structure displays deep pointed arched reveals on the east side; eight gallery reveals opening into the higher wall surfaces of the chamber; and a continuous passageway or gallery below the base of the dome and opening toward the exterior of the structure. At the base of the dome eight minarets spring from the corner angles.

The monument is the fitting culmination of a steady line of prototype structures with dome chambers and side galleries among which are the tomb of Ismā'īl the Samanid, the dome chamber at Sangbast and the mausoleum of Sulṭān Sanjar at Merv. The dome no longer rests upon a massive square, for here the walls are pierced and lightened with deep niches, bays, stairways, windows, and galleries. Glimpses of the interior may be seen from without, while from within the blue atmosphere seems to permeate the structure. Loads and thrusts are properly concentrated upon a relatively small number of points and the enormous mass has an air of lightness and grace. The articulated scheme served as a model for later structures erected both in Persia and India.

Apparently no main avenue led up to the mausoleum and no major axis ended at its entrance portal. Actually it is uncertain which side of the structure was planned as the principal entrance, perhaps changes during the periods of construction and decoration shifted the emphasis

from the west to the north sides. An octagonal plan can have no inherent directional axis of its own, but the following consideration of the two periods of decoration shows that four bays, and hence two axes, were emphasized by more elaborate ornamentation.

The first decorative ensemble executed for the interior (and exterior) of the structure was certainly related to the plan for converting the mausoleum to a shrine housing the remains of 'Alī and Ḥusayn. Most of the wall surfaces had a revetment of light buff fired brick laid in common bond, in some cases combined with a diagonal square pattern, in some cases spelling out words in rectangular *kūfī*, including the name of 'Alī, these patterns being executed in square ended light blue glazed bricks. This type of decoration was used in the four bays on the minor axes of the chamber from the floor level to a visible height of at least 7 m. above the floor. In the major bays the decoration is more elaborate, consisting of all-over geometrical patterns of specially cut brick, thin light blue glazed strips, dark blue glazed strips and unglazed terra cotta cut to special shapes. Across the corner angles (both the outer and inner angles of each bay) were flat surfaces displaying a composition in light and dark blue complete mosaic faïence.

Flanking the doorways in the rear face of each minor bay (and perhaps surmounting the doorways) were strips of faïence mosaic in light and dark blue with portions of the biscuit exposed. Surrounding the inner (rear) wall face of each bay, fragments of mosaic faïence in light and dark blue with areas of exposed biscuit are visible. The minor bays are vaulted with stalactite systems, of which the original surface displays diagonal square patterns in light blue glazed bricks with interstitial patterns in light and dark blue glazed bricks, on a ground of fired bricks.

The intrados faces of the eight major arches have all-over patterns in mosaic faïence in light and dark blue with areas of exposed biscuit. On the intrados areas of the major bays, the decoration was continuous from the exterior wall surfaces to the interior and consisted of specially cut buff fired bricks, light blue glazed bricks and square ended carved terra cotta pieces.

At higher levels of the chamber other elements of the first period can be seen. The spandrels of the eight major arches of the chamber display light and dark blue faïence and the arch is outlined with a mosaic of light blue faïence and carved, unglazed terra cotta. Above the spandrels, the chamber was originally encircled by an inscription band, the details of which are not clear; it shows white letters painted on a dark blue ground, evidently with a vertical band of

faïence at the ends of each section of the frieze. At the top of this band was a narrow scotia moulding with a white palmette pattern painted on a dark blue ground. Immediately above this band and at the very base of the dome is a standard light blue glazed brick, suggesting the same type of decoration as on the lower wall surfaces.

After the plan to use the monument as a Shī'a shrine was given up, the entire interior of the chamber was redecorated. A dado about four meters high was applied, consisting of a continuous surface of hexagonal light blue glazed tiles, the dado interrupted at the sixteen corner angles of the chamber by inserted, five-sided engaged colonnettes completely covered with faïence mosaic in light and dark blue and white. This dado was crowned by a border about .12 m. in height, of underglaze painted rectangular tiles, with a ground of dark blue, a pattern in a light blue with a greenish cast and details in white.

Above the dado area the entire wall is covered with a thick coating of white plaster displaying traces of polychrome ornament and inscriptions in light blue, red, black, green, reddish brown and yellow gold, partly executed in low relief on two levels.

The chapel added to the south of the dome chamber has the hexagonal tile dado set in plaster directly against the core brickwork.

In the first period the patterns swept upward from the floor to the base of the dome and four bays were given special interest. In the second period horizontality was emphasized by means of the dado, the uniform wall treatment and the high encircling frieze below the base of the dome. In the first period all sixteen corners of the eight bays were treated alike while in the second period eight of them were given engaged colonnettes. More important than any of the separate details of either period is the fact that the craftsmen and designers were able to plan and execute two entirely different systems of ornamentation in a different combination of materials.

The decoration of the exterior of the structure probably all belongs to the first period of decoration. This is obviously true for the beautifully carved and painted plaster surfaces of the side walls and vaults of the highest gallery level. Twenty-four individual vault patterns are picked out in tones of red, yellow, green, and white. Pope has well illustrated and discussed the ornamentation of this gallery in the *Survey of Persian Art*. The gallery itself was quite well protected from the weather and all its exposed exterior surfaces were covered with sections of glazed

bricks, faïence combined with unglazed terra cotta, and complete mosaic faïence.

Complete mosaic faïence occurs in strapwork patterns in the spandrels of the pointed arch entrance portals. The surfaces of the piers and of the spandrels of the highest gallery are clad with a revetment of light and dark blue glazed bricks, the bricks rectangular rather than the standard square shape. The main cornice of the monument and the cornices at the top of the minarets were covered with simple patterns built up of strips of light and dark blue faïence and unglazed terra cotta. About two-thirds of the total color area is light blue. The dome was originally covered with an unbroken surface of rectangular light blue glazed bricks.

Identification: Iranian National Monument No. 166.

Recorded: Visited in 1936, 1937, 1939, and 1943.
Illustrations: Pls. 69-86.

BIBLIOGRAPHY

Nuzhat-al-Qulūb, English translation, p. 61, Persian text, p. 55.
Hâfiz-i Abrû, pp. 5, 6, 49.
Le Strange (Trans.), *Clavijo, Embassy to Tamerlane, 1403-1406*, pp. 158-159.
Relation du Voyage d'Adam Olearius en Moscovie, Tartarie et Perse, I, pp. 454-457.
Tavernier, *Les six voyages*, p. 73.
Les Voyages de Jean Struys, II, pp. 260-262.
Voyages de monsieur le chevalier Chardin, I, pp. 194-195, pl. XII.
Bell, *Travels from St. Petersburgh*, I, p. 99.
Hommaire de Hell, *Voyage*, III, p. 400.
Voyages de P. (ietro) della V. (alle), IV, p. 62.
Porter, Ker, *Travels*, I, pp. 275-280.
Morier, *A second journey*, p. 257, fig. opposite p. 257.
Texier, *Description de l'Armenie*, II, p. 76.
Dubeux, *La Perse*, pls. 29-34.
Flandin, *Relation du voyage*, I, pp. 202-204.
———, and Coste, *Voyage en Perse*, pls. XI, XII.
Dieulafoy, J., *La Perse, la Chaldée et la Susiane*, p. 45.
Dieulafoy, M., *L'art antique de la Perse*, p. 172.
———, "Mausolée de Chah Koda-Bendè," pp. 98-103, 145-151, 194-198, 242-243, pls. 23-26.
Merāt al-Boldān, IV, pp. 105-106.
Howorth, *History of the Mongols*, III, pp. 555, 560, 573, 581, 584.
Browne, *A year amongst the Persians*, p. 75.
Berchem, van, "Une inscription du Sultan mongol Uldjaitu," p. 374.
Feuvrier, *Trois ans a la cour de Perse*, p. 103.
Sarre, *Denkmäler*, p. 16, pls. XIII, XIV.
Godard, "Les monuments de Māragha," pp. 15-16.

Byron, "Between Tigris and Oxus-III," p. 544, fig. 2 on p. 541.
Survey, pp. 1062-1063, 1103-1118, 1339-1345, figs. 397-401, 491, 493-497, pls. 381-385, 525, 526.
Wilber, "The Institute's Survey of Persian architecture," pp. 112-113, fig. 4.
———, "Mosaic faience," pp. 44-46, figs. 21-25.

48

Iṣfahān miḥrāb in the Masjid-i-Jāmi'
710/1310

Summary: This fine miḥrāb is situated in the prayer hall contained in the area between the northwest corner of the court of the Masjid-i-Jāmi' and the north wall of the west īvān. This miḥrāb is at the south end and on the axis of the hall and apparently was built into an existing structural wall which itself has been repaired at some date subsequent to the erection of the miḥrāb. According to the inscription located within the head of the larger arch of the miḥrāb, published in full by Godard, the miḥrāb was executed in 710/1310 by 'Aẓad ibn 'Alī al-Mastari from funds supplied by the minister Sa'd al-Ḥaqq w'ad-dīn Muḥammad al-Sāva as part of the sections in structures rebuilt in the reign of Sulṭān Muḥammad Ghiyath al-dunya wal-dīn (Öljeitü).

The miḥrāb reflects the highest level of craftsmanship in plaster and is rather different in style from other miḥrābs of the period, both as regards pattern forms and the fact that the frontal plane of the plaster is quite flat and not in the usual bold relief.

Other writers have remarked that the miḥrāb was executed just after the conversion of Öljeitü to the Shī'a rite in A.D. 1309.

Identification: The entire Masjid-i-Jāmi' is Iranian National Monument No. 95.

Illustrations: Pls. 87, 88.

BIBLIOGRAPHY

Berchem, van, "Une inscription du Sultan mongol Uldjaitu," p. 374.
Gabriel, "Le Masdjid-i Djum'a d'Isfahān," *Ars Islamica*, pp. 32 and 33, fig. 27.
Godard, "Historique du Masdjid-é Djum'a d'Iṣfahān," pp. 230, 234, 236, fig. 155.
———, "Iṣfahān," p. 24, figs. 3 and 4.
Survey, pls. 396, 397A, 397B, p. 1314.
Godard, "Masdjid-é Djum'a d'Iṣfahān," *Athār-é Īrān*, pp. 315, 317, 319, 320.

49

Ashtarjān (Iṣfahān) Masjid-i-Jāmi'
715/1315-16

Summary: The Masjid-i-Jāmi' of Ashtarjān, erected by the command of Muḥammad ibn

Maḥmūd ibn 'Alī al-Ashtarjānī and dated A.D. 1315-1316, is situated on the northern outskirts of the village of that name and just a few hundred meters to the northwest of the Imāmzāda Rabi'a Khātūn, dated A.D. 1308.

The basic elements of the mosque are the north entrance portal, the open court with flanking prayer halls, and the dome chamber with its vaulted īvān. It seems probable that the complex was erected within a limited number of years in a series of consecutive building campaigns. Both the dome chamber and the Imāmzāda Rabi'a Khātūn are built of mud bricks of identical dimensions and both may have been erected at the same time and before A.D. 1308. At first the dome chamber stood as an isolated structure with portal on four sides but then the decision may have been taken to erect additional elements. Possibly the north entrance portal was then built and its location to one side of the north-south axis of the dome chamber may have been established by the existence of earlier structures, possibly an earlier mosque, on the site. As a third step the court, prayer halls, and east portal were built, possibly replacing the earlier construction. Once the entire constructional core of these elements was completed work was begun on the decoration which was brought to completion in the dome chamber and the east portal in A.D. 1315-1316 and in the north portal at the same time or slightly later.

The major interest of the builder of the complex was not in carefully executed and elaborately bonded constructional walls of fired brick, but rather in the decoration of a rapidly executed constructional core. This decoration, in plaster and glazed and unglazed terra cotta, is an authentic tour de force. In the number of materials used, in the various combinations of materials, and in variety of patterns, the decorative details are a compendium of the knowledge displayed on earlier structures and may well have been executed by craftsmen brought from several sections of the country. The names of two craftsmen occur in the inscriptions in the north entrance portal: one is "Aḥmād ibn Muḥammad, the builder" and the other is "Ḥājjī Muḥammad, the (tile-) cutter." A striking feature of the decoration is the extensive traces of polychromy within the dome chamber. When the decoration was newly completed the entire surfaces of the side walls and dome were a blaze of white, red, blue, green, beige, buff and gray-buff.

Location: At Ashtarjān, a village some 33 kilometers to the southwest of Iṣfahān.

Condition: Good. The tops of the minarets are missing. Within recent years repairs have been carried out in the prayer halls.

Plan-type: Mosque. Entrance portal leads to open court flanked on three sides by prayer halls and on fourth by entrance īvān of dome chamber.

Exterior: North entrance portal. The portal consists of a stalactite vaulted recess. The rear face of the recess displays a pointed arch portal within a pointed arch recessed panel, the whole within a rectangular recessed panel. The spandrels of the portal arch have geometric patterns executed in mosaic faïence, the patterns consisting of stars, hexagons, and complementary pieces in light blue and dark blue glazed tile and unglazed terra cotta. The spandrels are surmounted by a *naskhi* inscription band of rectangular pieces of light blue glazed tile set in a plaster ground. Framing the portal element is a rectangular band with a strapwork pattern executed in offset pieces of unglazed terra cotta with the voids filled with pieces of light blue glazed tile.

The lateral walls of the portal recess have at their base a ledge 75 cm. in height. Above the ledge each lateral face displays a pointed arch recessed panel, its tympanum filled with rectangular *kūfi* script in pieces of unglazed terra cotta offset against strips of light blue glazed tile. Immediately below the tympanum is a rectangular panel of mosaic faïence, consisting of a *naskhi* inscription in white letters on a dark blue ground and with a light blue frame; below this is an elaborate fret pattern in unglazed terra cotta offset on a plaster ground. The pointed arch panels are flanked by octagonal angle columns with simple abacus capitals, and the whole is enclosed within a rectangular reveal. The spandrels above the pointed arch panels are filled with geometric paterns executed in light blue glazed tiles and unglazed terra cotta and above is a rectangular panel filled with rectangular *kūfi* executed in the same materials as the tympanums of the pointed arch panels. Enclosing the areas described are, first, a rectangular band and, second, a rectangular recessed panel. The band is of mosaic faïence with a strapwork pattern in light blue, dark blue, and white on the left side of the recess, and, on the right side, a pattern of stars and heptagons in light blue and dark blue glazed tiles. The panel displays a strapwork pattern of pieces of unglazed terra cotta offset on a plaster ground.

Above the heads of the pointed arch recessed panel and the lateral panels runs a wide horizontal inscription band surrounding the three faces of the recess. The band is of mosaic faïence, the letters dark blue, with some of the diacritical marks in white, on a light blue ground, the band bounded top and bottom by a braid pattern in light blue and dark blue tile and unglazed terra cotta on a plaster ground.

Above the inscription band is the springing line of the transverse offset pointed arch, its intrados lined with a geometrical pattern in light blue and dark blue tile, unglazed terra cotta and glazed tile in which areas have been scraped off to expose the biscuit.

Just below the base of the stalactite vault is a series of panels containing rectangular *kufi* in offset pieces of unglazed terra cotta. Over the panels of the lateral walls are panels of elaborate bond executed in light blue and dark blue glazed cut bricks and cut fired bricks. The panel above the entrance portal is surrounded by geometric patterns made up of triangular and irregular triangular pieces of light blue and dark blue tile with sections of the tile scraped away to expose the biscuit.

The stalactite vault is in six tiers and displays geometric and floral patterns in light blue and dark blue tile with areas of biscuit exposed and in small glazed and unglazed cut bricks.

The flanking north walls of the portal recess have at their base an extension of the ledge of the lateral walls of the recess. Above each ledge is a pointed arch recessed panel, its rear face displaying an elaborate bonding pattern executed in bricks offset on square light blue glazed tiles. At the level of the capitals of the colonnettes which flank the panel is a horizontal band of *naskhi* script, the letters made by scraping to the biscuit on square dark blue glazed tiles. The tympanum has a repeat pattern in horizontal superimposed rows of alternating diamonds and hexagons in unglazed terra cotta offset on a plaster ground. The spandrels display floral patterns in light blue glaze with the pattern voids represented by areas which have been scraped back to the biscuit.

The pointed arch recessed panel is surmounted by a second and third similar panel. Wall surfaces flanking and between recessed panels display an elaborate bond offset against voids. The outer edge of each flanking wall of the portal is bounded by a moulding with a splayed edge and then a scotia moulding which displays rectangular *kufi* in light blue cut glazed bricks on a ground of cut unglazed bricks.

Minarets: Paired minarets rise from the outer edge of the portal walls. At their base is a zone of common bond with narrow rising joints and wide horizontal joints. Above, and to the preserved height of the minarets, are diagonal corkscrew bands of rectangular *kufi*, the bands are executed in glazed bricks on a ground of common bond. The bands are alternately light blue and dark blue. The minarets are entered from portals on the roof of the mosque. On the south lower zone of each minaret is a rectangular recessed

panel. Thin vertical slits open into the stairways of the minarets.

East portal: This portal does not have the decorative details of the north entrance portal. It consists of a vaulted recess. Over the entrance doorway in the rear wall of the recess is an inscription with letters of carved plaster offset on a ground of floral scrollwork, also in plaster.

Exterior walls: The bounding walls of the mosque are of mud brick.

Exterior walls of the dome chamber: These battered walls have a lining of fired brick.

Interior: From the north entrance portal a corridor leads to the northeast corner of the court of the mosque. Immediately within the corridor, steps on the east mount 1 m. to an area covered by a series of six vaulted bays, ranged three in depth and two in width. Below this area is the winter prayer room, reached by steps leading down from the corridor level. Within the corridor and to the west is a low flat-arched opening leading to adjoining bays; just beyond is a flat-arched opening giving access to a stairway which leads to the roof. The corridor itself consists of three vaulted bays spanned by transverse ribs of pointed arch profile, resting on rectangular piers. The floor of the corridor displays very large fired bricks laid in an elaborate bond.

At the center of the north side of the court is a wide bay spanned by a pointed tunnel vault, the whole as deep as two adjoining bays. Below the springing line of the vault is a cove, its face covered with an inscription in white plaster on a blue painted plaster ground. Immediately above this is a band of geometric ornament executed in cut unglazed terra cotta offset on a plaster ground. The lower walls and piers of the central bay display a plaster dado 1.20 m. high. The core of the inner faces of the piers has a simulated elaborate bond pattern in plaster with false joint lines and false end plugs and the same treatment is displayed on the intrados of the offset arches, in their spandrels, and as a revetment to the surface of the vault. Along the court face of the intrados of the vault is an offset panel containing an inscription and floral ground, with letters and ground painted blue and the geometric border painted red. In the north face of both piers which flank the vault is a small miḥrāb recess, consisting of a pointed arch recessed panel. The upper portion of the recesses display plaster ornament with traces of polychromy in red and blue.

On the west of the central bay, in a position corresponding to that of the entrance corridor on the east, are three bays in depth, the vaults of fired brick, resting on rectangular piers.

The east and west lateral faces of the court

display four pointed arch bays of equal width, each two bays in depth. On the east side, the south end displays a fragment of the original plaster revetment with incised false joint lines and false end plugs. On this face the arches and most of the piers have been rebuilt. On the west face, at the south corner, a larger fragment of the plaster revetment is visible.

The south face of the court displays, at the center, a wide tunnel vaulted īvān which leads to the dome chamber. The flanking walls, east and west of the īvān rise plain as high as the level of the top of lateral faces of the court, above this level a panel division begins but only the outer edge is now visible at either side since both the vault and the flanking walls have been rebuilt. At both exterior corner angles of the īvān are octagonal columns of moulded brick, their outer faces flush with the adjacent wall surfaces.

The rear wall of the īvān displays, at the center, an offset pointed arch opening flanked by octagonal angle columns. The intrados of the pointed arch displays, on a plaster slip over the constructional bricks, false joint markings and false end plugs. The jambs of the opening display similar false joints and end plugs. Flanking the center opening, at either corner of the rear wall, are similar offset pointed arch openings, with similar false joints and false end plugs on plaster.

Each lateral face of the īvān is pierced by two pointed arch openings leading to adjoining bays; these openings are similar to the ones at either corner of the rear wall of the īvān. The wall surface nearest the outer face of the īvān displays an elaborate bonding pattern with decorated plaster end plugs. The wall surface between the two openings is laid in common bond with decorated plaster end plugs and an outer frame of rectangular *kūfi* in red painted plaster. Above the reveals which frame the openings a wide horizontal band runs around three faces of the īvān. It was originally filled with an inscription of which only the stucco bed remains. Above this level and adjacent to the outer face of the īvān are traces of an offset intrados panel. Preserved is about 1 m. of an inscription band, the letters executed in pieces of light blue glazed tile with the interstices of the letters set with small pieces of dark blue glazed tile, the whole set into a floral ground of buff-colored plaster.

The dome chamber walls are of mud brick faced with a .035 m. thick coating of buff-colored plaster, originally covered with a slip of gray-buff plaster. Each interior face of the chamber displays a triple panel division.

The south, or miḥrāb, wall of the chamber has at its center the miḥrāb element. This consists of a pointed arch recess, of half-octagonal plan, with the head of the recess filled with stalactites, the whole outlined by a rope moulding. Above is a rectangular reveal, its outline continued by the outer edge of the rope moulding to form a rectangular frame, which is filled with carved plaster floral ornament, executed in high relief and painted blue, green, and white. The whole is enclosed in a rectangular panel with a splayed edge and with two lines of inscription painted blue and white; the whole within a wide rectangular scotia moulding with a plaster inscription painted red on a blue ground, the whole within a rectangular recessed panel ornamented with palmettes outlined in blue; this is surmounted by a high cove ornamented with floral plaster in high relief and with blue, green, and white polychromy.

The dome chamber is surrounded by a dado 1.70 m. high which displays an elaborate geometric pattern incised in plaster. Above the dado the walls are plaster-coated and have incised false bonding patterns and false end plugs.

On either side of the miḥrāb panel and near the corner angles of the chamber is a pointed arch recessed panel, the lower rear surface plaster-coated and with false bonding patterns and false end plugs, the tympanum filled with an elaborate strapwork pattern executed in plaster.

The west lateral face of the chamber displays flanking pointed arch recess panels near the corner angles. Each is pierced to about half its total height by a pointed offset arch opening leading to adjoining bays. On the axis of this wall is a pointed arch opening leading to adjoining bays; some 50 cm. above its crown, and continuing up to the top of the surmounting wall arch, the wall is pierced to admit light to the chamber.

The east lateral face of the chamber displays the triple openings of the west face but the openings are filled with modern grills; above the lateral arches the wall is pierced by rectangular openings admitting light from above the adjoining vault level.

Directly below the zone of transition a horizontal band encircles the chamber: its plaster surface bears incised false end plugs which are so arranged as to create, in rectangular *kūfi*, a continuous repetition of the word Allāh.

The zone of transition consists of four pointed arch squinches filled with built brick stalactites in four tiers and four wall arches of similar profile. The pointed wall arches display, along their profile, a plaster inscription band with *naskhi* letters on a ground of scrollwork and with traces of polychromy in red, blue, and white. The wall arch over the miḥrāb is deeply recessed and its intrados and rear face is filled

with plaster decoration in high relief with traces of polychromy in red, blue, white, and green while the wall arches of the lateral faces display on their intrados a strapwork pattern with the voids containing insets of rectangular *kūfi*, scrollwork, and inscription medallions, all in beige and white plaster. The wall arch over the entrance wall of the chamber was originally pierced by a rectangular window; it was blocked when the vault of the īvān was rebuilt.

Above the zone of transition rises the sixteensided drum of the dome, composed of sixteenpointed arch wall arches whose faces are filled with an elaborate bonding pattern. The arches of the octagon rest on half-arches which extend down to a point slightly above the string course, the wall surfaces above and below these arches are set in common bond with plaster end plugs in the rising joints.

Above the drum rises the slightly offset base of the dome. A wide horizontal inscription band encircles the dome at this point. The background of the plaster is painted blue and the inscription is surmounted by a narrow band of plaster ornament in red and blue which is surmounted by another band in red, white, and beige. At points corresponding to the mid-points of the four sides of the chamber the dome is pierced near its base by rectangular windows with lintels of wood. The dome, ovoid in profile, displays eight radiating ribs decorated with terra cotta diamonds and hexagons and with painted plaster interstitial elements, each such element is within a scrollwork frame of blue and white painted plaster. The segments of the surface of the dome between the ribs are alternately common and elaborate bond, covered with plaster bearing false joints painted white and decorated with false end plugs painted red and blue.

Structural features: The combination of core walls of mud brick lined with fired brick or, in the dome chamber, with a thick coat of plaster, differentiates this structure from both earlier and later monuments in the vicinity of Iṣfahān which are constructed entirely of fired brick.

Date control: 1. The plaster inscription band, in *naskhi* characters, within the east portal of the mosque includes Qur'ān LXXII, 18, followed by, "In the year seven hundred and fifteen" (A.D. 1315-1316).

2. The plaster inscription band, in *kūfi* characters, at the base of the dome, includes Qur'ān XLVIII, 1-6, followed by, "the year seven hundred and fifteen" (A.D. 1315-1316).

3. The period of later repairs to the structure is indicated by the inscription on a stone panel set into one of the piers on the east face of the court. The inscription contains the name of Abu'l Nasr Ḥasan Behador Khān.

Ornamentation: Bricks: standard (.21 m. by 0.45 m.): cut; moulded. Mud brick (.28 m. by .055 m.) containing straw and black pebbles.

Bond: common; elaborate.

Joints: horizontal joints .02 m.; rising joints .105 m. (in īvān). Plaster and terra cotta end plugs. Joint lines painted white (in dome).

Terra cotta: unglazed; strips of geometric, strapwork, fret and braid patterns; squares, diamonds, and hexagons; *kūfi* script; end plugs.

Glazed: strips of geometric, strapwork and braid patterns in light blue, dark blue, and white, squares, triangles, rectangles, hexagons, heptagons, stars, and irregular shapes in light blue and dark blue; *naskhi* and *kūfi* script in light blue, dark blue, and white; letters of inscriptions and pattern voids created by scraping back to biscuit on small glazed tiles or on square glazed tiles.

Plaster: thick, .035 m., coatings on wall surfaces; slip wash over these coatings; inscriptions and grounds of these inscriptions; plain plaster grounds of glazed tile inscriptions; incised geometric and strapwork patterns; false bonding patterns, false end plugs and false end plugs forming *kūfi* script; floral patterns in high relief; areas of plaster painted white, red, blue, green, beige, buff, and gray-buff.

Identification: Iranian National Monument No. 263.

Recorded: November 1936, June 1939, and April 1943. Plan not previously published.

Illustrations: Pls. 89-102; Figs. 26, 27.

BIBLIOGRAPHY

Smith, M. B. and K. D., "Islamic Monuments of Iran," p. 215.
Survey, pp. 1079-1080.

50

Ṭūs Hārūniya

early 14th century

Summary: This structure, known locally as the Hārūniya, rises in impressive isolation above the cultivated fields which now cover the site of the once important town of Ṭūs, located some twenty kilometers north of Mashhad.

The monument was first studied in detail by Diez who published a plan and an excellent section drawing. Pope, in *A Survey of Persian Art* has devoted careful attention to the question of the probable date of the structure.

The structure, rectangular in plan, includes a vaulted portal (vault now fallen), a square dome chamber with side wall entrances and reveals and

circular stairs at the corners, and three auxiliary rooms. The exterior walls of the building show no traces of faïence decoration. These wall surfaces are broken back in a bond design of arch headed panels with a wider central panel used between subdivided flanking panels. The presence of recessed horizontal panels suggests that some type of exterior decoration was planned but never carried to completion. Traces of decorative plaster remain within the portal bay.

The interior wall surfaces are coated with white plaster. The top of the unusually high plaster dado is marked by a horizontal plaster moulding and from the level of this moulding rise the vertical mouldings which emphasize the angles at which the square of the chamber changes to the octagon of the base of the dome. The squinch arches bridging the corner angles are not filled in, instead each one opens into a chamber accessible from the circular stairs. This gallery level is continued above each of the four axial portals. The inner dome of the monument is intact but the upper three quarters of the exterior dome are missing.

No inscriptions survive on the monument. Plaster decoration in very low relief is found in the main entrance portal and in the auxiliary rooms, while the chamber sides of the axial portals display nonstructural plaster stalactite vaults.

The monument bears a strong family resemblance to the tomb of Sulṭān Sanjar at Merv, erected about the middle of the twelfth century and to the tomb of Shaykh Muḥammad ibn Muḥammad Luqmān which was constructed at nearby Sarakhs in 757/1356. Although the plan form and the system of a second story gallery which masks the area of the zone of transition is so close to that of the tomb at Merv, it is much more likely that the monument at Ṭūs was erected in the early fourteenth century and served as the immediate model for the tomb of Shaykh Luqmān.

Pope has listed many of the features which suggest the early fourteenth century dating, including the exterior blind arcading which is found at the mausoleum of Öljeitü, the use of nonstructural plaster stalactites, the naturalistic floral forms of the plaster, and the double dome. To this list may be added the use of offset arches; the use of plaster mouldings of very slight projection and with incised edges; the emphasis upon verticality in the exterior panels; the profiles of the bases of the applied colonnettes which flank the corners of the entrance façade; and the method of breaking up the massive walls by the use of deep reveals, corner stairs, and galleries.

Identification: Iranian National Monument No. 173.
Recorded: November 1936 and later dates.
Illustrations: Pls. 103, 104, 105.

BIBLIOGRAPHY

Fraser, *Narrative of a Journey*, pp. 517ff.
Khanikoff, de, "Mémoire sur la partie méridionale," p. 346.
O'Donovan, *The Merv Oasis*, II, pp. 15ff.
Yate, *Khurasan and Sistan*, p. 316.
Sykes, "Historical notes on Khurasan," p. 1118.
Diez, *Churasanische baudenkmäler*, pp. 55-62, figs. 25, 26, pls. 19, 20.
———, *Persien*, pp. 95, 96, 170, fig. 40.
Byron, "Between Tigris and Oxus-III," fig. 3 on p. 541.
Survey, pp. 1072-1074, figs. 383-385, pl. 380.

51

Tabrīz Masjid-i-Jāmi' of 'Alī Shāh
c. /1310-20

Summary: Near the center of modern Tabrīz are the tremendous battered walls of an ancient structure which now shelter an open-air motion picture palace. A few decades ago the structure served as a strong citadel and shots fired in repeated attacks from the cannons in use in the nineteenth century produced only pox marks on its excessively thick walls. The monument is known locally as the *Arg* or "fortress," although its correct name, that of the Masjid-i-Jāmi' of 'Alī Shāh was in use from the time of its construction until at least the end of the seventeenth century.

Tāj ad-dīn 'Alī Shāh Jilān Tabrīzi, vazīr of Öljeitü, was a notable patron of architecture. He ordered the construction of a mosque at Tabrīz, and it seems likely that the work was carried out between A.D. 1310 and 1320. One early source suggests that 'Alī Shāh was himself responsible for the plan form of the monument. The monument deserves special consideration as being one of a trio of Mongol buildings—the others are the mausoleums of Ghāzān Khān and of Öljeitü—which were of tremendous scale and whose construction represented a bold step beyond traditional prototype models.

An extensive bibliography relates to this structure, but before drawing upon certain sources in a study of the plan and appearance of the original monument it may be well to establish the fact that the standing walls are actually those of a vaulted īvān which was the principal element of the mosque built by 'Alī Shāh. First, the standing walls are certainly part of a deep, rectangular īvān. Second, Ḥamd-Allāh Mustawfī, writing

about A.D. 1335, stated that the inner part of the Masjid-i-Jāmi' erected at Tabrīz by 'Alī Shāh was larger than the īvān at Ctesiphon. Third, Chardin, writing before 1673, describes the mosque of 'Alī Shāh and in his detailed view of the town illustrates the present structure with a label bearing this same name.

Three nearly contemporary accounts of the mosque are most useful: that of Ḥamd-Allāh Mustawfī; that of Ibn Baṭṭūṭa, writing between 1330 and 1350; and that of a "young, handsome and exceedingly intelligent young man." This young man, a member of the suite of the Ambassador from Cairo to the court of Abū Sa'īd, wrote a description of the mosque which was copied by Ibn Dukmak, writing in 1388. In 1451 Badi ad-dīn, in his 'Uqd al-Jamān, quoted Ibn Dukmak and, to complete the chain, Tiesenhausen summarized the material given by Badi ad-dīn.

The accompanying restored plan attempts to recreate the original layout of the mosque and its adjacent structures. It should be noted at once that this plan is based upon literary sources with the exception of two of the three crosshatched areas: one marked, "extant remains of original work" and the other, "extant remains of early rebuilding."

The complex may now be considered in some detail. First, there is the tremendous īvān itself which is 30.15 m. in width with side walls 10.40 m. thick, an assumed depth of 65 m., and a probable height to the springing of the vault of 25 m. The area shown in double crosshatching is undoubtedly part of the original construction scheme of the īvān. The openings on either side of the miḥrāb were not portals, but windows serving to bring light into the vast interior and their sills were several meters above the exterior ground level. Examination of the miḥrāb wall reveals signs of very skillful construction as well as of possible changes in scheme as the work progressed. Specifically, the final facing was applied several bricks in depth onto the fabric; three relieving arches were built into the wall above the head of the miḥrāb; the offsets and wall projections were supported on wooden beams; and the profile of the facing is not identical on either side of the miḥrāb.

The double crosshatched area is ended on the right and left wing walls with the finished surface of a door jamb and preserved springing lines indicate that wide and very high pointed arched openings occurred at these points. The single line crosshatched area on the right side of the īvān is an attempt to fill out the original plan form of the īvān. The hatched area on the left of the īvān appears to be a later rebuilding since it abuts against the finished portal jamb. It is true that the highest level of the wall is of fairly recent date, but on the other hand the reveals of the east (left) face of this wall are decorated with characteristic fourteenth century plaster. Before looking at the details of this wall it may be well to suggest why construction almost contemporary with that of the original īvān is found at this place. It is natural and logical to assume that the īvān was originally roofed by a transverse barrel vault. Ḥamd-Allāh Mustawfī is our witness that the structure came down shortly after its erection. The probability that he meant that the vault had collapsed is strengthened by a careful reading of the account given by an Italian merchant who saw the structure in A.D. 1514. He wrote, " (the mosque) is very large, but has never been covered in the centre. On the side towards which the Mahometanns pray, there is a choir that is a vault of such a size that a good bowshot would not reach the top; but the place has never been finished. . . ." The īvān appears in such detail in the illustration given by Chardin that one can see that at that period it still retained the entire rear wall against which the vault abutted and also a segment of the transverse vault itself. Thus, it is probable that shortly after the vault was built a section of it—but not the entire vault—collapsed. Either the actual fall or some structural weakness which occasioned the fall resulted in damage to the side walls and to the portal arches of at least one of the wide side portals. The contemporary repairs included the rebuilding of the left side and the filling up of the portal opening.

The reveals on the east side of this wall had an intimate relationship with the monastery structure located in that region. Traces of abutting lines of vaults or of a dome remain while decorated plaster panels framed the new opening from the īvān (this opening was later blocked up but dotted lines on the plan show its location).

To conclude this brief examination of the plan form of the īvān two points should be noted. First, the finished end of the east side of the īvān is not preserved. The older construction ends at the dotted line shown some 4 m. south of the existing repaired end of the wall but this existing end is thought to be at about the point at which the original wall ended. Second, there are no traces of the west side of the īvān north of the portal jamb other than a cohesive mass of fallen brick within the line of this wall.

The source material provides some information as to the decorative treatment of the interior wall surfaces of the īvān, but not enough for a complete picture. The young man from Egypt noticed that the pointed arch of the miḥrāb was

supported on two columns of Andalusian copper and that the miḥrāb frame was embellished and painted with gold and silver: it is probable that he saw a metallic luster faïence miḥrāb. The early witnesses speak of faïence decoration on the court façades, but do not mention this material in connection with the interior walls of the īvān. The interior surfaces of the brick walls are pitted with rows of scaffold holes spaced at rather regular intervals: other holes penetrate the surfaces but hardly in sufficient number to have provided attachment points for a faïence or other type of revetment decoration. The īvān is filled with debris to well above its original floor level so that no traces of a dado section are to be seen but it is probable that the dado was of cut stone or marble. It is possible that the interior wall surfaces were coated with white plaster but more probable that they were hung with woven materials. The young Egyptian reported that lamps, hung on copper chains adorned with gold and silver, illuminated the interior and he added that each latticed window had twenty large, round pieces of gold and silver decorated glass.

Aside from the īvān just described, no other section of the mosque remains standing and it is necessary to cite the sources which supplied the information used in preparing the restored plan. Ibn Baṭṭūṭa said: "on the exterior to the right of a person facing the qibla is a religious school (madrasa) and on the left a monastery (zāvieh, which can also mean the living quarters for dervish)." On the plan these elements have been composed in the general size of the period, although both plan forms and sizes are purely speculative.

The open forecourt of the mosque covered a very large area. Ibn Baṭṭūṭa wrote that the court was paved with marble; that the walls were covered with qashani (kāshāni, faïence decoration which took its name from the workshops at Kāshān); that a stream ran through it and that it contained trees, vines bearing grapes, and beds of jasmine. The Egyptian supplies the statement that the arches of the porticoes which flanked the court were all decorated with gold. The Italian merchant described the court in these words: ". . . all around it is vaulted in with fine stones, which are sustained by marble columns, which are so fine and so transparent that they resemble fine crystal, and are all equal in height and thickness, the height being about five or six paces." He adds: "Beside the principal door of the mosque is a stream flowing under stone arches. In the midst of the edifice is a large fountain . . . one hundred paces in length and as many in breadth, and it is six feet deep in the middle." He also speaks of a platform located at the center of the pool, stating that it is of recent date. However, the Egyptian gives a precise account of the original form of this square pool: it was 150 cubits wide, was lined with marble, and had a central platform each side of which represented a lion spurting water into the pool. Above the platform rose an octagonal fountain with two jets.

In restoring the plan of the court area the stream mentioned above has been located outside the enclosing walls and conceived of as a supply channel within built banks, leading from the river which flows about a half kilometer to the north. The arcades around the court have been treated very simply, although actually each bay may have been marked by a single column or by coupled columns. The plan forms of the principal entrance and of the side entrances are entirely assumed: it is also possible that there were large īvāns at the center of each side wall of the court.

The rather numerous references to the minaret or minarets of the structure and to its three doorways are neither clear nor precise. A minaret may have risen from the top of each side wall of the īvān (as in the portal at Qumm, the khānaqāh portal at Naṭanz, the portal of the Masjid-i-Niẓāmiya at Abarqūh, and other monuments of the period), or the semi-circular projection behind the miḥrāb of the īvān may have served as the base for a single lofty minaret. On this subject Chardin says: "the mosque of Ali-cha is almost totally ruined. Only they have repaired the lower part where People go to Prayers, and the Tower which is very high and is the first that discovers itself to the Eye, coming from Erivan." His drawing shows no high tower or minaret, but two round towers crowned with low domes which are placed on either side of the īvān façade, start at the ground level, and rise no higher than the springing line of the vault. The Egyptian stated that the mosque had two turrets, each 70 cubits high and 5 cubits wide, but he does not locate these turrets (minarets?). Possibly their upper sections collapsed and the stumps were finished off in a regular fashion prior to Chardin's visit. It seems less probable that a lofty minaret rose from the semicircular projection behind the īvān miḥrāb. Had the beds of the bricks of the huge vault been inclined toward the rear wall of the īvān the vertical extension of this projection would have served to buttress the vault. Chardin, in speaking of the very high tower, may have had in mind the high rear wall of the īvān and the segment of the vault itself which show up so clearly in his drawing.

The Italian merchant describes the portals of the mosque: "This mosque has three doors, of which two only are used and are arched; they are about four paces wide and about twenty

high and have a pillar made not of marble but of stones of different colors, while the rest of the vault is all of layers of decorated plaster. In each doorway there is a tablet of transparent marble ... even at the distance of a mile, one can clearly see these tablets, which are three yards each way, the door which shuts and opens being three yards broad and five high of huge beams cut into planks, covered with large cast bronze plates smoothed down and gilt." Now these three doorways may have been grouped in a curtain wall placed across the front, or open end, of the īvān; they may have been grouped at the principal entrance to the court itself; or they may have been placed separately at the three sides of the court. Again, Chardin's illustration does suggest that a curtain wall closed off the īvān, but such a feature may have been a later addition. The use of such a curtain wall would be quite contrary to known examples and to the architectural style and heritage as applied to this feature. It is rather more probable that the three doorways were placed in some such a huge entrance īvān as is suggested on the plan and that the central doorway was only opened for special occasions.

In conclusion, a word should be said to sum up the significance of the structure. The monument is a splendid witness to the material resources at the height of Mongol rule in Persia and to the healthy interest in architecture displayed by the leading figures. The plan reflects a highly individual adaptation of established architectural tradition. It also displays the ability of the builders to carry out a specific program. The aim seems to have been to surpass in size the īvān at Ctesiphon (according to the Egyptian, 'Alī Shāh ordered it to resemble Ctesiphon with an additional 10 cubits in height and width) and in actual fact the span of the īvān at Tabrīz is wider than at Ctesiphon. The envelope of the īvān was also considerably wider and higher than any of the European cathedrals.

Identification: Iranian National Monument No. 170.

Recorded: September 1937 and July 1939. Restored plan not previously published.

Illustrations: Pls. 106-112; Fig. 30.

BIBLIOGRAPHY

Nuzhat-al-Qulūb, English translation, p. 80, Persian text, pp. 76-77.
Hâfiz-i Abrú, II, pp. 90, 156.
Voyages d'Ibn Batoutah, II, pp. 129-130.
Grey (Trans. and Ed.), *A narrative of Italian travels in Persia*, p. 167.
Hammer-Purgstall, von, *Geschichte der Ilchane*, II, p. 390.
Hammer (-Purgstall), von, *Narrative of travels*, p. 135.

The travels of Sir John Chardin, I, pp. 353-354, pl. XI.
Morier, *A second journey*, p. 226.
Porter, Ker, *Travels*, I, p. 222.
Southgate, *Narrative of a tour*, II, p. 5.
Flandin, *Relation du voyage*, I, pp. 176-177.
————, and Coste, *Voyage en Perse*, pl. VI.
Hommaire de Hell, *Voyage en Turquie*, pl. LII.
Morgan, de, *Mission scientifique*, I, figs. 175-177.
Merat al-Boldan, IV, p. 99.
Tiesenhauesen, "Brief notes and information on the mosque of Ali-Shah in Tabriz," pp. 115-116.
Dieulafoy, J., *La Perse, la Chaldée et la Susiane*, p. 52, fig. on page 53.
Howorth, *History of the Mongols*, III, p. 653.
Survey, pp. 1056-1059, figs. 379-381, pls. 377-379.
Berezin, *Travels in Northern Persia*, pp. 26, 45-46.

52

Buzān (Iṣfahān) tomb shrine
 713/1313?

Summary: At Buzān, near Iṣfahān, is a complex which includes a mosque and a shrine. The early dated section of the complex, erected during the Seljūq period, has been published by M. Smith. Built at an angle against the Seljūq structure is a square chamber crowned by a dome. According to Smith the chamber is of recent date and an inscription on a stone set into its wall states that, "The name of this Imamzade is Shah Zadeh Karrar in Buzun and Hajji Mohammad Kazim has repaired it in 1313 (A.D. 1896)." However, F. Bazl states that in this same chamber is an inscription stating that it was built for Imāmzāda Shāhzāda walad Imām Ja'far Sardegh (*sic.*, for al-Sadīq?), and repaired in 713/1313. The present author has not been able to resolve the contradiction between these two accounts.

Recorded: Not visited.

BIBLIOGRAPHY

Smith, and Herzfeld, "Imām Zādè Karrār at Buzūn," pp. 65-81.
Pope, "The Photographic Survey," p. 30.
————, "Some recently discovered Seldjūk stucco," p. 114, figs. 3, 4.
Godard, "Iṣfahān," p. 27.

53

Dāmghān portal of ruined mosque
 c. /1315

Summary: Adjoining a tomb tower of the Seljūq period called Pīr-i-'Ālamdār is the site of a mosque which was probably erected in the Il Khānid period. The short stretches of fragmentary walls which now survive scarcely merit

detailed description, but it is apparent that they are the remains of an arched entrance portal.

Somewhat less than half of an inscription band which once ran around three sides of the portal bay is preserved. Following the opening invocation (bismillāh . . .), it reads, "the order for the construction of this mosque . . ." and then gives the title of the judge responsible for its erection. At the end of the surviving section can be read, "the work of Ḥājjī ibn al-Ḥusayn, the builder of Dāmghān." The Ḥājjī is the brother of the builder who had charge of the extensive work undertaken around A.D. 1300 at nearby Bisṭām and his name appears in an inscription at Bisṭām. The type of stalactite system used in the corner angle of this ruined portal is very similar to that of the entrance portal to the shrine of Bāyazīd at Bisṭām which is dated A.D. 1313, although it lacks the attenuated proportions common to all the work of the period at Bisṭām.

The Dāmghān portal may be assigned to c. A.D. 1315 and its estimated dimensions suggest that the mosque itself was rather small in size.

Recorded: November 1937.

Illustrations: Pl. 113; Fig. 28.

BIBLIOGRAPHY

Fraser, *Narrative of a journey*, p. 315.
Maṭla' ash-Shams, III, p. 279.
Khanikoff, de, *Mémoire*, p. 73.
Sarre, *Denkmäler*, pp. 113-114, pl. LXXXIV, figs. 154-155.
Herzfeld, "Gumbadh-i 'Alawiyyān," p. 196.
Survey, p. 1086, pl. 552C.
Yaghmānī, *Joghrāfāyī tārīkhī Dāmghān*, p. 49.
Répertoire chronologique, XIII, pp. 240-241, no. 5156.

54

Gaz (Iṣfahān) Īvān of the Masjid-i-Buzurg
 c. /1315

Summary: The Masjid-i-Buzurg at Gaz is a monument which has undergone many structural alterations during the past eight hundred years. Only a brief reference will be made to those sections which are not of the Mongol period.

Remains of the Seljūq period are the exposed portions of clustered piers. At that period, probably c. A.D. 1080, the mosque may have consisted of rows of these piers with their vaults or it may also have included one or more īvāns. The standing minaret is approximately contemporary with the clustered piers. (The above construction is indicated on the plan by double cross-hatching.) A few decades later the south and north façades of the court were established.

The Mongol period is represented by the con-struction of the west īvān (indicated on the plan by single direction hatching). Extensive work was undertaken at various later periods: the dates 1546, 1669, and 1931, etc., occur. For example, the entire north īvān was rebuilt in 1931.

There are a few elements of the west īvān which are not of the Mongol period. At a later date the vault was rebuilt and the springing line lowered to cover part of an inscription band while the top line of the façade was brought to the same horizontal plane as the other īvāns. The grille in the back wall of the īvān and the decorative panels which flank the interior corner angles are also later. The brick facing of the exterior or street side of the īvān is of recent date.

The īvān may be assigned to c. A.D. 1315, primarily on the affinity of structure and ornament to the dated mosque at Ashtarjān, west of Iṣfahān, although André Godard would assign it to the Seljūq period.

Location: Gaz is a small village some seventeen kilometers north of Iṣfahān.

Condition: Excellent.

Plan-type: Four-īvān mosque with minaret.

Description of the west īvān:

Exterior: The street façade of the īvān is of recent date.

Interior: The west façade of the court displays a central īvān flanked on both sides by two-storied pointed arch openings. Each opening consists of a pointed offset arch, enclosed from its springing line by a rectangular reveal, below which is an impost block of fired bricks, below which the line of the reveal is continued. The spandrels are filled with geometrical ornamentation in unglazed terra cotta. Between the arched openings and the īvān, on each side, are two superimposed elongated vertical recesses, rectangular in plan to slightly below the springing line where they are of flattened concave plan, the arched heads resting on a simple abacus below which are octagonal angle columns, offset from the outer face of the arch; the arch is enclosed from the impost blocks by a rectangular reveal, the line of which is continued by the outer face of the columns; the spandrels are filled with the same geometrical pattern.

The central īvān consists of a tunnel-vaulted īvān (vault rebuilt). Round angle columns of unglazed terra cotta with light blue glazed brick insets with elaborate capitals support an ornamental string course which ran around the three faces of the īvān, of terra cotta with a circle and diamond pattern, with ornamental carved stucco insets. Above this line the wall rises vertically and the intrados displays a fragment of a light

blue glazed tile *kūfi* inscription on an ornamented mortar ground, now almost completely concealed by the later *īvān* vault.

The lateral faces of the *īvān* recess display two offset pointed arch openings, of the same type as those flanking the *īvān*, but in each spandrel is a disk ornamented with rectangular *kūfi* in unglazed terra cotta with ornamental stucco in the interstices; a fragment of light blue glazed tile still adheres. The south lateral face displays a deeply recessed *miḥrāb* niche: the entire compositional unit framed by a rectangular frame with a rectangular *kūfi* inscription in unglazed terra cotta on a light blue glazed tile ground, within which is a rectangular reveal enclosing the *miḥrāb* arch, below which is an impost block (continuing as a string course), below which is an empty space (formerly the column capital), below which are the flanking octagonal angle colonnettes. The *miḥrāb* arch which is offset and which has its exterior face set back from the line of the impost blocks, displays a floral pattern in the spandrels, of unglazed terra cotta; the arch is vaulted with built stalactites in cut brick in three tiers, each arch outlined with light blue glazed tiles. Below the string course, which is similar to the larger one, is a small offset pointed arch recess with similar angle colonnettes, the spandrels filled with a geometrical pattern in unglazed terra cotta and carved stucco, the panel from the impost line being of flattened concave plan and filled with a geometrical pattern in unglazed terra cotta offset on a light blue glazed tile background. Below this is a decorated panel with a strapwork pattern offset in unglazed terra cotta on a light blue glazed ground, surmounted by a light blue glazed *kūfi* inscription on a ground of white plaster.

The rear corner of this wall face, and of the rear wall face each display a pointed arch recessed panel with a diagonal square pattern in fired bricks with light blue, dark blue, black, and white tile insets and plaques of rectangular *kūfi*, surmounted by a geometrical pattern in mosaic of the same colors, the two corner panels to the north enclosed at the outer sides by a frame of rectangular *kūfi* in black glazed tiles and fired bricks enclosed by light blue glazed tiles, the two panels to the south by an ornamental strapwork pattern in the same colors. The center of the rear face of the *īvān* displays a pointed arch grilled opening of the same period as the flanking panel, the intrados lined with rectangular *kūfi* in light and dark blue glazed tile and unglazed bricks. (The grille and the panels described in this paragraph are later in date than the *īvān* itself.)

The north lateral face of the *īvān* displays a plain wall surface opposite the *miḥrāb*. The intrados of the arched lateral openings display an elaborate bonding pattern with decorated end plugs. Above the string course, a wide inscription band of the same type as that blocked up on the intrados must have surrounded the three sides, continuing the one above.

Date control: 1. A close affinity of minor architectural features such as applied colonnettes, offset arches, arch headed recesses of elongated proportions, etc., and ornamental materials and details with the Masjid-i-Jāmi' at Ashtarjān, dated A.D. 1315-1316.

Ornamentation: Bricks: (reddish buff) standard (.215 m. by .045 m.); cut; moulded (angle columns of *īvān* and their capitals). Many reused bricks.

Bond: common; elaborate (intrados of openings to lateral passages).

Joints: incised line in horizontal joints; decorated end plugs. Mortar hard, grayish white, with minute pebbles. Horizontal joints .02 m.; rising joints .025 m.

Terra cotta: unglazed; strips of strapwork patterns, angle columns, circles and diamonds in string course, *kūfi* inscriptions, floral patterns. Glazed; light blue insets, light blue *kūfi* inscriptions, light blue border strips, light blue background tiles.

Identification: Iranian National Monument No. 324.

Recorded: June 1939. Plan not previously published.

Illustrations: Pl. 114; Fig. 29.

BIBLIOGRAPHY

Porter, Ker, *Travels*, I, p. 400.
Godard, "Masdjid-é Djum'a d'Iṣfahān," p. 321, figs. 219, 220.
———, "Khorāsān," p. 64, fig. 55.

55

Hamadān Gunbad-i-'Alayivān
c. /1315

Summary: This structure is known as the Gunbad-i-'Alayivān. There has been some difference of opinion as to whether this building was erected in the Seljūq period and hence before A.D. 1200 or whether it is a monument of the Mongol period. Herzfeld, in a detailed monograph, studied such documentary sources as appeared to concern this question and came to the conclusion that it dates between A.D. 1309 and 1316. Further, on stylistic grounds alone the structure would seem to date after A.D. 1300, although it does display features reminiscent of work of the Seljūq period. The geometric patterns in terra cotta

strapwork, the inscriptions executed in terra cotta letters and the brick bonding pattern are all very like Seljūq work at Marāgha and are even closer to the decorative details of the tomb tower of Mu'mina Khātūn at Nakhichevan of 582/1186-87. Two common decorative devices of the Mongol period are lacking in this monument; polychrome plaster and glazed tile. On the other hand, there are dated monuments later than A.D. 1300 in which faïence is not employed.

However, the monument does display a certain elaboration and expansion of Seljūq design and decoration. First, in the manner in which the exterior and interior wall faces are broken back into three dimensional niches and panels. Second, in the multiplicity of applied colonnettes and angle mouldings which give a quality of fluidity and restlessness to the façades. Third, in the stucco decoration which uses motifs common to the Seljūq period in a manner much like such a Mongol structure as the Pīr-i-Bakrān near Işfahān. The relief stucco abounds in reverse curves, tends to crowd beyond its frames, and seems somewhat loose and flabby when compared with the crispness and precision of Seljūq work.

The structure was clearly built to be free standing and to be viewed from all sides. In general aspect it has the air of provincial design and does not have a marked relationship either with the Āzerbāijān or the Işfahān style of the Mongol period. It probably was constructed c. A.H. 1315.

Location: Near the center of the important town of Hamadān.

Condition: Fair. Walls preserved to below springing line of dome and entire dome missing. Exterior wall of miḥrāb face damaged and portion of entrance portal destroyed. Some modern repairs.

Plan-type: Tomb shrine; square on the exterior; square on the interior.

Exterior: No visible foundation or base. Corners have stellar flanges crowned by pointed arches, above this point was a continuous inscription band (now all but destroyed) with terra cotta letters. Side walls of structure have two pointed arch panels within rectangular frames. Entrance façade displays pointed arch portal within a rectangular frame within a second pointed arch panel with a rectangular frame, the whole surrounded by a cavetto moulding.

Interior: Interior floor not preserved. All existing surfaces plaster coated. Dado about 1 m. high crowned by a continuous inscription band. Each wall face has a three panel division marked, except for the miḥrāb and entrance doorway panels, by a pointed arch niche within a rec-

tangular frame. Clusters of applied colonnettes separate the panels and eight pairs of these colonnettes are carried on up over the squinch arches. A blocked door led to a stair in the northeast corner angle of the structure.

Structural features: Most unusual is the use of stellar flanges at the corners of a square plan. The interior of the structure displays a clustering of vertical colonnettes and mouldings which are a plaster shell applied to the plane surfaces of the bearing walls.

Ornamentation: Bricks: standard; cut.

Bond: common (not exposed on exterior or interior of structure); elaborate.

Terra cotta: unglazed; cut strips in strapwork patterns, strips, and moulded pieces in inscriptions and colonnette patterns.

Plaster: elaborate patterns in bold relief, knife cut flush patterns on colonnettes and angles, inserts within terra cotta strapwork.

Date control: See *Summary* above.

Identification: Iranian National Monument No. 94.

Recorded: October 1937 and later visits.

Illustrations: Pls. 115, 116; Fig. 31.

BIBLIOGRAPHY

Herzfeld, "Die Gumbadh-i-'Alawiyyân," pp. 186-199.
Pope, "The Photographic Survey," p. 22, fig. 1.
Survey, p. 1019, pls. 329-332.
Morgan, de, *Mission scientifique*, II, p. 136.

56

Gārlādān (Işfahān) īvān below the shaking
 minarets
 c. /1315

Summary: This structure includes an open court three sides of which represent fairly recent construction. The court is entered next to the south corner of the īvān and the side walls of the court are built against the wings of the īvān. There is a small īvān at the center of the south side of the court. On the north side of the court is an īvān of the Mongol period which shelters the tomb of Shaykh 'Amū 'Abd Allāh bin Muḥammad bin Maḥmūd Soqla who, according to the inscription on the gravestone, died in A.D. 1316. The corners of the south face of the īvān bear a pair of minarets.

The minarets have made the structure one of the few authentic "tourist traps" in Iran. When a person ascends to the gallery level of one minaret and rocks back and forth the minaret sways and the shaft of the other minaret also sways in rhythm. This feature is considered so

wonderful and miraculous that the minarets are famed throughout the country. Many books of travel describe the minarets while scarcely anyone has troubled to look at the fine īvān itself.

The minarets are not high and, indeed, the īvān walls could not support much more of a load. They have no scale relationship with the īvān, seem to be of recent construction and are used in a manner not common to monuments of the Mongol period. Thus, it is certain that the minarets have nothing in common with the īvān below.

The īvān displays many features characteristic of the first quarter of the fourteenth century. Apparently this monument, unlike several others of the Iṣfahān area, was completely decorated after the construction work was finished. It is possible that the īvān was erected in relationship to existing structures. If it had been built as an isolated monument it probably would have been reversed in plan so that a properly oriented miḥrāb could have been placed on the axis of the rear interior wall.

The īvān may have been constructed c. A.H. 1315.

Location: Adjacent to a main road leading west from Iṣfahān, some four kilometers from the center of the city, in a section called Gārlādān.

Condition: Excellent. Vaults restored and some walls repointed in 1925.

Plan-type: Vaulted īvān, with side bays and galleries.

Exterior: The façade of the īvān displays a transverse arch springing from angle colonnettes with a chevron bonding pattern in the spandrels above. The wings of the façade display rectangular recessed panels in two stages, both crowned by pointed arches. The lower panels have angle colonnettes and a simple plaster pattern within the arch heads. Five rows of unplugged scaffold holes are visible. Minarets spring from the top of the façade wings. There is nothing of interest on the other exterior faces of the structure.

Interior: The floor is of bricks laid flat. Each side wall of the īvān displays a system of two rectangular recessed wall panels and two deep rectangular bays. The panels begin some distance above the floor, have angle colonnettes of small moulded bricks, and are crowned by pointed arches. The bays are covered with tunnel vaults having offset springing lines. The undersurfaces of the vaults show an elaborate bonding with some bricks raised above the surface, but this bonding may reflect modern repairs.

The rear wall has an axial, deep rectangular bay covered by a flat, broken headed vault. The rear surface of the bay, above the springing line,

has a diagonal square bonding pattern. The bay contains a tomb and a gravestone (position of stone shown by an arrow on the plan), set against the wall, with a dated inscription. West of the bay a door leads into a simple rectangular room. East of the bay a door leads into a room which contains a stair leading to the gallery level. Above each of these doors is a panel containing a pattern of stars and crosses done in dark blue and light blue glazed tiles.

The axial bay on the gallery level is covered by a vault similar to that used on the bay below. The side bays of the gallery have built stalactite vaults and elaborate bonding in a herringbone and other patterns. The gallery bays are fronted by low balustrades whose faces are covered with star patterns done in dark blue and light blue glazed tile and unglazed terra cotta.

The springing line of the vault occurs at the gallery level. Beginning with the line of the façade the treatment of the vault over the īvān is as follows. A transverse pointed arch with its soffit coated with white plaster which may have contained an inscription band. A transverse pointed arch with a soffit decoration of square ends of dark blue glazed brick set into a diagonal brick lay. A wider section containing a flat central vault with a star inside an octagon and flanking flat, broken headed vaults. A transverse pointed arch with a soffit decoration of square ends of dark blue glazed brick set into a diagonal lay. A wider section containing a flat central vault with a star inside a hexagon (may represent a recent restoration) and flanking flat, broken headed vaults.

Structural features: The type of vault construction found in the sections of the main īvān vault and in the gallery bays is very similar to that used in the galleries of the mausoleum of Öljeitü at Sulṭāniya.

Date control: 1. The inscription on the gravestone begins with "this tomb," gives the name of the deceased and then the date of his death: the 17th of Dhu'l-Ḥijja in 716/2 March 1317. Neither the horizontal tomb nor the upright gravestone are an integral part of the structure.

2. The date 861/1456 is found on a dark blue tile set into a wall of the gallery corridor. It is done in strips of light blue tile and represents a reuse of a star tile which was contemporary with the original structure.

3. Panels on the upper rear wall of the īvān state that the vaults were restored in 1344/1925.

Ornamentation: Bricks: buff, standard (.20-.25 m. by .05 m.); cut; small moulded.

Bond: common; elaborate.

Joints: horizontal averaging .015 m.; vertical are minimum. The pointing is modern.

Terra cotta: dark blue and light blue glazed star tiles, crosses, square end bricks, and smaller geometrical shapes. Unglazed pieces of cut terra cotta.

Identification: Iranian National Monument No. 349.

Recorded: April 1943. Plan and elevation not previously published.

Illustrations: Pls. 117-120; Figs. 32, 33.

BIBLIOGRAPHY

Sādeqi, *Iṣfahān*, pp. 162-164.
Heydayat, *Iṣfahān nisf-i-jahān*, pp. 43-44.

A considerable number of travel accounts mention the minarets, but not the īvān proper.

57

Kūfa—Dhu'l-Kifl ('Irāq) minaret
c. /1316

Summary: This minaret is adjacent to the so-called tomb of the prophet Ezekiel at Dhu'l-Kifl, near Kūfa. Herzfeld has published the fragmentary inscription, given illustrations, and discussed the question of the identification of the sanctuary with a mosque and minaret which Ḥamd-Allāh Mustawfī stated was built at Dhu'l-Kifl by Öljeitü. Herzfeld has not described the monument and the following brief account derives from his illustrations.

The shaft of the minaret rises from a high, square brick base, the base being set into the projecting bay of a lofty enclosure wall. The circular shaft has the following decorated divisions: a section in common bond; an elaborate section built up of small pieces of moulded terra cotta, the whole spelling out pious words in alternate upright and inverted triangles; a section with a diagonal square pattern in which the pattern is composed of standard bricks whose rising joints are inset with end plugs of moulded terra cotta; an inscription band in two lines composed of a series of terra cotta slabs, each slab containing several letters on a patterned ground. An elaborate stalactite cornice built up of long terra cotta strips with the salient faces inset with decorated slabs of moulded terra cotta; a balcony over the cornice with a door leading into the highest portion of the shaft which is laid in common bond.

The decoration of the shaft is a revetment about .08 m. thick applied to the structural core.

The inscription implies that the erection of the monument was ordered by Öljeitü and it states that it was completed by his son, the Sulṭān (Abū Sa'īd). Since Öljeitü died in 716/1316, the minaret must date very close to that year.

Apparently glazed tiles were not used on the minaret and, indeed, the use of well executed pieces of moulded terra cotta in a great variety of shapes is much more closely related to contemporary technique at Baghdād than to the decorative features of the monuments of the Iranian plateau.

BIBLIOGRAPHY

Tarikh-i Guzida, p. 60.
Herzfeld, "Damascus," pp. 29, 30, figs. 70-72.

58

Nasmus mosque
720/1320

Summary: The site of Nasmus is located within the present boundaries of the U.S.S.R., between the Aras River and the important old town of Berda'a.

Khanikoff says not a word about the plan, appearance or condition of a mosque which he discovered at this site. However, he does give the text of its long Arabic inscription which includes these phrases: ". . . during the reign of the king of Islam, Abū Sa'īd Bahādor Khān . . ." and ". . . this was written on Monday, the fourth of Ramazān of the year 720 [8 October 1320]."

Recorded: Not visited.

BIBLIOGRAPHY

Khanikoff, de, "Mémoire sur les inscriptions musulmanes du Caucase," p. 72.

59

Abarqūh tomb of al-Ḥasan ibn Kay Khusraw
c. /1320

Summary: Inscriptions state that this structure served as the burial place for al-Ḥasan ibn Kay Khusraw, who died in A.D. 1318, and as the resting place of his daughter.

The tomb is an interesting example of a class of monuments which has almost entirely disappeared: those structures which were built almost completely of mud brick. Here the structure was really too large in size for the strength of such a material and as a result parts of two walls and a segment of the dome have collapsed. Often the mud brick structures were lined with a single thickness of fired bricks. Commonly the exterior walls were left unfinished or perhaps coated with a mud wash while the interior wall surfaces bore a plaster undercoat and a finish coat of hard, white plaster.

At the present day the number of mud brick structures of the Mongol period is very small compared to those of fired brick, but it is safe to assume that originally many more buildings were

put up in mud brick than in fired brick. Work went much more rapidly and could be started without preliminary preparation and costs were lower.

It is of interest to compare the painted decoration of this tomb with the contemporary plaster miḥrāb in the Masjid-i-Jāmiʻ at Abarqūh and to see how two techniques carried on side by side. The decoration of the tomb tower reflects the influence of the mausoleum of Öljeitü and the development of the type appears in the later structures at Yazd.

The structure was erected c. A.D. 1320.

Location: In the vicinity of the Masjid-i-Jāmiʻ of Abarqūh.

Condition: Fair. One corner angle of the plan is missing and the gap continues up into the shell of the dome.

Plan-type: Tomb tower. Square on the exterior; square on the interior. Hemispherical dome on a high drum.

Exterior: Walls are six mud bricks thick to springing line where a slight set-back thins down the walls. High drum and dome itself are of mud brick. The dome was clad with light blue glazed bricks (probably original). The eight arches of the zone of transition are of fired bricks laid with their long dimensions parallel to the direction of the arch. Exposed scaffold holes are visible on walls and dome. A protective shell of mud bricks abuts against each corner angle arch.

Interior: No trace of an original floor. Three pointed arch portals and a miḥrāb occupy the axial points of the plan. Each interior wall displays a tripartite composition: at the center a stilted, flat headed arch panel surrounds the doorways (and miḥrāb) and at the corners are pointed arch panels with the arches springing from delicate plaster colonnettes and the arch heads filled with plaster stalactites. The miḥrāb is treated as a two dimensional feature, except for its simple vaulted niche, and is kept low to allow space above it for a long historical inscription.

Above the tripartite wall treatment is a horizontal band, about 1 m. high, encircling the four walls and with an inscription executed in dark blue pigment. The zone of transition has a rather unusual treatment. The four arches over the corner angles are built within the actual structural arches and are somewhat smaller in size. They are filled with nonconstructive stalactites. The structural wall arches are completely concealed by plaster and a simple painted line on the plaster indicates their approximate size and location. There is a rectangular window in the area above the miḥrāb. The zone of transition is

crowned by a simple painted frieze which runs horizontally around the eight sides of the structure. At the base of the dome is an encircling inscription in dark blue painted letters. The entire inner surface of the structure is covered with a hard, white plaster coat applied to a plaster undercoat with a total plaster thickness of .08 m.

Structural features: The predominance of mud brick with fired brick used only in the eight arches of the zone of transition. The plaster treatment of the interior which conceals and contradicts, rather than emphasizes, the actual structural system.

Date control: 1. The inscription above the miḥrāb (published in full by Godard) states that the tomb was built for Ḥasan ibn Kay Khusraw who died in the year 718/1318 and for his daughter, deceased in 707/1307. Of course, the monument may have been erected a few years after this date.

Ornamentation: The decoration is primarily linear. Mouldings are of slight projection and even the salients of the stalactites are grounds for linear patterns. In decoration of this kind it would have been possible to draw all the pattern forms directly on the white plaster without regard as to whether the outlines would be filled with pigment or plaster in low relief. Stencils may have been used in applying the patterns. At Abarqūh the decoration is largely confined to mouldings, bands, and panels while in the slightly later development of this technique at Yazd an attempt is made to decorate the entire wall surface. The colors used on the plaster were light blue, dark blue, red, green, and yellow.

Identification: Iranian National Monument No. 196.

Recorded: February 1934. The plan is after one published by Godard.

Illustrations: Pls. 121, 123; Fig. 34.

BIBLIOGRAPHY

Godard, "Abarkūh," pp. 60, 61, 63, 68, figs. 42-47.

60

Salmās Mīr-i-Khātūn
c. /1320

Summary: Material for an adequate study of this monument, formerly called Mīr-i-Khātūn, is lacking since the tower was completely destroyed by earthquake (1929?) and information concerning it comes principally from a single published photograph taken before 1907.

The structure displayed features common to the region of Āzerbāijān and may well have

served as the model for the rather more elaborate tomb tower at Khiav. Herzfeld has made the suggestion that the Salmās tower was the tomb of a daughter of Amīr Arghūn Khān of Rādkān (cf. tomb tower, Rādkān) who married the vazīr Tāj ad-dīn ʿAlī Shāh. Herzfeld states that the date must be either 700/1300 or 710/1310. Actually no name is legible in the single damaged inscription. The "seven hundred" shows clearly in the photograph of the tower, but there is no trace of the rest of the date. Judging from the faïence technique, the structure might date from about A.H. 1320. The composition of the main entrance portal is very similar to that of the Khiav tower. In view of the location of Salmās adjacent to the western frontier of Iran it is of interest to note that the decorative band, which is knotted above the portal stalactite vault and then run up and over to create a frame for the inscription, is a feature more characteristic of thirteenth century architecture in Asia Minor than of Iranian work of the period at which the tower was built.

Location: On the outskirts of the town of Salmās, some 195 kilometers west of Tabrīz. The town is now called Shapur.

Condition: Completely destroyed.

Plan-type: Tomb tower; circular exterior.

Exterior: Cut stone base; exterior walls of fired brick crowned by stalactite cornice; conical roof which disappeared long before the rest of the structure was destroyed. Two opposed entrance portals; main portal with square head was surrounded by miḥrāb-like frame enclosed by rectangular cavetto moulding. Damaged inscription in panel at top of portal frame, continuous inscription below exterior cornice.

Ornamentation: Bricks: standard.

Bond: common.

Terra cotta: mosaic faïence in portal frame, exterior cornice and continuous inscription band —probably in light blue, dark blue, and white glazed tile. Glazed; in wider rising joints of exterior wall were inset small squares of light blue glazed tile.

Date control: 1. According to damaged inscription, later than A.D. 1300.

2. Decorative details are of type of later Mongol period.

Illustrations: Pl. 122.

BIBLIOGRAPHY

Berchem, van, "Arabische Inschriften," pp. 158-160.

Herzfeld, "Die Gumbadh-i ʿAlawiyyân," p. 193.

Survey, p. 1072, pl. 344.

61

Farūmad Masjid-i-Jāmiʿ

c. /1320

Summary: The Masjid-i-Jāmiʿ is situated on the outskirts of a small village, but the extensive areas of ruined construction in the vicinity indicate that several centuries ago there was a prosperous town at the site.

The earliest construction work at the mosque which can be assigned to a specific period was done in Seljūq times. The ensemble was brought to completion in the Mongol period and was later complicated by additions and alterations, some of which date from quite recent times. It would be beyond the scope of this catalogue to attempt to trace out the various periods of construction and it is only necessary to show that the south īvān was first erected in the Seljūq period. In the east wall of this īvān is a pointed arch portal which was filled in during the Mongol rebuilding. On this same wall Seljūq basket-weave bond is visible, but nowhere to a height of more than 4 m. and it seems certain that the original īvān collapsed not long after its building and that its stub walls served to carry the Mongol rebuilding. On the miḥrāb wall traces of earlier plaster decoration can be seen through gaps in the Mongol plaster.

In the Mongol period the south īvān was rebuilt and the arches of the flanking court façades and the entire north īvān were newly constructed. The small size of the court in relation to the plan area of the īvāns is rather striking as is the consistent emphasis on verticality: the īvāns are actually higher than the court is long. Small mosque courts are common to Mongol monuments, but here the restricted size might have been caused by the nearness of existing buildings. Nearly all constructional surfaces are covered with finely executed ornament: the miḥrāb wall has plaster decoration in high relief, the soffits of the arcade arches have incised patterns cut in from flat surfaces, the front faces and wings of the īvāns have elaborate strapwork patterns with occasional faïence insets.

The inscriptions of the mosque are badly damaged and no date was located. However, above the miḥrāb frame is the signature of a master workman ʿAlī Jāmiʿ al-Sanai' of Simnān (a town situated some 320 kilometers west of Farūmad). This Mongol monument may date from c. A.D. 1320. This dating is based upon general features, upon the similarity of strapwork patterns to those at Bisṭām and upon the resemblance of the plaster soffit patterns to those at the mausoleum of Öljeitü at Sulṭāniya.

It should be noted that André Godard has arrived at an earlier date in his study of the

monument. He believes that its "characteristic Khorasan architecture" necessitates a dating as close as possible to several dated twelfth century structures in Khorāsān, but since Farūmad achieved importance as a provincial center only in the Il Khānid period he assigns the mosque to the thirteenth century. He also believes that very little time elapsed between the construction of the south īvān and its consolidation and appears to believe that these repairs were less extensive than has been suggested earlier in this summary.

Location: Some 120 kilometers west of Sabzavār, on the road between Tehrān and Mashhad, is the hamlet of 'Abbāsabad. A track leads off to the north and at a distance of some 30 kilometers is the small village of Farūmad. The mosque is situated on the eastern outskirts of the town.

Condition: Fair. The vault of the south īvān has fallen and that of the north īvān is badly damaged, but both retain their cross arches. The plan has been complicated by later work, probably of quite recent date.

Plan-type: Open court mosque plan with īvāns on the *qibla* axis (defined by André Godard as the typical Khorāsān type). Side arcades opened into (vanished) prayer halls.

Interior: Court façades of īvāns display pyramidal composition: the lofty cross arch of the īvān is flanked by pointed arch wings and above each flanking arch are two recessed pointed arch panels.

Date control: 1. Typical of the Mongol period are such features as the broken headed arches, offset mouldings with slight projections, and stalactite clusters applied on a framework rather than built up as cohesive units.

2. Relationship of various ornamental features with dated monuments of the Mongol period.

Ornamentation: Bricks: standard.

Bond: common; elaborate (in Seljūq work).

Terra cotta: glazed; insets of light blue and dark blue within interstices of strapwork patterns; unglazed, strips in patterns and inscriptions, and intricately moulded hexagons fitted together to form all-over patterns.

Plaster: high relief on miḥrāb niche and frame: incised patterns and inscriptions on soffits of arcade arches. Complex stalactite development above the miḥrāb is a plaster shell adhering to bricks which project from the structural wall surface.

Identification: Iranian National Monument No. 345.

Recorded: February 1946. Recording was carried out during a snowstorm at dusk and was not as complete as desired.

Illustrations: Pls. 124, 125, 126, 127; Fig. 39.

BIBLIOGRAPHY

Godard, "Khorāsān," pp. 83-112, figs. 64-95.

62

Safiabad khānaqāh and mazār of Shaykh
'Alā ad-daula Simnānī
c. /1320

Summary: According to the list of National Monuments of Iran, the khānaqāh and mazār of Shaykh 'Alā ad-daula Simnānī (in full, Rukn ad-dīn 'Alā ad-daula Aḥmad ibn Muḥammad Biābānaki) at Simnān is of the Il Khānid period.

Additional information on this monument was given to the writer by André Godard. The structure is located some 18 kilometers to the west of Simnān in the village of Safiabad and the khānaqāh, or monastery, was erected for the learned shaykh by one of the ministers of Sulṭān Öljeitü. In an article Godard gives a photograph of part of the structure, possibly the mazār, or tomb, and remarks that it is crowned by a double dome. This mazār is reported to have collapsed in about 1951.

Contemporary references reveal that the shaykh was invited by Öljeitü to attend the celebrations incidental to the inauguration of Sulṭāniya. It is also stated that he retired to a monastery in 720/1320 and died in 736. These facts suggest a date of close to 1320 for the structure.

Identification: Iranian National Monument No. 320.

Recorded: Not visited.

BIBLIOGRAPHY

Eqbāl, *Tārīkh-i-mofaṣṣal Īrān*, p. 509.
Godard, "Khorāsān," p. 90, fig. 70.

63

Qumm Imāmzāda Ibrāhīm
721/1321

Summary: On the outskirts of the town of Qumm are two (or three) tombs called Imāmzāda Ibrāhīm. This particular Imāmzāda Ibrāhīm, east of the town and in the area of the former Kāshān gate, is dated 721/1321 and contains an additional inscription which states that the structure was repaired in 805/1402.

The structure is of Type II of the tombs at Qumm (see p. 115). In plan and exterior appearance the monument closely resembles the slightly earlier Imāmzāda 'Alī ibn Ja'far. However, the zone of transition is higher, the polyhedral tent dome is more steeply pitched and the construction is more carefully executed than in the 'Alī ibn Ja'far.

Illustration: Pl. 128.

Identification: Iranian National Monument No. 298.

Recorded: April 1943.

BIBLIOGRAPHY

Pope, "The Photographic Survey," p. 38.
Godard, "Pièces datées . . . de Kāshān," p. 310, fig. 136.
Survey, p. 1346.
Rāhnāma-yi-Qumm, p. 4 and unpaged illustration.

64

Varāmīn Masjid-i-Jāmi'
722/1322
726/1326

Summary: On the outskirts of the village of Varāmīn, some 42 kilometers south of Tehrān, is the Masjid-i-Jāmi' built during the early years of the reign of Abū Sa'īd. The western side of the mosque has entirely disappeared during the centuries, but the preserved sections are in good condition.

The monument is of significance primarily because it displays the "ideal" or "normal" four-īvān plan built as a balanced unit at a single period of construction. This mosque is the only structure on this entire list of structures of the Mongol period which fits these conditions and, further, only the Masjid-i-Jāmi' at Zavāra can be cited as a prototype in the Seljūq period. There must have been many more of these early four-īvān mosques, but they have not survived to the present day and known examples of the type come principally from the Tīmūrīd and Ṣafavid periods.

The fabric of the monument was constructed with real care and then clad with decoration in plaster, terra cotta, and faïence. It is unnecessary to describe the architectural features of the mosque in detail both because of its standardized plan and because it has already been the subject of fairly detailed study. Worthy of note is the rather small area of the open court in relation to the size and scale of the structure: such restricted court areas are a hallmark of the Mongol period. The sanctuary dome rises far above the rest of the structure and both the entrance portal and the entrance to the sanctuary were kept quite low so that the mass of the dome could be clearly seen.

Two dates are associated with the construction of the mosque. One is found in the horizontal inscription frieze of the sanctuary īvān. Preserved are the numerals –22 with the missing number a seven and the original date 722/1322. This same inscription gives a long list of the honorifics of Abū Sa'īd including one Mongol title. Within the sanctuary chamber itself is the date 726/1326, written in numerals.

Two panels on the back wall of the sanctuary īvān contain an historical inscription of Shāh Rukh. The numerals of the date are not clear and readings of 815/1412 (prior to the reign of Shāh Rukh and hence not possible), 821/1417 and 845/1441 have been suggested. A small plaster inscription in one of the side aisles of the mosque contains the words: "the work of 'Alī Qazvīnī. . . ."

Religious inscriptions abound throughout the structure; plaster friezes contain verses from the Qur'ān, the confession of the Shī'a faith and invocation, and decorative brick patterns spell out sacred names and pious phrases.

The decorative features of the mosque deserve brief mention in relation to the materials employed. Plaster was used in brilliantly designed friezes, for a great variety of cut patterns between the wider brick joints and for horizontal and vertical mouldings bearing floral and geometrical patterns. Brick bonding patterns were carried out in a combination of standard size, cut, and specially moulded pieces. The miḥrāb wall displays an elaborate design which combines herringbone and diagonal square patterns; the side walls of the sanctuary īvān have panels in which the bricks are alternately raised or depressed; the elaborately bonded tympanum of this same īvān uses depressed square ends of light blue glazed brick to spell out names and phrases. In general, the elaborate bonding patterns are set one brick thick into a very thick coat of plaster applied to the structural wall, but in one area the bonded bricks are set into a plaster coat applied to standard bricks laid flat in a square grid and this grid in turn is pressed into a plaster coat applied to the fabric. The vault of the sanctuary īvān and the squinches of the dome chamber are filled with constructed brick stalactites.

The faïence decoration consists for the most part in a combination of pieces of light blue and dark blue glaze with unglazed terra cotta. These materials are used together in the geometrical designs of a number of arch headed panels and also in the inscription frieze over the main entrance portal. Here the background of the inscription is in dark blue faïence, the letters in cut strips of unglazed terra cotta and the floral scroll above the letter stems of light blue faïence. The stalactite vault of the entrance portal is made up of the same materials and was hung and supported by timbers projecting from the structural semicircular brick vault. Within the dome chamber are panels of complete mosaic faïence in light blue and dark blue. Light blue hexagons are

surrounded by small triangles of dark blue to establish an over-all pattern of six-pointed stars. On the light blue pieces are narrow channels scraped down to the biscuit and these lines create a secondary pattern of hexagons. Not only does the use of faïence in this mosque fail to show any technical advance over the work in the mausoleum of Öljeitü, but not all of the colors and combinations of Sulṭāniya are found at Varāmīn.

It should be said that no actual construction was done at the time when the panels of Shāh Rukh were put into place. The work of that period was confined to the panels and to some decoration in the dome chamber; probably the miḥrāb itself since part of its plaster covers a section of elaborate brick bond.

Identification: Iranian National Monument No. 176.

Recorded: October 1937 and May 1939. Plan after Sarre.

Illustrations: Pls. 129-134; Fig. 35.

BIBLIOGRAPHY

Hommaire de Hell, *Voyages en Turquie*, pls. XCIII and XCIV.

Merāt al-Boldān, IV, pp. 121-122.

Sarre, *Denkmäler*, pp. 59-64, figs. 67-73, pls. XVIII, XIX, LIV, LVI.

Kratchkovskaya, "Notices sur les inscriptions," pp. 25-58.

Minorsky, "The mosque of Veramin," pp. 155-158.

Herzfeld, "Reisebericht," p. 234.

Survey, pp. 1093-1096, figs. 467, 473, 474, 478, 479, 480, 483, 488, and 489, pls. 405-411, 525.

Farhang-i-joghrāfīya-yi-Īrān, I, p. 229.

Herzfeld, "Damascus: Studies in Architecture—IV," pp. 136-137.

65

Berdaa tomb tower

722/1323

Summary: Berdaa, an important town in the Seljūq and Il Khānid periods and a favorite area of resort of the Il Khānid rulers, lay some distance to the north of the Aras River in the Qarabāgh region. The site is now within the U.S.S.R.

Khanikoff, visiting the site about 1857, found a single isolated funerary tower rising from the midst of widely scattered ruins. A Qur'ānic inscription in *kūfi* characters formed a frame around its two portals and continued along to encircle the base of the tower. Above the south portal could be read: "in [the month of] Shawwal, of the year 722 [January/February 1323]." Above the north portal was the phrase: "the work of

Aḥmad bin Ayyub al-Hāfiz ("the keeper") of Nakhichevan."

Recorded: Not visited.

BIBLIOGRAPHY

Khanikoff, de, "Mémoire sur les inscriptions musulmanes," p. 70.

66

Yazd Masjid-i-Jāmi'

724/1324 and later
777/1365

Summary: The Masjid-i-Jāmi' of Yazd is situated near the center of this large town whose history extends back into pre-Islamic times. The extensive complex of the structure surrounds a long and rather narrow open court. To the east of the court are the crumbling ruins of an early mosque, presumably pre-Seljūq in date. To the south of the court are structures of the fourteenth century and to the west a considerable section of late eighteenth or nineteenth century construction.

The mosque complex has recently been the subject of a masterly study by Maxime Siroux who combines the direct observation of the monument with a survey of important documentary material.

Several sections of the complex are assigned by Siroux to the fourteenth century and the material which follows is based upon his interpretations. These sections include the principal entrance to the mosque, a towering īvān portal crowned by paired minarets; the lofty īvān before the dome chamber; the dome chamber itself; and two prayer halls, one flanking and parallel to either side of the dome chamber and īvān. Siroux ties in two of these elements with precise information from the *Tārīkh-i-jedīd-i-Yazd* of Aḥmad ibn Ḥusayn ibn 'Alī al-Kateb, written toward the end of the fifteenth century. This work records that in A.H. 724 Sayyid Rukn ad-dīn Muḥammad acquired a large open area near the existing mosque and ordered the building of a *soffa* (the īvān), a dome (the dome chamber), *ghorfas* (upper balconies or galleries and probably the galleries of the īvān), and places of prayer. This work was not interrupted by his death which probably took place about 730-732, but was continued until the īvān and its galleries were completed.

Details of construction indicate that the īvān was erected against the front wall of the completed dome chamber. This chamber is crowned with a double dome and there is a space .50 m. wide between the two domes at their bases. Details of the secondary squinches in the chamber and details of decoration, such as the com-

bination of plain and glazed terra cotta and the manner in which plaster is employed, in the dome chamber and the galleries of the īvān are similar to these features in the mausoleum of Öljeitü and in several other structures erected about 1325. Siroux also believes that the entrance element was erected no later than 730-740. The type is common to a number of monuments of the Il Khānid period, while in this example verticality is stressed in every ascending line and moulding and in the great height of the paired minarets. Probably, as Siroux suggests, the portal, chamber, and īvān were erected as elements in a projected four-īvān plan mosque—a scheme that was never carried out.

A few years after these elements were erected and still within the period when the Muẓaffarid line controlled Yazd, additional work was done on the complex. The decoration of the dome chamber was completed, including the installation of a splendid faïence miḥrāb dated 777/1365 and the ornamentation of the inner surface of the dome. The flanking prayer halls with the spans of 8.10 m. and 9.37 m. were probably erected after 1360. These spacious halls have walls of mud brick and a roofing system which features a series of transverse cross arches joined by vaults running in the direction of the cross arches. This system had firm roots in the Sāsānian period and is also represented in Il Khānid times by the īvān at Gārlādān and the īvāns in the madrasa of the Masjid-i-Jāmiʿ at Iṣfahān.

Since much of the decoration of the Il Khānid elements of the complex is of the late fourteenth and fifteenth centuries these elements do not appear in harmony with contemporary structures at Yazd which feature a combination of painted ornament with plaster relief decoration.

Identification: Iranian National Monument No. 206.

Recorded: February 1935 and November 1936.

Illustrations: Pls. 135, 136, 137, 138.

BIBLIOGRAPHY

Merāt al-Boldān, IV, pp. 124-127.
Pope, "The Photographic Survey," p. 28.
Survey, pp. 1091-1093, pls. 438-439, 441-447.
Ayati, *Tārīkh-i-Yazd*, p. 123.
Siroux, "La Masdjid-e-Djumʿa de Yezd," pp. 119-176, figs. 1-13, pls. I-IX.

67

Yazd tomb of Sayyid Rukn ad-dīn
725/1325

Summary: The tomb of Sayyid Rukn ad-dīn, situated in the neighborhood of the Masjid-i-Jāmiʿ at Yazd, bears an inscription of 725/1325.

The monument, a square chamber crowned by a dome, is also known locally as the Masjid-i-Vaqt u Sāʿat and is the sole surviving element of a complex of structures erected by the order of Sayyid Rukn ad-dīn. Morteẓa ʿAẓam Sayyid Rukn ad-dīn Muḥammad bin Naẓām ad-dīn al-Ḥusayni al-Riāẓi, a notable patron of architecture, ordered this Muasasa Vaqt u Sāʿat, the "Institute of Time and the Hour," and its mechanical devices made the institute one of the marvels of the age.

A theoretical reconstruction of the complex may be suggested by the surviving descriptions of the area. The various structures of the institute were grouped about an open court. To the south of the court was a religious school and the mausoleum of Sayyid Rukn ad-dīn. To the north of the court was an īvān crowned by paired minarets. At the top of one of the minarets was the figure of a hen in plaster which turned to face the sun during its passage across the sky and on the other a banner rose to the top of its staff five times each day. Above the īvān itself was an elaborate automaton. The central element was a huge painted wooden wheel marked off into three hundred and sixty degrees. Each passing day was indicated by an Arabic letter in one of the divisions. Grouped about the central wheel were four smaller ones, each divided into thirty sectors in which the days of the Turkish, Arabic, Persian, and Western months were written. These wheels, constantly in motion, conveyed all the pertinent details relative to the calendars and the passage of time. On one lateral side of the court was a mosque and on the other a library containing three thousand precious volumes on the subjects of science, literature, mathematics, medicine, and religion. The entire structure was completed in 725/1325.

The exterior of the existing tomb is encumbered on all sides by constructions of various kinds, some of which may represent later rebuilding on the original walls of the earlier complex. The north face of the structure displays plaster decoration and other indications of contemporary construction which once abutted on that face. The vanished work may have been a vaulted entrance hall or, as the traces seem to suggest, a rectangular hall covered with vaults spanning transverse cross arches.

On the interior every square centimeter of the surface is coated with hard, white plaster. Above a very low dado strip each wall is divided into an arrangement of three panels consisting of a wider central panel and narrower ones adjacent to the corners of the structure. The miḥrāb is within the central panel of the south wall. The arch heads panels are recessed a minimum amount and are actually linear patterns drawn

upon the wall surfaces. Above the line of the panel heads is a continuous encircling inscription frieze in carved plaster. Above this frieze the square of the chamber is brought to an octagon by the use of four simple corner arches while higher up sixteen incised wall arches establish the figure upon which the dome was set. Four small windows pierce the wall arches and four the base of the dome itself. The single dome of the structure is intact.

The entire interior is covered with a profusion of ornament. Painted designs, some of them done with stencils, were executed in blue, green, and brown with traces of gilding. Carved plaster is used in very low relief. Some of the pattern forms tend to represent three dimensional forms by two dimensional painting: this treatment is displayed in the linear stalactites within the arched heads of the wall panels. Some patterns have an architectonic relationship with the surfaces on which they appear while others are less well adapted and seem to have been taken over from book covers and manuscript illumination. For example, the painted patterns on the inner surface of the dome are extremely rich and fine but they have little relationship to the scale or the profile of the area to which they were applied.

The panel strips and pattern borders carry carved plaster inscriptions in cursive or *kūfī* script. The composition of the miḥrāb displays a certain elegance and suavity, but with its flat, three-centered crowning arch and its over-tall plaster stalactites, fails to express the force of the more simple and earlier designs. An unusual feature in the decoration of the miḥrāb is the treatment of the inscription band on the border which surrounds the miḥrāb on three sides. Here there are three separate inscriptions juxtaposed and interlaced with remarkable ingenuity.

Identification: Iranian National Monument No. 246.

Recorded: November 1936.

Illustrations: Pls. 139-143; Fig. 36.

BIBLIOGRAPHY

Sykes, *Ten thousand miles*, p. 421 n. 2.
Pope, "The Photographic Survey," p. 28.
Survey, pp. 1089-1090, fig. 482, pls. 418, 537B.
Tārīkh-i-Yazd, pp. 114-116.

68

Iṣfahān Imāmzāda Ja'far
72–/132–

Summary: This structure, known locally as the Imāmzāda Ja'far, is dated by a damaged inscription to the year 132–. Ṣādeqi, in his *Iṣfahān*, writes that the tower was erected in 725/1325 but
gives no source for this information. He also quotes a statement made by Herzfeld to the effect that the structure was built in 710/1310 for the "Ṣāhib Sayyid . . . (title) . . . Ja'far bin Shams ad-dīn al-Ḥusayn bin 'Imad ad-dīn."

In general appearance and in correspondence of its architectural details the monument resembles the tomb of Chelebi Oghlu at Sulṭāniya. The suggestion has been made that when Sulṭāniya and its monuments was completed for Öljeitü some of the workmen moved to Iṣfahān and built the tomb of Ja'far on the model of the Chelebi Oghlu. Now, however, the date of 733 has been found in the *khānaqāh* adjoining the Chelebi Oghlu and it appears probable that the *khānaqāh* and tomb are of the same building period.

The proportions of the Imāmzāda Ja'far are more slender and refined than those of any of its predecessors in the tomb tower type, while every detail displays craftsmanship of the highest order. If any fault were to be found, it is that the single dome is not adequate in scale for the rest of the structure. A. Godard has suggested that there was once an outer pyramidal roof, but there is no trace of any such construction and the ledge between the top of the cornice and the base of the existing dome is scarcely wide enough to have served as the base for an outer roof.

Location: Iṣfahān, between the Maydan-i-Shāh and the Masjid-i-Jāmi'.

Condition: Excellent. Upper face of dome displays modern revetment of blue glazed tile. Upper part of cornice almost completely destroyed.

Plan-type: Tomb tower; octagonal exterior; octagonal interior.

Exterior: Socle of fired brick. The portal face displays pointed arch entrance (modern) framed by a rectangular band of mosaic faïence; the spandrels were formerly filled with faïence; the door is surmounted by an inscription panel in mosaic faïence (almost completely destroyed); the portal motif is enclosed within an arched and a rectangular recessed panel, the latter an elaborate brick pattern. Each of the other faces of the structure is composed of a pointed arch recessed panel, within a similar, splayed panel and a rectangular panel, the spandrels filled with mosaic faïence. On the north, south, and west faces, the same panel division encloses a low rectangular opening (now blocked) surmounted by a mosaic faïence panel. A single row of exposed scaffold holes is visible. Above the large panel faces a mosaic faïence inscription frieze encircles the structure, surmounted by a second which curves forward at the top to form an overhanging cornice.

The inner, ovoid dome is set back from the exterior wall face and is loaded with one ring of bricks at its haunches; above this rises a revetment of light blue glazed tiles.

Interior: Interior wall faces, of fired brick, reflect the exterior panel division. The east (entrance) face bears a flat arched opening, surmounted by a pointed relieving arch. The north, south, and west faces were pierced by rectangular openings with wood lintels.

Each face displays a trefoil arched recessed panel, beginning at 1.40 m. above the floor level.

The zone of transition is composed of sixteen pointed wall arches, which in turn, spring from half arches placed at each angle of the octagon; the ovoid dome, its bricks laid in common bond in concentric rings, rises directly above the zone of transition. A single rectangular window with wood lintel (now blocked) pierces the dome above its base. Exposed scaffold holes at three levels.

Structural features: The treatment of the zone of transition, with its sixteen wall arches springing from half arches at the angles of the structure follows exactly the earlier Seljūq type.

Ornamentation: Bricks: (buff), standard (.21 m. by .05 m.; horizontal joints .02 m.; rising joints, minimum); cut; cut with false joints incised; moulded (corner angles).

Joints: raked to depth of .025 m.

Bond: common; elaborate (rectangular panel framing portal).

Faïence: Use of complete mosaic faïence in light blue, dark blue, and white; incomplete mosaic faïence, i.e. these colors used in combination with unglazed terra cotta.

Date control: 1. Inscription dated 72–/132– (lower of two inscription bands encircling structure. Last digit completely missing from inscription).

Identification: Iranian National Monument No. 198.

Recorded: May 1939 and April 1944. Plan and elevation-section not previously published.

Illustrations: Pl. 144; Figs. 37, 38.

BIBLIOGRAPHY

Dieulafoy, J., *La Perse, la Chaldée et la Susiane*, pp. 313-314, fig. on p. 315.
Sarre, *Denkmäler*, p. 75.
Lutyens, "Persian Brickwork—III," fig. 1 on p. 118.
Herzfeld, in *Āthār-i-Melli* (in Persian), 5.
Sādeqi, *Iṣfahān*, pp. 103-104, fig. on p. 103.
Godard, "Iṣfahān," p. 36, fig. 11.
Survey, p. 1099, pl. 354B.

69

Dashti (Iṣfahān) mosque
c. /1325

Summary: This monument has a number of features which are also common to the mosque at Kāj (No. 70) and the mosque at Eziran (No. 71) and it appears certain that all three structures were erected at the same period. The date of construction was probably c. A.D. 1325. In addition to general stylistic features which suggest this date is the specific feature of the three color mosaic faïence used at Kāj and at Dashti where simplified floral designs are executed in this material.

Because of their family resemblance these three structures are summarized together. They are situated close together: Dashti is some 19 kilometers from Iṣfahān on the south bank of the Zāyinda-rūd and Eziran is 32 kilometers from that city on the same bank. Kāj is on the north bank at a point approximately midway between the first two sites.

The original plans of all three structures comprised the elements of square dome chamber, with flanking corridors, monumental entrance and forecourt. No one of these structures has retained all of these elements: Eziran displays the chamber with corridors, entrance, and a single corner of the forecourt while Dashti and Kāj retain the chamber, with traces on its flanking walls of the abutment of the corridor vaults, and the entrance element.

Two of the structures display foundation courses of large field stones and all of the monuments have structural walls the cores of which are of mud brick. Each of the structures has a dome of pointed profile.

In the case of each structure the essential fabric was completed but not all the decorative details were installed although nearly all the decoration at Kāj was finished. Each of the structures displays a break in erection of the fabric: at a level below the zone of transition of each structure the bricks change color and size.

It is quite possible that historical research may serve to fix the date of construction of the monuments. The monuments themselves suggest that the following course of events took place. At the height of the Il Khānid power a plan was formed for the establishment of a number of new communities in the vicinity of Iṣfahān, along the banks of the Zāyinda-rūd. Work was started at at least three sites where mosques were erected as the focal points of the planned communities. After several months of construction some local incident interrupted the work, which was then carried through to completion except that not all the decorative inscriptions and panels were exe-

cuted. This failure to finish the structures may have been the result of some local incident or of local economic conditions or of a sudden lack of interest on the part of the authorities, local or national. Employing these assumptions a thorough examination of the historical material might serve to disclose corresponding conditions of fixed date.

Several features of the mosque at Dashti should be given separate consideration. The full depth of the entrance bay is not preserved and the extant area is not sufficient to indicate whether a tunnel vault or a stalactite half dome crowned this element. Cuttings and traces of the springing lines of vaults on the exterior lateral walls of the chamber indicate the position of now vanished flanking corridors. The presence of stiffening walls above the inner dome are reminiscent of the use of this feature in the Mīl-i-Rādkān.

Apparently the decoration of the structure was nearly completed. Well executed mosaic faïence is found on the rear wall of the entrance bay and the interior of the chamber displays ornamental patterns and inscriptions executed in faïence and in bright red brick. However, the decoration of the miḥrāb was never carried out nor was an inscription band on the rear wall of the entrance bay installed.

Location: Some 19 kilometers southeast of Iṣfahān, on the south bank of the Zāyinda-rūd (river).

Condition: Good. Double dome intact. Corners of chamber damaged and portal in damaged condition. Structures which adjoined the chamber to the east and west now missing.

Plan-type: Mosque, composed of square dome chamber with monumental portal.

Exterior: On the north side of the chamber is the entrance motif, consisting of the decorated north exterior wall of the chamber and decorated flanking side walls. The north wall face displays a similar treatment on either side of the doorway. Just next to the doorway is a recessed pointed arch panel within a rectangular frame. Within the head of the arch is an all-over star pattern executed in cut pieces of light blue, dark blue, and white glazed tile and of unglazed terra cotta, set into a coating of plaster. Within the spandrels is a simplified floral design in the same materials and colors. From the edge of this panel to the corner angle the wall has an elaborate bonding with sacred names spelled out in square-end light blue glazed bricks. This pattern continued on the side walls and on the east wall is visible as far as the edge of a recessed wall panel—beyond this point the wall is not preserved. Above the heads of the wall panels and the elaborate bond-

ing areas is a slightly recessed horizontal panel, some .90 m. high, intended for an inscription band which was never executed. At the depth of one full brick back from the wall faces were embedded timbers. Above the horizontal panel are wall arches with white plaster faces and sacred names in small moulded bricks. These wall arches once served as springing points for either vaults or a system of built stalactites: the manner of covering the entrance bay is not clear.

The east and west exterior faces of the structure display the traces of construction which abutted against them. There are cuttings in the wall surfaces and traces of vaults which rested against the walls. At both ends of the south wall are circular stair wells: apparently the actual winders were never constructed. At the northeast corner a passage leads to stairs which give access to the front and the side of the entrance motif and to another circular stair well. The corresponding corner of the structure is damaged, but a blocked door of similar width to that on the opposite side is visible.

The cube of the structure is transformed on the exterior first to an octagon and then to two stages of sixteen sides. Above rises the stilted, pointed dome which displays several rows of exposed scaffold holes.

Interior: The floor is of earth. Some .40 m. of the foundation of large field stones are visible. Three wide and very high pointed arch portals lead into the chamber. That to the north is interrupted at about one third of its height by a doorway crowned with a flat vault. The undersurface of the vault has a diagonal square pattern executed in light blue square end bricks.

The face of each interior wall has a wider axial motif (the three portals and the miḥrāb) and two recessed pointed arch wall panels of equal width. The south wall displays a miḥrāb constructed entirely of brick and from the evidence of the projecting brick edges bounding several surfaces it is clear that the work was carried up to the point at which a finished decorative treatment should have been applied. The corners of the wall panels display brick angle flanges which carry up into the squinch arches. The surfaces of the panels have two different complex bonding patterns in standard bricks which spell out sacred names. Above the spandrels of these panels is a line of bricks laid vertically. Just above this point the bricks display a variation in size and color and it appears as if construction work had been halted for some time when this level was reached.

The square of the chamber is brought to an octagon by means of eight pointed arches: three over the portals, one above the miḥrāb and four

across the corner angles of the chamber. The squinch faces are of a redder colored brick and a secondary arch carries up from the corner angle to the mid-point of the squinch arch face. Below the springing line of the eight arches horizontal wood beams were embedded in the walls. Above the heads of the eight arches a stage of sixteen wall arches serves to bring the octagon to a circle. The faces of these wall arches are laid up in common bond, but alternate faces are bonded in shorter bricks. Just above the heads of the wall arches is a slightly recessed horizontal panel which was intended to contain an encircling inscription band. Above this point four rectangular windows pierce the wall on the axes of the chamber. The dome itself is laid in common bond and several stages of exposed scaffold holes are visible. Alternating in position between and above the windows are eight patterns of sacred names spelled out in the square ends of bright red brick. At the apex of the dome is an eight-pointed star executed in strips of light blue glazed tile.

A double dome crowns the monument. The inner dome is of semicircular profile and the space between the two domes contains a number of brick stiffening walls built along radii of the dome.

Recorded: April 1943. Plan not previously published.

Illustrations: Pls. 145-148; Fig. 40.

BIBLIOGRAPHY

Smith, "The Manārs of Iṣfahān," p. 357.

70

Kāj (Iṣfahān) Masjid-i-Jāmiʿ
 c. /1325

Summary: This monument, certainly a mosque, has been called the Masjid-i-Jāmiʿ by the Archaeological Service of Iran without presentation of the basis for this attribution.

The distinctive features of the mosque have been presented in the general discussion of the structures at Dashti, Kāj, and Eziran (see pp. 162-163).

Adjacent to the monument, to the northeast, are the battered remains of a large structure constructed entirely of mud brick which originally included an īvān some 4 m. in width, flanked by a narrower īvān. Eric Schroeder, writing in the *Survey*, considered that the mud brick structure was one of the earliest of the Islamic monuments of Iran. Regardless of its precise date, it seems certain that the mud brick structure existed at the site when the mosque now under consideration was erected in the fourteenth century and that this mosque was so placed as to represent the

south side of an open court which was bounded on the west by the mud brick structure.

Both the fabric and the decorative features of the mosque appear to have been completed with the exception of the miḥrāb, the faces of which are roughly built. Noteworthy is the presence of an encircling inscription band on the interior of the structure just below the base of the dome. The inscription, executed in three color mosaic faïence, is comprised of verses from the Qurʾān. Frequently the date of execution of such a band appears at the end of the inscription: in this band a small portion of the very end of the inscription is damaged but it is certain that no date was included in this general area.

Location: Some 21 kilometers southeast of Iṣfahān, on the north bank of the Zāyinda-rūd (river).

Condition: Fair. Lower courses of all walls robbed of brick in modern times. Entrance portal largely destroyed.

Plan-type: Mosque, consisting of square dome chamber and monumental entrance with some indication of adjoining structure.

Exterior: Apparently this structure was situated on the south side of an open court for a short distance away are the three walls of a (now roofless) īvān built entirely in mud brick which would have formed the west side of the court.

Two piers with their connecting offset arches exist on either side of the entrance motif, with the element to the east the better preserved. From the inner face of the east pier springs the first few meters of a (now destroyed) pointed transverse arch which indicates that the entire entrance bay was covered with a tunnel vault. Back of the inner edge of the transverse arch the core of the piers is of mud brick. Decorated wall surfaces are present. On the north face of the east pier is an elaborate bond with wide, unpointed joints spelling out sacred names, the west face of this pier is similarly treated to above the head of the arch between the two piers with the pattern of standard bricks set their full depth into the wall. Above the arch head the wall breaks back .05 m. and rises in common bond (the empty channel which once held an embedded beam is present in this area). This surface was covered with a thick coating of mud and plaster in which was set a revetment in common and elaborate bond of small cut bricks only .04 m. deep. The intrados of the transverse arch once bore an inscription in cut pieces of light blue glazed tile in a plaster surround, the whole set against a patchwork ground of flat bricks.

The original treatment of the north exterior face of the chamber is not entirely clear. At the

east and west corners are traces of stair wells which could have been brought to a circle only by additional construction against a finished structural wall. The bases of the piers which flank the entrance portal project forward and may have borne one side of a lateral tunnel vault which covered the approaches to the corner portals.

The east and west exterior faces of the chamber display the springing offsets of transverse arches while above is a continuous ledge, interrupted by the central portal, upon which a vault once rested. These traces are indicative of the former presence of either flanking corridors or of a more complex type of vaulted area. The south exterior face of the structure is quite damaged and it is possible that additional construction adjoined this side as well.

Interior: Earth floor, no trace of stone foundations. Three wide pointed arch portals lead into the chamber and their heads are at a point about 1 m. below the heads of the wall arches which bring the square of the chamber to an octagon. Flanking the three wide portals are secondary entrances with pointed offset arches.

The treatment of the vertical surfaces of the chamber is as follows. The miḥrāb consists of a deep rectangular reveal crowned by a pointed arch within a rectangular frame, with the lower side walls in elaborate bond. Back of the pointed arch is a niche whose rear wall is almost completely destroyed. The miḥrāb faces are roughly constructed and were certainly intended to be hidden under a decorative treatment. At the corners of the miḥrāb wall are rectangular recessed panels enclosing a low pointed arch portal. Above the portal head is a flat vertical surface in which raised whole and cut bricks spell out sacred names against a ground of red bricks. Above is the pointed arch head of the panel with the space within the arch decorated with an elaborate pattern done in cut bricks only .04 m. deep set into a coating of plaster .03 m. thick. The eight vertical wall surfaces of the chamber located between portals and reveals are decorated with one elaborate bonding pattern in whole and cut bricks in which wide, unpointed joints spell out sacred names.

The points of springing of the eight wall arches are corbeled out slightly beyond the wall surfaces of the chamber. Just at this point a change in construction is visible. Below, the material was buff-colored fired bricks; above, the bricks are lighter in color and somewhat smaller. On the eight vertical wall surfaces described above the elaborate bond gives way to common bond and common bond is used over the heads of the wider portals. The elaborate revetments within

the heads of the corner portals are also of the work done after the break in construction.

The square of the chamber is brought to an octagon by eight pointed arches. The interior faces of the squinch arches are filled with a system of simple stalactites which begin halfway up the arch and whose salient faces are of flat bricks plastered alternately with white and buff plaster. Above the heads of the eight arches the chamber is brought to sixteen sides by the use of as many wall arches the faces of which are laid in common bond but with wider rising joints in alternate faces. Just above is an encircling horizontal inscription band with sixteen sides which is some .60 m. high. This Qur'ānic inscription is executed in complete mosaic faïence with the letters in white, the background in dark blue, and the borders in light blue pieces of glazed tile. Just above the dome is brought to the full circle by a slight corbeling beyond the face of the inscription. At this level are four rectangular windows on the axes of the chamber. The interior surface of the dome is laid in common bond. Between each window is a large diagonal square with interior patterns, the whole in square ends of red brick. Radiating from the apex of the dome is an eight pointed star with four pendant diagonal squares containing sacred names: star and pendants in square ends of red brick.

The double dome of the structure is intact. The inner dome has a semicircular profile, the outer dome is stilted and almost pointed.

Identification: Iranian National Monument No. 328.

Recorded: April 1943. The plan corrects an acknowledged error in the plan published in the *Survey* where the side walls of the entrance bay are placed too close together and where the mud brick construction is placed too far to the east.

Illustrations: Pls. 149-153; Fig. 41.

BIBLIOGRAPHY

Schroeder, "Preliminary Note on Work in Persia and Afghanistan," p. 131.
Survey, p. 931, fig. 313, pl. 404A.
Schroeder, "M. Godard's review of the architectural section of *A Survey of Persian Art*," p. 210.

71

Eziran (Iṣfahān) mosque
c. /1325

Summary: The distinctive features of this mosque have been presented in the general discussion of the structures at Dashti, Kāj, and Eziran (see pp. 162f.).

The plan elements of this structure have survived in better condition than they have at the

related monuments at Dashti and Kāj. The preserved sections of the corridors flanking the dome chamber are sufficiently complete to allow a restoration of one entire corridor and at the north end of the east corridor wall a short stretch of the east side of the forecourt remains.

Within the chamber a plaster inscription surrounds the three sides of the miḥrāb recess, while just above the recess are three stages of built stalactites. The area within the recess is empty save for fragments of a plaster screen. It seems possible that at some period the original miḥrāb was removed from the recess and the empty space blocked with plaster. It has already been noted that luster faïence miḥrābs are known to have been stolen from other monuments. Within the chamber an inscription band executed in cut bricks encircles the base of the dome. No date could be found in this inscription.

Location: Some 32 kilometers southeast of Iṣfahān, on the south bank of the Zāyinda-rūd River.

Condition: Fair. Part of the outer dome is destroyed. Less than half of the flanking corridors remain; entrance portal is partially destroyed. The forecourt no longer exists. The miḥrāb is missing and the wall broken through.

Plan-type: Mosque, consisting of a square dome chamber with flanking corridors, monumental entrance, and forecourt.

Exterior: At the north of the structure is the motif of the entrance portal which includes the thickened north wall of the chamber and flanking brick piers. The flanking piers have a core of mud bricks. The portal bay may have been crowned by a tunnel vault, but it is not easy to see how the back of the vault would have fitted against the wall of the chamber. The surfaces of the piers have simple recessed panels and exposed scaffold holes are visible. In the thickness of the north wall of the chamber were passageways with flights of steps to a higher level (perhaps to the upper face of the flat vault of the entrance doorway).

The flanking corridor and end of the forecourt wall are best preserved on the east of the structure. The corridor walls are of fired brick to a height of 2 m. and then of mud brick. The corridors were covered by a series of tunnel vaults and the springing lines of these vaults are visible upon the exterior faces of the walls of the chamber. At the end of each corridor was an axial recessed wall panel.

Interior: Earth floor and field stone foundations. The walls are of fired brick, but the south wall (and perhaps others) has a central core of mud brick .50 m. thick. Three wide portals lead into the chamber. The portal on the north rises to the full height of the chamber with the peak of its pointed arch on a line with the squinch arch heads. The east and west portals are of the same width but are much lower in height so that their heads come below the line of the vaults of the flanking corridors and in the curtain wall above their heads is a pointed arch window.

The face of each interior wall has a wider axial motif (three portals and the miḥrāb) and two recessed rectangular wall panels of equal width. The wall which contains the miḥrāb is completely broken through for the full width of the miḥrāb from the ground level to a point about 4 m. higher. Above (in the miḥrāb recess) are two wide strips of white plaster and the corner angles of the miḥrāb recess. It appears as if the original miḥrāb may have been removed at some period and the gap filled by a plaster screen. Above the plaster surface an inscription band, c. 50 m. high, surrounds the three faces of the miḥrāb recess. The Qur'ānic inscription is executed in wiry, elongated letters of white plaster. Above this band the head of the recess is filled with a fairly complex pattern of built stalactites in three stages. Some of the salient surfaces are coated with white plaster while others have an elaborate bond in square end and cut bricks. A break in the lower stalactites exposes a blind window in the south wall, the window corresponds in position to those in the east and west walls.

Within each of the recessed rectangular wall panels is a pointed arch, with the area within the arch laid in common bond. Above the head of each arch is a recessed horizontal strip, some .35 m. high, obviously planned to contain an inscription band.

The square of the chamber is brought to an octagon by means of eight pointed arches: three over the portals, one over the miḥrāb and four across the corner angles of the structure. The interior faces of the squinch arches contain a simple system of built stalactites which begin halfway up the face of the squinch. The lower area has elaborate bonding in cut and square end bricks and there is a similar treatment on the salient faces of the stalactites. The head of the west arch of the chamber is coated with white plaster.

Above the heads of the eight arches the octagon is brought to a circle by sixteen wall arches, the faces of which have elaborate paterns in whole, half, and square end bricks. Just above is an encircling inscription band, some .40 m. high, executed in cut bricks raised slightly from a ground of red bricks. On top and bottom of the band is a narrow border of moulded terra cotta pieces in alternating lozenges and broken rectangles. Above the inscription band are four

rectangular windows on the axes of the chamber. The inner surface of the dome is laid in common bond with two stages of eight diagonal squares with patterns which spell out sacred names. The patterns are in square ends of red brick, slightly recessed from the surface. There is no decorative motif within the apex of the dome.

The structure has a double dome. The inner dome is of semicircular profile. The outer dome is broken away at its peak; its profile was stilted and probably pointed at the top.

Recorded: April 1943. Plan not previously published.

Illustrations: Pls. 154, 155; Fig. 42.

72

Qumm tomb of Hārath ibn Aḥmad
 Zayin al-'Abedīn
 c. /1325

Summary: This structure, known locally as the tomb of Hārath ibn Aḥmad Zayin al-'Abedīn, is situated to the east of the town of Qumm.

The structure is of Type II of the tombs of Qumm (see pp. 162f.). In proportions and general appearance it resembles the Imāmzāda 'Alī ibn Ja'far. It has been repaired in fairly recent times and the tent dome and areas of the structural walls are clad with modern tiles.

The tomb is one element of a building complex known as the Khāk-i-Faraj which includes an open court with īvāns. Some of this construction is dated as late as the nineteenth century. However, tiles, apparently reused, which now decorate the tomb within the monument are similar to those which have come from the Imāmzāda 'Alī ibn Ja'far.

The structure may have been erected about A.D. 1325.

Recorded: April 1944.

BIBLIOGRAPHY

Pope, "The Photographic Survey," p. 38.
Rāhnāma-yi-Qumm, p. 130 and unpaged illustration.

73

Qumm portal with flanking minarets
 c. /1325

Summary: The present ruins represent the main entrance portal of a large structure which lay to the west and which has now completely vanished. According to an oral communication from the Archaeological Service of Iran, enough of the fragmentary minaret inscriptions can be read to determine that the large ensemble was a madrasa.

The character of the decoration suggests that the portal dates to c. A.D. 1325.

An interesting comparison may be made with the Masjid-i-Niẓāmiya at Abarqūh where the identical element of a large structure is preserved which seems to be of the same period.

Location: Qumm; east of the river and at the eastern end of a wide avenue cut through the old city within recent years.

Plan-type: Half dome and paired minarets comprising portal of a madrasa.

Condition: Fair; heads of minarets missing, stalactite cornices partially destroyed and double inscription bands below cornice in very bad condition.

Ornamentation: Brick bond: strapwork pattern on surfaces of minarets.

Terra cotta: fragments of blue glazed tile on lower walls of portal; glazed tile letters of inscription and glazed pieces in cornices.

Recorded: April 1943.

Illustration: Pl. 156.

BIBLIOGRAPHY

Dieulafoy, J., *La Perse, la Chaldée et la Susiane*, fig. on p. 181.

74

Abarqūh portal of the Masjid-i-Niẓāmiya
 c. /1325

Summary: A few hundred meters south of the Masjid-i-Jāmi' at Abarqūh is the portal of a now vanished monument. Locally the remains are known as the Masjid-i-Niẓāmiya. The remains include the entrance doorway which is flanked by two lofty square bases from which rise the preserved lower sections of the shafts of a pair of minarets. The general character of the work, the diagonal square pattern on the shafts, outlined with square ends of light blue glazed brick, and the faïence in the fragments of the stalactite cornices which once crowned the bases of the minarets suggest that the portal was erected about A.D. 1325.

Recorded: Visited in February 1934.

Illustration: Pl. 157.

BIBLIOGRAPHY

Godard, "Abarkūh," p. 72, fig. 52.

75

Iṣfahān Do Minār Dardasht and tomb chamber
 c. /1330-40

Summary: This portal, with its pair of crowning minarets, is known as the Do Minār Dardasht. The adjacent tomb chamber contains the grave-

stone of a lady named Bakht-i-Āqā; the stone is earlier in date (perhaps mid-twelfth century), than the building itself.

Godard has noted that the portal may well be the one described by the seventeenth century French traveler Chardin, as having two high towers and as giving access to a large (religious) school. The portal opens to the north and apparently the tomb chamber once had an auxiliary doorway in its north wall. The structure to which both elements were related has completely vanished.

The first problem concerning the portal and chamber is whether both are of the same date. They do appear to be contemporary work although there is the possibility that the chamber is an earlier structure which was extensively repaired and crowned with a new dome at the time the portal was erected.

Any thorough examination of the structures is complicated by the fact that they are almost completely embedded in and surrounded by late constructions. They were studied from the top of the portal and from the high ledge on the exterior of the chamber at the base of the dome and the plan established at this level. Some of the lines on the accompanying plan represent approximations (the north face of portal may not be on exactly the same line as the north face of the chamber) and dotted lines represent the approximate position of the set-back on the exterior walls of the chamber.

The dating of the portal poses an interesting problem. Rather definite conclusions may be drawn after a comparison of the portal features with certain existing monuments, but, of course, if more monuments had survived, these conclusions might be slightly different. Key structures for the comparison are the Imāmzāda Ja'far and the Imāmzāda Bābā Qāsim, both at Iṣfahān. The former is dated A.D. 132– and displays three color faïence of about the same stage of development as the portal. The latter is dated A.D. 1341 and displays four color faïence. Without discussing other details of structure and decoration found in the portal and the minarets which would support the following conclusion, it may be stated that the portal dates between A.D. 1330 and 1340.

MINARETS

Condition: Fair. Only fragments of the original inner wall face of the portal recess remain. The revetment at the base and at the top of the façade is partially destroyed. The tops of the minaret shafts are missing.

Plan-type: The structure consists of a portal facing approximately south, crowned by two minarets of circular plan. Nothing of the original structure to the rear of the portal remains. To the west and adjoining the left side of the portal is a square chamber crowned by a dome.

Exterior: The façade wall surfaces flanking the portal recess are covered with a revetment decoration laid over a structural core of fired bricks of irregular sizes. The total thickness of the revetment from the core face is .26 m., the actual revetment consisting of brick varying in depth from .04 to .12 m. set into an irregular mass of broken bricks and mortar.

A cable moulding, executed in fired brick and light and dark blue square end glazed brick, follows the profile of the pointed arch portal and the spandrels above are filled with a design in similar materials.

The façade is crowned by a cornice-like element consisting of a decorated flat face now about 80 m. in height (the upper portion is destroyed) with a design in similar materials which includes sacred names.

The lateral faces of the portal recess display continuous decorated surfaces, with recessed panel divisions; an inscription frieze formerly surrounded the three sides of the recess (only fragments remain) above the panel heads. Of the rear face of the portal recess only one small decorated area remains; a part of the original arched doorway.

Above the portal, rise the circular, slightly tapering shafts of the two minarets, each pierced in its lowest zone by a rectangular portal giving access to the stairway. The decoration of the minarets is composed in zones, the lowest of fired bricks laid in common bond, surmounted by a wide zone and a narrow encircling band of *kūfi* script executed in fired bricks and light blue and dark blue glazed bricks. Above this band are fragmentary remains of the base of an overhanging stalactite cornice, the lowest tier consisted of juxtaposed spherical triangles with salient points, filled with faïence ornamentation.

Ornamentation: Bricks: buff colored fired: standard (.24 m. by .05 m. at base of portal recess); cut. Other sizes of fired bricks and at top of portal some indication of mud bricks used in the core. Glazed bricks.

Joints: rising joints, minimum, horizontal joints, .005 m.; flush pointed with very hard buff mortar.

Bond: common; elaborate.

Terra cotta: Unglazed and glazed. The greater part of the ornamentation consists of diagonal geometrical patterns and rectangular *kūfi* inscriptions, large in scale, executed in unglazed bricks and light blue and dark blue glazed bricks. Complete mosaic faïence in light blue and dark blue glaze appears (some narrow borders; stalactite cornice), on which certain areas have the glaze scraped away to expose the biscuit; and

these two colors in combination with white (fragments of inscription frieze).

TOMB CHAMBER

Condition: Fair. The crown and left intrados of the entrance arch, and the revetment of the left side of the façade are destroyed. Sections of the exterior walls have deteriorated.

Plan-type: Square on the exterior, square on the interior. Crowned by a dome. Entered on the east.

Exterior: Connecting the minaret portal with the tomb chamber is a wall, at right angles to the outer face of the minaret portal, and turning at right angles to form the right intrados of the entrance portal of the chamber.

An arched portal recess provides access to the structure with the rear face of the recess pierced by a rectangular portal.

The face of the wall immediately adjoining the minaret portal, the wall surfaces flanking the entrances to the chamber, and the portal recess display patterned revetments executed in unglazed fired bricks and fired bricks glazed in light blue and dark blue, laid over a core of irregular-sized mud bricks.

The dome, of fired bricks, rises on a high drum of fired bricks laid in common bond; the dome, of pointed ovoid profile, displays a revetment in the same materials as that of the lower wall surface.

Interior: A tombstone occupies the center of the mud floor. It is dated –53; for 553/1158-59? The walls are of mud brick, plastered white, with traces of painted polychrome ornament on the plaster dado encircling the chamber.

Each wall face displays a single, deep rectangular recess, narrow and elongated, its head filled by an offset pointed arch. The right lateral (north) face was originally pierced to open into the structure behind the portal; the head of its arch is pierced by a window.

This zone is surmounted by a narrow string course encircling the structure, above which is the squinch course, consisting of four simple, groined, pointed arch squinches bridging the angles of the structure, and four pointed wall arches, each of the latter pierced by a narrow window. Between the squinches and the wall arches, on the angles of the octagon, are small, kite-shaped groined squinches, their sides contiguous with the curve of the squinches and the wall arches. The heads of the angle squinches, the wall arches, and the kite squinches form the hexadecagon on which the base of the ovoid dome rises.

Ornamentation: Bricks: buff-colored fired bricks, standard and cut; fired bricks glazed light blue and dark blue. These form a revetment over the mud brick constructional core, the mud bricks irregular in size. Dome of fired brick with narrow rising joints and wider horizontal joints.

Terra cotta: glazed; light blue and dark blue glazed bricks.

Structural features: (minarets and tomb chamber). The combination of mud bricks and fired bricks in the construction of the chamber and the employment of irregular sized bricks (possibly over a mud brick core) in the minaret portal are significant. The one-panel recess division of the interior wall surfaces of the chamber is an unusual variation on the normal two- or three-unit treatment. The treatment of the zone of transition in the dome chamber, with the angle squinches and wall arches functioning also as the hexadecagonal drum of the dome, represents a more evolved form than the more usual one in which the squinches support the hexadecagon.

Date control: 1. The building materials employed (mud brick in combination with fired brick; irregular sized used bricks) represent a characteristic aspect of fourteenth century work (cf. Madrasa Imāmī, Iṣfahān; Masjid-i-Gunabad, Āzādān; Masjid-i-Jāmi‘, Ashtarjān; Imāmzāda Ḥasan ibn Kay Khusraw, Abarqūh; etc.) as is also the employment of large scale geometrical patterns and architectural *kūfi* executed in light blue and dark blue faïence, with the addition of areas of white. Other typical features are the occurrence of offset pointed arches; areas of mosaic faïence where the glaze is scraped away to expose the biscuit; the combination of two minarets surmounting the portal motif (cf. Minār Bāgh-i-Qūsh Khāna, Iṣfahān; Masjid-i-Niẓāmiyya, Abarqūh; Madrasa portal at Qumm, etc.); the treatment of the stalactite cornice of the minaret.

Identification: Iranian National Monument No. 115.

Recorded: June 1939. Plan not previously published.

Illustrations: Pls. 158, 159, 160; Fig. 43.

BIBLIOGRAPHY

Byron, "Between Tigris and Oxus-I," fig. on p. 437.
Smith, "Manārs of Iṣfahān," p. 350, fig. 230.
Godard, "Iṣfahān," pp. 43-44.
Survey, p. 1066, fig. 382.

76

Iṣfahān Minār Bāgh-i-Qūsh Khāna
 c. /1330-50

Summary: On the northeastern limits of present day Iṣfahān is a shaft known as the Minār Bāgh-i-Qūsh Khāna or the "minaret of the garden of

the falcon house" after a structure which existed in the vicinity during the Ṣafavid period.

Today only the minaret itself remains but one hundred years ago a considerable amount of additional construction still stood at the site. Flandin has left an excellent drawing of the area and his sketch has been the source for the accompanying plan which suggests the ground plan of the site at that time. It is highly probable that the original scheme included paired minarets over a monumental portal which led into the open court of a mosque or a religious school. When Flandin reached the site one minaret had vanished and the entrance portal had been rebuilt, but traces of one and possibly of two of the exterior corners of the original structure still remained. One of the then surviving īvāns may have been of the original period, but the other īvān and the bulbous dome on its high cylindrical drum belonged to the Ṣafavid period.

The use of paired portal minarets has been shown to be a rather common feature of the Mongol period. The faïence decoration of the base and the shaft of this minaret suggests that it was erected between A.D. 1330 and 1350.

Location: Outside the Ṭūqchi gate and on the line of the old road from Iṣfahān to Qumm.

Condition: Good. The base of the wall has been dug away; the right (west) side of the structure, which included the entrance portal of the original building, displays only a fragment of the line of springing of the portal arch; the right side of the portal is completely destroyed.

Plan-type: A fragment of the main façade of the structure runs east-west, above which rises the base of the minaret, rectangular with the corners irregularly chamfered, surmounted by a circular shaft.

Exterior: To the west of the existing mass of brickwork was the orginial īvān entrance to the structure, with the line of springing of the arch marked by a few bricks still in place. Fragments of the original revetment are visible and include a bracket face with a geometrical pattern in light and dark blue glazed terra cotta.

On the east face of the mass of brickwork are traces of the lower stair well by which access was provided to the minaret. The south face displays a finished structural surface upon which may be seen the abutting lines of vaults in two stories.

The exterior north face of the mass of brickwork displays the core brick to about 2.00 m. above the present ground level, laid in common bond, above which the patterned revetment area begins, composed of a large scale rectangular *kūfi* pattern spelling out sacred names in light and dark blue glazed bricks on a ground of buff-colored fired bricks; this area rises to a height of about 10.00 m. and is surmounted by the irregularly chamfered, low rectangular plinth of the minaret. Upon this plinth rises the circular tapering shaft.

The entrance to the stairway of the minaret is by a pointed arched portal at the base of the shaft on the east side.

A short distance above the crown of this portal begins a narrow horizontal zone of mosaic faïence ornamentation, in light blue, dark blue, and white glazed terra cotta with unglazed terra cotta. Above this is the main zone, displaying parallel diagonal bands of rectangular *kūfi* in light blue glazed bricks, with secondary elements in dark blue and white glazed bricks. Surmounting this is a tripartite zone of ornamentation, the outer bands consisting of a pattern in mosaic faïence in light blue, dark blue, and white glazed terra cotta with unglazed terra cotta, enclosing a central inscription band in light blue, dark blue, and white.

This zone is surmounted by an overhanging three-tiered stalactite cornice in mosaic faïence in the three colors with unglazed terra cotta, above which is a zone of bricks laid in common bond (originally the level of the balcony). The top of the shaft displays a wide zone of geometric ornament in terra cotta in three colors; this zone is pierced by four windows, each with offset arch outlined with bricks laid vertically and crowned with an offset arch lined with bricks laid vertically.

Interior: The stairway of the minaret rotates spirally around a circular core of fired bricks.

Ornamentation: Bricks: construction core: bricks .21 by .05 m.; rising joints, minimum; horizontal joints, .015 m.; light buff mortar, soft, containing much mud. Revetment bricks: standard; .17 m. square, cut; .17 by .09 m.; flush pointed, the mortar of the revetments and of the pointing medium buff-white with minute pebbles. Glazed bricks: standard; cut; moulded (colonnette capitals of stalactite cornice).

Bond: common and elaborate.

Terra cotta: complete mosaic faïence in light blue, dark blue, and white occurs, in geometrical and inscription designs; also these colors are used in combination with unglazed terra cotta.

Identification: Iranian National Monument No. 313.

Recorded: May 1939. Plan not previously published.

Illustrations: Pls. 161, 162; Figs. 44, 45.

BIBLIOGRAPHY

Flandin, *Relation du voyage*, I, p. 284.
Flandin, and Coste, *Voyage en Perse*, pl. XLI.

Smith, "Manārs of Iṣfahān," pp. 350-351, fig. 231.
Godard, "Iṣfahān," pp. 44-45, fig. 14.
Survey, pl. 363A.

77

Iṣfahān Do Minār Dār al-Baṭṭīkh
 c. /1325-50

Summary: The minarets of this structure have
been known as the Do Minār Dār al-Baṭṭīkh and
as the Do Minār Dār al-Ḍiāfa. According to a
member of the Archaeological Service of Iran,
the first of these names is the correct one through
the sanction of contemporary local usage.

The present structure consists of an entrance
portal, oriented approximately northwest, flanked
by the high octagonal plinth of two minarets
above which rise the circular shafts. The existing
portal, spanning a narrow street of the modern
city, was built against the original portal, traces
of which may be seen both near the base of the
plinths and along their upper inner faces. The
top of the minaret plinths and the upper ter-
mination of both shafts is destroyed. Originally
portal and minarets formed the monumental
entrance to a building of some importance, pos-
sibly a madrasa. On the east side of the existing
structure are traces of the line of the façade of
this building.

Preserved surfaces of the original portal, the
zones of the tapering shafts and the overhanging
stalactite cornices all display faïence decoration.
This decoration includes complete faïence mosaic
in light blue, dark blue, and white, and incom-
plete mosaic faïence where the same colors appear
in combination with plaster.

The character of the faïence ornament, in its
motifs and in the use of three-color faïence,
relates the structure to the Minār-i-Bāgh Qūsh
Khāna and the Do Minār Dardasht at Iṣfahān
and the Masjid-i-Niẓāmiyya at Abarqūh and sug-
gest a construction date between A.D. 1325 and
1340.

Identification: Iranian National Monument No.
272.

Recorded: June 1939.

Illustration: Pl. 163.

BIBLIOGRAPHY

Smith, "Manārs of Iṣfahān," p. 350, fig. 229.
Godard, "Iṣfahān," p. 43.
Survey, pl. 364.

78

Marāgha Gunbad-i-Ghaffāriya
 c. /1328

Summary: This structure is known locally as the
Gunbad-i-Ghaffāriya. In general type it is very
similar to the earlier tomb towers at Marāgha
and is especially close in plan form and panel
treatment of the wall surfaces to the Gunbad-i-
Surkh, although the later structure displays a
developed use of faïence decoration.

A. Godard has identified the paired polo sticks
found in the decoration as the heraldic bearings
of Amīr Shams ad-dīn Qarasunqur, originally
Viceroy of Egypt and later governor of the
Marāgha region under Abū Saʿīd. He died at
Marāgha in 728/1328 and an inscription on the
structure states that it was erected in the time of
Sulṭān Abū Saʿīd Bahādur Khān.

Location: On the western outskirts of the village
of Marāgha.

Condition: Fair. Interior dome and exterior roof
are missing; cornice area and lower walls dam-
aged.

Plan-type: Tomb tower. Square on the exterior;
square on the interior. Crypt below the main
chamber, entered on the east side.

Exterior: Foundation and base of a number of
courses of carefully dressed stone, some blocks
1.50 m. by .70 m. Mason's marks in the shape
of a triangle.

At the four corners of the structure are colon-
nettes of buff and red fired brick laid in a
diagonal square pattern. The north side of the
structure displays a rectangular portal (damaged)
crowned by a horizontal inscription band and
then by a niche of built stalactites, the whole
within a pointed arch frame; crowned in turn by
a rectangular inscription panel. The entire portal
and niche motif surrounded by a rectangular
frame with a geometrical interlace pattern. On
either side of the portal is a narrow pointed arch
recessed panel the surface of which is filled with
a geometrical interlace pattern. The other three
sides of the structure display two pointed arch
recessed panels crowned by horizontal panels.
Horizontal panels and arch spandrels bear traces
of faïence decoration. Within each large recessed
panel is a smaller rectangular recessed panel; at
the base of the panel a window and above a
pointed arch crowned by a horizontal panel. The
bricks on the exterior walls of the structure are
laid in common bond.

Interior: The steps which lead up to the portal
are missing. The north interior wall surface dis-
plays no reveals; the south wall has a pointed
arch miḥrāb panel at the center which is flanked
by pointed arch recessed panels. The other two
walls display two pointed arch recessed panels.
Interior wall surfaces are coated with plaster
and there are traces of painted decoration on the
plaster.

The level of the zone of transition and the inner dome have completely vanished.

Structural features: A marked affinity with the earlier tomb towers at Marāgha. The use of cut stone is characteristic of the Āzerbāijān region.

Ornamentation: Bricks: light buff and red fired in standard, cut, and moulded shapes.

Bond: common; elaborate.

Joints: beaded; pointed.

Terra cotta: unglazed; specially cut and moulded pieces for the stalactites, blazons, etc. Glazed; white, light blue and dark blue with some of the dark blue pieces almost black in color. In the geometrical interlaces the three colors are used with unglazed terra cotta and in the portal head are small areas of complete mosaic faïence. The portal inscription consists of dark blue letters set into a plane surface of light blue glaze, but most of the background glaze has been scraped down to the biscuit to leave a delicate floral pattern in light blue.

Date control: 1. According to the inscription, within the reign of Abū Sa‘īd. Probably prior to the death of Qarasunqur in A.D. 1328.

Identification: Iranian National Monument No. 137.

Recorded: October 1937 and July 1939. Plan drawn by John B. McCool.

Illustrations: Pls. 164, 165, 166; Fig. 46.

BIBLIOGRAPHY

Morgan, de, *Mission scientifique*, I, p. 337, fig. 188.

Houtum-Schindler, "Reisen im nordwestlichen Persien," pp. 337-338.

Sarre, *Denkmäler*, p. 16, fig. 11.

Godard, "Les monuments de Māragha," pp. 16-18, fig. 8.

————, "Notes complémentaires," pp. 143-149, figs. 100-102.

Herzfeld, "Arabische Inschriften," pp. 95-96.

Survey, p. 1098, fig. 362, pl. 342A.

79

Marand Masjid-i-Jāmi‘
730/1330
740/1339

Summary: The Masjid-i-Jāmi‘ at Marand is a completely enclosed structure, rectangular in plan, with neither court nor monumental portal. Because of its variant form the suggestion has been made that the monument was originally a church which was converted into a mosque during the Mongol period. Actually, the plan form is the result of growth by accretion through a long period of time.

First, the square dome chamber, with portals on three sides, was erected in the Seljūq period. In the Mongol period this chamber was repaired and decorated. Later on a series of vaulted bays were built to the north, east, and west of the dome chamber and within quite recent times the walls of the structure were extended to the east and a rectangular prayer hall was established. At the northwest corner of the structure is the octagonal plinth of a minaret which may have been contemporary with the dome chamber. At some time during the centuries the dome over the square chamber fell in.

The work of the fourteenth century may be briefly described. The south wall of the dome chamber displays a carved stucco miḥrāb, elaborately ornamented and terminating in a high cove. Above the top of the miḥrāb a carved stucco inscription frieze encircles the chamber. The miḥrāb bears several inscriptions. Above the center panel is written, "Renewed by the abundant gift of the great Sulṭān, the possessor of the necks of the nations, Abū Sa‘īd Bahādur Khān, may God make his kingdom everlasting; the year seven hundred and thirty-one (A.D. 1330)." Above the inner arch is the sentence, "The work of the poor servant Niẓām, the pointer (mason) of Tabrīz." A third line, within the miḥrāb arch, gives the name of the local person who was responsible for the maintenance of the mosque.

The portal of the winter prayer hall has a stone door frame which bears the following inscription, "The repair of this building was ordered by the great chief Khwāja Ḥusayn ibn Sayf ad-dīn Maḥmūd ibn Tāj Khwāja; the end of Shawwāl, the year seven hundred and forty (A.D. March 1339)."

Thus, it seems certain that the activity of the Mongol period consisted in the repair and decoration of an existing structure and that no major building was undertaken. The stone door frame has probably been moved from its original position in or adjacent to the dome chamber.

Identification: Iranian National Monument No. 139.

Recorded: July 1939. The plan is a revised version of the plan published in the *Survey of Persian Art*.

Illustrations: Pl. 167; Fig. 47.

BIBLIOGRAPHY

Grey (Trans. and Ed.), *A narrative of Italian travels*, p. 164.

Morier, *A second journey*, p. 302.

Ouseley, *Travels in various countries of the East; more particularly Persia*, III, p. 411.

Merāt al-Boldān, IV, p. 85.

Sarre, *Denkmäler*, pp. 24-25.
Survey, pp. 1096-1098, fig. 392, pl. 398.

80

Sulṭāniya tomb of Chelebi Oghlu and
adjacent complex
c. /1330
733/1333

Summary: This structure is known locally as the tomb of Chelebi Oghlu. It is adjacent to a badly ruined complex comprising elements of īvāns and arcades, constructed in rubble masonry and arranged around a central open court. According to a communication from André Godard, the complex was a *khānaqāh* and is dated 733/1333. One well-preserved detail of the khānaqāh is a small portal of dressed stone: on the stones have been incised false joints which simulate the elaborate stereotomy common to Asia Minor at this period (Fig. 50).

The tomb tower now displays no apparent plan relationship to the khānaqāh, just a few meters away, and might be earlier, later, or contemporary with the complex. The tomb is near enough to the mausoleum of Öljeitü to have fallen within the limits of the imperial city and it has been suggested that some of the builders who had completed their tasks at Sulṭāniya moved on to Iṣfahān where they modeled the Imāmzāda Jaʿfar of 72– after the Chelebi Oghlu. It does not seem likely that the tomb was built after the khānaqāh: conditions were unfavorable to architectural activity in Āzerbāijān after 1335; all the stylistic features common to the structure may be found in monuments of this region dated before 1335; and if it were later it should have a closer architectural relationship to the larger structure. It appears probable that the tomb was erected before the khānaqāh and the site of the khānaqāh was chosen because of the sanctity of the tomb. The date of 1330 is suggested as the date of the tomb tower.

Location: At Sulṭāniya, a few hundred meters southwest of the mausoleum of Öljeitü.

Condition: Good; top of exterior wall faces damaged; upper part of dome is disintegrating.

Plan-type: Tomb tower; octagonal on exterior; octagonal on interior; crypt below chamber.

Exterior: Foundation and base of at least three courses of cut stone (two courses now visible above ground level to a height of 1.20 m.). Each side of the structure has a pointed arch recessed panel within a similar splayed panel, within a rectangular frame the spandrels of which contain hexagons once filled with a decorative motif. To 2.50 m. above the base an elaborate brick lay

which then gives way to common bond. Upper line of rectangular panels serves as a cornice. Single row of exposed scaffold holes on wall faces. Dome set back from exterior wall line on a sixteen-sided drum, then highly stilted to rise with semicircular profile. Three rows of exposed scaffold holes.

Interior: Threshold of cut stone blocks; floor of stone slabs laid in mortar; crypt visible through hole in floor. Each wall face displays a pointed arch recess. Walls to 1.42 m. from floor have a blue-gray plaster coat, then a white coat on gray plaster. Stucco stalactite miḥrāb niche. Zone of transition composed of sixteen pointed-arch wall arches. Single window in dome above wall arches. Intramural winding stair entered above head of wall recess, lit from exterior by single small window.

Structural features: Use of cut stone characteristic of Āzerbāijān. Definite alteration of scheme where elaborate brick lay of exterior faces stops: final structure probably much simpler than original concept. Profile of stilted dome unusual for the period. Close affinity with Imāmazāda Jaʿfar at Iṣfahān.

Ornamentation: Bricks: (light buff) standard (.20 m. by .05 m.; horizontal joints .02 m.; rising joints minimum); cut; cut with false incised joints; moulded; a few standard bricks .28 m. long.

Bond: common; elaborate (in conjunction with terra cotta end plugs to spell out pious names).

Faïence: missing from hexagonal panels in spandrels.

Stone: gray-green closely fitted blocks with mason's marks | | | and I.

Date control: 1. Structure possibly model for Imāmzāda Jaʿfar at Iṣfahān.

2. Site relationship to larger monument of 733/1333.

Identification: Iranian National Monument No. 167.

Recorded: September 1943. Plan and elevation-section not previously published.

Illustrations: Pls. 168, 169, 170, 171; Figs. 48, 49, 50.

BIBLIOGRAPHY

Ogilby, *Asia, the first part*, p. 22.
Flandin, *Relation du voyage*, I, p. 205.
———, and Coste, *Voyage en Perse*, pl. x.
Dapper, *Umstandliche und eigentliche beschreibung von Asia*, p. 36.
Dieulafoy, J., *La Perse, la Chaldée et la Susiane*, p. 92, fig. on p. 97.
Sarre, *Denkmäler*, pp. 22-23.
Survey, p. 1099, pl. 354A.
Farhang-i-joghrāfīya . . . , II, p. 153.

81

Turbat-i-Shaykh Jām part of shrine complex
c. /1330

Summary: The small village of Turbat-i-Shaykh Jām is situated on the main road between Mash-had and Herāt, some 166 kilometers from Mash-had and only a short distance from the frontier between Iran and Afghanistān.

At the edge of the village is the imposing shrine complex which was built up through the centuries around the grave of Aḥmad ibn Abū'l Ḥasan, known as Shaykh Jām. A noted author, teacher, and Sūfī theologian, the Shaykh died in this village in 536/1141-42. His tomb is situated in the monumental forecourt of the shrine and just in front of the lofty īvān.

In his early account of the complex Khanikoff gave the names of several individuals who or-dered the construction of various sections of the shrine together with the dates of the work and he also stated that one area was erected during the lifetime of the Shaykh. However, he gave no precise source for this material which may have come either from local tradition or from two biographies of Shaykh Jām, one completed in 840/1436 and the other in 929/1522. Two of his dates check with dated elements of the complex.

Present attention must be devoted to work of the Mongol period, but it may be noted that no traces were found of construction work earlier in date than the fourteenth century. A descrip-tion of the later building activity may be found in *A Survey of Persian Art*.

The area of the complex marked A on the plan was found to be in poor condition—con-siderably worse than when seen by Diez in 1913. Thus, on the accompanying plan the eastern section of this area is completed following a sketch plan given by Diez. The area appears to be earlier in date than any of the section adjacent to it, but examination of the points of contact was complicated by the ruined condition of some walls and the evidence of many periods of repair on others.

This area has been referred to in other pub-lications as the Sunni oratory. The plan arrange-ment comprises five aisles with the brick piers carrying brick vaults and with the presumed cen-tral point of the plan crowned by a brick dome. On the south and east the side aisles were two stories in height. Soffits, spandrels, angle colon-nettes, and other elements are covered with extraordinarily fine plaster relief decoration bear-ing traces of blue and yellow pigment. The intra-dos planes of the arches on the southern side have false brick patterns incised in the plaster

and the patterns used are very similar to those found in the galleries of the tomb of Öljeitü at Sulṭāniya.

On purely stylistic grounds the plaster decora-tion dates from the first half of the fourteenth century. The left-hand leaf of a pair of carved wooden doors which are now used in the portal of the principal dome chamber of the complex—erected in the middle of the fifteenth century—bears an inscription which ends ". . . Rajab in the year 733 (A.D. March 1333)." It is highly probable that these doors were originally in posi-tion in the area under discussion and that their date corresponds to that of the execution of the plaster decoration.

Identification: Iranian National Monument No. 174.

Illustrations: Pls. 172-176; Fig. 52.

Recorded: November 1937. The plan, not pre-viously published, was originally measured and drawn by John B. McCool. In 1937 the Archae-ological Service of Iran was carrying out extensive repairs intended to protect the plaster from the weather.

BIBLIOGRAPHY

Voyages d'Ibn Batoutah, III, pp. 74-77.
Khanikoff, de, "Mémoire sur la partie meri-dionale," pp. 354ff.
Merāt al-Boldān, IV, pp. 85-86.
Elias, "Notice of an inscription," pp. 47-48.
Yate, *Khurasan and Sistan*, pp. 36-37.
Diez, *Churasanische Baudenkmäler*, pp. 78-82, pls. 35-37.
——, *Persien*, pp. 44, 70, 135, pls. 57, 64, 65.
Gluck, and Diez, *Die Kunst des Islam*, pl. 288.
Survey, pp. 1160-1161.

82

Marāgha Joi Burj
c. /1330

Summary: This structure has been known as the Khoi Burj, but it seems more reasonable to refer to it as the Joi Burj: meaning "Blue Tower." Godard would date the monument in the second half of the fourteenth century, but it seems more likely that it was erected about A.D. 1330. This earlier dating would make it contemporary with the Gunbad-i-Ghaffāriya at Marāgha and, indeed, the mosaic faïence work is similar in both struc-tures.

Location: Northern edge of the town of Marāgha.

Condition: Ruined; the structure is almost com-pletely destroyed except for a small portion of the rear wall, but the ground plan and interior wall-surface treatment are discernible. The orig-inal structure had a crypt.

Plan-type: Tomb tower; circular exterior, decagonal interior.

Exterior: Cut stone base course, surmounted by upper walls of red fired brick. Arched entrance portal surmounted by a rectangular panel (originally containing an inscription), and the whole enclosed within a rectangular cavetto moulding, the entire portal motif displaying geometrical ornament executed in complete and incomplete mosaic faïence. Nothing of the encircling frieze at the top of the structure, nor of the roof, remains.

Interior: Each interior wall face was composed of a single recessed panel, probably of pointed arch profile (cf. "round tower," Marāgha), executed in fired bricks.

Structural features: The structure displays the combination of stone and fired bricks so common to the Āzerbāijān region. The ground plan is to the circular tomb in Marāgha as the Gunbad-i-Ghaffāriya is to the Gunbad-i-Surkh, Marāgha.

Ornamentation: Bricks: standard (interior surface .205 m. by .055-.06 m.; rising joints, minimum to .005 m.; horizontal joints, .015 m.).

Bond: common on interior; elaborate on exterior, brick lay displaying a large-scale allover pattern of rectangular *kūfi*.

Terra cotta: glazed; voids of exterior brick lay filled with light blue glazed fired brick in standard and cut lengths, joints flush pointed.

In the debris surrounding the structure, various fragments of the ornament were found: one showing complete mosaic faïence in white, light blue, and dark blue glazed terra cotta; one using these colors as polygonal interstitial units in a strapwork pattern formed of unglazed terra cotta; a hexagonal dark blue tile with part of the glaze scraped away to expose the biscuit, the whole framed in light blue glazed strips and enclosed in cut fired bricks.

Date control: Character of brickwork and faïence techniques employed are typical of the later Mongol period. Close relationship in geometrical ornamentation, scale of ornament, and in use of three color faïence with the Gunbad-i-Ghaffāriya, Marāgha, c. A.D. 1328.

Identification: Iranian National Monument No. 138.

Recorded: July 1939. Plan not previously published.

Illustration: Fig. 51.

BIBLIOGRAPHY

Morgan, de, *Mission scientifique*, I, fig. 189.
Sarre, *Denkmäler*, p. 16.
Godard, "Note complémentaires," pp. 152, 153, 156, fig. 106.
————, "Les monuments de Marāgha," pp. 18-19, fig. 10.

83

Khiav tomb of Sulṭān Haidar
c. /1330

Summary: This structure is known locally as the tomb of Sulṭān Haidar. Surviving portions of the inscriptions are badly damaged and no dated inscription was found. However, the tomb tower may well date c. A.D. 1330, a supposition which is based upon the type of mosaic faïence, the use of cut stone as compared with dated monuments, and specific decorative details. In addition, the structure has features which relate it to the regional school of architecture which existed in Āzerbāijān during the Mongol period.

Location: On the outskirts of Khiav, a village on the northern of two roads between Tabrīz and Ardabīl.

Condition: Fair; tent dome has fallen, cornice destroyed, original entrance portal encumbered by a modern construction.

Plan-type: Cylindrical exterior; dodecagonal interior; crypt under tower.

Exterior: Cut stone foundation and base; wall revetment of reddish brick applied one brick thick to core; entrance portal and three blind windows with miḥrāb-like frames on main axes; mosaic faïence inscription band and cornice at base of roof almost entirely destroyed.

Interior: Dodecagonal wall surfaces are accentuated at a higher level with corner strips and still higher by semicircular niches crowned by a stalactite cornice in brick.

Structural features: General plan type (cf. such Seljūq structures as tomb tower Resget; tomb tower Lajim; "round tower," Marāgha); relatively massive core with applied brick revetment.

Ornamentation: Bricks: standard (.20 m. by .06 m.); cut.

Bond: common; elaborate (herringbone in revetment).

Joints: flush pointed (originally).

Terra cotta: mosaic faïence, miḥrāb-like frames of portal and blind windows in black, light blue, dark blue, and white, also in cornice; glazed tile, interstices of brick revetment inset with squares of light blue glaze tile which form all-over pattern spelling out holy names; unglazed, red terra cotta letters in much damaged inscription around entrance portal.

Date control: 1. Mosaic faïence more developed than at mausoleum of Öljeitü, Sulṭāniya, 709-711/1309-1311.

2. Stalactite cluster over portal very like that of miḥrāb of Masjid-i-Jāmi', Ardabīl.

3. Cut stone base relates structure to group of monuments of Āzerbāijān which display influence from Syria and Asia Minor (cf. "caravanserai of Hūlāgū"; caravanserai at Sarcham; Gunbad-i-Ghaffāriya, Marāgha; Joi Burj, Marāgha; tomb tower, Salmās).

Identification: Iranian National Monument No. 184.

Recorded: October 1936. Plan not previously published.

Illustrations: Pls. 177, 178; Fig. 53.

BIBLIOGRAPHY

Morgan, de, *Mission scientifique*, pl. XLIV.
Survey, pl. 343.
Herzfeld, "Die Gumbadh-i 'Alawiyyân," p. 193.

84

Abarqūh Gunbad-i-Sayyidun and
Gunbad-i-Sayyidun Gul-i-Surkhi
c. /1330

Summary: The two structures known as the Gunbad-i-Sayyidun and the Gunbad-i-Sayyidun Gul-i-Surkhi are almost entirely destroyed. A photograph, published by Godard, of the miḥrāb wall of the latter monument furnishes sufficient evidence for a dating of c. A.D. 1330. The plaster miḥrāb is very badly damaged, but its general composition and arrangement of elements is almost identical with that of the dated miḥrāb in the Masjid-i-Jāmi' at Abarqūh. It is of interest to note that the outer panel bands of the miḥrāb were applied directly, without any attempt at bonding, to a smooth plaster undercoat which covered the structural wall. The wall surface above the miḥrāb and adjacent to it displays plaster stalactites, offset mouldings, incised plaster designs and broken-headed arches; all small in scale and delicately done and all features characteristic of the Mongol period.

Recorded: Not visited.

Illustration: Pl. 180.

BIBLIOGRAPHY

Godard, "Abarḳūh," p. 72, fig. 50.

85

Marand (vicinity) caravanserai
c. /1330-35

Summary: In Iran the villagers normally assign all the older caravanserais to the time of Shāh 'Abbās. However, the present structure is known locally as the caravanserai of Hūlāgū and in this case local tradition is fairly close to the mark.

The structure must date from about A.D. 1330, not much earlier because of the use of complete mosaic faïence and not later than 1335, because of the general character of the decoration.

Originally the monument bore several inscriptions, but at the present time only a little more than half of the *kūfi* inscription on the extrados of the transverse arch of the portal is in place and it is too fragmentary to be legible. When Khanikoff saw the caravanserai in 1857 the portal was already in a ruinous state. However, he found features which reminded him of an inscription of A.H. 582 at Nakhichevan which was Persian written in *kūfi*, and in the caravanserai inscription he noted the repetition of two words which led him to believe that Persian verse made up the text. Dr. George C. Miles, after studying a hand copy of the inscription, asserts that it is not in Arabic and Khanikoff's assumption may be accepted. The primary point of interest is that only a handful of inscriptions have been noted on Islamic architecture in Iran which are both in Persian and prior to the fifteenth century.

As originally erected the caravanserai must have been one of the finest monuments of the period. The decoration is most carefully executed and the patterns are well related to the type and shape of the surfaces upon which they were placed.

Location: Some 13 kilometers north of Marand, on the road between Tabrīz and Julfa.

Condition: Fair. Base courses of very large blocks of dressed sandstone are preserved, bastions and stretches of the outer wall, 1.10 m. thick, are preserved. Entrance portal nearly intact. Chambers along the interior wall faces are missing.

Plan-type: Caravanserai, rectangular plan with ten bastions and monumental portal.

Exterior: The portal fronts east. South of the portal element the exterior wall is preserved to a height of about 4 m. Its fired bricks are in common bond except for a crowning horizontal band about .80 m. high in consecutive diagonal square patterns of standard and cut bricks.

The following description of the portal begins with the outer edge of the south side of the motif and continues around to the entrance doorway. First, a flat vertical surface running up to the highest preserved point of the portal, about 9 m., above ground level. Rising joints have inset pieces of light blue glazed tile. Then, a cavetto profile vertical surface consisting of a strapwork pattern with twelve-pointed stars as focal points in which solids are unglazed terra cotta strips and voids cut pieces of light blue glazed tile. Then, a forty-five degree vertical panel with a simple strapwork pattern, solids and voids as in surface just de-

scribed. At either edge of this panel is a vertical row of moulded brick. Then, an angle colonnette with a diagonal square pattern executed in very small pieces of light blue glazed tile and buff terra cotta. Then, a narrow vertical face of cut bricks with light blue tile insets in the rising joints. Then, two adjacent broken-arched recessed panels composed as follows. The main surface of the panels has a pattern of hexagons and six-pointed stars in terra cotta with the voids light blue glazed tile lozenges. Glaze very irregular in color, ranging to quite an intense green. Panel crowned by a straight-sided trefoil arch and in spandrels is complete mosaic faïence in light blue, dark blue, and white (hexagons and six-pointed stars in dark blue with voids in white and light blue). On the west side of the portal these same spandrels have a continuous floral scroll which was executed as follows. Three large pieces of dark blue glazed tile were cut to fill the area and the pattern formed by scraping the glaze down to the biscuit to leave the scroll in dark blue. Above the spandrels were horizontal inscription bands in complete mosaic faïence, the letters white, the background dark blue and the borders and incidental accents in light blue. Above these bands the three faces of the entrance were encircled by a continuous horizontal inscription about .60 m. high composed of complete mosaic faïence, the letters white, background dark blue, edges light blue.

The exterior face of the portal arch is composed as follows. Springing from the angle colonnettes is an inscription some .25 m. wide of *kūfi* letters in cut terra cotta against a light blue glazed tile ground. In the spandrels above is an all-over strapwork pattern with solids of terra cotta strips and voids of light blue glazed tile.

The vault over the portal entrance is almost completely destroyed. Intact is the intrados of the transverse arch of the portal entrance. It is ornamented with diagonal squares in glazed cut brick in light blue, dark blue, and white with voids on plain cut bricks. The few preserved elements of the vault display completely ornamented surfaces, in which the salients have the following types of patterns. Diagonal patterns in light blue glazed and plain bricks, all-over patterns with solids light blue glazed tile and voids unglazed, with terra cotta slightly raised above surface of the faïence, triangular-shaped areas above the salients consisting of complete mosaic faïence in light and dark blue.

The wall of the entrance doorway is pierced by a wide, slightly elliptical arch of dressed sandstone. The keystone has a semispherical boss on its face. The spandrels above are of brick with insets of light blue tile in the rising joints.

Structural features: Typical of northwest Iran is the combination of fired brick and dressed stone. Cut stone voussoirs, moulding on edge of voussoirs, and keystone boss suggestive of Syrian and Asia Minor influences.

Date control: 1. Complete mosaic faïence indicates a date later than A.D. 1310.

2. Dressed stone entrance doorway as in caravanserai at Sarcham, dated 733/1332-33.

Ornamentation: Bricks: standard (.21 m. by .06 m.); cut; moulded.

Bond: common; elaborate.

Joints: horizontal .015 m.; vertical .025 m.

Stone: dressed stone voussoirs with simple moulding on outer edge.

Terra cotta: unglazed, strips of strapwork pattern, strips of angle colonnettes, hexagons and six-pointed stars, cut letters of inscription band. Glazed; complete mosaic faïence in light blue, dark blue, and white, insets of light blue, cut pieces of dark blue in voids of strapwork patterns, floral scroll in dark blue with scraped biscuit as ground.

Recorded: July 1939. Plan redrawn after an original measured plan made by Peter B. Baggs. Plan not previously published.

Note: Unverified reports are current to the effect that the entrance portal was destroyed between 1942 and 1945.

Illustrations: Pls. 179, 180; Fig. 55.

BIBLIOGRAPHY

Dieulafoy, J., *La Perse, la Chaldée, et la Susiane*, p. 38.

Porter, Ker, *Travels*, I, p. 216.

Khanikoff, de, "Mémoire sur les inscriptions musulmanes du Caucase," p. 115.

86

Varāmīn	Imāmzāda Shāh Ḥusayn
	c. /1330

Summary: This structure is known locally as the Imāmzāda Shāh Ḥusayn and is situated near the center of modern Varāmīn, a few hundred meters southeast of the Masjid-i-Jāmiʿ.

Although the fundamental elements of the tower and miḥrāb are simple in themselves, their relationship is complicated by the presence of building remains of various periods each in a different stage of ruin.

Today the complex includes a walled entrance court, a prayer hall containing the miḥrāb, and the tomb tower. According to the *Merāt al-Boldān* the mosque with its miḥrāb was built in A.H. 819 and the tomb was that of Sayyid Fath Allāh.

Study of exterior wall surfaces is made difficult by adjacent modern houses. Fortunately, Jane Dieulafoy was at the site in 1881 and published two drawings. One shows the tomb tower in much better condition than at present, while the other illustrates the miḥrāb which was then almost free standing and entirely exposed to the weather. Thus, it is certain, as was verified in the examination of the structure, that the scheme of the prayer hall is entirely modern. On the other hand, there are certain wall surfaces which may be assumed to date from the period of the miḥrāb itself. These are hatched on the accompanying plan.

The original development of the complex was along the following lines. First, construction of the tomb tower. Second, construction of the structure which housed the miḥrāb. The miḥrāb was then on the axis of a dome chamber which opened toward the east into an open court surrounded by arcades. Two pilaster faces of the arcades still exist. A very short period of time elapsed between the first and the second construction. The decorative features and details of both tomb tower and miḥrāb are very like similar work in the Masjid-i-Jāmiʿ at Varāmīn and thus they may date to c. A.D. 1330.

Description of the tomb tower:

Condition: Fair; roof missing; cornice missing; interior repaired and rebuilt.

Plan-type: Tomb tower; octagonal on the exterior; circular on the interior.

Exterior: Wall surfaces have rectangular recessed panels with a portal and three windows on alternating sides. Inscription frieze and cornice now missing.

Interior: Interior wall surface coated with modern plaster; above is a shallow, modern mud brick dome.

Ornamentation: Bond: common; elaborate; a diaper pattern made by recessing certain bricks.

Terra cotta: unglazed combined with light blue glazed on corner angles. Occasional small squares of light blue glazed tile inset in brick bonding pattern.

Description of the miḥrāb: Ornamentation is composed of strapwork designs executed in dark blue faïence strips, light blue faïence strips, and unglazed terra cotta strips set into white plaster. Inscription band was of dark blue faïence letters set into white plaster: only a few letters remain.

Description of pilaster faces: Partially covered by an elaborate bond of cut bricks with the spaces in the pattern filled by decorative insets in the shape of hexagons and six-pointed stars.

Date control: 1. Stalactite head of miḥrāb much like similar forms in the Masjid-i-Jāmiʿ, Varāmīn.

2. Strapwork decoration similar to that in the Masjid-i-Jāmiʿ, Varāmīn.

3. Shaped insets of pilaster faces much like those used in the Masjid-i-Jāmiʿ, Varāmīn.

Identification: Iranian National Monument No. 339 under name of Shāhzāda Husein.

Recorded: May 1939 and April 1943. Plan not previously published.

Illustrations: Pl. 184; Fig. 54.

BIBLIOGRAPHY

Dieulafoy, J., *La Perse, la Chaldée et la Susiane*, pp. 149-150, figs. on pp. 148 and 149.
Merāt al-Boldān, IV, p. 122.

87

Qumm Gunbad-i-Sabz
 c. /1330

Summary: This monument, known locally as the Gunbad-i-Sabz, is a near neighbor of the tombs of ʿImād ad-dīn and ʿAlī Sāfī. All three monuments are near the former Kāshān gate of Qumm and within the area of the Bāgh-i-Sabz, the "Green Garden." The Gunbad-i-Sabz is the northernmost of the trio.

The structure is of Type II of the tombs of Qumm (see p. 115) but has twelve sides rather than the usual octagonal plan. The structure is in fair condition: at the cornice level and below, sections of the fabric have disintegrated. The lower walls have recently been repaired and the platform on which the tomb stands rebuilt. Interior wall surfaces are covered with polychrome relief plaster.

Because of the fact that a high level of technical skill in the use of plaster was maintained throughout the entire fourteenth century at Qumm it is difficult to suggest a precise date for the erection of the monument. It was certainly erected between A.D. 1315 and 1365 and probably about 1330.

Identification: The three tombs of the Bāgh-i-Sabz are listed together as Iranian National Monument No. 129.

Recorded: April 1944.

Illustration: Pl. 182.

BIBLIOGRAPHY

Sarre, *Denkmäler*, pp. 71-72, pl. LIX.
Flandin, and Coste, *Voyage en Perse*, pl. XXXVI.
Herzfeld, "Reisebericht," p. 234.
Rāhnāma-yi-Qumm, p. 132.

88

Qumm Imāmzāda Ibrāhīm
 c. /1330

Summary: This structure, known locally as the Imāmzāda Ibrāhīm or the Shāhzāda Ibrāhīm,

rises from the cultivated fields to the west of the town.

The structure is of Type III of the tombs at Qumm (see p. 115). It is in good condition except for the fact that the outer polyhedral tent dome has vanished so that the exterior surface of the loaded inner dome is exposed. A few years ago the entrance was repaired and decorated with blue tiles at the expense of a local resident.

Tiles on the grave within the tomb contain the names of Ibrāhīm ibn Mūsā ibn Ja'far and Muḥammad ibn Mūsā ibn Ja'far.

The monument was probably erected between A.D. 1330 and 1365.

Recorded: Not visited.

Illustration: Pl. 189.

BIBLIOGRAPHY

Pope, "The Photographic Survey," p. 37, fig. 3 (this illustration may be of another structure of the same name).

Rāhnāma-yi-Qumm, pp. 131-132 and unpaged illustration.

89

Sīn (Iṣfahān) caravanserai

730/1330
731/1330-31

Summary: This caravanserai is located along the road which for centuries was the main route leading north from Iṣfahān. The chambers which once surrounded the spacious central court have almost entirely vanished in the course of time as villagers removed the material for building and even dug out the stones at the base of the structure. The plan arrangement and details of the entrance portal and vestibule are entirely consistent with earlier work in Iran and display none of the regional feeling of the caravanserai at Sarcham and the so-called caravanserai of Hūlāgū.

One point of interest is the fact that the decoration of the structure was never completed and in this respect the monument may be classed with the group of dome chambers adjacent to Iṣfahān which are of the same period and which have uncompleted ornamentation. For example, either inscription bands or other decoration should be found on the entrance portal in the panel on the extrados of the façade arch, in the recessed panel on the soffit of the cross arch and in the horizontal recessed panel of the portal. Actually the bricks in these areas were never pointed while the completed areas of the structure display flush pointing.

An inscription on the vault of the vestibule contains the date of A.H. 730 while small panels on the portal faces give the name of "Hājjī Muḥammad, the builder of Sāva," and the date

of A.H. 731. We may believe that the craftsmen who were to decorate such a monument arrived on the scene some time after the fabric was completed. In this case the ornamentation of the vestibule was completed several months in advance of that surviving in the portal, but there is no certainty that both sections were executed by the same hand.

Location: South of Sīn, a village some 21 kilometers north of Iṣfahān.

Condition: Fair. Exterior walls and bastions preserved, entrance portal preserved but stalactite vault fallen, octagonal vestibule behind portal preserved, but bays at east side altered and decoration badly damaged by smoke. Chambers along interior wall all destroyed.

Plan-type: Caravanserai, rectangular plan with monumental entrance.

Exterior: Base of rough stone masonry, enclosure walls, .80 m. thick, and bastions of fired brick. Parapet of wall in three stages of projecting triangles and rectangles, above this point two meters of later mud brick wall. Entrance portal of fired brick. At outer corners of portal façade recessed panels in three stages, rectangular, square, rectangular; adjacent vertical mouldings break back to stellar corner flanges. Within portal entrance is recessed rectangular panel, then deep-pointed arch recess. At back wall cross arch of doorway is preserved. Above the heads of panel and recess is a horizontal recessed panel, .60 m. high, which once ran around the five faces of the portal. Above and in line with portal façade is a pointed cross arch .50 m. wide, with a square inscription panel at either springing line (position of inscriptions indicated by arrows on plan). Section behind the cross arch was once stalactite vaulted, but only traces of the lowest plaster decorated stalactites remain. Scaffold holes in three stages on portal façade.

Interior: Flanking either side of the rectangular bay behind the entrance doorway are passageways leading to stairs which give access to the top of the bastions. A vestibule, octagonal in plan, displays recesses on the east and west sides; the recesses at the east were apparently altered at a later date. Offset arches at entrances to vestibule and in west recesses. Octagon is crowned by a groined vault of flat profile which is coated with carved plaster with patterns and a continuous inscription band.

Ornamentation: Bricks: standard (.22-.23 m. by .05 m.).

Bond: common.

Joints: flush pointed in completed areas; horizontal joints .02 m.; vertical joints .015 m.

Plaster: inscription panels, stalactite faces, polychromed on vestibule vault.

Structural features: An unusual combination of material in lintels at the corners of façade and entrance portal. Below bottom of horizontal recessed panel are horizontal wooden beams; one is embedded in the façade and the other at right angles along the side wall of the portal. At their meeting point they are connected by nails through a right-angle piece of iron which seems to be contemporary with the structure.

Date control: 1. Inscriptions dated 730/1330 and 731/1330-31.

Recorded: April 1943. Plan not previously published.

Illustrations: Pl. 183; Fig. 56.

BIBLIOGRAPHY

Smith, "Two dated Seljuk monuments at Sīn (Isfahan)," p. 1 n. 6, figs. 6, 12, and on p. 15 "Epigraphical Notes," by G. C. Miles.

90

Sarcham caravanserai
733/1332-33

Summary: At Sarcham, between Zenjān and Miāneh, on the route between Qazvīn and Tabrīz are the ruins of an important caravanserai. This structure, called a *robat* in the portal inscription, has been discussed by André Godard. The monument is located on the bank of the Zenjān River with its portal facing the river and the south. The original plan consisted of a rectangular enclosure within which was a large central court surrounded by chambers and with four īvāns on the principal axes. Today all these sections are a mass of debris. The south īvān was entered through the main portal. This entrance portal survives in fairly good condition. Its corner bastions, vertical surfaces, transverse arch and built stalactite vault are all features typical of the general building tradition of the country. The brick joints were not pointed and it seems probable that decoration planned for such areas as the spandrels of the side wall recesses and the salient faces of the stalactites was never put into place. In contrast to the style of the rest of the motif is the entrance doorway and surmounting inscription: the former in sandstone and the latter in marble. This feature might have been taken directly from a Syrian monument of the period and in particular from one of the structures still standing at Aleppo. Most indicative of such a source is the narrow moulding at the outer edge of the voussoirs which is knotted above the keystone and carries on up around the inscription panel. The stonework shows quite careful cutting and fitting, but apparently the pieces were not quarried in large enough blocks for a good deal of patching was done in the voussoirs and other areas.

The inscription gives the name of the last Mongol ruler, Abū Saʿīd, that of his principal minister, Ghiyath al-Ḥaqq wa ad-dīn Muḥammad, and the date A.H. 733 (A.D. 1332-33).

Recorded: September 1943. Plan not previously published.

Illustrations: Pls. 188, 189; Fig. 57.

BIBLIOGRAPHY

Godard, "Notes complémentaires," pp. 149-152, figs. 104, 105.
Herzfeld, "Arabische Inschriften," p. 100.

91

Īj rock-cut hall
733/1332-33

Summary: Located outside of the village of Īj and 20 some kilometers south of the town of Nayrīz, this monument has been described by Sir Aurel Stein under the name of the mosque of Shahr-i-Īj.

Behind a plain vertical façade cut into the cliff face is a single room or hall about thirteen feet square and crowned by an elliptical-shaped vault, also cut into the solid rock. An inscription contains the Moslem confession of faith, the date 733/1332-33, and the title (not the name) Amīr-al-Ḥājib or "Lord Chamberlain."

The hall is certainly several hundred years earlier than this date and in respect to the reuse of an earlier monument may be compared with the Masjid-i-Sang at Dārāb.

BIBLIOGRAPHY

Stein, "An Archaeological Tour," *Geographical Journal*, p. 495.
———, "An Archaeological Tour," *Iraq*, 2 (1936), p. 172, fig. 23.

92

Mashhad tomb chamber of the
shrine of Imām Riẕā
735/1335
760/1359

Summary: Only within the last twenty years has it been possible for non-Moslem scholars to visit the shrine of the Imām Riẕā, the largest and most revered place of pilgrimage within Iran and to inspect the actual tomb chamber of the saint.

The references given in the bibliography to this monument contain the statement that Sulṭān Öljeitü ordered restoration work done at the tomb chamber and the following discussion is intended to examine that possibility.

The earliest dated architectural construction

within the vast complex of the shrine is of the early fifteenth century. It is certain that earlier buildings had existed and did exist for there are historical references to the repair and restoration of the sanctuary in the Seljūq period and by Öljeitü, and a traveler who visited the shrine before the middle of the fourteenth century saw a dome surmounting the tomb chamber. However, Yate states that the dome, destroyed by an earthquake, was rebuilt and gilded by Shāh Sulaymān in A.D. 1672.

A summary description of the tomb chamber follows. The portal frames and jambs and chamber walls are decorated with luster-painted tiles and luster-painted miḥrābs. Some of these elements may have been executed in connection with structural work while others were merely ornamentation applied to an existing surface. According to my notes—the fact does not seem to have been published elsewhere—the outer frame of the main south portal of the tomb chamber is clad with luster-painted tiles in a border 1 m. wide on either side of the opening and 1.50 m. high over its head. The date of Jumada I, 612/1215 appears on these tiles.

The walls and ceiling of the chamber itself have the following treatment. Above the floor is a dado some 1.20 m. high made up of eight-pointed stars, octagons, eight-sided figures and space fillers almost all of luster-painted tiles, set in various combinations. Some tiles are dated 612/1215. Continuing the dado is a band of luster-painted tiles, probably reused, .15 m. high and with some tiles dated 612/1215. Just above is a band .30 m. high of luster-painted tiles, each tile some .40 m. long and with the blue letters on an inscription raised from a floral ground, some of which are dated 612/1215. Just above the dado ends in a cavetto moulding of luster-painted tiles some .15 m. high. At dado height on the south wall are two luster-painted miḥrābs (612/1215 and undated) and within the south jamb of the west door of the chamber another miḥrāb.

The wall surfaces above the dado are entirely covered with mirror work of the nineteenth century and the ceiling is a stalactite dome executed at the same time and of the same material as the upper walls.

From this description it should be apparent that no structural walls of the chamber are visible and that an intensive decoration of the chamber was carried out in the early thirteenth century. The only evidence of Mongol activity are the points, noted by A. U. Pope, that "the door frame just beyond the north corner of the tomb chamber . . . is dated 735/1335" (or 1334?) and that, "there are several inscription tiles in the tomb chamber dated 760/1359."

Identification: Iranian National Monument No. 140.

Recorded: November 1936.

BIBLIOGRAPHY

Yate, *Khurasan and Sistan*, p. 316.
De Kasr-e Shirin, p. 48.
Maṭla' ash-Shams, III, p. 61.
Répertoire chronologique, XII, p. 96, no. 4543.
Donaldson, "Significant miḥrābs in the Ḥaram at Mashhad," pp. 118-127.
Survey, pp. 1201-1203, 1207-1209, 1548, 1569-1571.
(The *Survey* also gives references to other publications dealing with the tomb chamber and its decoration.)

93

Kūhpā Masjid-i-Miyān-i-Deh
735/1335

Summary: The village of Kūhpā is situated on the highway between Iṣfahān and Nāyīn, some 77 kilometers east of Iṣfahān.

According to a communication from André Godard to the present author, the mosque at Kūhpā contains a minbar executed in faïence and a plaster miḥrāb. The minbar is dated 735/1335, while the mosque itself was erected prior to that date.

Recorded: Not visited.

Illustration: Pl. 190.

94

Abarqūh Masjid-i-Jāmi'
738/1337-38

Summary: The Masjid-i-Jāmi' of Abarqūh is situated in a desolate and sparsely populated village which lies on a crossroad which connects the Yazd-Kirmān road with the road between Iṣfahān and Shīrāz. The ancient remains of the village are striking both as regards their number and their advanced stage of ruin.

André Godard has devoted a few paragraphs to this mosque in the only published account of the monument. Four īvāns with flanking arcades establish the façades of a large, rectangular court. Construction was probably begun in the Seljūq period, but Godard believes that most of the standing structure dates from the Mongol period. Nearly all existing wall surfaces are undecorated.

On the south interior wall of the east īvān is a plaster miḥrāb which was installed without any attempt to relate it to the īvān as a whole. The design of the miḥrāb is unusually simple, but all the details are executed with a craftsmanship of the first order. It bears an inscription dated 738/1337-38.

Behind the south īvān is a prayer hall five bays

in depth which Godard suggests belongs to the later fourteenth century. It is of a type which was well developed at Yazd: between each bay is a transverse pointed arch, the space between arches is spanned by a tunnel vault and there are large window openings on the walls below the vaults.

Identification: Iranian National Monument No. 197.

Recorded: Visited in February 1934.

Illustration: Pl. 192.

BIBLIOGRAPHY

Godard, "Abarķūh," pp. 56-60, figs. 38-41.
Pope, "Preliminary Report of the Sixth Season of the Survey," fig. 1 on p. 30.

95

Işfahān Imāmzāda Bābā Qāsim
740/1340-41

Summary: This structure, known locally as the Imāmzāda Bābā Qāsim, is in the vicinity of the Masjid-i-Jāmi' and is less than twenty meters to the east of the Madrasa Imāmī. It consists of a square chamber, crowned by a hemispherical inner dome and an exterior polyhedral tent dome which is entered from the north through a small stalactite-vaulted portal, and an octagonal chamber which was converted into a square tomb chamber in A.D. 1880.

Incomplete and complete mosaic faïence decoration is used extensively within and without the structure. The colors of the glazes are white, light blue, dark blue, and a manganese-brown which shades toward yellow. Black had also been employed in addition to the first three colors earlier so that with this structure a fifth color appears in mosaic faïence. The spandrels and frames of the entrance demonstrate a use of floral patterns in place of the earlier geometrical forms. These floral motives are formally composed and somewhat rigid but soon monuments at Işfahān and elsewhere will display a free flowing tracery of floral forms.

The horizontal inscription band over the entrance portal states that "these buildings" were erected in honor of the theologian Muḥammad Bābā al-Qāsim al-Işfahānī and that the work was completed in 741/1340-41.

Identification: Iranian National Monument No. 100.

Recorded: May 1939.

Illustrations: Pls. 191, 193, 194; Fig. 59.

BIBLIOGRAPHY

Godard, "Işfahān," pp. 38, 41-43, figs. 12, 13.
Survey, p. 1099, figs. 393, 394, pl. 417.

Crane, "A Fourteenth-Century Mihrab from Isfahan," pp. 98, 100, fig. 7.
Godard, "Le tombeau de Bābā Ķāsem et la madrasa Imāmī," pp. 165-182, figs. 137, 138, 140-142, 145.

96

Qazvīn tomb of Ḥamd-Allāh Mustawfī
c. /1340?

Summary: This structure, located in the eastern quarter of Qazvīn, is known locally as the tomb of Ḥamd-Allāh Mustawfī. In the list of Iranian National Monuments the tower is assigned to the Mongol period. No documentary or epigrahic material exists to relate the monument to Mustawfī, an important writer and official under the last Il Khānid rulers and a native of Qazvīn, who died about A.D. 1340.

About 1935 the local municipality cleared a space around the structure and enclosed the area with a wall and entrance gateway. Repairs were also made to the fabric of the structure.

At the exterior ground level the monument is a square in plan. A few meters above this level it becomes octagonal and this high octagonal drum is crowned by a two-stage stalactite cornice. Directly below the cornice zone is a horizontal area originally intended for an inscription band. The structure is covered by a pointed conical roof.

The bricks are laid in common bond with narrow horizontal joints and very wide rising joints. Many rising joints are decorated with elaborate cut mortar patterns. Traces of stucco decoration adhere to the head of the damaged portal of the tower.

The plan type of the monument and its constructional and surviving decorative features are consistent with a date of c. 1340. The exterior treatment of the structure is very close to that of a monument at nearby Abhar which is not earlier than A.D. 1400 and to a series of fifteenth century tomb towers found along the shore of the Caspian. It is difficult to say whether the Qazvīn monument was an earlier example of the structures which resemble it or whether it is contemporary with those monuments.

Identification: Iranian National Monument No. 332.

Illustration: Pl. 195.

Recorded: December 1934 and October 1936.

97

Kirmān Masjid-i-Jāmi'
750/1349

Summary: The Masjid-i-Jāmi' of Kirmān has a thoroughly typical large scale plan. On the cross

axes of a very spacious court are four īvāns while prayer halls fill the areas behind the court arcades. The vaulted main entrance portal leads into a domed vestibule which, in turn, opens into the shallow north īvān. The emphasis given to the entrance portal in plan and elevation is an early example of the manner in which this feature was treated in the Ṣafavid period.

Complete mosaic faïence is found throughout the monument. A faïence inscription band in the portal contains the date 750/1349 and the entire mosque seems to date from this period with the exception of some repairs and faïence decoration executed in the sixteenth century. Schroeder has published his plan of the monument.

Identification: Iranian National Monument No. 276.

Recorded: March 1946.

BIBLIOGRAPHY

Khanikoff, de, "Mémoire sur la partie méridionale," p. 195.
Merāt al-Boldān, IV, pp. 117-118.
Schroeder, "Preliminary Work," p. 132, fig. 3.
Survey, pp. 1099-1102, fig. 395, pls. 401, 534, 540, 545A.

98

Shīrāz structure in the court of the Masjid-i-Jāmi'
751/1351

Summary: Situated near the center of the spacious court of the old mosque at Shīrāz is an unusual structure whose walls are of rubble masonry lined with cut stone. Formerly badly damaged, the structure was largely rebuilt during the extensive reconstruction and repair of the entire mosque between 1944 and 1948.

The *Farsnāma-i-Nāṣirī* records that the building was completed in A.H. 752 upon the orders of Shāh Shaykh Abū Ishaq ibn Shāh Maḥmud Injū. It was then called the Beit al-Moshāf, or House of the Book, and housed several Qur'āns from which passages were read every day in the mosque.

The main structure, square in plan, was provided with a circumambulatory passage within a wall having four corner bastions. Portions of an encircling inscription frieze were preserved on two of the bastions. The letters are of cut stone inset into light blue glazed slabs and the date 752/1351 is clearly legible.

Identification: The entire Masjid-i-Jāmi' at Shīrāz is Iranian National Monument No. 72.

Recorded: January 1935 and June 1939.

Illustrations: Pls. 196, 197, 198.

BIBLIOGRAPHY

Hājjī Mirza Ḥasan Shīrāzī, *Farsnāma-i-Nāṣirī*, p. 160.
Salnāmayi Mo'aref-i-Fārs, p. 116—"Masjid-i-Jāmi' 'Atiq (Ādina)."

99

Simnān Masjid-i-Jāmi'
755/1354

Summary: The Masjid-i-Jāmi' is a large and complex structure which awaits publication. André Godard has planned the monument and has supplied the author with valuable notes.

At one corner of the complex is a Seljūq minaret, originally related to the now vanished Masjid-i-Maydan. The Seljūq and later periods saw the construction of prayer halls around the open court and of a large square dome chamber preceded by a monumental south īvān. Limited modifications of the structure were carried out during the nineteenth century.

The *Merāt al-Boldān* states that the southern prayer halls of the mosque were built by a local shaykh in the time of Arghūn Khān (A.D. 1284-91). Inset into the fabric of the south īvān (built in 828/1424) is an endowment inscription which is dated 755/1354. No part of the standing structure can be specifically related to this inscription.

Identification: Iranian National Monument No. 163.

Recorded: Not visited.

BIBLIOGRAPHY

De Kasr-e Shirin à Meshhed et à Tus, pp. 334-336.
Merāt al-Boldān, IV, p. 106.
Nūrīzāda-Busherī, *Nazarī be-Īrān wa Khalīj-i-Fārs*, p. 48.

100

Iṣfahān Madrasa Imāmī
755/1354?

Summary: The fabric of this structure was built at one time and as a unit with the exception of these elements: the present street façade, the portal on this façade and part of the corridor behind this portal. The monument includes four īvāns located on the cross axes of the central court. The īvāns are flanked by two-storied arcades which, on the east and west, open into a series of chambers. The north and south īvāns are more fully developed than the other two and a portal leads from the south īvān into a square chamber crowned by a dome. The south wall of this chamber once contained a fine miḥrāb done in complete mosaic faïence. Complete mosaic faïence covers much of the total wall surface of the structure.

A study of the monument by Mary Crane which deals with it as the place of origin of a fine miḥrāb now in the Metropolitan Museum describes the faïence decoration in some detail and assigns the structure to 755/1354. This date was found in two places where fragments of mosaic faïence had been reused in the course of minor repairs. Godard opposes this dating, believing that the madrasa is one of "these edifices" referred to in the portal inscription of the Imāmzāda Bābā Qāsim. He also thinks that the madrasa is actually a little older than the imāmzāda and that areas of its decoration were applied between 759 and 796. Considerable attention has been devoted to the question of the date of the madrasa because of the interest in the role of its faïence decoration in the development of this technique. In addition to the four colors used in the mosaic faïence at the Imāmzāda Bābā Qāsim (light blue, dark blue, white, and manganese-brown) green was also used at the madrasa. Crane sees progress from the imāmzāda toward freer and more varied floral forms at the madrasa, while Godard finds the decoration of the important miḥrāb from the madrasa to be very similar to the mosaic faïence of the imāmzāda and ascribes the freer floral patterns to work done in the second half of the century.

Identification: Iranian National Monument No. 114.

Recorded: May 1939. Preliminary plan published in *Ars Islamica* (see below).

BIBLIOGRAPHY

Godard, "Iṣfahān," p. 37.
Crane, "A Fourteenth-Century Mihrab from Isfahan," pp. 96-100, figs. 1-6.
Godard, "Le tombeau de Bābā Ḳāsem et la madrasa Imāmī," pp. 165-167, 171-183.
Survey, pp. 1328-1329, pl. 402.

101

Sarakhs	tomb of Shaykh Muḥammad ibn Muḥammad Luqmān
	757/1356

Summary: At Sarakhs, in the extreme northeastern corner of Iran, is a mausoleum of impressive scale. It is composed of a square chamber with an īvān portal. The chamber is crowned by a double dome.

An inscription dated 757/1356 indicates that the tomb was erected for Shaykh Muḥammad ibn Muḥammad Luqmān. Extensive areas of plaster decoration are preserved.

Recorded: Not visited.

BIBLIOGRAPHY

Diez, *Churasanische Baudenkmäler*, pp. 62-66, fig. 27.
Survey, p. 1076, fig. 386.

102

Khārg	Imāmzāda Mīr Muḥammad
	after /1350

Summary: This structure, known as the Imāmzāda Mīr Muḥammad, is located on the island of Khārg in the Persian Gulf. The sanctuary has a cupola spire of the type common to Baghdad and the region near the Persian Gulf in which the stages and salients of the interior stalactites (technically *muqarnas*) are reflected on the exterior.

The entrance portal has a stalactite semi-dome in complete mosaic faïence in which (from an examination of a photograph) light blue, dark blue, white, and probably black glazes were used. The name of the worker, 'Alī ibn Amīr Ḥusayn of Bokhara, is preserved, but the date is missing. Herzfeld, who described the structure, would date the portal from the style of the faïence which he assigns to about A.H. 700. Actually the patterns used are stylized floral forms and the work was more probably executed after the middle of the fourteenth century A.D.

BIBLIOGRAPHY

Herzfeld, "Reisebericht," p. 261.
———, "Damascus," pp. 30-31, figs. 64, 66.
Répertoire chronologique, XIII, p. 219, no. 5127.

103

Mashīz	dome chamber
	after /1350

Summary: In 1935 Eric Schroeder, engaged in carrying out an architectural reconnaissance in the Kirmān region, visited the village of Mashīz and recorded that: ". . . a fourteenth century dome whose shell presents interesting parallels with that of Sulṭāniya (was) planned and photographed at Qal'a-i-Mashīz, in the Bardasīr district of Kirmān."

In the *Survey* Schroeder writes of ". . . the Mausoleum of Pīr-i-Jāsūs in the Bardsīr of Kirmān, which seems to have been built in the latter half of the fourteenth century." He adds that the still unpublished structure has been dated on stylistic grounds. The location of the mausoleum is not given but it is probably identical with the dome at Mashīz since the *Survey of India* map sheet of this area shows a Ziārat Pīr Jāsūs at Mashīz.

The village of Mashīz is some 43 kilometers

southwest of Kirmān and is reached by a road which branches south from the main Kirmān-Yazd highway at a point some 29 kilometers west of Kirmān.

Recorded: Not visited.

BIBLIOGRAPHY

Schroeder, "Preliminary note on work in Persia," p. 135.
Survey, p. 1254, pl. 334B.

104

Qumm Imāmzāda 'Alī ibn Abī'l-Ma'ālī
 ibn 'Alī Sāfi
 761/1359-60

Summary: This structure, known locally as the Imāmzāda 'Alī ibn Abī'l-Ma'ālī ibn 'Alī Sāfi, is the southernmost of the three tombs in the Bāgh-i-Sabz at the former Kāshān gate of Qumm.

The monument is preserved only to the cornice level and the inner dome and the outer tent dome are missing. In the interior the fine and elaborate polychrome relief plaster is well preserved. Two plaster inscriptions in *thulth* script encircle the interior. One, the lower, is a building inscription ending with the date 761/1359-60. According to the interpretation suggested by the *Rāhnāma-yi-Qumm* the same inscription reveals that monument was built by 'Alī Sāfi to shelter the bodies of his uncle and of his son. According to the *Survey of Persian Art* the construction was carried out by the masons Ḥasan ibn 'Alī . . . and 'Alī Muḥammad ibn Abī Shujā', but the present author read in the two small spandrels of the arched panel back of the entrance, "work of 'Alī bin Muḥammad bin Abū Shujā'."

Illustrations: Pls. 199, 200.

Recorded: April 1943.

Identification: The three tombs of the Bāgh-i-Sabz are listed together as Iranian National Monument No. 129.

BIBLIOGRAPHY

Sarre, *Denkmäler*, pp. 71-72, pl. LX.
Herzfeld, "Reisebericht," p. 134.
Survey, pp. 1099 and 1346, pl. 353 (after Sarre).
Rāhnāma-yi-Qumm, p. 132 and two unpaged illustrations (actually labeled as the Gunbad-i-Sabz).

105

Āzādān (Iṣfahān) Masjid-i-Gunbad
 766/1364
 767/1365

Summary: This mosque is situated just to the north of the principal avenue leading west from the city and on the outskirts of the city.

It consists of a square chamber crowned by a dome with a modern rectangular arcaded court before the main north entrance of the chamber. The walls of the structure display a batter and are entirely of mud brick coated on the exterior with a mud wash. The dome is of fired bricks.

The interior wall surfaces are coated with white plaster and display polychrome decoration in dull red, salmon, green, black, beige, and white. The subjects of the decoration include views of Medina and Mecca, standards, two-bladed swords, rosettes, etc. An inscription referring to the structure as "the building in which the standards are kept" is dated 767/1365. There is also a date in numerals of 766/1364.

Recorded: May 1939. Plan not previously published.

Illustrations: Pls. 201, 202, 203.

106

Iṣfahān mausoleum of Khwāja Sa'd
 c. /1365

Summary: The complex of structures which includes the so-called mausoleum of Khwāja Sa'd is located on the eastern outskirts of Iṣfahān. The principal feature of the complex, a square dome chamber, is adjacent to a rectangular structure composed of a series of vaulted rooms.

The walls of the square chamber and the ovoid dome, destroyed at the crown, are entirely of mud brick and the structure must be considered as a chance survival of one of hundreds of monuments erected in this impermanent material. The walls of the chamber are battered on the exterior and on the interior and on the interior they are coated with white plaster. Each interior wall displays a wide central arched panel flanked by two narrow rectangular recessed panels: the upper part of each narrow recess encloses a pointed arch panel with an elaborate cusped shell in its head. Three types of cusped heads are used.

The transition from the square of the chamber to the dome is sufficiently distinctive to warrant a complete description. The angles of the structure are bridged by trefoil arched squinches; the lowest tier of the squinch consists of two spherical triangles flanking a secondary pointed arch. This is surmounted by a second tier consisting of a single squinch the crown of which is at the same level as the adjoining arches of the hexadecagon. Between the squinches are four trefoil wall arches of approximately the same profile as the trefoil squinches; the center of each wall arch is pierced at its base by a pointed arched window; the upper lobe of the wall arch in each case forms one of the wall arches of the hexadecagon; between the upper lobe of the squinch and the wall

arch is a wall arch rising from the half-arches formed by the outer edges of the squinches and the lower wall arches, completing the hexadecagonal drum. Above this zone is a slight projecting string course, above which the circle of the base of the dome projects slightly.

The dome chamber was originally assigned to the twelfth century A.D. but it appears more probable that it was erected at a considerably later date, possibly c. 1365. White plaster surfaces, the simulated brick bonding in plaster with joint incisions and decorative end plugs, concave profiles, over-sailing vaults and dome, thin applied mouldings: all these features suggest a fourteenth century dating, while the similarity of material and the use of battered walls recalls the Masjid-i-Gunbad of Āzādān.

Recorded: May 1939.
Illustration: Pl. 204.

BIBLIOGRAPHY

Survey, pp. 1011, 1013, figs. 348, 350, 351.

107
Yazd Madrasa Shamsiya
c. /1365

Summary: This structure is commonly known as the mausoleum of Shams ad-dīn. Actually, it is the Madrasa Shamsiya, built by the order of Amīr Shams ad-dīn Muḥammad during his lifetime.

When Shams ad-dīn, the son of Sayyid Rukn ad-dīn, died at Tabrīz, his wife requested that his coffin be sent back to Yazd and at the same time two slabs of marble were dispatched from the quarries at Tabrīz. The coffin was placed in the Shamsiya in a tomb of ebony and sandalwood.

The structure contains a marble tombstone dated 767/1365. This stone is probably the material brought from Tabrīz and hence the monument may be assumed to have been erected a few years before this date.

The monument comprises a narrow, arcaded forecourt, a vaulted entrance īvān of considerable depth and a square tomb chamber crowned by a damaged dome. The bewilderingly rich decoration recalls that of other monuments of Yazd and, indeed, the structure displays two types of ornamentation, one of which is on the decline while the other is assuming the ascendancy. The surfaces of the portal īvān and of the dome chamber are covered with painted panels and carved plaster in very low relief. This decoration is similar to that of the dome chamber of Sayyid Ruhn ad-dīn at Yazd, but the patterns have become too multiple and the scale too fine so that

the general effect is one of restlessness and unrestraint. On the other hand, the façades of the īvān portal and of the forecourt arcades display complete mosaic faïence in the style common to the Masjid-i-Jāmi' at Yazd.
Identification: Iranian National Monument No. 208.
Recorded: November 1936. Plan measured, but not published.
Illustrations: Pls. 205, 206, 207.

BIBLIOGRAPHY

Pope, "The Photographic Survey," p. 28.
Survey, p. 1090, pls. 535, 536A and C.
Tārīkh-i-Yazd, p. 134.

108
Iṣfahān portals of the Masjid-i-Jāmi'
768/1366
759-76/1358-75
c. /1366

Summary: The three portals given brief mention below are clearly associated with the period of the construction of the madrasa within the Masjid-i-Jāmi' and in one case with the madrasa itself.

1. This portal forms an exterior entrance to the mosque complex and is on the north side, adjoining the well-known Small Dome Chamber. It is decorated with complete and incomplete mosaic faïence in floral and geometrical patterns in glazed pieces of white, light blue, dark blue, brown, and black. The decoration includes an inscription dated 768/1366.

BIBLIOGRAPHY

Gabriel, "Le Masdjid-i Djum'a d'Iṣfahān," p. 37.
Godard, "Historique du Masdjid-é Djum'a d'Iṣfahān," pp. 236-237.

2. This portal lies just within, and to the north, of the present main (southeast) entrance to the mosque. Probably it originally served as a secondary means of access to the madrasa. The portal is decorated in a similar fashion to that listed above but green is also found in the faïence patterns. The inscription (fragmentary) states that Sulṭān (Qutb ad-dīn Shāh) Maḥmūd (who reigned from 759-776/1358-1374-75) constructed this building.

BIBLIOGRAPHY

Godard, "Historique," p. 237.

3. This portal is on the south side of one of the bays in the corridor which leads from the central court to the present southwest entrance of the mosque. It is undated, but the faïence decora-

tion is almost identical with that on the two portals mentioned above.

Recorded: The three portals in June 1939.

109

Iṣfahān	madrasa in the Masjid-i-Jāmiʿ
	768/1366-67
	778/1376-77

Summary: This structure includes a court with a wide īvān on the south side, and originally with a corresponding one on the north, with two-storied arcades on each lateral (east and west) face; various entrances give access to the structure from the exterior and from the adjoining units of the mosque.

Behind the south īvān is a long vaulted rectangular hall (its long axis running east-west) with a miḥrāb in the south wall. Back of the north façade of the court and of the site of the north īvān is a comparable vaulted rectangular hall with an east-west axis.

The exterior wall surfaces of the structure were, and for the most part are, enclosed within other building units of the mosque.

The dated inscriptions of the madrasa which belong to its construction in the fourteenth century are as follows:

1. On the intrados of the transverse arch of the south īvān is the date 768/1366-67 executed in complete mosaic faïence.

2. On the rectangular band framing the miḥrāb and executed in complete mosaic faïence is the date 778/1376-77. The colors of the glazed tile used in the decoration of the miḥrāb are white, light blue, dark blue, dark green, brown, and black.

Recorded: June 1939. Plan drawn, but not published.

BIBLIOGRAPHY

Gabriel, "Le Masdjid-i Djumʿa," p. 37, fig. 32.
Godard, "Historique," pp. 238, 241, figs. 157, 159.

110

Qāyin	Masjid-i-Jāmiʿ
	770/1368
	796/1393

Summary: Herzfeld recorded that the mosque at Qāyin had an inscription of the Qāḍī Shams ad-dīn al-Qāranī dated 770/1368. This inscription is actually on a stone set into the south wall of the west īvān of the structure.

This note by Herzfeld has been both corrected and augmented in a communication from André Godard to the present author. According to Godard, the west īvān, the principal feature of

the monument, was constructed in 770/1368 by Jamshīd ibn Qāran. The stone referred to above states that the structure was restored in 796/1393 upon the orders of Jamshīd ibn Qāran ibn Jamshīd ibn ʿAlī ibn Ashraf ibn Qāḍī Shams ad-dīn ibn al-Qāyinī. At least a part of the two prayer halls adjacent to the west īvān were built in the Ṣafavid period while the vault of the west īvān and these prayer halls were repaired in the nineteenth century.

Identification: Iranian National Monument No. 295.

Recorded: March 1946.

BIBLIOGRAPHY

Herzfeld, "Reisebericht," p. 274.

111

Qumm	Imāmzāda Ismāʿīl
	776/1374

Summary: This structure, known locally as the Imām-Ismāʿīl, is dated 776/1374.

Recorded: Not visited. Exact location not known.

BIBLIOGRAPHY

Bazl, "Preliminary report," p. 38.

112

Bākū	Masjid-i-Jāmiʿ
	780/1378

Summary: Bākū, in Persian Bādkūba, lay within the northwestern limits of the Iranian empire until the nineteenth century.

According to the *Merāt al-Boldān*, the Masjid-i-Jāmiʿ at Bādkūba was one of the constructions of Sulṭān ibn es-Sulṭān Shaykh Khalīl Allāh whose name and the date 780/1378 appear in an inscription which survives in the mosque. The precise location of the inscription is not given and the suggestion is made that a part of the mosque which was entirely roofed over is of an earlier period.

Recorded: Not visited.

BIBLIOGRAPHY

Merāt al-Boldān, IV, p. 98.

113

Yazd	Boqʿayi-Shāh Kemālī
	792/1390

Summary: Although there are two very brief published references to this monument, the most useful information is in a communication from André Godard to the present author.

The structure of the *boqʿa*, or mausoleum, was

erected alongside a tomb of considerably earlier date. The mausoleum, which is poorly preserved, displays an inscription in painted blue letters which includes the following: "Shaykh 'Alī Fath Allāh, the least of God's servitors, has ordered the construction of this blessed boq'a—may God improve his lot—Saturday the fourth of the month of Dhu'l-Ḥijja of the year 792 of the Hijra [August 5, 1390]."

According to Godard, the decoration of the damaged structure closely resembles that of the tomb of Sayyid Rukn ad-dīn at Yazd and the author of the *Tārīkh-i-Yazd* also speaks of faïence decoration of the fourteenth century.

Recorded: Not visited.

BIBLIOGRAPHY

Godard, "Abarḳūh," p. 68.
Tārīkh-i-Yazd, p. 79.

114

Qumm Imāmzāda Khwāja 'Imād ad-dīn
792/1390

Summary: The local designation of this structure, situated in the Bāgh-i-Sabz at the former Kāshān gate of Qumm, as the Imāmzāda Khwāja 'Imād ad-dīn is not sufficiently precise. Dieulafoy, Sarre and Godard, who all illustrate the tomb, do not identify it by name. However, the *naskhi* inscription encircling the interior chamber which is published in the *Rāhnāma-yi-Qumm* names three brothers who were buried there. These individuals were Khwāja Jamal al-Haq wa ad-dīn 'Alī; Khwāja 'Imād ad-dīn Maḥmūd; and Khwāja Safi ad-dīn. At the end of this inscription is the date, in numerals, of 792/1390.

The structure is of Type III of the tombs at Qumm (see p. 115). This type surpasses Types I and II in the development of interior and exterior recesses and reveals: by this means wide bearing walls were used only at vital points and a three dimensional quality introduced within and without the structure. Open structures of this character were to reach their maximum development in the Ṣafavid period.

The fabric of the monument is in very good condition. The cornice level of the exterior walls is damaged and there is a hole at the tip of the tent dome. Traces of the original exterior decoration remain: they include brick end plugs on the lower walls and patches of blue glazed tiles on the tent dome. The lower walls and platform of the structure have been recently repaired.

The entire interior is covered with a rich overlay of polychrome plaster in dark blue, light blue, red, and buff which is executed in low relief, nearly all in excellent condition except for the lower part of the recess used as a miḥrāb niche. The eight recesses of the lower walls and their rectangular frames bear inscriptions, rosettes, and spandrel patterns while plane surfaces are decorated with false end plugs and false joint markings. Below the zone of transition runs the inscription frieze mentioned in the first paragraph. The sixteen wall arches of the zone of transition bear false plugs and joint lines and the encircling frieze just above is executed in *kūfi* script. The surface of the dome displays interlocking geometrical patterns with elements diminishing in size toward its crown to increase the apparent height of the element.

Were the structure not so clearly dated in the year 1389 it might well be assigned, on general stylistic grounds, to about A.D. 1335. For this reason it is a good example of the persistent use of favored decorative forms and techniques, although the dry, linear quality of the ornament in the background of the inscription bands and the fact that this ornament is rather sparse in proportion to its areas does reflect the character of late fourteenth century decoration.

Identification: All three tombs of the Bāgh-i-Sabz are classified together as Iranian National Monument No. 129.

Recorded: April 1943.

Illustrations: Pls. 208, 209, 210.

BIBLIOGRAPHY

Dieulafoy, J., *La Perse, la Chaldée, et la Susiane*, p. 96.
Sarre, *Denkmäler*, pp. 71-72, pl. LIX.
Herzfeld, "Reisebericht," p. 234.
Godard, "Pièces datées . . . de Kāshān," fig. 137.
Survey, p. 1099.
Rāhnāma-yi-Qumm, p. 132.

115

Kirmān Masjid-i-Pā Minār
793/1390

Summary: The Masjid-i-Pā Minār is located a few hundred meters northwest of the Masjid-i-Jāmi' of Kirmān. It comprises a small open court with adjoining vaulted prayer halls and it is entered, at one corner, through a small, but elaborately decorated, portal. The portal is clad in complete mosaic faïence including an elaborate stalactite vault of this material. At the end of the horizontal inscription band above the head of the door is the date 793/1390.

Identification: Iranian National Monument No. 210.

Recorded: March 1946.

Illustration: Pl. 211.

BIBLIOGRAPHY

Schroeder, "Preliminary Note," p. 135.
Survey, p. 1102, pls. 451B, 545B.

116

Zavāra Masjid-i-Pā Minār
 ?

Summary: The date of the Seljūq minaret of the Masjid-i-Pā Minār has been published by André Godard. He has also mentioned that the small mosque displays an abundant amount of decoration of the Mongol period which was applied over plaster decoration of the Seljūq period.

Identification: Iranian National Monument No. 284.

Recorded: Not visited.

BIBLIOGRAPHY

Godard, "Ardistan et Zaware," pp. 305, 309, fig. 205.

117

Maraq tomb of Afzal ad-dīn Kāshānī
 ?

Summary: The village of Maraq is situated some 30 kilometers southwest of Kāshān.

According to a communication received from André Godard, the burial place of Afzal ad-dīn Kāshānī is of the Il Khānid period. In his history of this period Eqbāl writes that Afzal ad-dīn Muḥammad ibn Hasan Kāshānī, a noted philosopher and poet commonly known as Bābā Afzal Kāshānī, died in 707/1307 and was buried in the village of Maraq, a dependency of Kāshān.

Recorded: Not visited.

Illustration: Pl. 212.

BIBLIOGRAPHY

Eqbāl, *Tārīkh-i-mofaṣṣal Īrān*, p. 506.

118

Darjazīn Imāmzāda Hūd
 ?

Summary: The village of Darjazīn, or Daryazīn, is situated a short distance to the east of the main highway between Hamadān and Qazvīn, at a point some 70 kilometers from Hamadān.

According to a communication received from André Godard, the Imāmzāda Hūd, sometimes called the Imāmzāda Safīyeh Khātūn, is of the Il Khānid period.

Recorded: Not visited.

Illustration: Pl. 213.

119

Darjazīn Imāmzāda Azhar
 ?

Summary: According to a communication received from André Godard, the Imāmzāda Azhar at Darjazīn is of the Il Khānid period.

Recorded: Not visited.

Illustration: Pl. 214.

Material included: This catalogue is intended to give some fairly definite indication of the number and type of structures known to have been erected during the Il Khānid period but no longer extant. The list is not to be considered exhaustive, for a number of buildings erected by local personages at Yazd, Shīrāz, and other sites which have been mentioned in the main catalogue are not included.

Order: Monuments are listed in chronological order under the reigns of the various Il Khānid rulers.

CATALOGUE LIST

Churches built at Tabrīz and Nakhichevan about
 A.D. 1233.

Hūlāgū: 1256-1265

Castle at Khoi, just prior to 1265.
Castle, probably of wood, at Ālātāgh (Ala Dagh), just prior to 1265.
Town of Khābūshān (Qūchān) rebuilt with new shops, houses, and gardens.
Buddhist temple at Khoi.

Abāqā: 1265-1281

Palace at Enjerud (Sojās).
Monastery of Saint Mar Sehyon, in the vicinity of Ṭūs.

Aḥmad Takudar: 1281-1284

Burial place at Qarā Qapchilghai.

Arghūn: 1284-1291

Four minarets at Tabrīz, in 1290.
Palace at Enjerud (Sojās).
Summer palace at Ālātāgh (Ala Dagh).
Palace of Bāghī Arran at Manṣūriya, where Arghūn died.
Summer palace, called "Arghūn's Kiosk," at Lār, near Mount Demāvand.
Rebuilding of the church of Mar Shalita at Marāgha.
Two palaces at the Arghūniya, the site later called Shenb.
Town at Sharūyāz, the site later called Sulṭāniya.
Church adjacent to a palace known as the "Gate of the Kingdom," site of the palace not known.
Burial place of Arghūn, variously ascribed to Enjerud (Sojās), Zobir, or Avizeh (all in the same locality).

Ghaykhātū: 1291-1295

Monastery of Saint John the Baptist, two miles north of Marāgha.
After the death of Arghūn one of his daughters, Öljei Khātūn, built a cloister near his tomb.
Church of Mar Mari and Mar George at Marāgha.
Church at Ālātāgh (Ala Dagh).
Burial place of Ghaykhātū at Qarābāgh.

Ghāzān: 1295-1303

A *khānaqāh* of Ghāzān Khān at Baghdād.
A Moslem monastery at Hamadān.
A pharmacy (*Dārū Khāna*), and hospital (*Dāru'sh-Shifā*), at Hamadān, founded by Rashīd ad-dīn.
An alms-house for Sayyids, *Dāru's-Siyyādat-i-Ghāzānī*, at Sivas, founded by Ghāzān.
A house for Sayyids, *Dāru's-Siyyāda*, and a dervish monastery, both at Kūfa.
Completion of the Buddhist monastery begun by Arghūn at Qūchān.
A caravanserai, bazaar, and bath at each gate of Tabrīz.
A new wall around Tabrīz.
A new wall and moat around Shīrāz.
The town of Aūjān rebuilt with new bazaars and baths.
Completion and dedication, in 1301, of the monastery of Saint John the Baptist at Marāgha.
Edict that a mosque and a bath should be erected in every community.
Twenty-four caravanserais, 1,500 shops, 30,000 houses, baths, storehouses, mills, factories, mint, dyehouse, and gardens at the Rab'-i-Rashīdi.
At Shenb, in addition to the tomb of Ghāzān, a dervish monastery, college for the Shafi sect, college for the Hanafi followers, hospital, palace or administration building, library, observatory, academy of philosophy, fountain, residence for Sayyids, and garden palace.

Öljeitü: 1303-1316

Foundation of the town of Sulṭānabād (now Arak), in 1312.
At Sulṭāniya, in addition to the mausoleum of Öljeitü, mosques, hospital, college, citadel, palaces, and residential quarters.

Bridge over the Andarāb River, built by ʿAlī Shāh.

A wall around Sāva.

The walls of Salmās rebuilt by ʿAlī Shāh.

Castle in the town of Arjīsh in Greater Armenia, built by ʿAlī Shāh.

Abū Saʿīd: 1316-1336

At Herāt, by a local ruler, madrasa, reception hall or *bārgāh*, caravanserai, and bazaar.

At Shīrāz, by a local ruler, seven caravanserais, mosque, bath, hospital, aqueduct, madrasa, and a fountain.

Introductory note: The bibliography lists all publications and articles which have been consulted during the preparation of the text. Approximately a third of these titles were used in the writing of Part I. This group included general histories of the Mongols and of the Il Khāns, accounts of local dynasties in Iran and neighboring regions, material relating to relations between the Il Khāns and nearby countries, and material relating to relations between the Il Khāns and the nations of Europe. All the other titles are of works which contain precise mention of monuments which are either described in the main Catalogue or are mentioned in the Supplementary Catalogue. These titles are also listed in abbreviated form in the main Catalogue with page and illustration references for the monuments.

Ackerman, P., *Guide to the exhibition of Persian art*, New York, 1940.

Allemagne, H. R. d', *Du Khorassan au pays des Backhtiaris, trois mois de voyage en Perse*, 4 vols., Paris, 1911.

Arnold, T. W. and Nicholson, A. [Eds.], *A volume of Oriental studies presented to Edward G. Browne . . .* , Cambridge, 1922.

Āyati, A. H., *Tārīkh-i-Yazd* (in Persian), Yazd, 1938.

Bachman, W., *Kirchen und moscheen in Armenien und Kurdistan*, Leipzig, 1913.

Baecker, L. de, *L'extrême Orient au moyen-âge; d'après les manuscrits d'un Flamand de Belgique, moine de Saint-Bertin à Saint-Omer et d'un prince d'Arménie, moine de Prémontré à Poitiers*, Paris, 1877.

Bahrami, M., *Recherches sur les carreaux de revêtement lustré dans la céramique persane du XIIIe au XVe siècle*, Paris, 1937.

——, "Le problème des ateliers d'étoiles," *Revue des Arts Asiatiques*, x, 4 (1937).

——, "La reconstruction des carreaux de Damghan d'après leur inscriptions," *IIIe Congrès International d'art et d'archéologie Iraniens*, Leningrad, 1935.

——, "Some examples of Il-Khanid art," *Bull. Am. Inst. Iranian Art and Archaeology*, v, 3 (1938).

Baião, A., *Itinerários da India a Portugal por terra, revistos e prefaciados por António Baião*, Coimbra, 1923.

Baltrusaitis, J., *Études sur l'art médiéval en Georgie et en Arménie*, Paris, 1929.

——, *Le problème de l'ogive et l'Arménie*, Paris, 1936.

Barbier de Meynard, C. A. C. [Trans.], "Description Historique de la ville de Qazvin extraite du Tarikhe Guzideh de Hamd Allah Mustofi Kazvini," *Journal Asiatique*, 5th series, x (1857).

——, "Extraits de la Chronique d'Herat," *Journal Asiatique*, 5th series, xvi (1860).

Barthold, V. V., *Turkestan down to the Mongol invasion*, London, 1928.

——, "The Persian inscription on the wall of the Manucha Mosque in Ānī" (in Russian), *Series of Ānī*, No. 5, Saint Petersbourg, 1911.

Bayāni, K. [Trans. and Ed.], *Hâfiz-i Abrú, Chronique des Rois Mongols en Iran*, Paris, 1936.

——, *Dhīl-i-jāmi' at-tawārīkhī Rashīdī, tā'līf Hāfiz-i-Abru* (in Persian), Tehran, 1317 [1938].

Bazl, F., "Preliminary Report of the Tombs of the Saints at Qumm," *Bull. Am. Inst. Persian Art and Archaeology*, IV, 1 (1935).

Beazley, C. R. [Ed.], *The texts and versions of John de Plano Carpini and William de Rubriquis, as printed for the first time by Hakluyt in 1598, together with some shorter pieces*, London, 1903.

Behrnauer, W., *Mémoire sur les institutions de police chez les Arabes, les Persans et les Turcs*, Paris, 1861. (Originally published in the *Journal Asiatique*, 5th series, xv-xvii.)

Bell, J., *Travels from St. Petersburgh in Russia, to various parts of Asia*, 2 vols., Edinburgh, 1788.

Benoit, F., *L'architecture—L'Orient médiéval et moderne*, Paris, 1912.

Berchem, M. van, "Arabische Inschriften," in Lehmann[-Haupt], C. F., "Materialien zur älten Geschichte Armeniens und Mesopotamiens," *Abhandlungen der Koniglichen Gesellschaften der Wissenschaften zu Gottingen Philologisch-Historische Klasse*, n.f., IX, 3 (1907).

——, *Amida: Matériaux pour l'épigraphie et l'histoire musulmanes du Diyar-Bekr*, Heidelberg, 1910.

——, "Une inscription du sultan mongol Uldjaitu," *Mélanges Hartwig Derenbourg*, Paris, 1909.

Berchet, G., *La repubblica di Venezia e la Persia*, Torino, 1865.

Bergeron, P., *Voyages fait principalement en Asie dans le XII, XIII, XIV et XV siècles, par Benjamin de Tudele, Jean du Plan-Carpin, N. Ascelin, Guillaume de Rubruquis, Marc Paul Venetien, Haiton, Jean de Mandeville, et Ambroise Contarini: accompagne's de l'histoire des Sarasins et des Tartares, et pre'ce'dez d'une introduction concernant des principaux voyageurs*, La Haye, 1735.

Blochet, E., *Tarikh-i-moubarek-i Ghazani, histoire des Mongols de la Djami el-tevarikh de Fadl Allah Rashid ed-Din*, vol. III, London, 1912.

——, *Introduction à l'Histoire des Mongols par Fadl Allah Rashid ed-Din*, Leyden and London, 1910.

——, *Les peintures des manuscrits orientaux de la Bibliothèque Nationale*, Paris, 1914-1920.

Bouvat, L., "Essai sur les rapports de la Perse avec l'Europe, de l'antiquité au commencement du XIXe siècle," *Revue du Monde Musulman*, XXXVI (1918), XLVI (1921).

——, *L'empire mongol*, Paris, 1927.

Brehier, L., *L'église et l'Orient au moyen âge; les croisades*, Paris, 1907.

Bretschneider, E., *Mediaeval researches from eastern Asiatic sources. Fragments towards the knowledge of the geography and history of central and western Asia from the 13th to the 17th century*, 2 vols., London, 1910.

——, "Notices of the Mediaeval Geography and History of central and western Asia," *Journal of the North China Branch of the Royal Asiatic Society*, X (1876).

Brosset, M. I. [Trans.], *Collection d'historiens armeniens*, 2 vols., Saint Petersbourg, 1874-1876.

Browne, E. G. [Trans. and Ed.], *The Ta'rikh-i-guzída or "Select history" of Hamdu'llah Mustawfí-i Qazwíní; compiled in* A.H. *730 (*A.D. *1330), and now reproduced in fac-simile from a manuscript dated* A.H. *857 (*A.D. *1453)*, 2 vols., Leyden and London, 1910-1913.

——, "Suggestions for a complete edition of the Jami'u't-Tawarikh of Rashidu'd-din Fadlu' llah," *Journal Royal Asiatic Society*, XL (1908).

——, *A Literary History of Persia. Vol. III. Persian Literature under Tartar Dominion (1265-1502)*, Cambridge, 1928.

——, *A year amongst the Persians. Impressions as to the life, character, and thought of the people of Persia, received during twelve months' residence in that country in the years 1887-1888*, London, 1893.

Bruyn, C. Le, *Travels into Muscovy, Persia and Part of the East-Indies*, 2 vols., London, 1737.

Budge, E. A. W. [Trans.], *The chronography of Gregory Abû'l Faraj, the son of Aaron, the Hebrew physician, commonly known as Bar Hebraeus; being the first part of his political history of the world*, 2 vols., London, 1932.

——, *The monks of Ḳûblâi Khân, Emperor of China; or, The History of the life and travels of Rabban Ṣâwmâ, envoy and plenipotentiary of the Mongol Khâns to the Kings of Europe, and Maṛkôs who as Mar Yahbh-Allâhâ III*

became patriarch of the Nestorian church in Asia, 2 vols., London, 1928.

Byron, R., "Between Tigrus and Oxus," *Country Life*, LXXVI, no. 1971 (1934), LXXVI, no. 1975 (1934).

——, "Timurid Monuments in Afghanistan," *IIIe Congrès International d'art et d'archéologie Iraniens*, Leningrad, 1935.

——, *The Road to Oxiana*, London, 1937.

Cahun, L., *Introduction à l'histoire de l'Asie; Turcs et Mongols, des origines à 1405*, Paris, 1896.

Catalogue of the International Exhibition of Persian Art, London, 1931.

Chabot, J. B., "Histoire du patriarche Mar Jabalaha III et du moine Rabban Çauma, traduite du syriaque," *Revue de l'Orient Latin*, II (1894).

——, "Notes sur les relations du roi Argoun avec l'Occident," *Revue de l'Orient Latin*, II (1894).

—— [Trans. and Ed.], *Histoire de Mar Jabalaha III . . . et du moine Rabban Çauma . . .*, Paris, 1895.

The travels of Sir John Chardin into Persia and the East Indies . . ., London, 1686.

Voyages de monsieur le chevalier Chardin, en Perse, et autres lieux de l'Orient, 3 vols., Amsterdam, 1711.

Chevalier, [C.] U., *Répertoire des sources historiques du moyen âge*, 2 vols., Paris, 1905-1907.

Cohn-Wiener, E., "Die Ruinen der Seldschuken Stadt von Merv und das Mausoleum Sultan Sandschars," *Jahrbuch der Asiatischen Kunst*, II (1925).

Combe, E., Sauvaget, J., and Wiet, G., *Répertoire chronologique d'épigraphie arabe*, X-XIII, Cairo, 1939-1945.

Conolly, Lieut. A., *Journey to the north of India, overland from England, through Russia, Persia and Affghaunistan*, 2 vols., London, 1834.

Cordier, H., *Les voyages en Asie au XIVe siècle du bienheureux frère Odoric de Porenone, religieux de Saint-François; publiés avec une introduction et des notes par Henri Cordier*, Paris, 1891.

Coste, P., *Monuments moderne de la Perse, mesurés, dessinés, et décrits par Pascal Coste*, Paris, 1867.

Crane, M., "A Fourteenth-Century mihrab from Isfahan," *Ars Islamica*, VII, 1 (1940).

Creswell, K. A. C., "The origin of the Persian double dome," *Burlington Magazine*, XXIX (1913-1914).

——, "Persian domes before 1400 A.D.," *Burlington Magazine*, XXVI (1915-1916).

Curzon, G. N., *Persia and the Persian question*, 2 vols., London and New York, 1892.

Dapper, O., *Umstandliche und eigentliche beschreibung von Asia . . .* , Nürnberg, 1681.

Defremery, C. [Trans. and Ed.], "Histoire des Sultans Ghourides, extraite de l'Histoire universelle de Mirkhond," *Journal Asiatique*, 4th series, 3 (1844).

Denike, B. P., *The Art of Central Asia* (in Russian), Moscow, 1927.

———, *Architectural ornament of Central Asia* (in Russian), Moscow, 1939.

Desmaisons, Baron, *Histoire des Mogols et des Tatares par Aboul-Ghâzi Behadour Khan*, Vol. II (translation), Saint Petersbourg, 1874.

Dieulafoy, J., *La Perse, la Chaldée et la Susiane*, Paris, 1887.

Dieulafoy, M., *L'art antique de la Perse; Achéménides, Parthes, Sasanides . . .* , 5 vols., Paris, 1884-1889.

———, "Mausolée de Chah Koda-Bendè," *Revue générale de l'architecture et des travaux publics*, x (1883).

Diez, E., *Die kunst der islamischen völker*, Berlin, 1917.

———, *Churasanische baudenkmäler*, Berlin, 1918.

———, *Persien. Islamische Baukunst in Churasan*, Gotha, 1923.

Donaldson, D., "Significant miḥrābs in the Ḥaram at Mashhad," *Ars Islamica*, II (1935).

Dorn, B. A., "Voyage scientifique dans le Mazanderan, le Ghilan, les provinces musulmanes du Caucase et le Daghestan," *Journal Asiatique*, 5th series (1862).

——— [Trans.], *History of the Afghans; translated from the Persian of Neamet Ullah*, 2 vols., London, 1829-1836.

———, *Atlas zu Bemerkungen einer Reise in dem Kaukasus und den südlichen Küstenlandern des Kaspischen Meeres in den Jahren 1860-61*, Saint Petersbourg, 1895.

Dubeux, L., *La Perse*, Paris, 1841.

DuBois de Montpéreux, F., *Voyage autour du Caucase, chez les Tcherkesses et les Abkhases, en Colchide, en Géorgie, en Arménie, et en Crimée . . .* , 6 vols., Paris, 1839-1843.

Dulaurier, E., "Les Mongols d'après les historiens arméniens," *Journal Asiatique*, 5th series, xi (1858), xvi (1860).

———, "Recueil des historiens des croisades; Documents arméniens," *Academie des Inscriptions et Belle-Lettres*, Paris, i (1869), ii (1906).

Eastwick, E. B., *Journal of a diplomate's three years' residence in Persia*, 2 vols., London, 1864.

Elias, N., "Notice of an inscription at Ṭurbāt-i-Jām, in Khorāsān," *Journal Royal Asiatic Society*, xxix (1897).

——— [Ed.], and Ross, E. D. [Trans.], *The Tarikh-i-Rashidi of Muhammad Haidar, Dughlát; a history of the Moghuls of central Asia*, London, 1895.

Eqbāl, 'Abbās, *Tārīkh-i-mofaṣṣel Īrān az estīlāyi moghul tā e'lān mashrūṭiat. I. Az hamlayi Chengīz tā tashkīl dawlat Tīmūrī* (in Persian), Tehran, 1312 [1933].

Ettinghausen, R., "Important pieces of Persian pottery in London Collections," *Ars Islamica*, II, 1 (1935).

Farhang-i-joghrāfīya-yi-Īrān (Ābādiha), (Az enteshārat-i-dāryereh joghrāfīya-yi-setad-i-artesh (in Persian), I. Ostān markazi, II. Ostān yekom, III. Ostān dovum, Tehran, 1328 [1949].

Ferrand, G. [Ed. and Trans.], *Relations de voyages et textes géographiques: arabes, persanes et turks relatifs à l'Extrême-Orient du VIIIe au XVIIIe siècles*, 2 vols., Paris, 1913-1914.

Feuvrier, J. B., *Trois ans à la cour de Perse*, Paris, 1906.

Flandin, E. and Coste, P., *Voyage en Perse*, 2 vols. and atlas, Paris, 1851-1854.

———, *Relation du voyage*, Paris, 1851.

Fraser, J. B., *Narrative of a journey into Khorosān in the years 1821 and 1822*, London, 1825.

———, *Travels and adventures in the Persian provinces on the southern bank of the Caspian Sea*, London, 1826.

———, *Historical and descriptive account of Persia, from the earliest ages to the present time . . .* , New York, 1836.

———, *A winter's journey (Tátar) from Constantinople to Tehran; with travels through various parts of Persia*, London, 1838.

———, *Travels in Koordistan, Mesopotamia . . .* , 2 vols., London, 1840.

Fryer, J., *A new account of East India and Persia. Being nine years' travels, 1672-1681*, 3 vols., London, 1909-1915.

Gabriel, A., "Le Masdjid-i Djum'a d'Iṣfahān," *Ars Islamica*, II, 1 (1935).

———, *Voyages archéologiques dans la Turquie Orientale*, 2 vols., Paris, 1940.

———, *Monuments turc d'Anatolie*, 2 vols., Paris, 1931-1934.

Galotti, J., *Le Jardin et la Maison Arabes au Maroc*, 2 vols., Paris, 1926.

Giro del Mondo del dottor D. Gio: Francesco Gemelli Careri, Vol. II, Venice, 1719.

Gluck, H. and Diez, E., *Die Kunst des Islam*, Berlin, 1925.

Godard, A., "Les Monuments de Māragha,"

Société des Études Iraniennes et de l'art Persan, Paris, 9 (1934).

——, "The Tomb of Shah Abbas," *Bull. Am. Inst. Persian Art and Archaeology,* IV, 4 (1936).

——, "Iṣfahān," *Athār-é Īrān,* II, 1 (1937).

——, "Ardistan et Zaware," *Athār-é Īrān,* I, 2 (1936).

——, "Historique du Masdjid-e Djum'a d'Iṣfahān," *Athār-é Īrān,* I, 2 (1936).

——, "Naṭanz," *Athār-é Īrān,* I, 1 (1936).

——, "Notes complémentaires sur les tombeaux de Mārāgha," *Athār-é Īrān,* I, 1 (1936).

——, "Abarḳūh," *Athār-é Īrān,* I, 1 (1936).

——, "Pièces datées de ceramique de Kāṣhān a decor lustré," *Athār-é Īrān,* II, 2 (1937).

——, "Masdjid-é Djum'a d'Iṣfahān," *Athār-é Īrān,* III, 2 (1938).

——, "Khorāsān," *Athār-é Īrān,* IV, 1 (1949).

——, "Le tombeau de Bābā Ḳāsem et la madrasa Imāmī," *Athār-é Īrān,* IV, 1 (1949).

——, "Voûtes Iraniennes," *Athār-é Īrān,* IV, 2 (1949).

Goldsmid, F. J. [Ed.], *Eastern Persia: an account of the journeys of the Persian boundary commission, 1870-71-72,* 2 vols., London, 1876.

Grey, C. [Trans. and Ed.], *A narrative of Italian travels in Persia, in the fifteenth and sixteenth centuries,* London, 1873.

Guide du Musée Archéologique de Téhéran, Tehran, 1948.

Gunther, R. T., "Contributions to the Geography of Lake Urmi and its neighbourhood," *Geographical Journal,* XIV (1899).

Halphen, L., *L'essor de l'Europe (XIe-XIIIe siècles),* Paris, 1932. With *Supplément bibliographique,* Paris, 1937.

Hammer [-Purgstall], J. von [Trans.], *Narrative of Travels in Europe, Asia, and Africa, in the 17th c. by Evliyá Efendí (Chelebí),* 3 vols., London, 1834-1850.

Hammer-Purgstall, J. von, *Geschichte Wassaf's. Persisch herausgegeben und deutsch übersetzt von Hammer-Purgstall,* Vienna, 1856.

——, *Geschichte der Ilchane, das ist der Mongolen in Persien,* 2 vols., Darmstadt, 1842-1843.

Hanway, J., *An historical account of the British trade over the Caspian Sea . . . ,* 2 vols., London, 1754.

Hedayat, S., *Iṣfahān niṣf-i-jahān* (in Persian), Tehran, 1311 [1932].

Herbert, Sir Thomas, *Some yeares travels into divers parts of Asia and Africa . . . ,* London, 1638.

Herzfeld, E. E., Notes to, "Imam Zade Karrar at Buzun. A Dated Seldjuk Ruin," *Archaeologischen Mitteilungen aus Iran,* VII, 2/3 (1935).

——, *Archaeological history of Iran,* London, 1935.

——, "Khorasan. Denkmälsgeographische Studien zur Kulturgeschichte des Islam in Iran," *Der Islam,* XI (1921).

——, "Arabische inschriften aus Iran und Syrien," *Archaeologische Mitteilungen aus Iran,* VIII, 1 (1936).

——, "Reisebericht," *Zeitschrift der Deutschen morgenland Gesellschaft,* V, 3 (1926).

——, "Damascus: Studies in Architecture—I," *Ars Islamica,* IX (1942).

——, "Die Gumbadh-i 'Alawiyyân und die Baukunst der Ilkhane in Iran," *A Volume of Oriental Studies presented to Edward G. Browne,* Cambridge, 1922.

Heyd, W. von, *Histoire du commerce du Levant au moyen-âge,* 2 vols., Leipzig, 1885-1886.

——, "Le Colonie commerciali degli Italiani in Oriente nel Medio Evo," *Dissert. Rifatt. dall'Autore e recate in Italiano dal Prof. G. Müller,* Venice and Turin, 1866.

Hommaire de Hell, X., *Voyage en Turquie et en Perse exécuté par ordre du gouvernement français pendant des années 1846, 1847 et 1848,* 4 vols. and atlas, Paris, 1854-1860.

Howorth, H. H., *History of the Mongols. Part III. The Mongols of Persia,* London, 1888.

Voyages d'Ibn Batoutah; texte arabe, accompagné d'une traduction, par C. Defrémery et le dr. B. R. Sanguinetti, 4 vols., Paris, 1854-1874.

"I Conti dell'Ambasciata al Chan di Persia nel MCCXCII, pubbliciati dal socio Cornelio Desimoni," *Atti della Societa Ligure di Storia Patria,* Genoa, XIII (1877-1884).

Jackson, A. V. W., *Persia past and present . . . ,* London and New York, 1906.

——, *From Constantinople to the home of Omar Khayyam,* New York, 1911.

Jacobsthal, E., *Mittelalterliche Backsteinbauten zu Nachtschewân, im Araxesthale,* Berlin, 1899.

Jahn, K., "Geschichte der Ilchane Abaga bis Gaihatu," *Abhdl. d. deutsch. Gesellschaft d. Wissenschaft u. Kunste in Prag, phil.-histor. Kl. 1.,* Reichenburg (1941).

——, [Ed.], *Geschichte Ġāzān-Ḫān's aus dem Ta'rīḫ-i-mubārak-i-Ġāzānī des Rašīd al-Dīn . . .* (Persian text), London, 1940.

Jakoubovski, A., "Les ruines d'Ourgenč" (in Russian), *Bull. de l'Academie de l'Histoire de la Culture Materiale,* Leningrad, V, 2 (1930).

Janāb, Mīr Sayyid 'Alī, *Al-Iṣfahān* (in Persian), Isfahan, 1303 [1924].

Jourdain, A., "Mémoire sur l'observatorie de

Méragel et sur quelques instruments employées pour y observer," *Magasin encyclopedique*, 1810.

Karīmī, B., *Joghrāfi-yi-mofaṣṣel tārikhi gharb-i-Īrān* (in Persian), Tehran, 1318 [1939].

Shams-i-Kāshānī . . . , Bibliothèque Nationale, MS Suppl. persan 1443.

Abu'l Qāsim 'Abd Allāh ibn 'Alī Muḥammad ibn Abī Taher al-Kāshānī, *Tārikh-i- . . . Öljeitü Sulṭān Muḥammad*, Bibliothèque Nationale, MS. Suppl. persan 1419.

De Kasr-e Shirin à Meshhed et à Tus (Publications du Service archéologique de la Perse), Tehran, 1934.

Khanikoff, N. de, "Mémoire sur la partie méridionale de l'Asie Centrale," *Recueil de voyages et de mémoires publiés par la Société de Géographie*, VII (1861).

———, "Mémoire sur les inscriptions musulmanes du Caucase," *Journal Asiatique*, 5th series, XX (1862).

Klaproth, J. H. von, *Mémoire relatif à l'Asie, contenant des recherches historiques, géographiques, et philologiques sur les peuples de l'Orient*, 3 vols., Paris, 1824-1828.

———, *Travels in the Caucasus and Georgia, performed in the years 1807 and 1808, by command of the Russian government*, London, 1814.

———, *Tableau historique, géographique, ethnigraphique et politique du Caucase et des provinces limitrophes entre la Russie et la Perse*, Paris, 1827.

Kohler, C., "Documents relatifs a Guillaume Adam, archevêque de Sultanieh, puis d'Antivari et son entourage (1318-1346)," *Revue de l'Orient Latin*, X (1905).

Kotwicz, W., *En marge des lettres des il-Khans de Perse retrouvées par Abel-Rémusat*, Lwow, 1933.

———, *Quelque mots encore sur les lettres des il-khans de Perse retrouvées par Abel-Rémusat*, Wilno, 1936.

Kratchkovskaya, V. A., "Notices sur les inscriptions de la Mosquee Djoûma'a à Véramine," *Revue des Études Islamiques*, V (1931).

———, "The mihrab in lustre-painted faïence in the Hermitage" (in Russian), *Iran*, I (1926-1927).

———, "Fragments du Miḥrāb de Vārāmin," *Ars Islamica*, II (1935).

———, "Les faïences du mausolée de Pir-Houssayn," *IIIe Congrès International d'art et d'archéologie Iraniens*, Leningrad, 1935.

———, *Steles funaires du Musée de Paleographie*, Leningrad, 1929.

———, *The Tiles of the Mausoleum from the Khanakah Pu Husain* (in Russian), Tiflis, 1946.

Kühnel, E., "Datierte persische Faÿencen," *Jahrbuch der Asiatischen Kunst*, I (1924).

———, "Dated Persian lustred pottery," *Eastern Art*, III (1931).

La Croix, P. de, *The History of Genghizcan the Great*, London, 1722.

Laufer, B., *Sino-Iranica* . . . , Chicago, 1919.

Le Comte, E., "Tébriz (Azerbaïdjan)," *Revue de Geographie*, XVI, 3 (1892).

Le Strange, G., *Mesopotamia and Persia under the Mongols, in the fourteenth century A.D.*, London, 1903.

———, *The Lands of the eastern Caliphate* . . . , Cambridge, 1905.

——— [Trans. and Ed.], *The geographical part of the Nuzhat-al-Qulūb composed by Ḥamd-Allāh Mustawfī of Qazwīn in 740 (1340)*, (Persian text) London, 1915, (English translation) London, 1919.

——— [Trans.], *Clavijo, Embassy to Tamerlane, 1403-1406*, London, 1928.

Levy, R., "The Letters of Rasīd al-Dīn Faḍl-Allāh," *Journal Royal Asiatic Society*, 1/2 (1946).

Long, W. R. [Ed.], *La Flor de las Ystorias de Orient by Hayton Prince of Gorgios*, Chicago, 1934.

Lutyens, E., "Persian Brickwork—II," *Country Life*, LXXIII, no. 1881 (1933).

Lycklama, T. M. a Nijeholt, *Voyage en Russie, au Caucase et en Perse, dans la Mesopotamie, le Kurdistan* . . . , 4 vols., Paris, 1872-1875.

Lynch, H. F. B., *Armenia, Travels and Studies*, 2 vols., London and New York, 1901.

MacGregor, Colonel C. M., *Narrative of a Journey through the province of Khorassan and on the n.w. frontier of Afghanistan in 1875*, 2 vols., London, 1879.

Malcolm, J., *The History of Persia, from the most early period to the present time* . . . , 2 vols., London, 1815.

Margoliouth, D. S. [Trans. and Ed.], *The Eclipse of the Abbasid Caliphate; original chronicles of the fourth Islamic century* . . . , 7 vols., Oxford, 1920-1921.

Marr, N. Y., *Ani* (in Russian), Leningrad, 1934.

Mas Latrie, L. de, "Priviléges commercial accordé en 1320 à la République de Venise par un roi de Perse, faussement attribué à un roi de Tunis," *Bibliothèque de l'École de Chartres*, Paris, XXX (1870).

Mendel, G., "Les Monuments Seldjoukides en Asie Mineure," *La Revue de l'art ancien et moderne*, XXIII (1908).

————, and Sakisian, A. B., "Les faïences d'Asie Mineure du XIIIe au XVIe siècle. 1. La ceramique Seldjoukide du XIIIe siècle," *Revue de l'Art ancien et moderne*, XLIII (1923).

Migeon, G., and Sakisian, A. B., "Les faïences d'Asie-Mineure du XIIIe siècle au XVIe siècle. 1. La ceramique Seldjoukide du XIIIe siècle," *La Revue de l'art ancien et moderne*, XLIII (1923).

Miles, G. C., "Epigraphical Notice," following Smith, M. B., "Two dated Seljuk monuments at Sīn (Isfahan)," *Ars Islamica*, VI, 1 (1939).

Miles, S. B., *The Shajrat ul Atrak*, London, 1839.

Minorsky, V., "Maragha," *Encyclopedia of Islam*.

————, "The Mosque of Varamin," *Apollo*, XIII (1931).

Mirsky, D. S., *The Life of Chingis-Khan*, London, 1930 (a translation of Vladimirtsov, B., *Tchingiz-Khan* [in Russian], Leningrad, 1922).

Montgomery, J. A. [Trans. and Ed.], *The History of Yaballaha III, Nestorian patriarch, and of his vicar, Bar Sauma, Mongol ambassador to the Frankish courts at the end of the thirteenth century* . . . , New York, 1927.

Morgan, J. de, *Mission scientifique en Perse*, 5 vols. in 7, Paris, 1894-1905.

Morier, J. J., *A Journey through Persia, Armenia and Asia Minor, to Constantinople, in the years 1808 and 1809* . . . , London, 1812.

————, *A second journey through Persia, Armenia, and Asia Minor, to Constantinople, between the years 1810 and 1816*, London, 1818.

Morley, W. H., *The History of the Atabegs of Syria and Persia by Mirchond*, London, 1848.

Moule, A. C. and Pelliot, P. [Trans. and Ed.], [*Marco Polo*], *The description of the world*, 2 vols., London, 1938.

Munshi Mohun Lal, "A brief description of Herat," *Journal Asiatic Society of Bengal*, III (1834).

Napier, G. C., "Extracts from a diary of a tour in Khorassan and notes on the Eastern Alburz Tract," *Journal Royal Geographical Society*, XLVI (1876).

Niedermayer, O. von, *Afganistan*, Leipzig, 1924.

O'Donovan, E., *The Merv Oasis; travels and adventures east of the Caspian during the years 1879-80-81* . . . , 2 vols., London, 1883.

————, "Merv and its surroundings," *Proceedings of the Royal Geographic Society*, IV (1882).

Ogilby, J., *Asia, the first part. Being an accurate description of Persia, and the several provinces thereof* . . . , London, 1673.

d'Ohsson, C. M., *Histoire des Mongols, depuis Tchinguiz-Khan jusqu'à Timour Beg, ou Tamerlan* . . . , 4 vols., La Haye, 1834-1835.

Relation du voyage d'Adam Olearius en Moscovie, Tartarie et Perse . . . , 2 vols., Paris, 1666.

Olschki, L., *Marco Polo's Precursors*, Baltimore, 1943.

Ouseley, W., *Travels in various countries of the East; more particularly Persia* . . . , 3 vols., London, 1819-1823.

Pauty, E., "L'architecture dans les miniatures islamiques," *Bull. de l'Institut d'Egypte*, Cairo, XVII (1935).

Pelliot, P., *Les Mongols et la Papauté*, 3 vols., Paris, 1923. (Originally published in *Revue de l'Orient Chrétien*, 3rd series, III, 1 and 2, 1922-1923).

————, "Les documents mongols du musée de Ṭeherān," *Athār-é Īrān*, I, 1 (1936).

————, *Mongols et papes au XIIIe et XIVe siècles*, Paris, 1922.

Pope, A. U. [Ed.], *A Survey of Persian Art from prehistoric times to the present*, 6 vols., London and New York, 1938.

————, "Some recently discovered Seldjūk stucco," *Ars Islamica*, I, 1 (1934).

————, "New findings in Persian ceramics of the Islamic period," *Bull. Am. Inst. Iranian Art and Archaeology*, V, 2 (1937).

————, "The Photographic Survey of Persian Islamic Architecture," *Bull. Am. Inst. Persian Art and Archaeology*, 7 (1934).

Porter, R. Ker, *Travels in Georgia, Persia, Armenia, ancient Babylon . . . during the years 1817, 1818, 1819 and 1820*, 2 vols., London, 1821-1822.

Prawdin, M. [Charol, M.], *The Mongol Empire: its rise and legacy*, London, 1940.

The Collection formed by J. R. Preece at the Vincent Robinson Galleries, London, 1913.

Preusser, C., *Nordmesopotamische baudenkmäler, altchristlichen und islamischen Zeit*, Leipzig, 1911.

Quatremere, E. M., *Histoire des Mongols de la Perse écrite en persan par Raschid-eldin, publiée, traduite en français, accompagnée de notes et d'un mémoire sur la vie et les ouvrages de l'auteur*, Paris, 1836.

Rāhnamā-yi Qumm (in Persian), Tehran, 1317 [1938].

Raverty, Major H. G., *Tabakat-i-Nasiri* (of *Minhaj-ud-Din Abu 'Umar-i-'Usman al-Jurjani, or al-Jusjani*), London, 1881, index volume of 1897.

Raymond, A. M., *Vielles faïences turques en Asie Mineure et à Constantinople*, Karlsruhe, 1921.

Reinaud, M. and Guyard, S. [Trans. and Ed.],

Géographie d'Aboulféda, 2 vols., Paris, 1848-1883.

Remusat, J. P. A. Abel-, "Mémoire sur les relations politiques des princes chrétiens, et particulièrement des rois de France, avec les empereurs Mongols," *Mémoires de l'Institut Royal de France, Académie des Inscriptions et Belle-Lettres*, VI (1822), VII (1824).

Reuther, O., *Das Wohnhaus in Baghdad und anderen Städten des Irak*, Berlin, 1910.

Rey, E. G., *Les colonies franques de Syrie aux XIIme et XIIIme siècles . . .* , Paris, 1883.

Riefstahl, R. M., *Turkish Architecture in Southwestern Anatolia*, Cambridge, 1931.

Rockhill, W. W. [Trans. and Ed.], *The journey of William of Rubruck to the eastern parts of the world, 1253-55, as narrated by himself . . .* , London, 1900.

Rodkin, A., *Unveiled Iran*, London, n.d.

Rosintal, J., *Pendentifs, trompes, et stalactites dans l'architecture orientale*, Paris, 1928.

———, *Le réseau, forme intermédiaire perse inconnue jusqu'à present*, Paris, 1937.

———, *L'origine des stalactites de l'architecture orientale*, Paris, 1938.

Sachau, E., *Zur geschichte und chronologie von Khwarizm*, Vienna, 1873.

Ṣādeqi, N. H., *Iṣfahān* (in Persian), Tehran, 1316 [1937].

Salnamayi mo'aref-i-Fārs, 1315-1316 (in Persian), Shiraz [1937].

Sanī' ad-dawla Muḥammad Ḥasan Khān, *Maṭla' ash-Shams* (in Persian), 3 vols., Tehran, 1301-1303 [1884-1886].

———, *Merāt al-Boldān Nāṣirī* (in Persian), 4 vols., Tehran, 1293-1296 [1876-1879].

Sarre, F., *Reise in Kleinasien—sommer 1895 . . .* , Berlin, 1896.

———, *Konia; seldschukische baudenkmäler*, Berlin, 1910.

———, *Denkmäler persischer baukunst . . .* , 2 vols., Berlin, 1901-1910.

———, "Eine keramische Werkstatt von Kashan im 13.—14. Jahrhundert," *Istanbuler Mitteilungen, herausgegeben von der Abteilung Istanbul des Archaeologischen Institutes des Deutschen Reiches*, 3 (1935).

———, *Der Kiosk von Konia*, Berlin, 1936.

Beiträge zur Kunst des Islam. Festschrift fuer Friedrich Sarre . . . , Leipzig, 1925.

Sarre, F. and Herzfeld, E. E., *Archäologische reise im Euphrat- und Tigris- gebiet*, 4 vols., Berlin, 1911-1920.

———, and Kühnel, E., "Zwie persische Gebetnischen aus lüstrierten Fliesen," *Berliner Museen*, XLIX (1928).

Sayali, A., "Ghāzān Khān's observatory" (in Turkish), *Belletin*, Ankara, 10 (1946).

Schaube, A., *Handelsgeschichte der Romanischen Völker des Mittelmeergebiets bis zum ende der Kreuzzüge*, Munich-Berlin, 1906.

Schindler, A. Houtum-, *Historical and archaeological notes, on a journey in South-Western Persia, 1877-78*, London, 1880.

———, "Reisen im südlichen Persien," *Zeitschrift der Gesellschaft für Erdkunde zu Berlin*, XVI (1881).

———, "Reisen in nordwestlichen Persien," *Zeitschrift der Gesellschaft für Erdkunde zu Berlin*, XVIII (1883).

———, *Eastern Persian Irak*, London [1897].

Schmidt, E., *Flights over Ancient Cities of Iran*, Chicago, 1940.

Schmidt, I. J., *Philologisch-Kritische Zugabe zu den von Herrn Abel-Rémusat bekannt gemachten . . . zwei mongolischen Original-Briefen der Könige von Persien Argun und Öldshaitu an Philipp den Schönen*, Saint Petersbourg, 1824.

Schroeder, E., "M. Godard's review of the architectural section of *A Survey of Persian Art*," *Ars Islamica*, IX (1942).

———, "Preliminary Note on work in Persia and Afghanistan," *Bull. Am. Inst. Persian Art and Archaeology*, IV, 3 (1936).

Schwarz, P., *Iran im Mittelalter nach den arabischen geographen*, 9 vols., Leipzig and Stuttgart, 1896-1936.

Serdārvar [Trans.], *Bārtuld—Joghrāfīyayi tārīkhī Īrān* (in Persian), Tehran, 1307 [1929].

The Sherley Brothers, An historical memoir of the lives of Sir Thomas Sherley, Sir Anthony Sherley, and Sir Robert Sherley, Knights. By one of the same house, London, 1848.

The Three Brothers; or, The travels and adventures of Sir Anthony, Sir Robert, & Sir Thomas Sherley, in Persia, Russia, Turkey, Spain . . . , London, 1825.

Muḥammad Naṣīr Mirza Āqā Forṣat Ḥusayni Shīrāzī, *Āthār-i-'Ajam* (in Persian), Bombay, 1314 [1896].

Ḥājjī Mirzā Ḥasan Shīrāzī, *Farsnāma-i-Nāṣirī* (in Persian), Tehran, 1313 [1895-1896].

Abu'l 'Abbās Aḥmad bin Abī al-Kheir Zarkūb Shīrāzī, *Shīrāz Nāma* (in Persian), Tehran, 1350 [1931].

L'Ambassade de D. Garcias de Silvia Figuerra en Perse, Paris, 1667.

Siroux, M., "La Masdjid-e Djum'a de Yezd," *Bulletin de l'Institut français d'Archéologie orientale*, XLIV (1947), pp. 119-176, figs. 1-13, pls. I-IX.

———, "La Mosquée Djoumeh d'Ardabil," *Bul-*

letin de l'Institut français d'Archéologie orientale, XLIV (1945).

Sisojeff, B. M., "Nakchevan on the Araxes and its antiquities" (in Russian), *Bulletin Archaeological Society of Azerbaijan*, Baku, IV (1929).

Skrine, F. H. and Ross, E. D., *The Heart of Asia*, London, 1899.

Slane, M. de [Trans.], *Les Prolégomenes d'Ibn Khaldoun*, 3 vols., Paris, 1934.

Smith, M. B., "Imām Zādè Karrār at Buzūn. A Dated Seldjuk Ruin," *Archaeologischen Mitteilungen aus Iran*, VII 2/3 (1935).

———, "The Manārs of Iṣfahān," *Athār-é Īrān*, I, 2 (1936).

———, "Two dated Seljuk monuments at Sīn (Isfahan)," *Ars Islamica*, VI, 1 (1939).

———, and Smith, K., "Islamic Monuments of Iran," *Asia*, XXXIX, 4 (1939).

Soberheim, M., "Die Inschriften der Zitadelle im Damaskus," *Der Islam*, XII (1922).

Sorrento, G., *Il Papato, l'Europe Cristiana e i Tartari*, Milan, 1930.

Southgate, H., *Narrative of a tour through Armenia, Kurdistan, Persia and Mesopotamia*, 2 vols., New York, 1840.

Spuler, B., *Die Mongolen in Iran*, Leipzig, 1939.

———, *Die Goldene Horde: Die Mongolen in Russland*, Leipzig, 1939.

Stainton, B. W., "A Masterpiece from Old Persia," *International Studio*, LXXVII (1935).

Stein, M. A., "An Archaeological Tour in the Ancient Persis," *Geographical Journal*, LXXXVI (1935).

———, "An Archaeological Tour in the Ancient Persis," *Iraq*, III, 2 (1936).

Storey, C. A., *Persian Literature: A Bibliographical Survey. Section II*, London, 1936.

Les voyages de Jean Struys, en Moscovie, en Tartarie, en Perse, aux Indes, et en plusieur autres Païs étrangers, 3 vols., Amsterdam, 1718.

Stryzgowski, J., "Die persische Trompenkuppel," *Zeitschrift für Geschichte der Architektur*, III (1909).

Sykes, P. M., *Ten thousand miles in Persia; or, Eight years in Iran*, London, 1902.

———, "Historical notes on Khorasan," *Journal Royal Asiatic Society* (1910).

———, "A sixth journey into Persia," *Geographical Journal*, XXXVII (1911).

———, *A History of Persia*, 2 vols., London, 1921.

———, *The Quest for Cathay*, London, 1936.

"Preliminary Report on Takht-i-Sulayman. II. The Historical Documents by ·Mary Crane. III. Summary Description of the Extant Structures by Donald N. Wilber," *Bull. Am. Inst. Iranian Art and Archaeology*, V, 2 (1937).

Tate, G. P., *Seistan: a memoir on the history, topography, ruins and people of the country*, 2 vols., Calcutta, 1910-1912.

Tavernier, J. B., *Les six voyages de Jean-Baptiste Tavernier, chevalier baron d'aubonne, qu'il a fait en Turquie, en Perse et aux Indes . . .*, 2 vols., Paris, 1681-1682.

Texier, C. F. M., *Description de l'Armenie, la Perse et la Mesopotamie . . .*, 3 vols., Paris, 1842-1852.

Thomas, W. and Roy, S. A. [Trans.], *Travels to Tana and Persia, by Josafa Barbaro and Ambrogio Contarini*, London, 1873.

Tiesenhausen, V., "Brief notes and information on the mosque of Ali-Shah in Tabriz" (in Russian), *Zapiski Vosochnogo Otdeleniya Imperatorskogo Arkheologicheskogo Obshchestro*, Moscow, I (1886).

Voyages de P.(ietro) della V.(alle) dans la Turquie, l'Egypte, la Palestine, la Perse, les Indes Orientales, et autres lieux, 8 vols., Paris, 1745.

The Travels of Ludovico di Varthema in Egypt, Syria, Arabia Deserta and Felix, Persia, India and Ethiopa, A.D. 1503 to 1508, London, 1863.

Villard, V. M. de, "The Fire Temples," *Bull. Am. Inst. Persian Art and Archaeology*, V, 4 (1936).

Walker, C. C., *Jenghiz Khan*, London, 1940.

Wilber, D. N., "Preliminary Report of the Eighth Season of the Survey," *Bull. Am. Inst. Iranian Art and Archaeology*, V, 2 (1937).

———, "Preliminary Report on Takht-i-Sulayman. III. Summary Description of the Extant Structures," *Bull. Am. Inst. Iranian Art and Archaeology*, V, 2 (1937).

———, "The development of mosaic faïence in Islamic architecture in Iran," *Ars Islamica*, VI, 1 (1939).

———, "Preliminary Report of the Sixth Season of the Survey," *Bull. Am. Inst. Persian Art and Archaeology*, IV, 2 (1935).

———, and Minovi, M., "Notes on the Rab'-i-Rashidi," *Bull. Am. Inst. Iranian Art and Archaeology*, V, 3 (1938).

Wilson, C. E. [Trans.], *The Haft Paikar*, 2 vols., London, 1924.

Wilson, J. C., "The Masjid-i-Jami' of Riza'iya," *Bull. Am. Inst. Iranian Art and Archaeology*, V, 1 (1937).

Wulzinger, K., Wittek, P. and Sarre, F., *Das islamische Milet*, Berlin and Leipzig, 1935.

Wylie, A., *Chinese researches. Part III. The Mongol astronomical instruments in Peking*, Shanghai, 1897.

Yaghmānī, Eqbāl, *Joghrāfāyī tārīkhī Dāmghān* (in Persian), Tehran, 1326 [1947].

Yate, C. E., *Khurasan and Sistan*, Edinburgh and London, 1900.

Yule, H. [Trans.] and Cordier, H. [Ed. of third edition], *The Book of Ser Marco Polo, the Venetian, concerning the kingdoms and marvels of the East* . . . , 2 vols., London, 1929.

—— [Trans. and Ed.], and Cordier, H. [Ed.], *Cathay and the Way Thither; being a collection of medieval notices of China* . . . , 4 vols., London, 1913-1916.

Zasipkin, W., "The mausoleum of Sultan Sanjar at Merv" (in Russian), *Voprosij Restavratsy*, Moscow, II (1928).

INDEX

PLATES

SOURCES OF PHOTOGRAPHS (BY PLATE NUMBERS)

Aerial Survey—Oriental Institute: 3.
Farajollah Bazl: 50, 51.
Joseph Covello: 157.
André Godard: 1, 7, 17, 18, 158, 170, 180, 185, 191, 196, 213, 214, 215.
Stephen H. Nyman: 14, 16, 48, 68.
Arthur Upham Pope: 5, 6, 11, 20, 26, 27, 28, 29, 30, 32, 36, 37, 38, 39, 40, 41, 43, 44, 45, 46, 49, 55, 56, 57, 58, 59, 60, 63, 64, 65, 69, 71, 72, 73, 74, 75, 76, 77, 78, 87, 88, 96, 104, 106, 114, 116, 117, 122, 123, 130, 131, 132, 134, 135, 137, 138, 140, 141, 142, 143, 144, 145, 166, 167, 171, 175, 176, 178, 179, 183, 195, 201, 209, 210, 211.
Sevrugin: 42, 124.
Donald N. Wilber: 4, 8, 9, 12, 13, 21, 22, 23, 24, 25, 33, 34, 35, 47, 52, 53, 54, 61, 62, 66, 67, 79, 80, 81, 82, 84, 85, 86, 89, 90, 91, 92, 93, 94, 95, 97, 98, 99, 100, 101, 102, 103, 105, 115, 118, 119, 120, 121, 125, 126, 127, 128, 129, 133, 136, 139, 146, 147, 148, 149, 150, 151, 152, 153, 154, 155, 156, 160, 161, 162, 163, 165, 169, 172, 173, 174, 181, 184, 186, 187, 188, 189, 190, 192, 193, 194, 197, 198, 199, 200, 202, 203, 204, 205, 206, 207, 208, 212, 217, 218.
J. Christy Wilson: 10, 168.

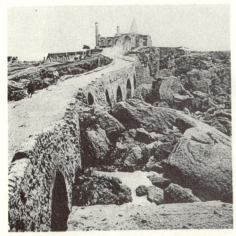

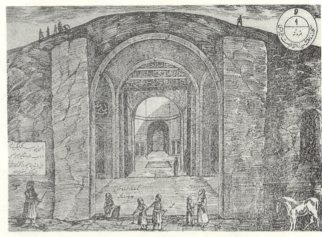

1. CAT. NO. 5. Shūstar. Imāmzāda 'Abd Allāh

2. CAT. NO. 8. Dārāb. Masjid-i-Sang, after Forṣat Shīrāzī

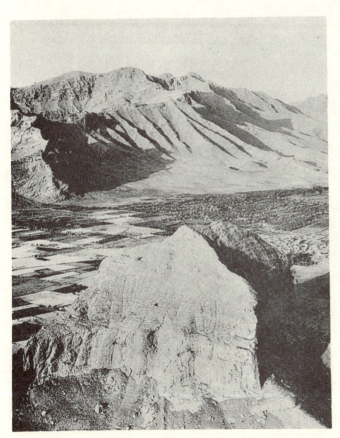

3. CAT. NO. 10. Shāhī island. Aerial view of the rock near Serai village, looking southwest

4. CAT. NO. 10. Shāhī island. Rock near Serai village, looking northeast from the village

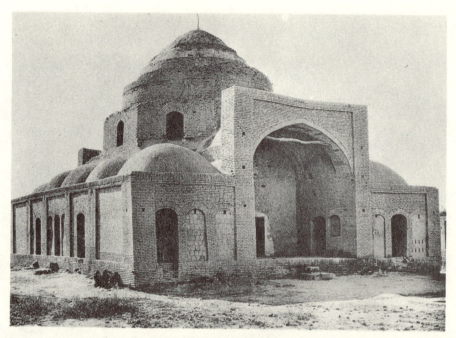

5. CAT. NO. 11. Varāmīn. Imāmzāda Yaḥyā (the entrance and vaults around dome chamber are recent)

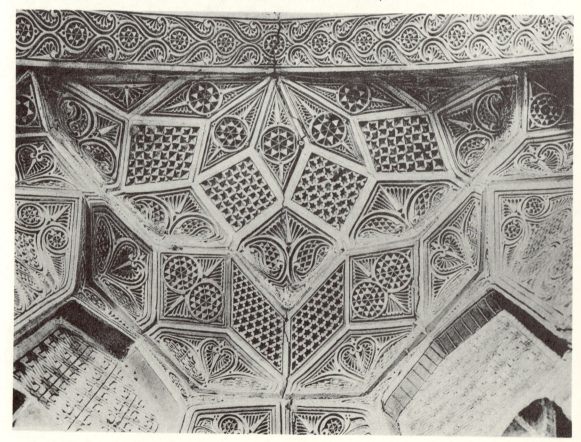

6. CAT. NO. 11. Varāmīn. Looking vertically at a squinch in the dome chamber of Imāmzāda Yaḥya

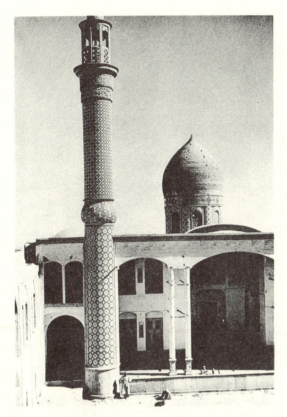

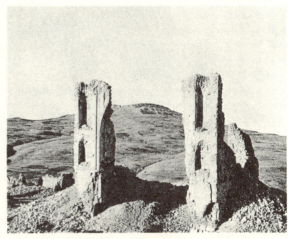

8. CAT. NO. 15. Takht-i-Sulaymān, façade of vaulted hall

7. CAT. NO. 14. Kāshān Imāmzāda Habib ibn Mūsā
(all visible construction is later
than the Il Khānid period)

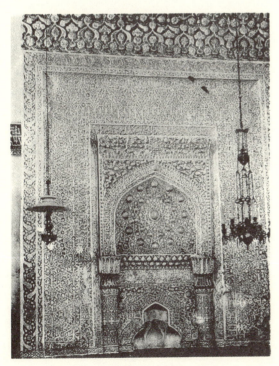

9. CAT. NO. 16. Riẓā'iya. The miḥrāb
of the Masjid-i-Jāmi'

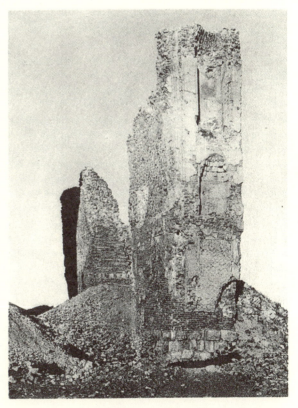

10. CAT. NO. 15. Takht-i-Sulaymān, right façade pier
of the vaulted hall

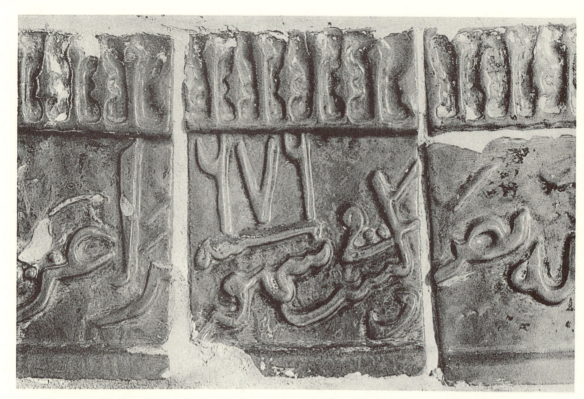

11. CAT. NO. 17. Sāva. Imāmzāda Sayyid Isḥāq. Plaques glazed with light blue and improperly reassembled on a grave within the structure. One of the plaques shown bears the numerical date 676

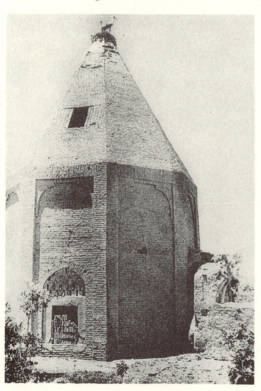

12. CAT. NO. 18. Qumm. Elevation of the Imāmzāda Ja'far

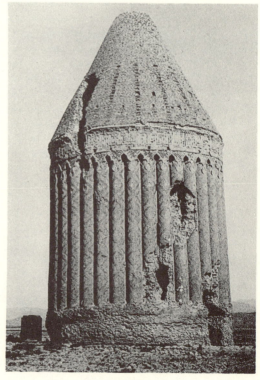

13. CAT. NO. 19. Rādkān. Elevation of the Mīl-i-Rādkā

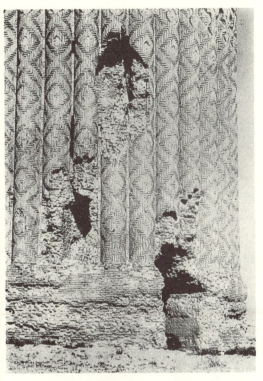

14. Detail of engaged half round columns

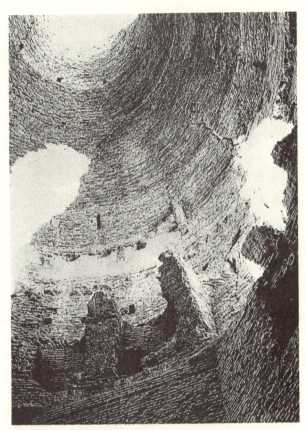

15. Interior of the conical roof

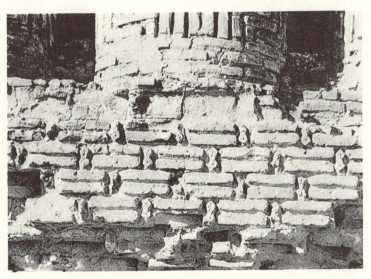

16. Detail of brickwork at the base

14-16. CAT. NO. 19. Rādkān. The Mīl-i-Rādkān

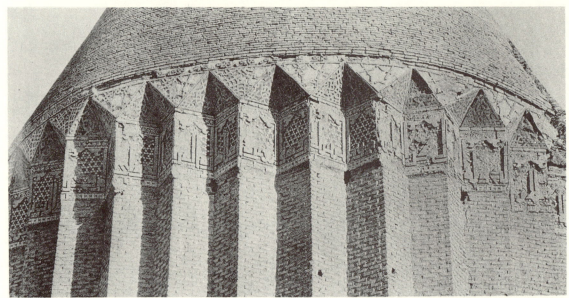

17. CAT. NO. 21. Varāmīn. Detail of the cornice of the tomb tower of 'Ala ad-dīn

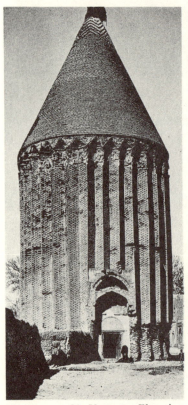

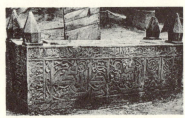

19. CAT. NO. 20. Sarvistān. Sarcophagus of Shaykh Yusuf Sarvistānī

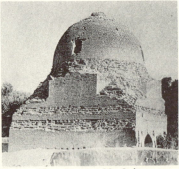

20. CAT. NO. 22. Sojās. Exterior of the Masjid-i-Jāmi'

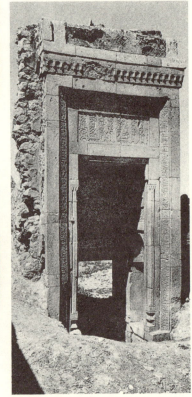

18. CAT. NO. 21. Varāmīn. Elevation of tomb tower of 'Ala ad-dīn

21. CAT. NO. 20. Sarvistān. Imāmzāda Shaykh Yusuf Sarvistānī, portal dated 714/1314

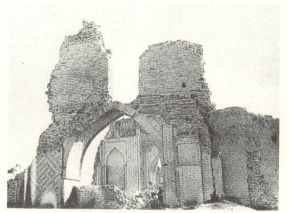

22. CAT. NO. 23. Gar (Iṣfahān). The dome chamber

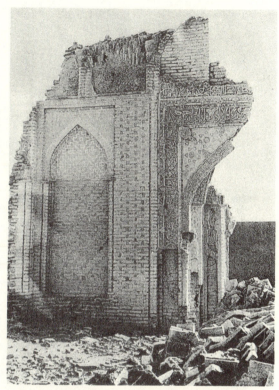

23. CAT. NO. 23. Gar (Iṣfahān). Wall of dome chamber, with section of the miḥrāb

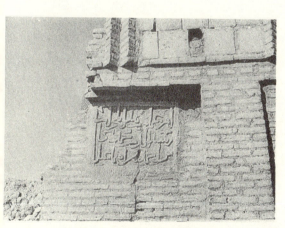

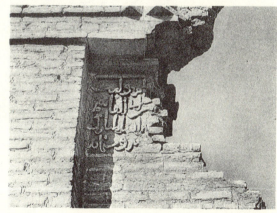

24-25. CAT. NO. 23. Gar (Iṣfahān). Inscription panels on north wall of the dome chamber

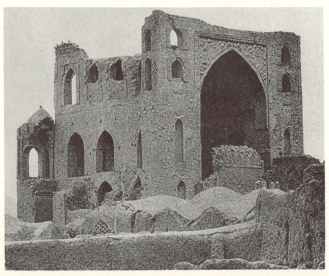

26. CAT. NO. 26. Linjān (Iṣfahān). The Pīr-i-Bakrān

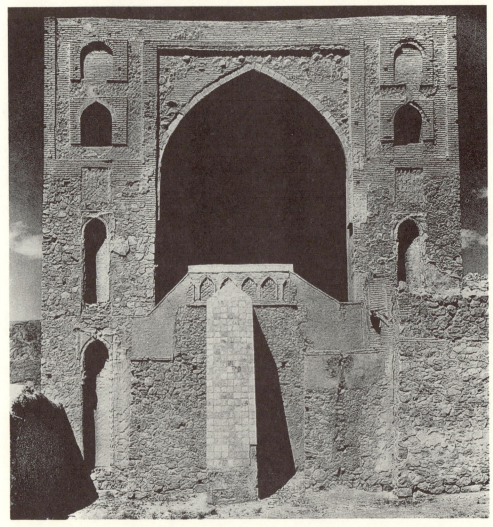

27. CAT. NO. 26. Linjān (Iṣfahān). Façade of the īvān of Pīr-i-Bakrān, blocked by the screen wall
containing the miḥrāb (buttress and mud coated surfaces represent recent repairs)

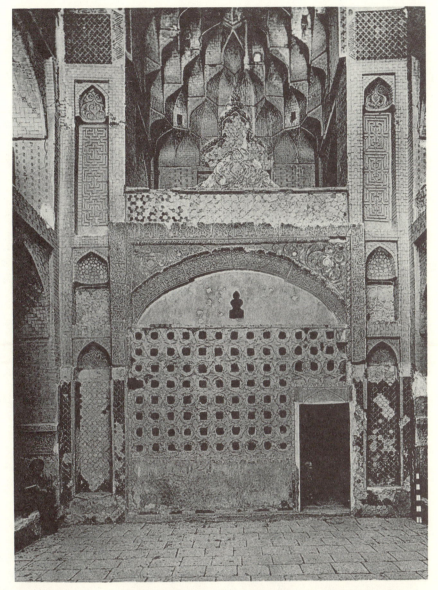

28. CAT. NO. 26. Linjān (Iṣfahān). Rear face of the īvān of Pīr-i-Bakrān

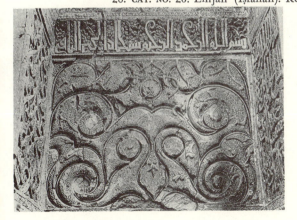

29. CAT. NO. 26. Linjān (Iṣfahān). Detail of plaster work in lateral wall recess in the īvān of Pīr-i-Bakrān

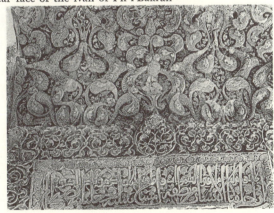

30. CAT. NO. 26. Linjān (Iṣfahān). Detail of the miḥrāb of Pīr-i-Bakrān

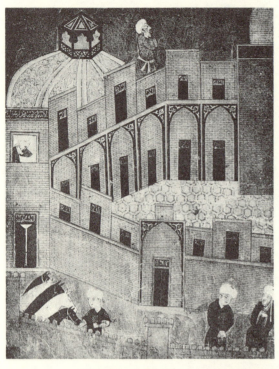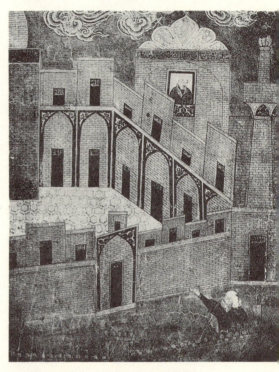

31. CAT. NO. 27. Tabrīz. The Ghāzāniya: the mausoleum and adjacent structures
as portrayed in a manuscript believed to have been painted before A.D. 1318

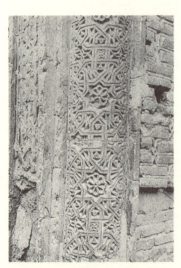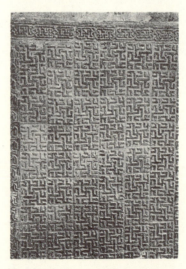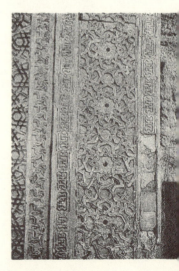

32. Engaged column of entrance
portal, in moulded terra cotta

33. Identical moulded terra cotta
plaques in bay of entrance portal

34. Decorative panels of entrance
portal

32-34. CAT. NO. 28. Bistam. The shrine of Bāyazīd

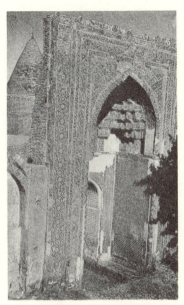

35. Entrance portal

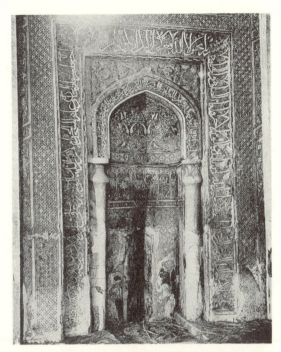

36. Miḥrāb

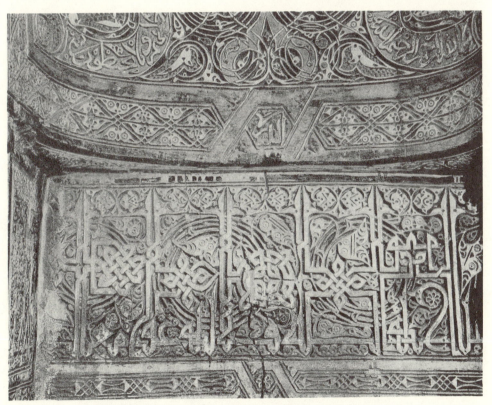

37. Detail of the miḥrāb

35-37. CAT. NO. 28. Bistam. The shrine of Bāyazīd

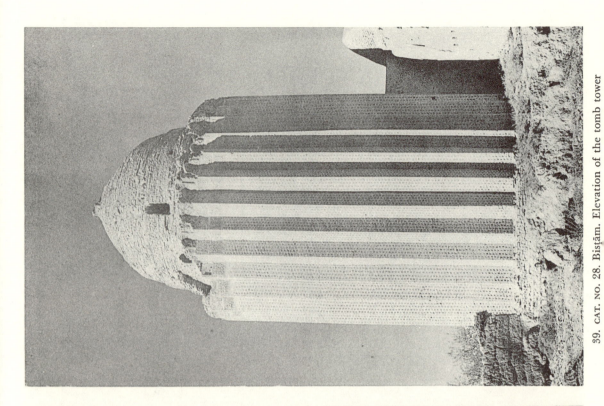

39. CAT. NO. 28. Bisṭām. Elevation of the tomb tower

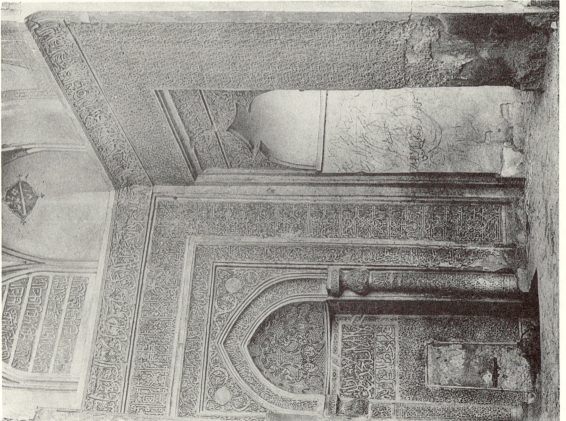

38. CAT. NO. 28. Bisṭām. The miḥrāb in the Masjid-i-Jāmiʿ

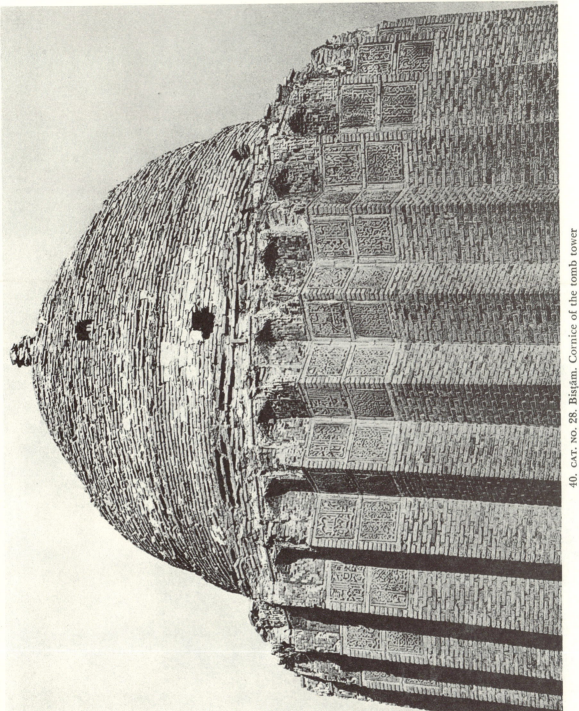

40. CAT. NO. 28. Bisṭām. Cornice of the tomb tower

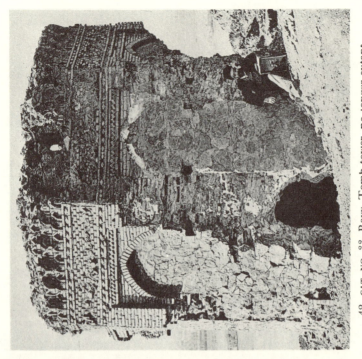

42. CAT. NO. 33. Rayy. Tomb tower, no longer extant.

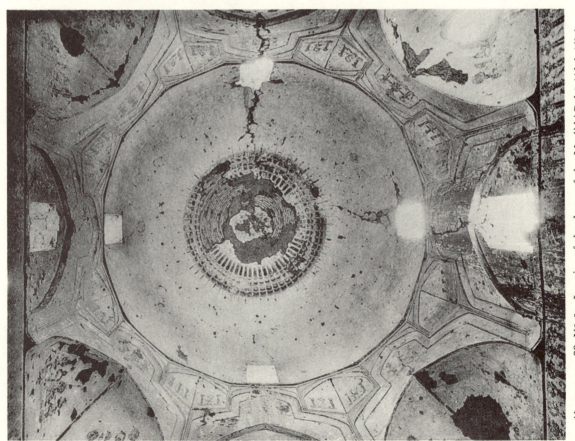

41. CAT. NO. 29. Nāyin. Interior of the dome of the Masjid-i-Bābā 'Abd Allāh

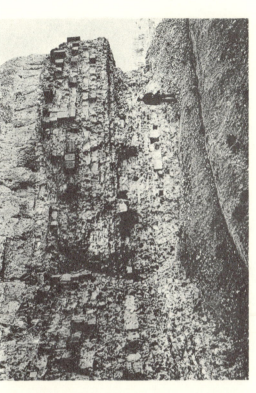

43-44. Looking northeast over the site

45. Ruins of a circular masonry base

46. Detail showing upper courses projecting beyond lower dressed blocks

43-46. CAT. NO. 34. Tabriz. The Rab'-i-Rashidi

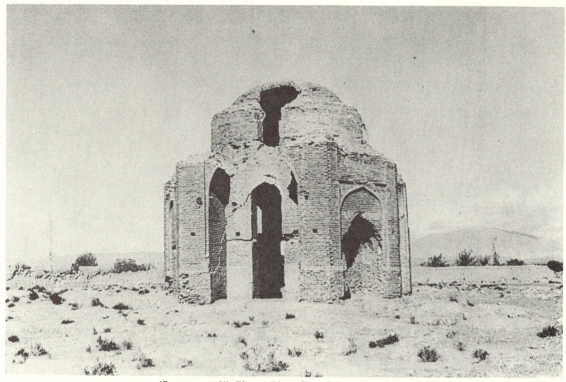

47. CAT. NO. 35. Ziāret. Elevation of the tomb shrine

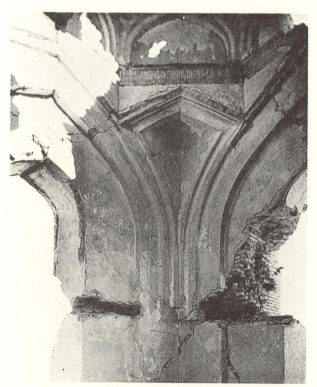

48. CAT. NO. 35. Ziāret. Corner angle and squinch
in the dome chamber of the tomb shrine

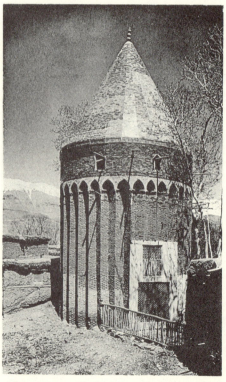

49. CAT. NO. 36. Demāvand. Elevation of
the Imāmzāda 'Abd Allāh

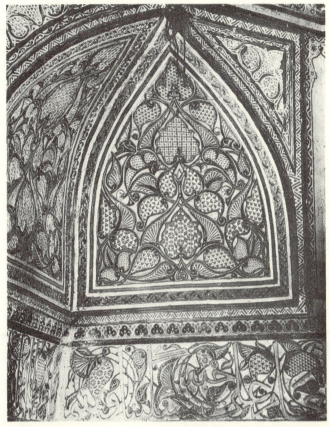

50. CAT. NO. 37. Qumm. Polychrome plaster in the Imāmzāda ʻAlī ibn Jaʻfar

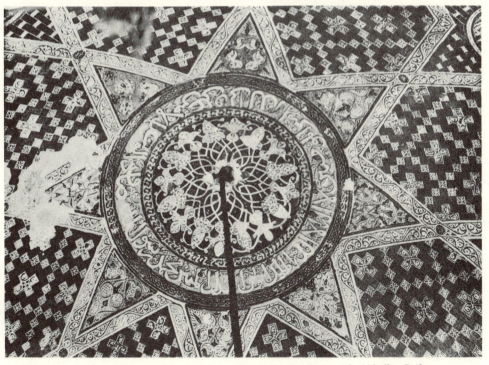

51. CAT. NO. 37. Qumm. Polychrome plaster in the Imāmzāda ʻAlī ibn Jaʻfar

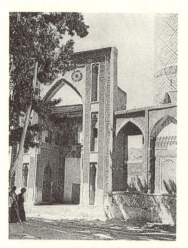

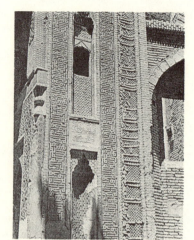

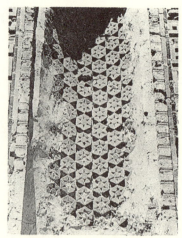

52. Portal 53. Decorative terra cotta panels 54. Detail of panels with faïence inset

52-54. CAT. NO. 39. Naṭanz. Portal of the *khānaqāh*

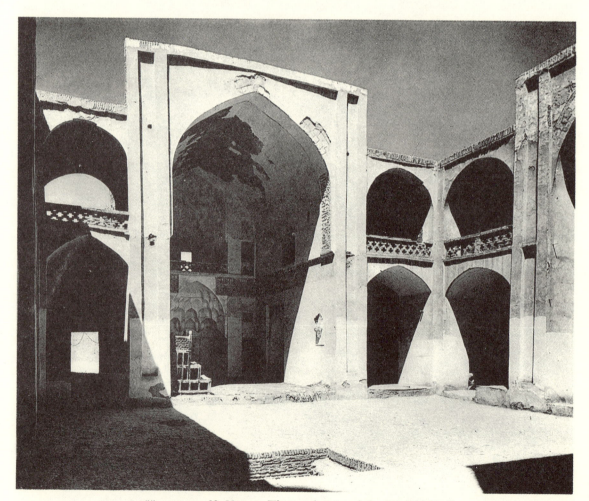

55. CAT. NO. 39. Naṭanz. The north īvān of the Masjid-i-Jāmi‘

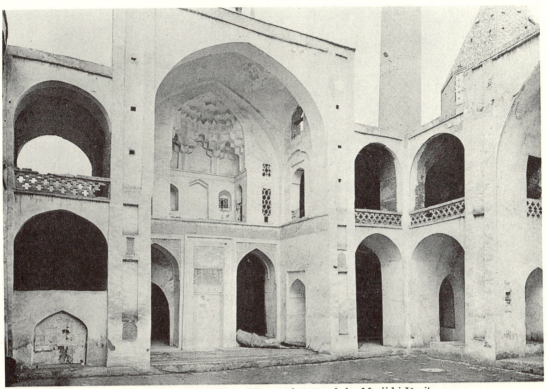

56. CAT. NO. 39. Naṭanz. The south īvān of the Masjid-i-Jāmi'

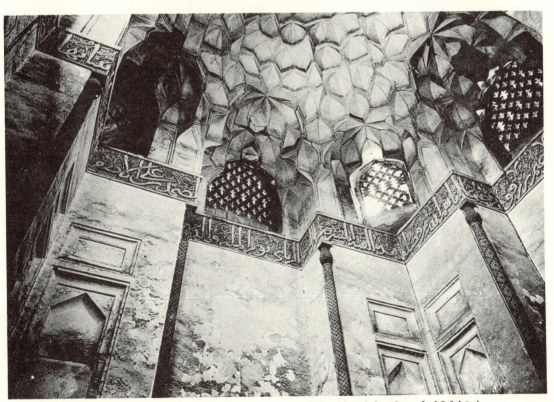

57. CAT. NO. 39. Naṭanz. Interior of the tomb of Shaykh 'Abd as-Samad al-Iṣfahāni

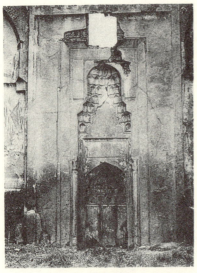

58. Miḥrāb

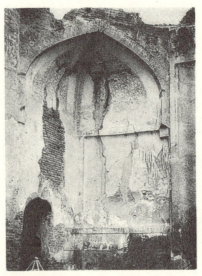

59. Corner angle and squinch

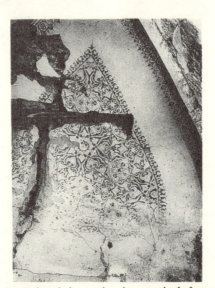

60. Painted decoration in a squinch face

58-60. CAT. NO. 40. Ardabīl. The dome chamber of the Masjid-i-Jāmi'

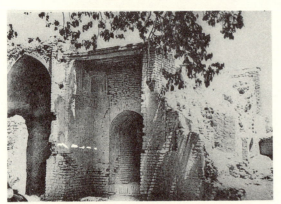

61-62. CAT. NO. 42. Varāmīn. Portal and detail of the inscription frieze of the Masjid ash-Sharīf

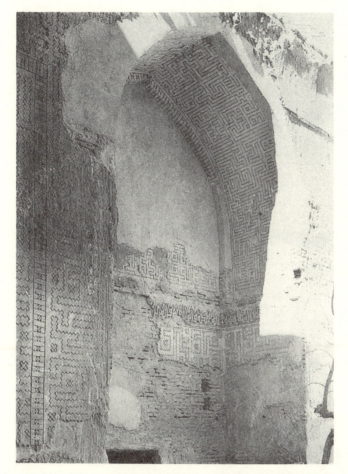

63. Detail of bay in east wall of tomb chamber of Ghiyath ad-dīn Muḥammad

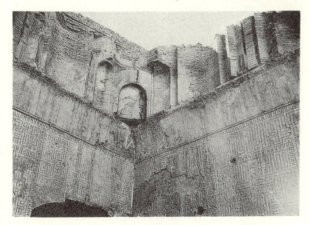

64. Zone of transition in tomb chamber of Ghiyath ad-dīn

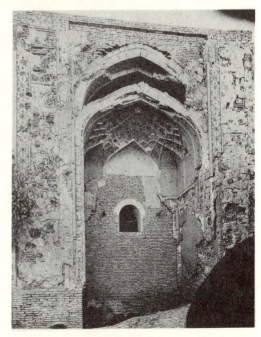

65. Portal on exterior wall showing two periods of decoration

63-65. CAT. NO. 43. Herāt. The Masjid-i-Jāmi'

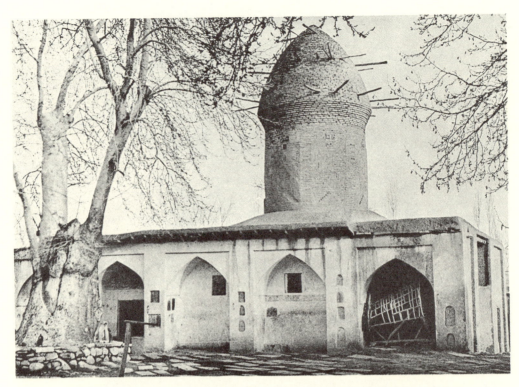

66. CAT. NO. 44. Mahāllat Bālā. Elevation of the Imāmzāda Abu'l Faẓl wa Yaḥyā

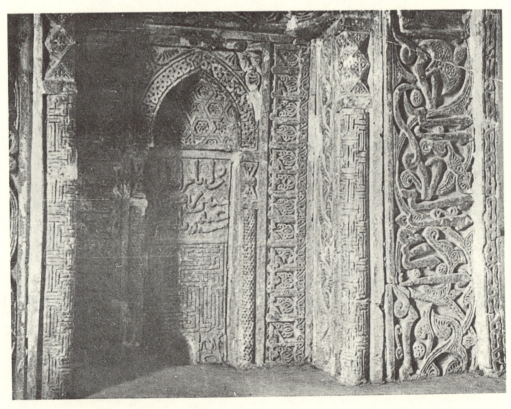

67. CAT. NO. 44. Mahāllat Bālā. The miḥrāb of the Imāmzāda Abu'l Faẓl wa Yaḥyā

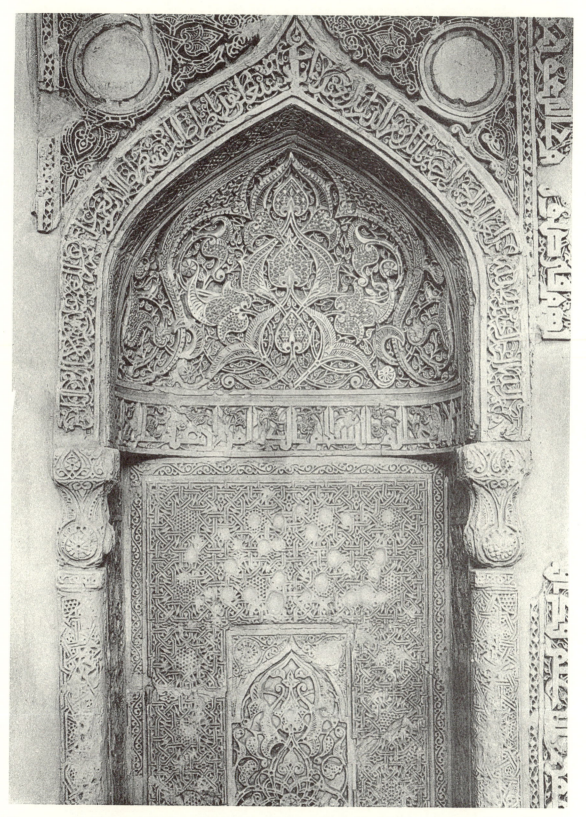

68. CAT. NO. 46. Ashtarjān (Iṣfahān). Miḥrāb from the Imāmzāda Rabi'a Khātūn, now in the Tehrān Museum

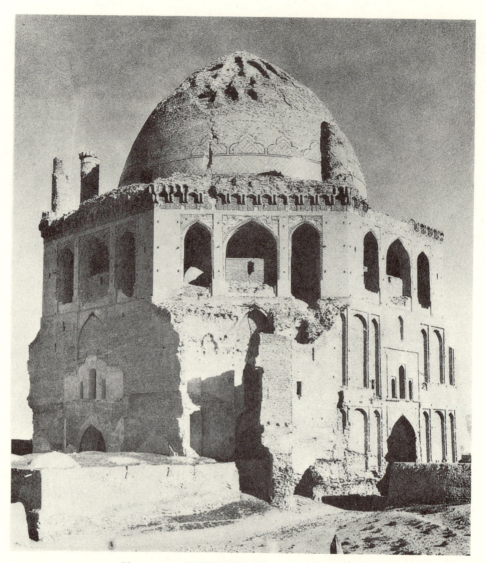

69. CAT. NO. 47. Sulṭāniya. Mausoleum of Öljeitü

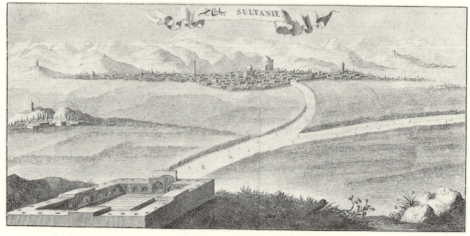

70. CAT. NO. 47. Sulṭāniya. The town as seen by Chardin with the mausoleum of Öljeitü

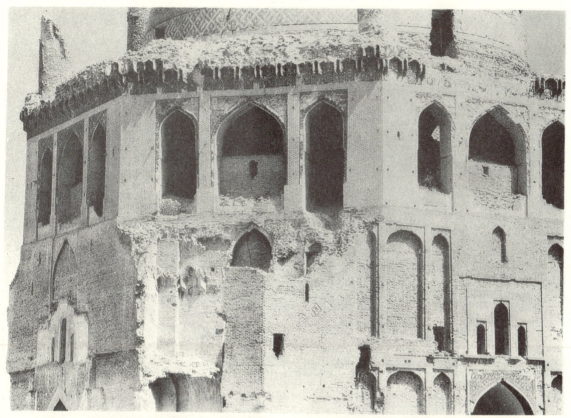

71. Detail of the exterior

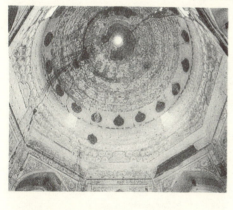

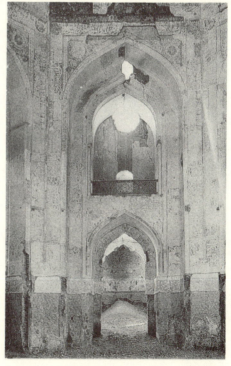

73. Structural brick stalactites

74. CAT. NO. 47. Sulṭāniya. Floor level to zone of transition

71-74. CAT. NO. 47. Sulṭāniya. The mausoleum of Öljeitü

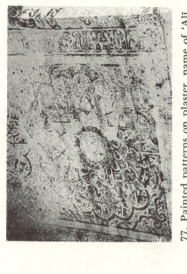

77. Painted patterns on plaster, name of 'Alī

78. Detail of plaster decoration

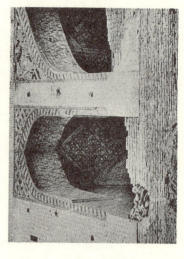

79. Vaults in the gallery

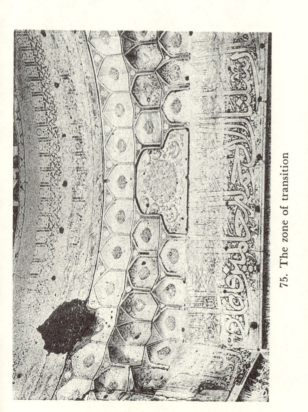

75. The zone of transition

76. Painted decoration in the head of a recess

75-79. 70, 113, 47, Sultāniya. The mausoleum of 'Alī Allāh

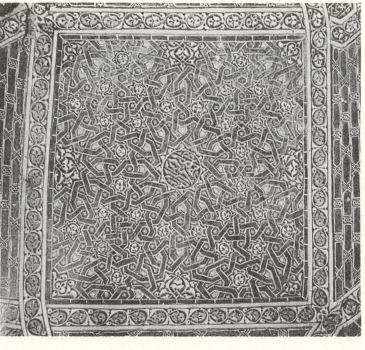

81. Polychrome plaster on a vault

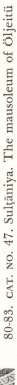

80-83. CAT. NO. 47. Sulṭāniya. The mausoleum of Öljeitü

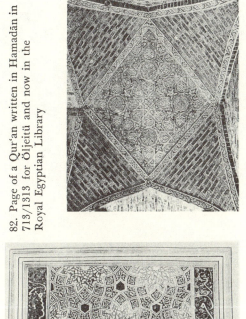

80. Polychrome plaster on a vault

82. Page of a Qurʻan written in Hamadān in 713/1313 for Öljeitü and now in the Royal Egyptian Library

83. Polychrome plaster on a vault

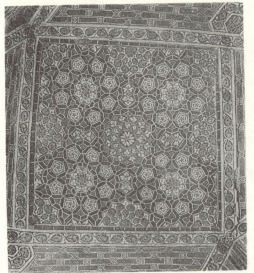

84. Polychrome plaster on a vault in the gallery

85. Simulated bonding patterns, painted on plaster in the gallery

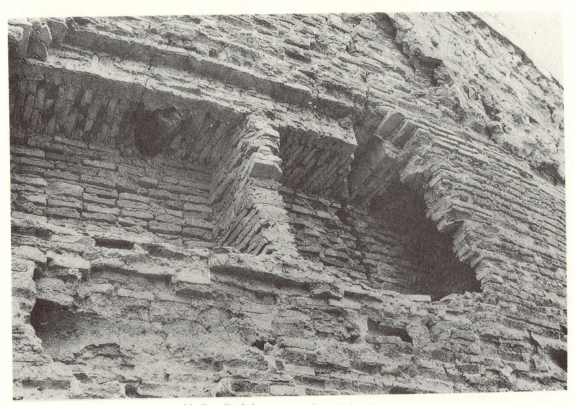

86. Detail of the construction of the dome

84-86. CAT. NO. 47. Sulṭāniya. The mausoleum of Öljeitü

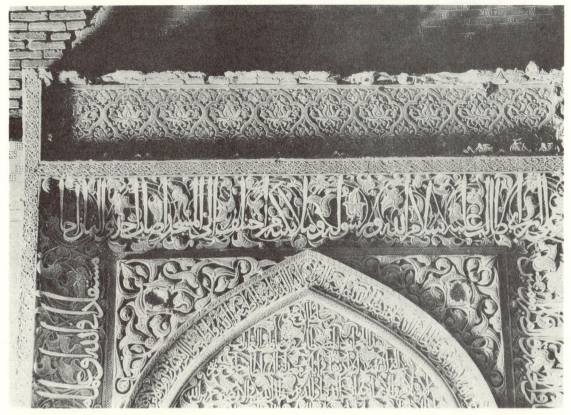

87-88. CAT. NO. 48. Iṣfahān. Miḥrāb dated A.D. 1310 in the Masjid-i-Jāmiʻ, and detail

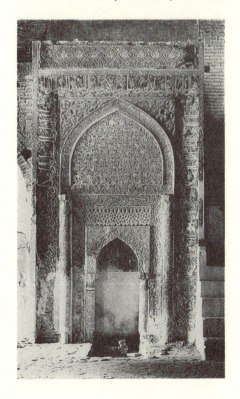

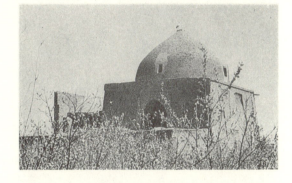

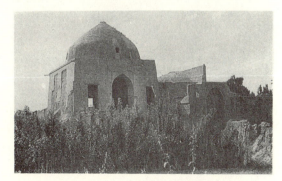

89-90. CAT. NO. 49. Ashtarjān (Iṣfahān).
Exterior of the Masjid-i-Jāmiʻ

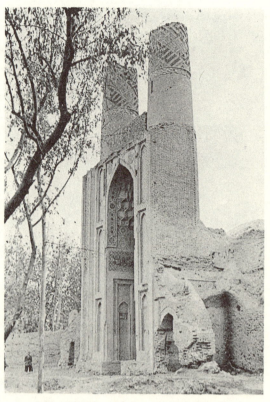

91. Side view of the entrance portal

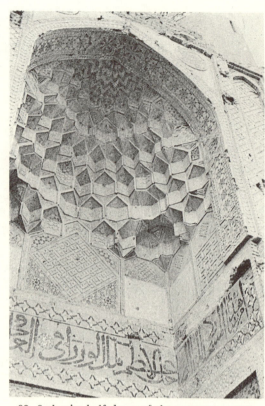

92. Stalactite half dome of the entrance portal

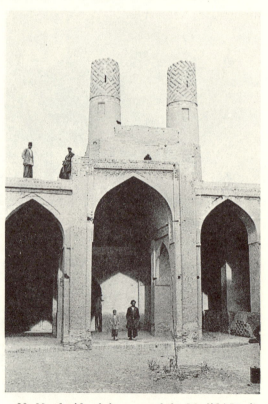

93. North side of the court of the Masjid-i-Jāmiʿ

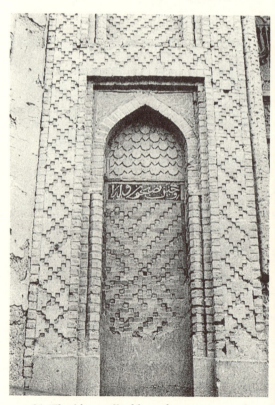

94. Flanking wall of bay of entrance portal

91-94. CAT. NO. 49. Ashtarjān (Iṣfahān). The Masjid-i-Jāmiʿ

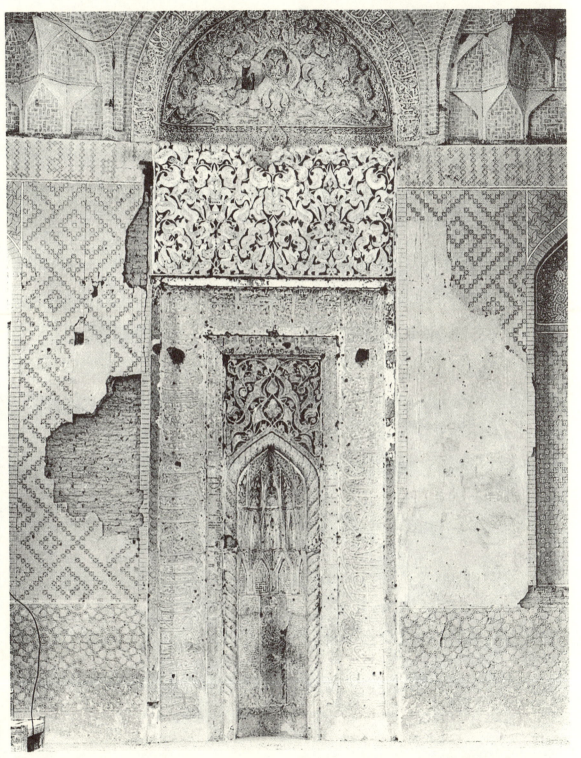

95. CAT. NO. 49. Ashtarjān (Iṣfahān). Miḥrāb in the dome chamber of the Masjid-i-Jāmi'

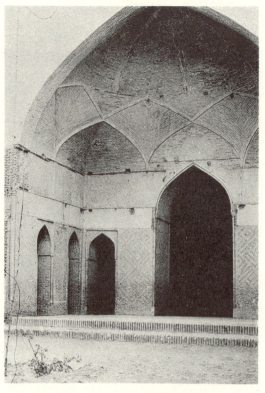

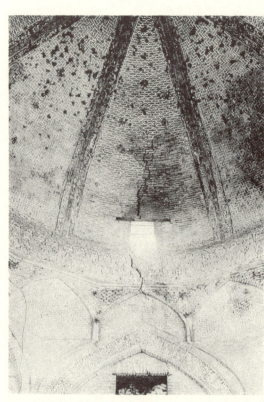

96. Īvān in front of the dome chamber

97. Zone of transition and dome of dome chamber

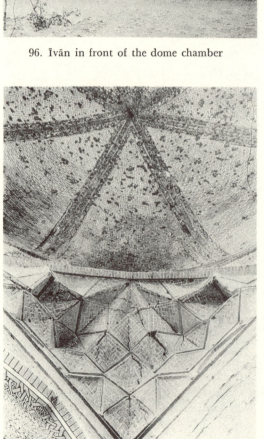

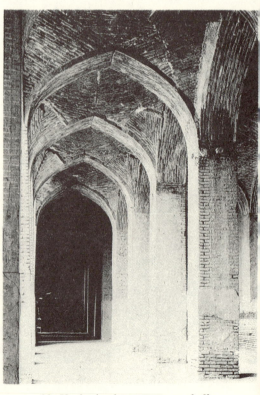

98. Vertical view of squinch area in dome chamber

99. Vaults in the west prayer hall

96-99. CAT. NO. 49. Ashtarjān (Iṣfahān). The Masjid-i-Jāmi'

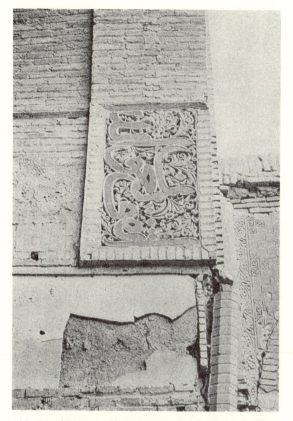

100. Detail of the īvān in front of the dome chamber

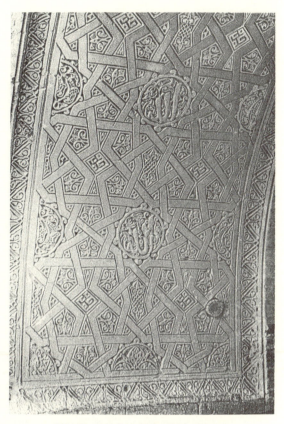

101. Decoration incised in plaster

102. Simulated incised brick joints and brick-end patterns

100-102. CAT. NO. 49. Ashtarjān (Iṣfahān). The Masjid-i-Jāmi

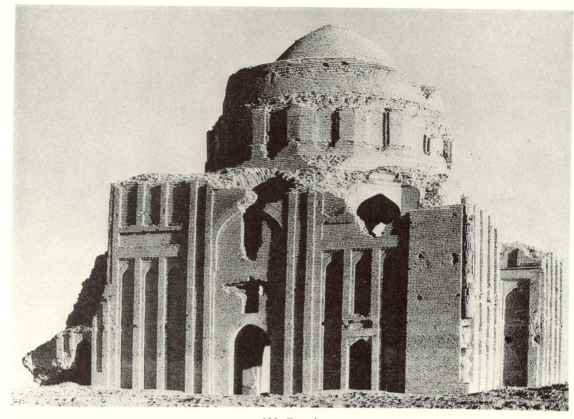

103. Exterior

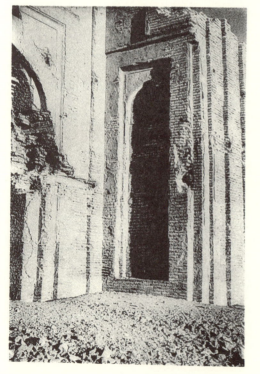

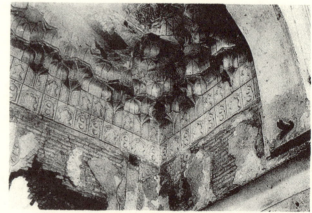

105. Interior: plaster stalactite vault in the bay
opposite the entrance portal

104. Exterior entrance bay

103-105. CAT. NO. 50. Tūs. The so-called Hārūniya

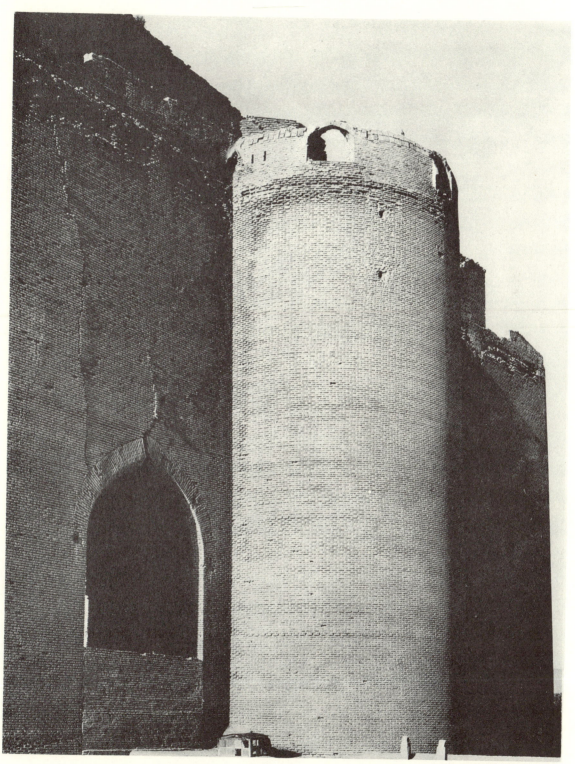

106. CAT. NO. 51. Tabrīz. South exterior face of the Masjid-i-Jāmi' of 'Alī Shāh

A. Can-cazan I. Tchar monar
B. Baba-assein L. Alicha metchet
C. Jafer Pachaca M. Oujtu chaguird
 lesi
D. Hassein-Pacha N. Dou monar
 Metchet
E. Saheb Saman O. Geon cha Metche
 Metchet
F. Adina Metchet P. Ach tu con
G. Can-metchet Q. Ayn Aly
H. Caiserié

107. CAT. NO. 51. Tabrīz. The town as seen by Chardin in the second half of the seventeenth century: the Masjid-i-Jāmiʻ of ʻAlī Shāh is near the center of the illustration

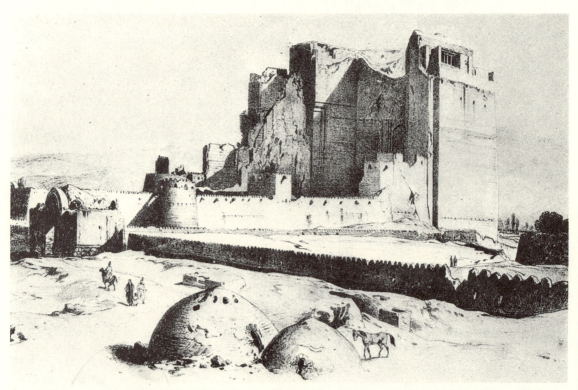

108. CAT. NO. 51. Tabrīz. The Masjid-i-Jāmiʻ of ʻAlī Shāh as seen by Hommaire de Hell about 1850 and called by him "L'Ark à Tauris"

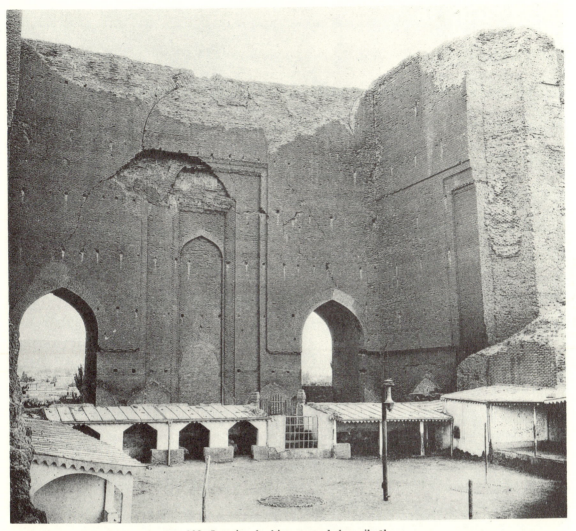

109. Interior, looking toward the miḥrāb

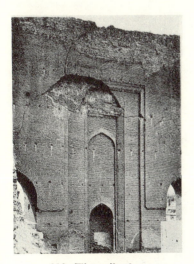

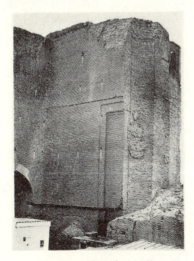

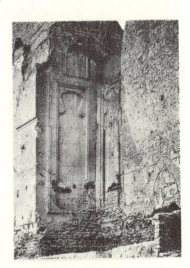

110. The miḥrāb 111. West interior wall 112. East exterior wall

109-112. CAT. NO. 51. Tabrīz. The Masjid-i-Jāmiʿ of ʿAlī Shāh

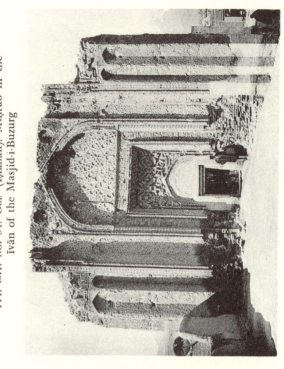

114. CAT. NO. 54. Gaz (Iṣfahān). Miḥrāb in the
ivān of the Masjid-i-Buzurg

115. CAT. NO. 55. Hamadān. Entrance façade of the
Gunbad-i-ʻAlawiyān

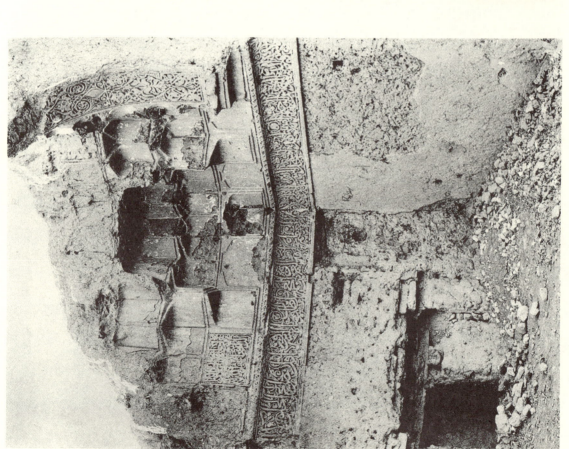

113. CAT. NO. 53. Dāmghān. Portal of a ruined mosque

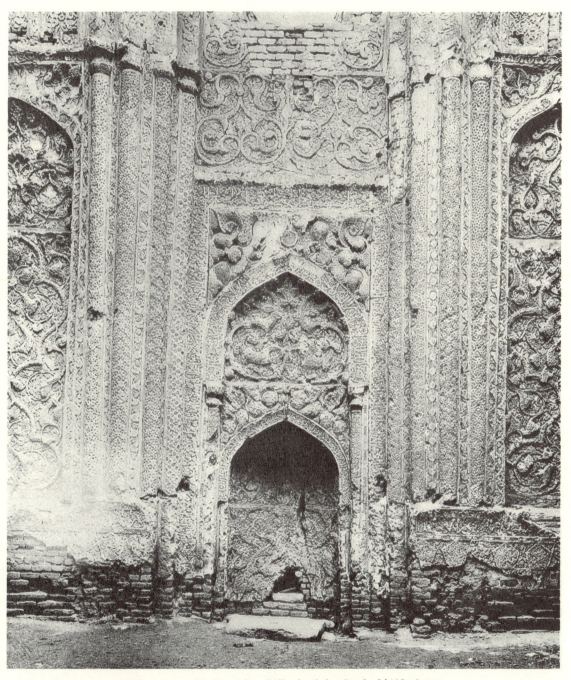

116. CAT. NO. 55. Hamadān. Mihrāb of the Gunbad-i-ʿAlayivān

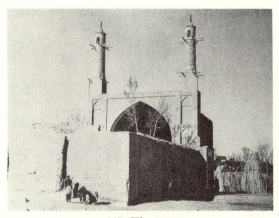

117. The īvān

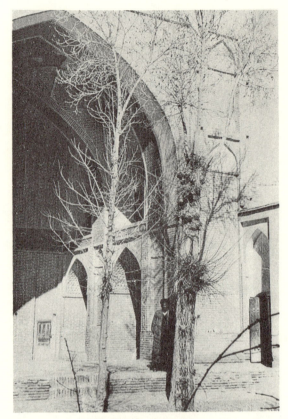

118. Detail of the īvān

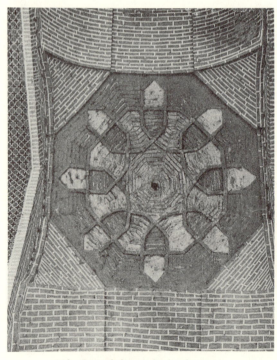

119. One of the vaults in the īvān

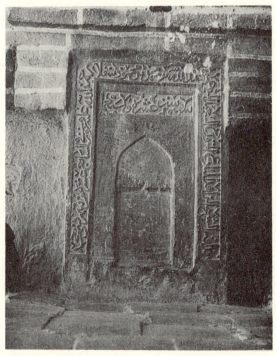

120. Gravestone of 'Abd Allāh ibn Muḥammad bin Maḥmūd, dated A.D. 1316, in the īvān

117-120. CAT. NO. 56. Gārlādān (Iṣfahān). The shaking minarets

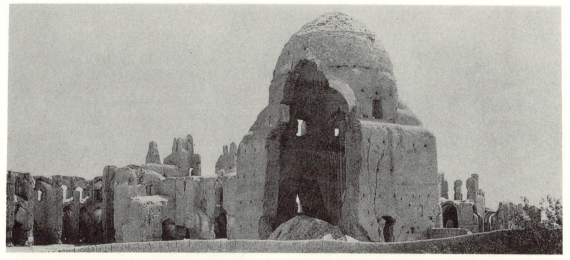

121. CAT. NO. 59. Abarqūh. Elevation of the tomb of al-Ḥasan ibn Kay Khusraw

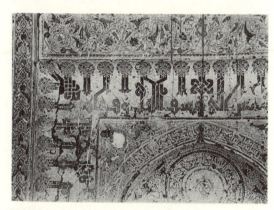

123. CAT. NO. 59. Abarqūh. Painted inscription frieze and ornamental details in the interior of the tomb of al-Ḥasan ibn Kay Khusraw

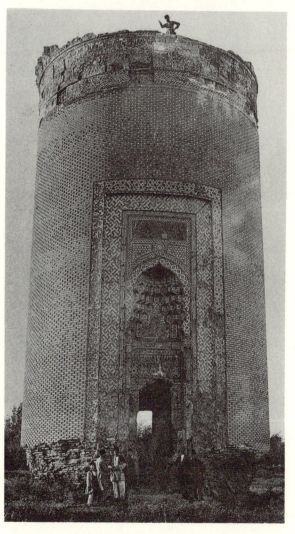

122. CAT. NO. 60. Salmās. Elevation of the Mīr-i-Khātūn, no longer extant

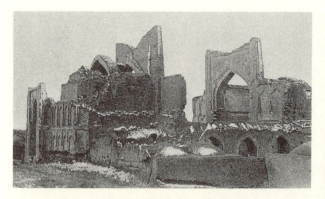

124. Looking southeast

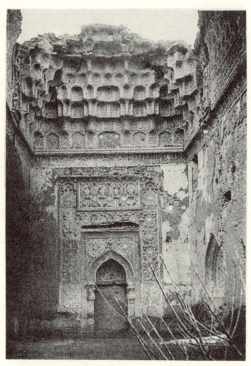

125. Sanctuary īvān and miḥrāb

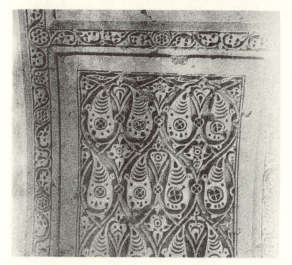

126. Incised plaster decoration on a transverse arch

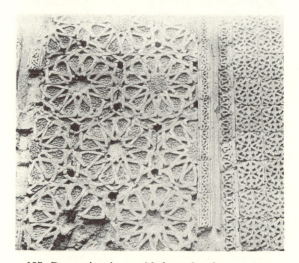

127. Decoration in moulded, unglazed terra cotta

124-127. CAT. NO. 61. Farūmad. The Masjid-i-Jāmiʿ

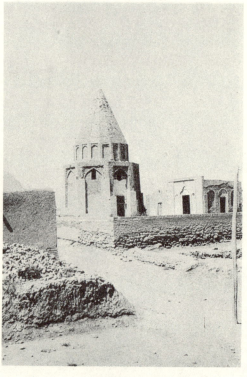

128. CAT. NO. 63. Qumm. Elevation of
the Imāmzāda Ibrāhīm

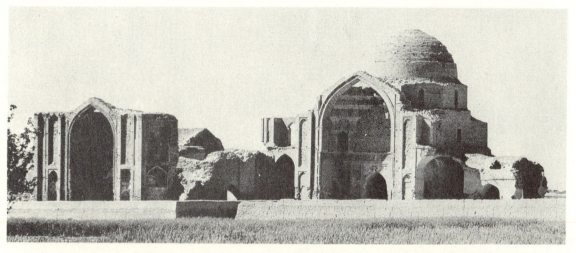

129. CAT. NO. 64. Varāmīn. The Masjid-i-Jāmi', looking north

130. Detail of the īvān

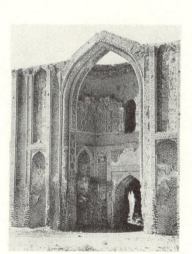

131. Entrance portal

132. Detail of vault construction

130-132. CAT. NO. 64. Varāmīn. The Masjid-i-Jāmi'

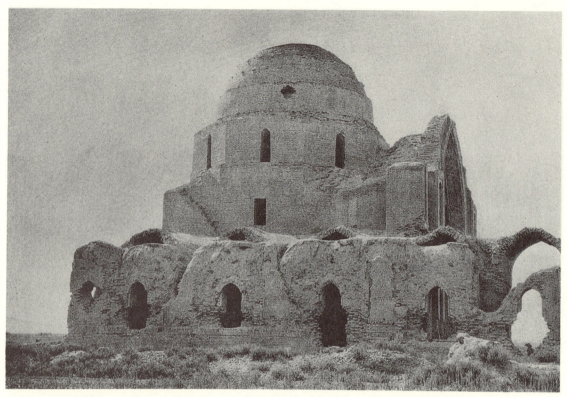

133. CAT. NO. 64. Varāmīn. The dome chamber of the Masjid-i-Jāmi', looking west

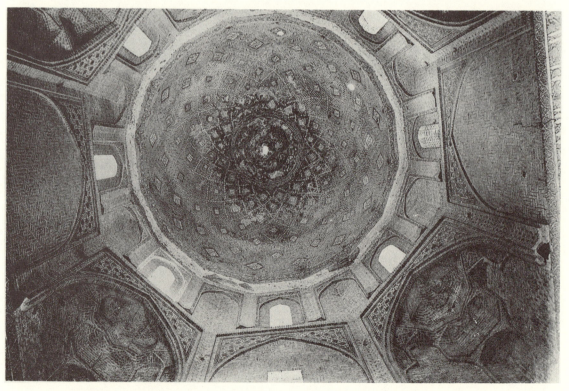

134. CAT. NO. 64. Varāmīn. Zone of transition and dome of the Masjid-i-Jāmi'

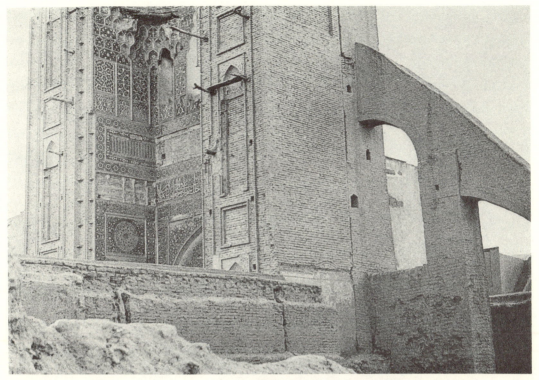

135. Entrance portal

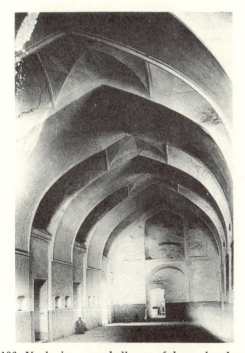

136. Vaults in prayer hall west of dome chamber

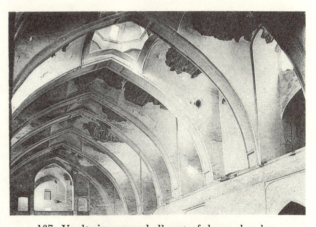

137. Vaults in prayer hall east of dome chamber

138. Detail of the mosaic faïence

135-138. CAT. NO. 66. Yazd. The Masjid-i-Jāmiʻ

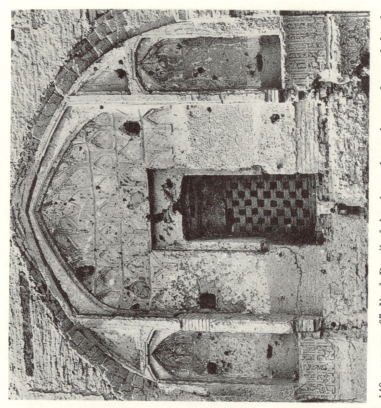

140. CAT. NO. 67. Yazd. Detail of the plaster decoration on the north façade of the tomb of Sayyid Rukn ad-din

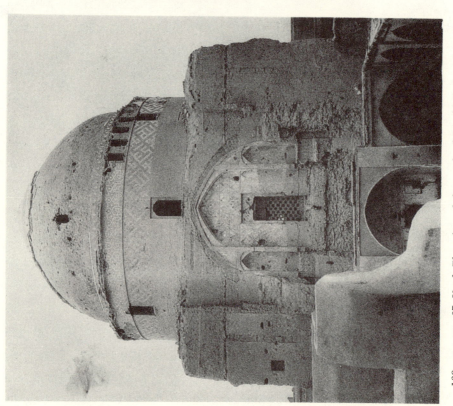

139. CAT. NO. 67. Yazd. Elevation of the tomb of Sayyid Rukn ad-din

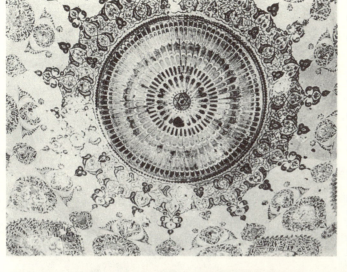

143. Polychrome painted decoration on the dome

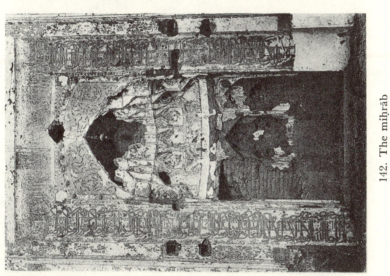

142. The miḥrāb

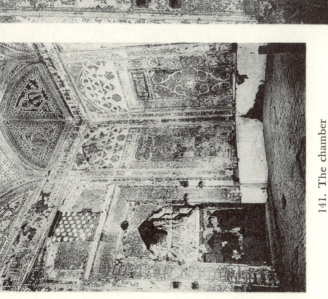

141. The chamber

141-143. CAT. NO. 67. Yazd. The tomb of Sayyid Rukn ad-dīn

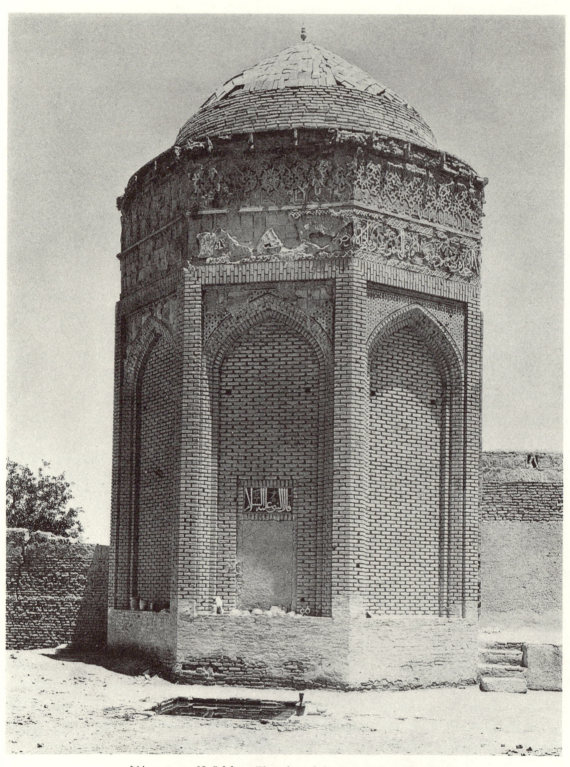

144. CAT. NO. 68. Isfahān. Elevation of the Imāmzāda Jaʻfar

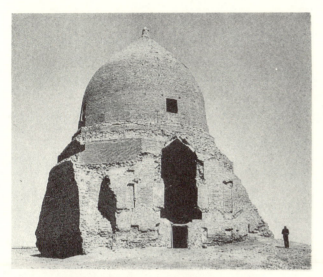

145. The mosque, looking west

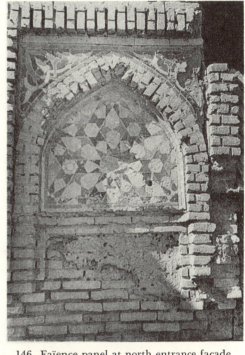

146. Faïence panel at north entrance façade

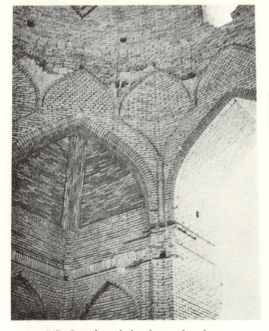

147. Interior of the dome chamber

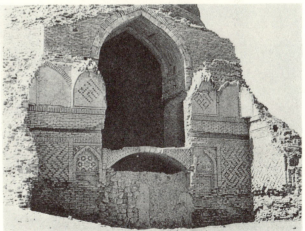

148. Entrance façade on the north side

145-148. CAT. NO. 69. Dashti (Iṣfahān). The mosque

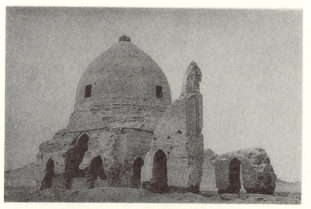

149. The mosque, looking southwest

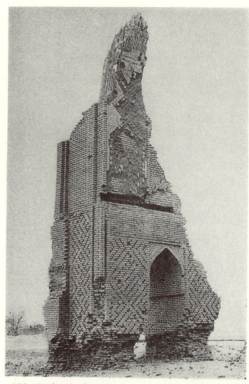

150. Ruined pier at north of entrance façade

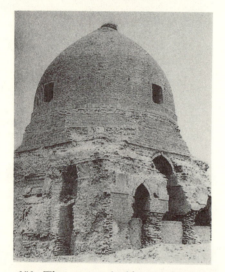

151. The mosque, looking northwest

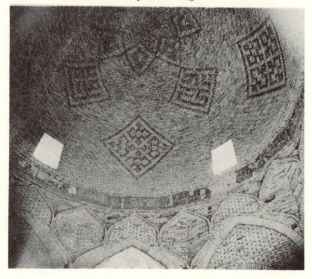

153. The inner surface of the dome

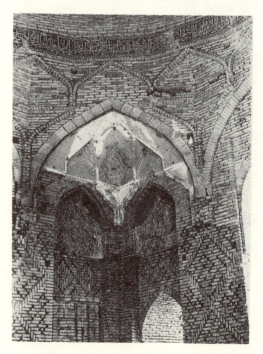

152. Interior of the dome chamber

149-153. CAT. NO. 70. Kāj (Iṣfahān). The mosque

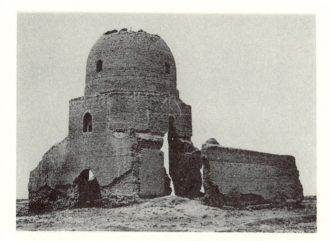

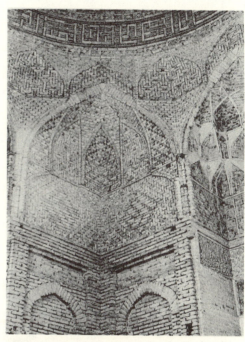

154-155. CAT. NO. 71. Eziran (Iṣfahān). The mosque, looking northwest and the interior of the dome chamber

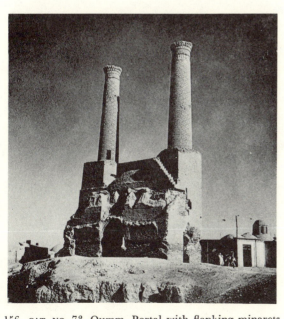

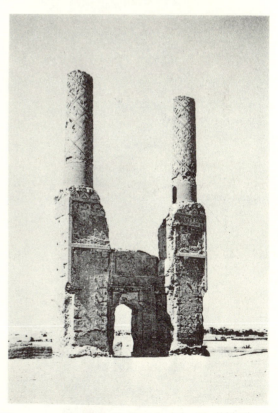

156. CAT. NO. 73. Qumm. Portal with flanking minarets 157. CAT. NO. 74. Abarqūh. Portal of the Masjid-i-Niẓāmiya

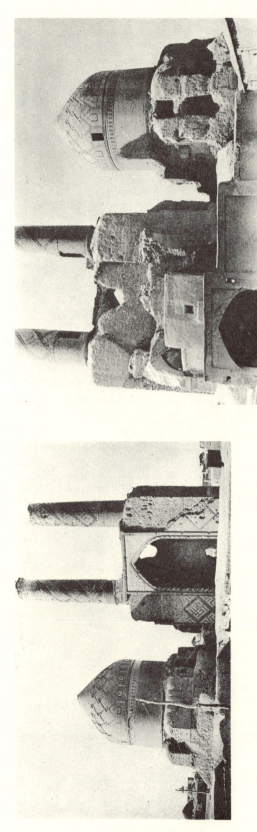

158-159. CAT. NO. 75. Iṣfahān. Do Minār Dardasht and tomb chamber, looking northwest, and looking south

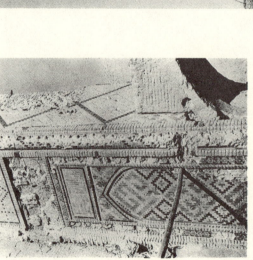

161-162. CAT. NO. 76. Iṣfahān. Minār Bagh-i-Qush Khāna, looking east, and detail

160. CAT. NO. 75. Iṣfahān. Detail of side wall of portal below Do Minār Dardasht

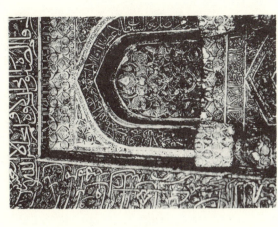

167. CAT. NO. 79. Marand. Miḥrāb
of the Masjid-i-Jāmi‘

166. CAT. NO. 78. Marāgha. A window
head in the Gunbad-i-Ghaffāriya

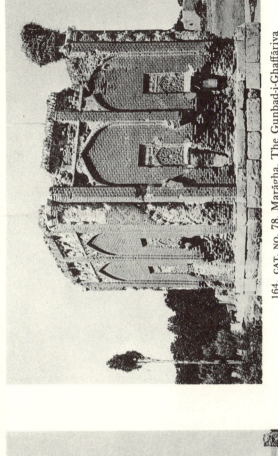

164. CAT. NO. 78. Marāgha. The Gunbad-i-Ghaffāriya

163. CAT. NO. 77. Iṣfahān. Do Minār Dār
al-Baṭṭikh, looking south

165. CAT. NO. 78. Marāgha. Detail of entrance
portal of the Gunbad-i-Ghaffāriya

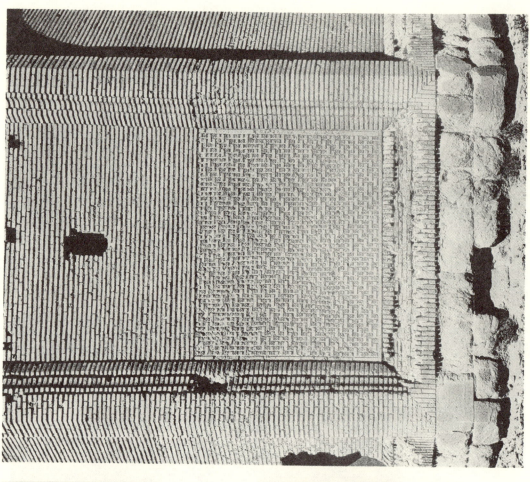

171. Construction details of the tomb

168. Tomb with adjacent complex

170. Detail of the cut stone base

169. Elevation of tomb

168-171. CAT. NO. 80. Sulṭāniya. Tomb of Chelebi Oghlu

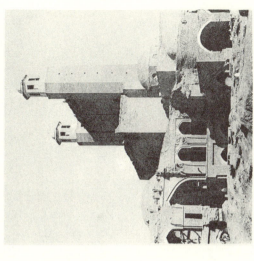

173. Carved plaster inscription frieze

176. The area within the shrine complex

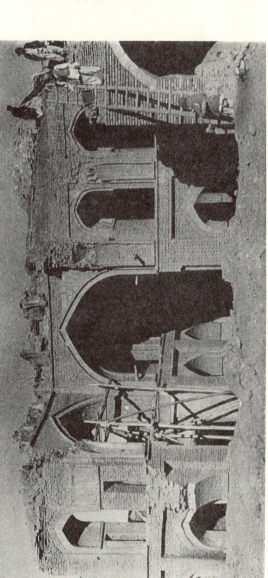

172. The shrine complex in the course of restoration

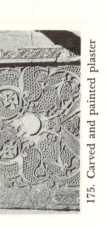

175. Carved and painted plaster

174. Plaster decoration

172-176. CAT. NO. 81. Turbat-i-Shaykh Jām. The "Sunni Oratory"

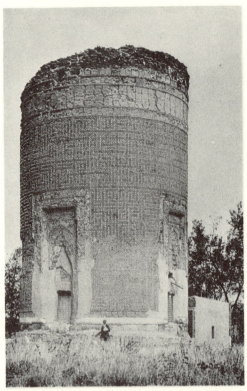

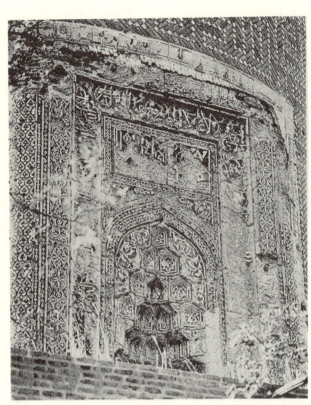

177-178. CAT. NO. 83. Khiav. The so-called tomb of Sulṭān Haidar, looking northwest, and detail of entrance portal

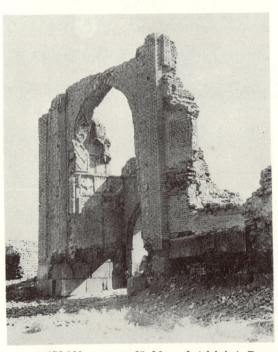

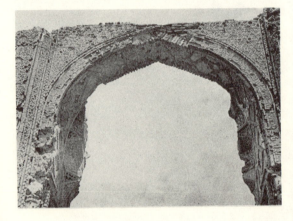

179-180. CAT. NO. 85. Marand (vicinity). Entrance portal of the caravanserai and transverse arch

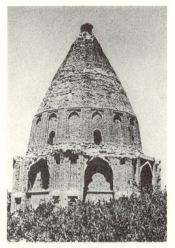

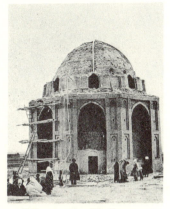

81. CAT. NO. 84. Abarqūh. Miḥrāb
Gunbad-i-Sayyidun Gul-i-Surkhi

182. CAT. NO. 87. Qumm.
Elevation of the Gunbad-i-Sabz

183. CAT. NO. 88. Qumm.
The Imāmzāda Ibrāhīm

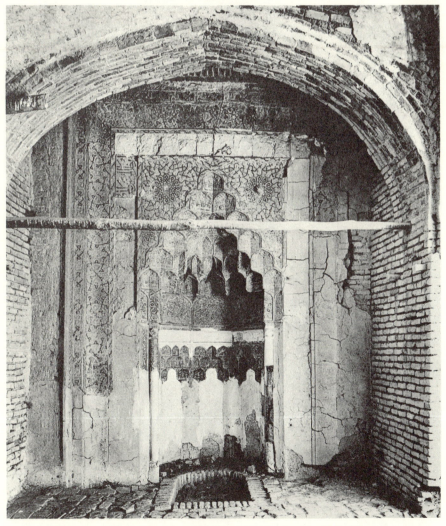

184. CAT. NO. 86. Varāmīn. Miḥrāb of the Imāmzāda Shāh Ḥusayn

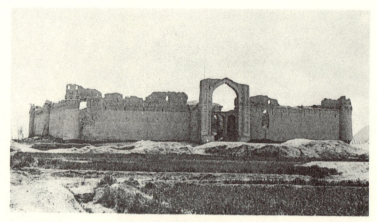

185. Distant view

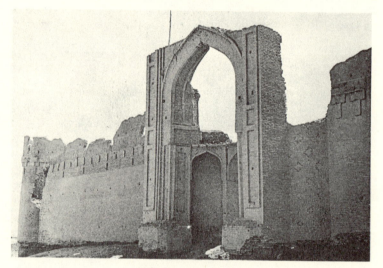

186. Entrance façade

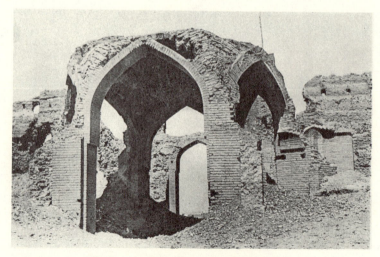

187. Damaged vault at a corridor crossing

185-187. CAT. NO. 89. Sīn (Iṣfahān). Caravanserai

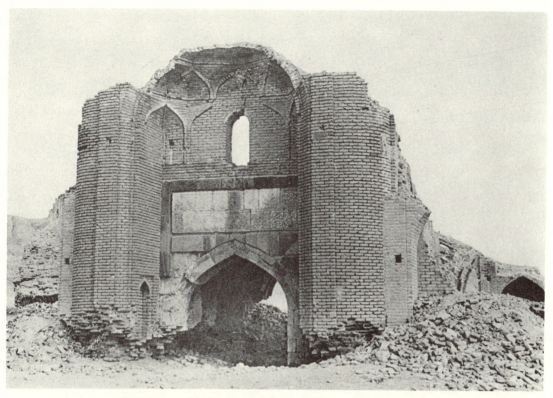

188. CAT. NO. 90. Sarcham. Entrance portal of the caravanserai

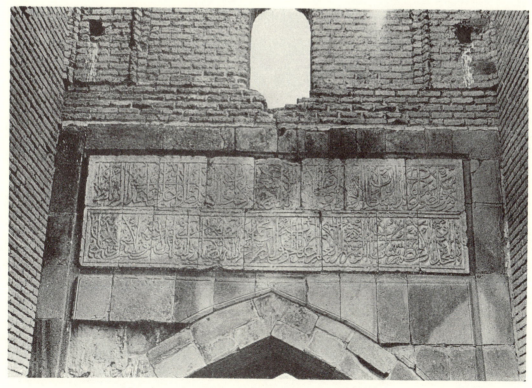

189. CAT. NO. 90. Sarcham. Inscription dated A.D. 1332-33 over the entrance portal

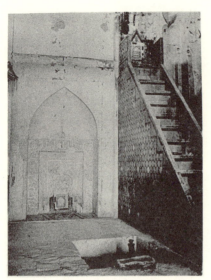

190. CAT. NO. 93. Kūhpā. Minbar of
the Masjid-i-Miyān-i-Deh

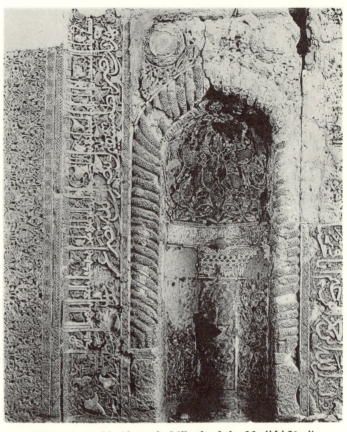

192. CAT. NO. 94. Abarqūh. Miḥrāb of the Masjid-i-Jāmiʿ

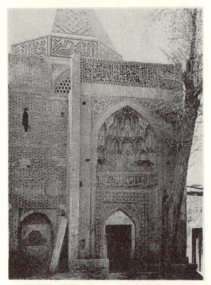

191. CAT. NO. 95. Iṣfahān. Entrance
portal of the Imāmzāda Bābā Qāsim

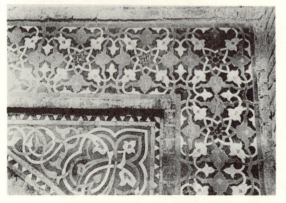
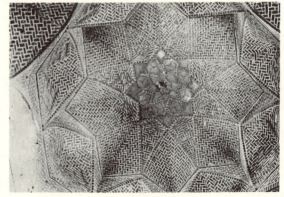

193-194. CAT. NO. 95. Iṣfahān. Imāmzāda Bābā Qāsim. Faïence decoration in portal and
vault over principal chamber

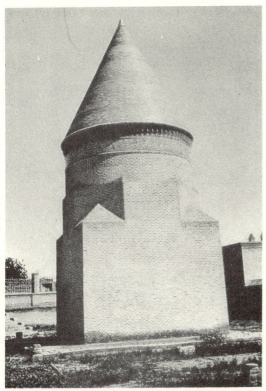

195. CAT. NO. 96. Qazvīn. Tomb of Ḥamd-Allāh Mustawfī, restored

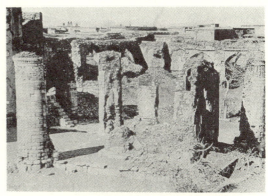

196. CAT. NO. 98. Shīrāz. The shrine in the court of the Masjid-i-Jāmiʻ in 1935

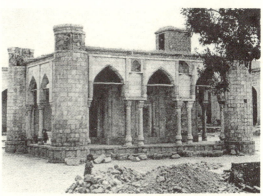

198. CAT. NO. 98. Shīrāz. The shrine in the court of the Masjid-i-Jāmiʻ, restored

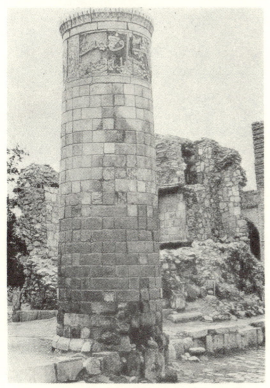

197. CAT. NO. 98. Shīrāz. Tower of the shrine, dated 752/1351, in the Masjid-i-Jāmiʻ

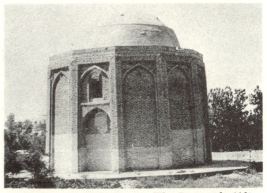

199. CAT. NO. 104. Qumm. The Imāmzāda ʻAlī ibn ʻAbiʼl-Maʻālī ibn ʻAlī Sāfi

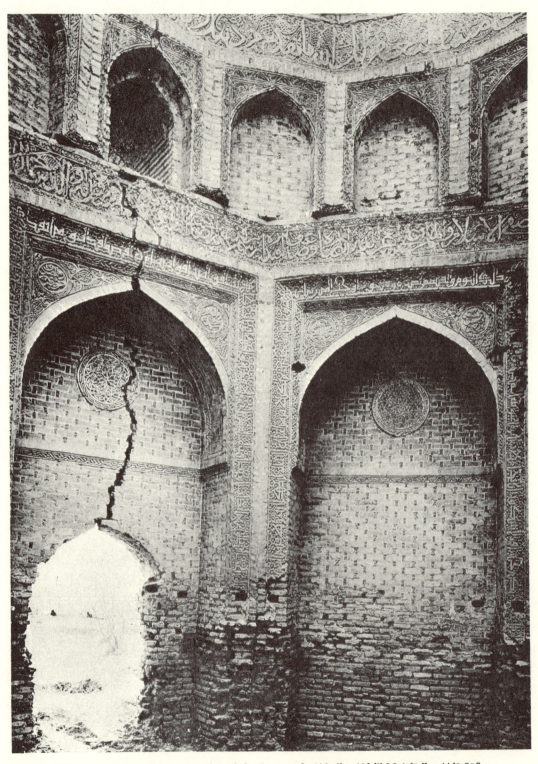

200. CAT. NO. 104. Qumm. Interior of the Imāmzāda ‘Alī ibn ‘Abi’l-Ma‘ālī ibn ‘Alī Sāfi

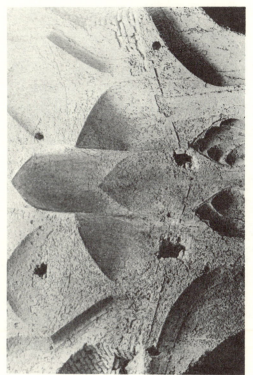

204. CAT. NO. 106. Iṣfahān. Zone of transition in the mausoleum of Khwāja Saʿd

201-202. CAT. NO. 105. Āzādān (Iṣfahān). The Masjid-i-Gunbad, looking northeast and zone of transition in the dome chamber

203. CAT. NO. 105. Āzādān (Iṣfahān). Painted decoration on the wall of the dome chamber of the Masjid-i-Gunbad

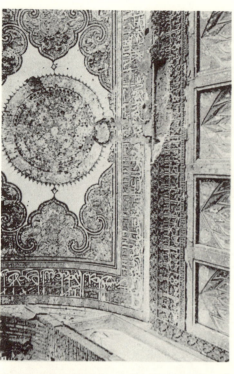

206. Polychrome and plaster decoration on vault of sanctuary īvān

207. Detail of plaster inscription band in the sanctuary īvān

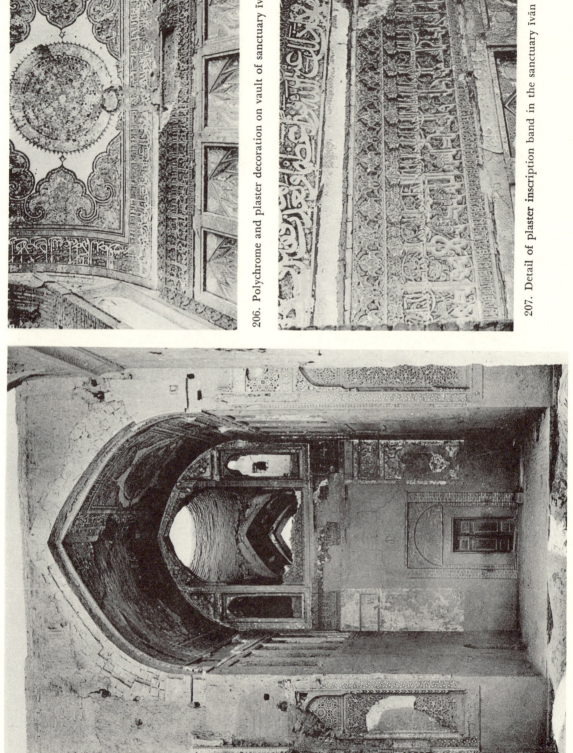

205. The sanctuary īvān

205-207. CAT. NO. 107. Yazd. The Madrasa Shamsiya

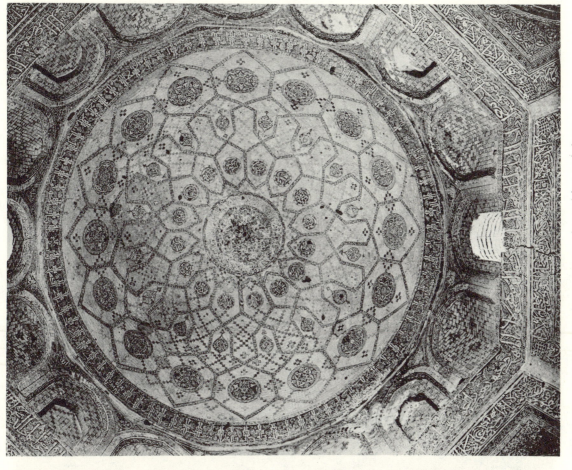

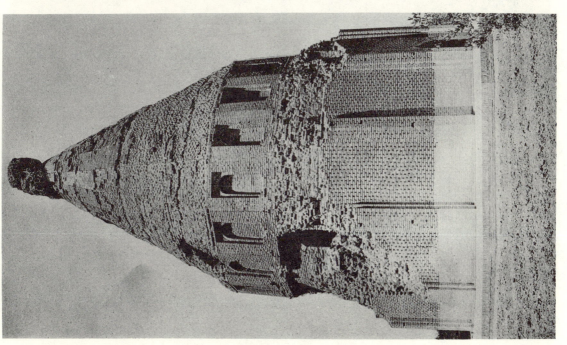

208–209. CAT. NO. 114. Qumm. The Imāmzāda Khwāja 'Imad ad-dīn: Exterior and zone of transition and dome

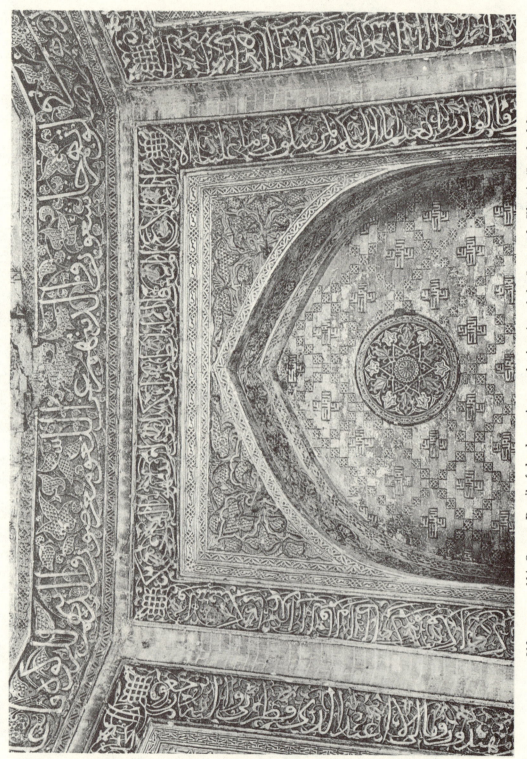

210. CAT. NO. 114. Qumm. Detail of the decoration on the interior of the Imāmzāda Khwāja 'Imad ad-dīn

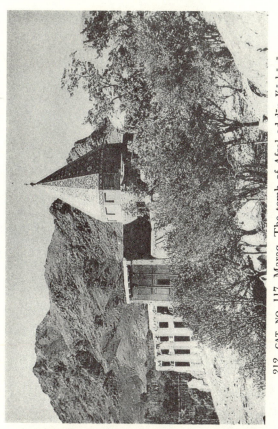

212. CAT. NO. 117. Maraq. The tomb of Afzal ad-dīn Kāshānī

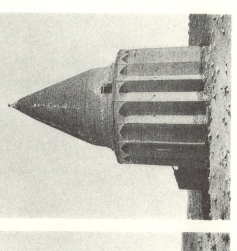

214. CAT. NO. 119. Darjazin.
The Imāmzāda Azhar

213. CAT. NO. 118. Darjazin.
The Imāmzāda Hūd

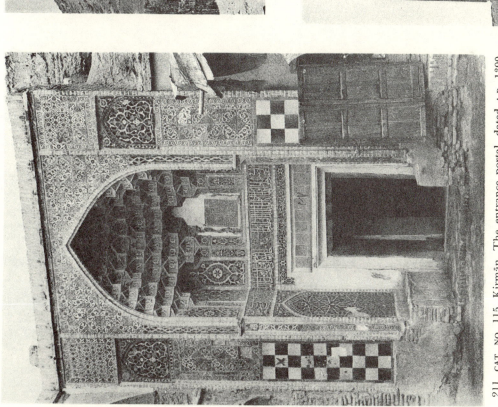

211. CAT. NO. 115. Kirmān. The entrance portal, dated A.D. 1390,
of the Masjid-i-Pā Minār

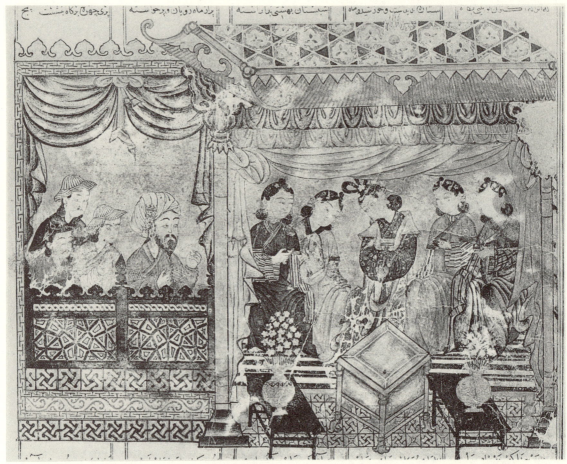

215. Mihran Sitad selects a Chinese princess for Nushirwan. A scene from the Shah Nama of Firdausi, probably illustrated early in the fourteenth century and now in the Museum of Fine Arts, Boston

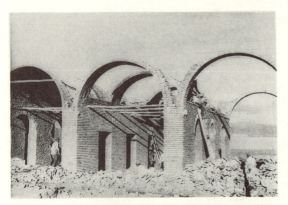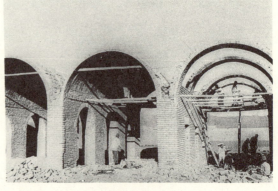

216-217. The construction of brick vaults without centering at Tehrān today

FIGURES

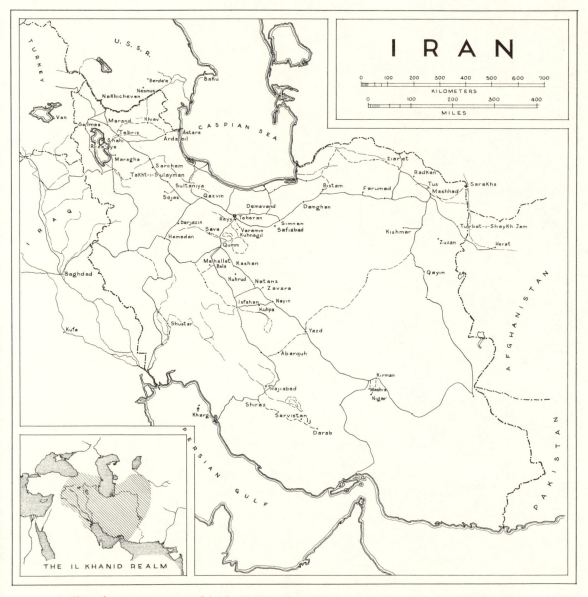

1. Sites of monuments erected in the Il Khānid period. Inset shows extent of Il Khānid realm

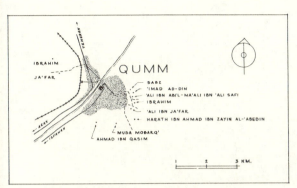

2. Sketch plan of the town of Qumm showing
the location of standing tomb towers

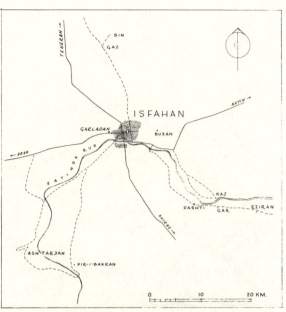

3. Sketch map of the vicinity of Iṣfahān, showing the
sites of monuments of the Il Khānid period

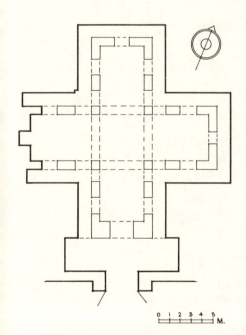

4. CAT. NO. 8. Dārāb. Plan of the
Masjid-i-Sang (After A. Stein and F. Shīrāzī)

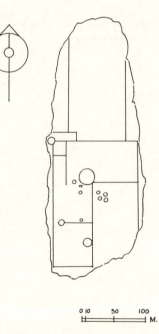

5. CAT. NO. 9. Marāgha. Plan of
ruins of astronomical observatory
(After A. H. Schindler, *Reisen
im nordwestlichen Persien*)

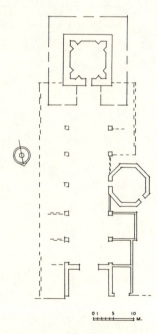

6. CAT. NO. 11. Varāmīn.
Restored plan of Imāmzāda
Yaḥyā and associated
structures about 1881

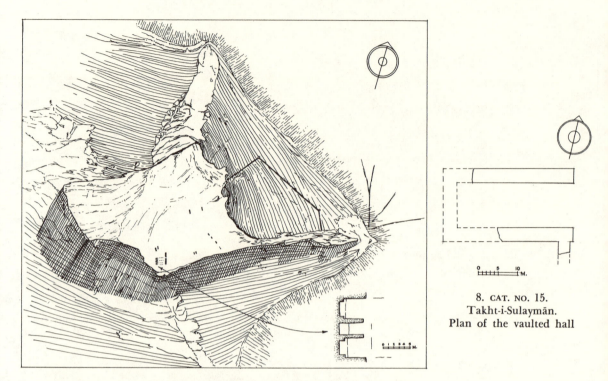

7. CAT. NO. 10. Shāhī Island. The ruins at Serai rock, with detail of rock cuttings
(After Aerial Survey-Oriental Institute)

8. CAT. NO. 15.
Takht-i-Sulaymān.
Plan of the vaulted hall

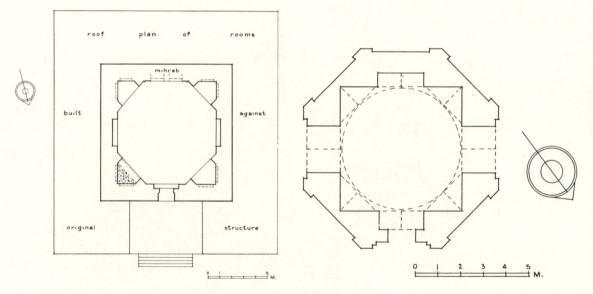

9. CAT. NO. 11. Varāmīn. Plan of the Imāmzāda Yaḥyā 10. CAT. NO. 18. Qumm. Plan of the Imāmzāda Ja'far

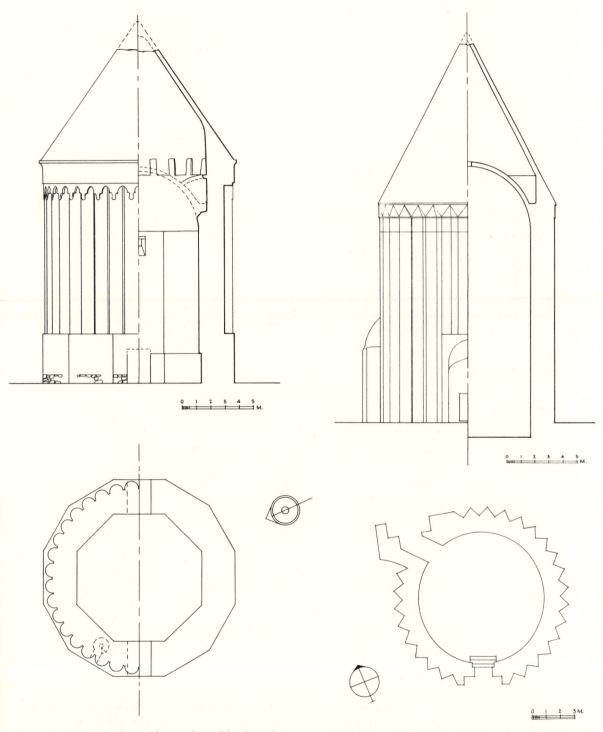

11. CAT. NO. 19. Rādkān. Plan and combined section
and elevation of the Mīl-i-Radkān

12. CAT. NO. 21. Varāmīn. Plan and combined section
and elevation of the tomb tower of 'Alā ad-dīn

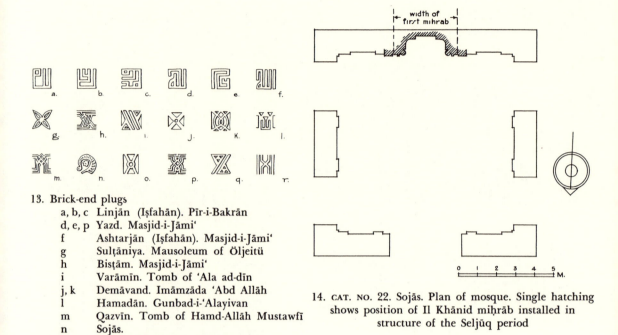

14. CAT. NO. 22. Sojās. Plan of mosque. Single hatching shows position of Il Khānid miḥrāb installed in structure of the Seljūq period

13. Brick-end plugs

a, b, c Linjān (Iṣfahān). Pīr-i-Bakrān
d, e, p Yazd. Masjid-i-Jāmi‘
f Ashtarjān (Iṣfahān). Masjid-i-Jāmi‘
g Sulṭāniya. Mausoleum of Öljeitü
h Bisṭām. Masjid-i-Jāmi‘
i Varāmīn. Tomb of ‘Ala ad-dīn
j, k Demāvand. Imāmzāda ‘Abd Allāh
l Hamadān. Gunbad-i-‘Alayivan
m Qazvīn. Tomb of Hamd-Allāh Mustawfī
n Sojās.
o Naṭanz. Tomb of ‘Abd as-Samad
q, r Varāmīn. Masjid-i-Jāmi‘

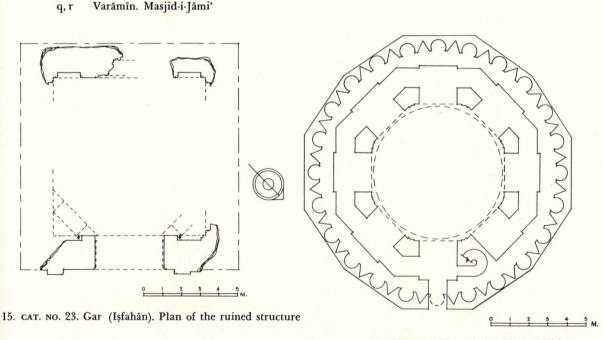

15. CAT. NO. 23. Gar (Iṣfahān). Plan of the ruined structure

16. CAT. NO. 25. Kishmār. Plan of the Minār-i-Kishmār, constructed after photographs and descriptions

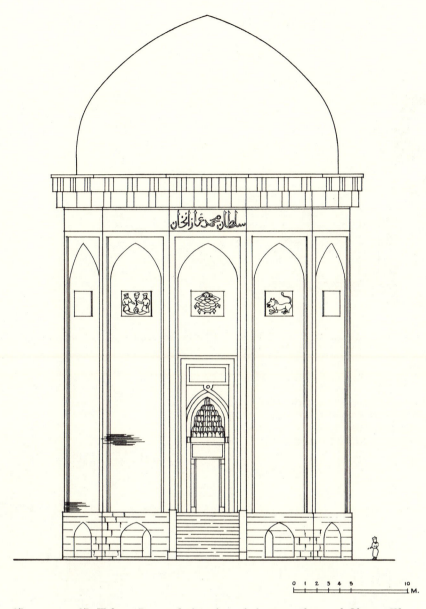

سلطان محمد غازان‌خان

17. CAT. NO. 27. Tabrīz. Restored elevation of the mausoleum of Ghāzān Khān

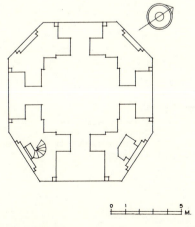

18. CAT. NO. 35. Ziāret. Plan of the tomb shrine

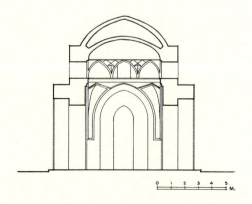

19. CAT. NO. 35. Ziāret. Section of the tomb shrine

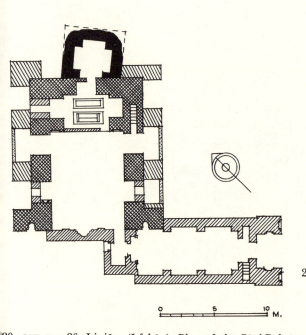

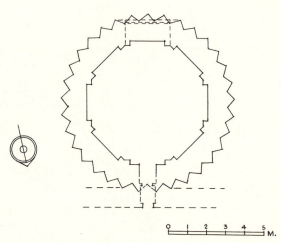

21. CAT. NO. 36. Demāvand. Plan of the Imāmzāda 'Abd Allāh

20. CAT. NO. 26. Linjān (Iṣfahān). Plan of the Pīr-i-Bakrān.
Solid poché represents pre-Il Khānid construction, single
and double hatching represent successive building
stages in the Il Khānid period

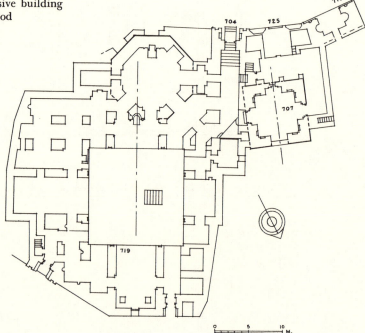

22. CAT. NO. 42. Varāmīn. Plan of
portal of Masjid ash-Sharīf.
Dotted line is length of preserved
section of plaster inscription frieze

23. CAT. NO. 39. Naṭanz. Plan of the complex of structures
(After A. Godard)

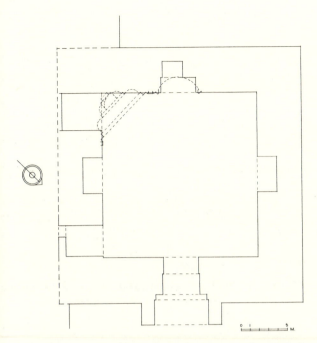

24. CAT. NO. 43. Herāt. Plan of the tomb chamber of
Ghiyath ad-dīn Muḥammad in the Masjid-i-Jāmiʻ

25. CAT. NO. 46. Ashtarjān (Iṣfahān). Plan of the
Imāmzāda Rabiʻa Khātūn

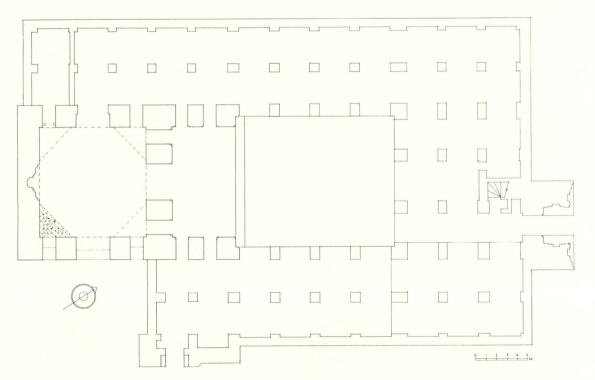

26. CAT. NO. 49. Ashtarjān (Iṣfahān). Plan of the Masjid-i-Jāmiʻ

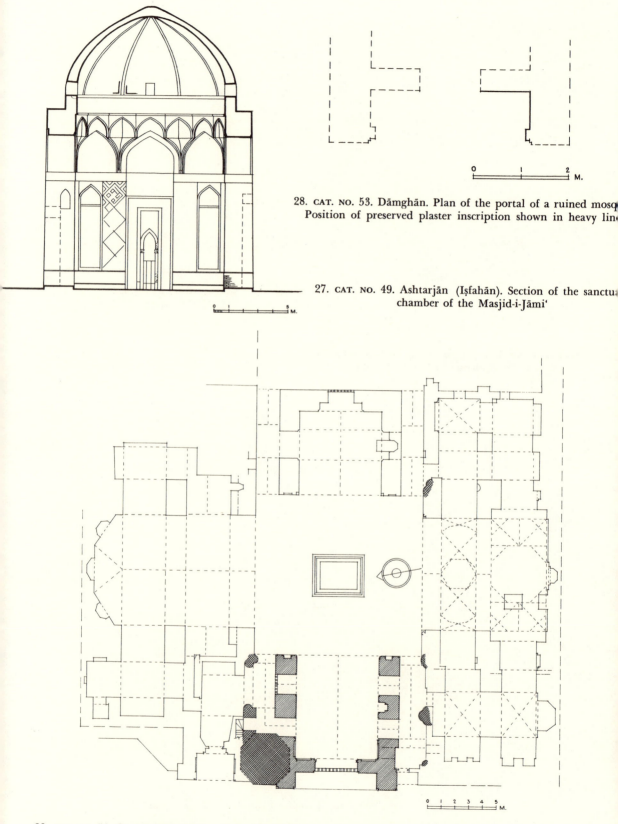

28. CAT. NO. 53. Dāmghān. Plan of the portal of a ruined mosq
Position of preserved plaster inscription shown in heavy lin

27. CAT. NO. 49. Ashtarjān (Iṣfahān). Section of the sanctu
chamber of the Masjid-i-Jāmiʿ

29. CAT. NO. 54. Gaz (Iṣfahān). Plan of the Masjid-i-Buzurg. Construction of the Seljūq period shown in double
hatching and work of the Il Khānid period in single hatching

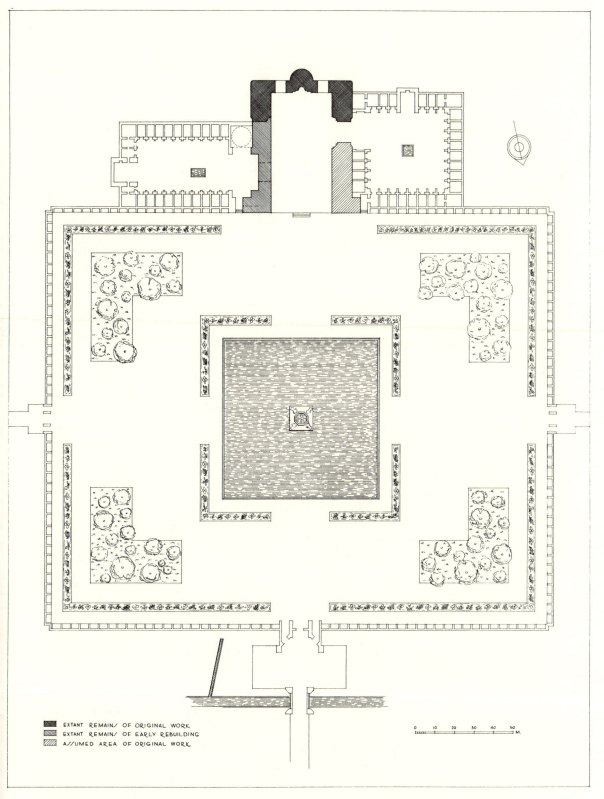

EXTANT REMAINS OF ORIGINAL WORK
EXTANT REMAINS OF EARLY REBUILDING
ASSUMED AREA OF ORIGINAL WORK

0 10 20 30 40 50
M.

30. CAT. NO. 51. Tabrīz. Restored plan of the Masjid-i-Jāmi' of 'Alī Shāh and neighboring structures

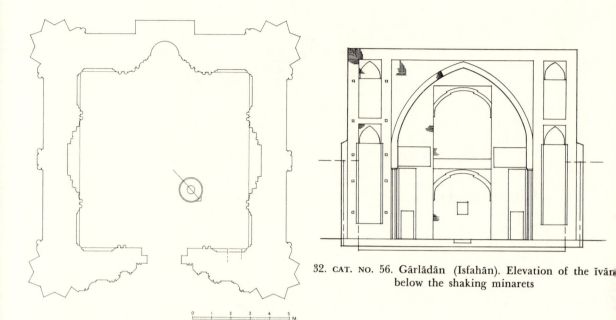

32. CAT. NO. 56. Gārlādān (Isfahān). Elevation of the īvān below the shaking minarets

31. CAT. NO. 55. Hamadān. Plan of the Gunbad-i-'Alayivan

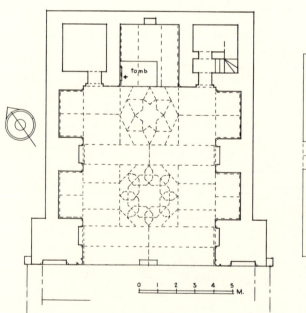

33. CAT. NO. 56. Gārlādān (Iṣfahān). Plan of the īvān below the shaking minarets

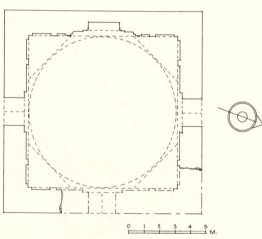

34. CAT. NO. 59. Abarqūh. Plan of the tomb of al-Ḥasan ibn Kay Khusraw

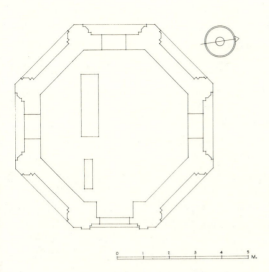

35. CAT. NO. 68. Iṣfahān. Plan of the Imāmzāda Ja'far

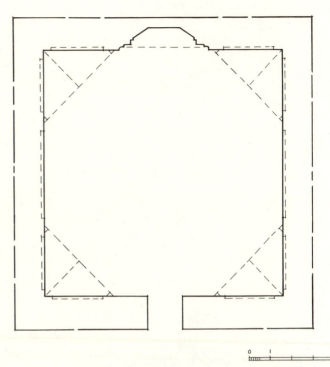

36. CAT. NO. 67. Yazd. Plan of the tomb of Sayyid Rukn ad-dīn

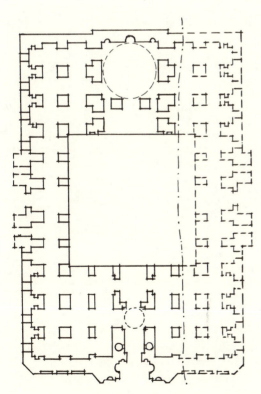

37. CAT. NO. 64. Varāmīn. Plan of the
Masjid-i-Jāmi' (after Sarre)

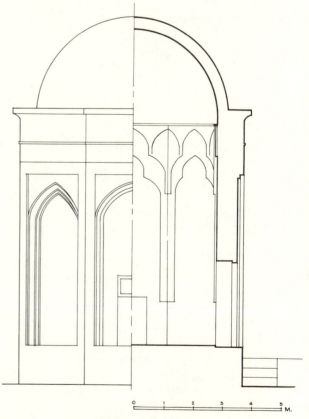

38. CAT. NO. 68. Iṣfahān. Combined elevation and section
of the Imāmzāda Ja'far

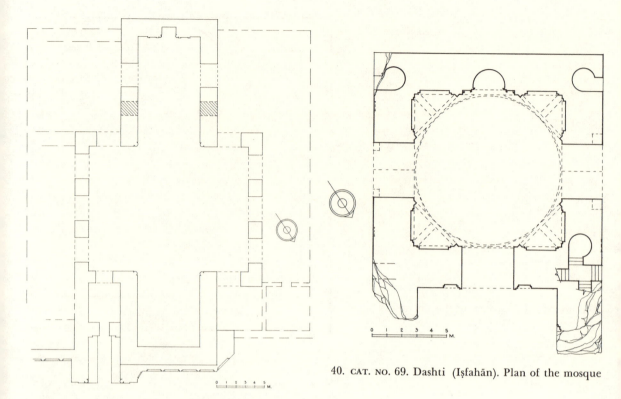

39. CAT. NO. 61. Farūmad. Plan of the Masjid-i-Jāmiʻ.
Single hatching represents blocking of the Il Khānid period
in original portals of Seljūq period

40. CAT. NO. 69. Dashti (Iṣfahān). Plan of the mosque

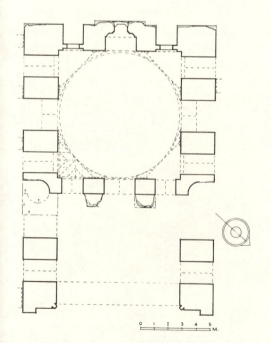

41. CAT. NO. 70. Kāj (Iṣfahān). Plan of the mosque

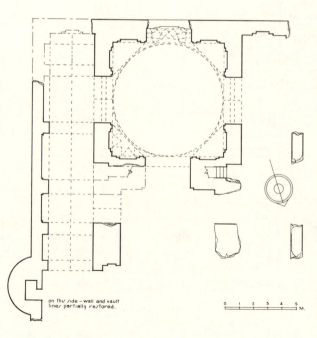

on this side – wall and vault
lines partially restored.

42. CAT. NO. 71. Eziran (Iṣfahān). Plan of the mosque

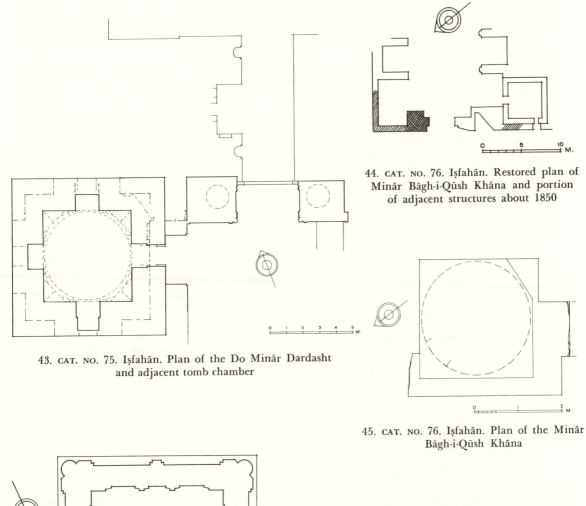

44. CAT. NO. 76. Iṣfahān. Restored plan of
Minār Bāgh-i-Qūsh Khāna and portion
of adjacent structures about 1850

43. CAT. NO. 75. Iṣfahān. Plan of the Do Minār Dardasht
and adjacent tomb chamber

45. CAT. NO. 76. Iṣfahān. Plan of the Minār
Bāgh-i-Qūsh Khāna

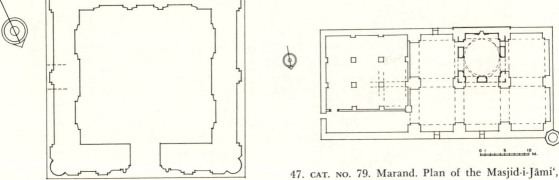

47. CAT. NO. 79. Marand. Plan of the Masjid-i-Jāmi',
with early walls shown in heavy poché lines

46. CAT. NO. 78. Maragha. Plan of the Gunbad-i-Ghaffāriya.
Broken lines show location of crypt portal

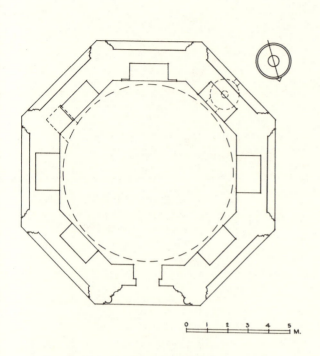

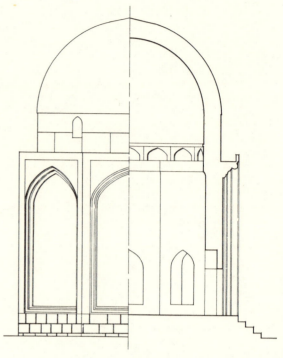

48. CAT. NO. 80. Sulṭāniya. Plan of the tomb of Chelebi Oghlu

49. CAT. NO. 80. Sulṭāniya. Combined elevation and section of the tomb of Chelebi Oghlu

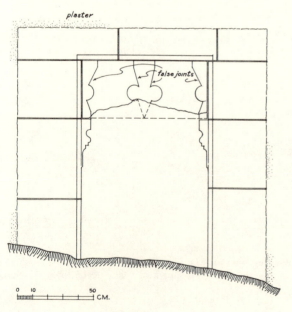

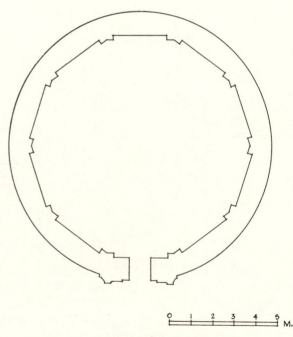

50. CAT. NO. 80. Sulṭāniya. Detail of a cut stone portal in the complex adjacent to the tomb of Chelebi Oghlu

51. CAT. NO. 82. Marāgha. Plan of the Joi Burj

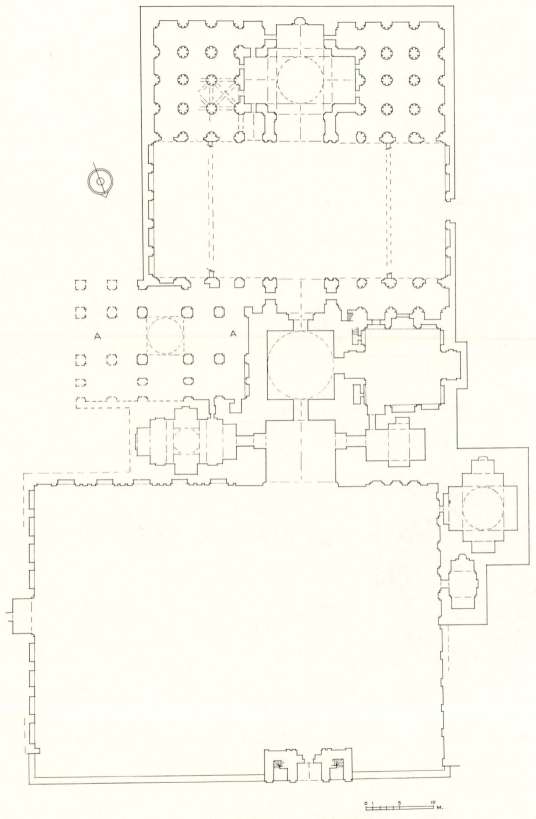

52. CAT. NO. 81. Turbat-i-Shaykh Jam. Plan of the shrine complex
with the area constructed about 1330 labeled "A"

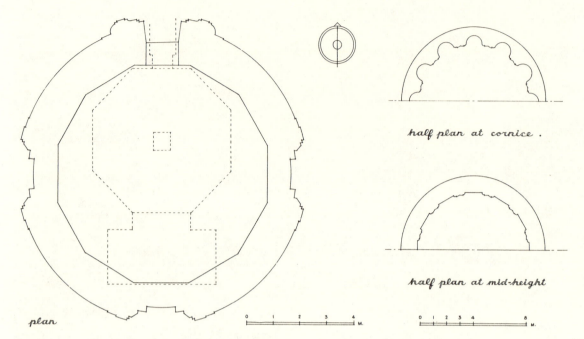

half plan at cornice.

half plan at mid-height

plan

53. CAT. NO. 83. Khiav. Plans—at different levels—of the tomb of Sulṭān Haidar

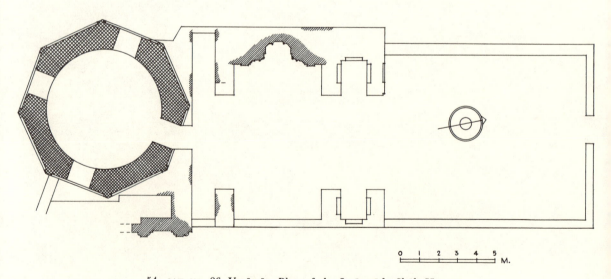

54. CAT. NO. 86. Varāmīn. Plan of the Imāmzāda Shāh Ḥusayn

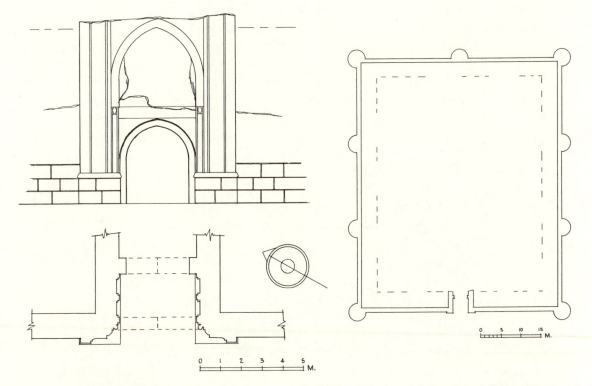

55. CAT. NO. 85. Marand (vicinity). Plan of the caravanserai with detailed plan and elevation of the entrance portal

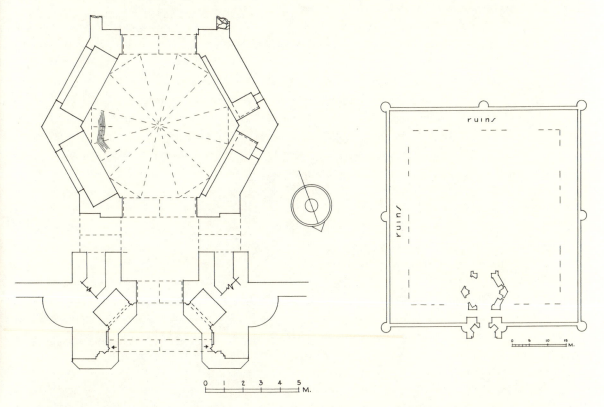

56. CAT. NO. 89. Sīn (Iṣfahān). Plan of the caravanserai, with detailed plan of the entrance area

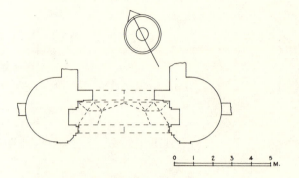

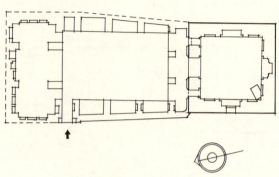

57. CAT. NO. 90. Sarcham. Plan of the entrance portal
of the caravanserai

58. CAT. NO. 105. Āzādān (Iṣfahān). Plan
of the Masjid-i-Gunbad

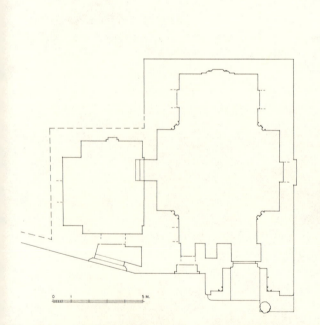

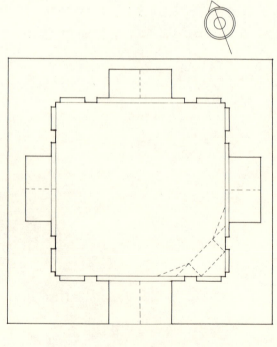

59. CAT. NO. 95. Iṣfahān. Plan of the Imāmzāda Bābā Qāsim

60. CAT. NO. 106. Iṣfahān. Plan of the mausoleum
of Khwāja Saʻd